PRODUCING

BEHIND
THE SILVER
SCREEN

BEHIND THE SILVER SCREEN

When we take a larger view of a film's "life" from development through exhibition, we find a variety of artists, technicians, and craftspeople in front of and behind the camera. Writers write. Actors, who are costumed and made-up, speak the words and perform the actions described in the script. Art directors and set designers develop the look of the film. The cinematographer decides upon a lighting scheme. Dialogue, sound effects, and music are recorded, mixed, and edited by sound engineers. The images, final sound mix, and special visual effects are assembled by editors to form a final cut. Moviemaking is the product of the efforts of these men and women, yet few film histories focus much on their labor.

Behind the Silver Screen calls attention to the work of filmmaking. When complete, the series will comprise ten volumes, one each on ten significant tasks in front of or behind the camera, on the set or in the postproduction studio. The goal is to examine closely the various collaborative aspects of film production, one at a time and one per volume, and then to offer a chronology that allows the editors and contributors to explore the changes in each of these endeavors during six eras in film history: the silent screen (1895–1927), classical Hollywood (1928–1946), postwar Hollywood (1947–1967), the Auteur Renaissance (1968–1980), the New Hollywood (1981–1999), and the Modern Entertainment

Marketplace (2000–present). *Behind the Silver Screen* promises a look at who does what in the making of a movie; it promises a history of filmmaking, not just a history of films.

Jon Lewis, Series Editor

1. ACTING (Claudia Springer and Julie Levinson, eds.)

2. ANIMATION (Scott Curtis, ed.)

3. CINEMATOGRAPHY (Patrick Keating, ed.)

4. COSTUME, MAKEUP, AND HAIR (Adrienne McLean, ed.)

5. DIRECTING (Virginia Wright Wexman, ed.)

6. EDITING AND SPECIAL/VISUAL EFFECTS (Charlie Keil and Kristen Whissel, eds.)

7. PRODUCING (Jon Lewis, ed.)

8. SCREENWRITING (Andrew Horton and Julian Hoxter, eds.)

9. ART DIRECTION AND PRODUCTION DESIGN (Lucy Fischer, ed.)

10. SOUND: DIALOGUE, MUSIC, AND EFFECTS (Kathryn Kalinak, ed.)

PRODUCING

Edited by Jon Lewis

RUTGERS
UNIVERSITY PRESS
New Brunswick, New Jersey

Library of Congress Cataloging-in-Publication Data
Producing / edited by Jon Lewis.
 pages cm. . — (Behind the silver screen ; 7)
Includes bibliographical references and index.
ISBN 978–0–8135–6722–8 (hardcover : alk. paper) — ISBN 978–0–8135–6721–1
(pbk. : alk. paper) — ISBN 978–0–8135–6723–5 (e-book (web pdf)) —
ISBN 978–0–8135–7532–2 (e-book (epub))
 1. Motion pictures—Production and direction. 2. Motion picture industry.
 I. Lewis, Jon, 1955– editor.
PN1995.9.P7P745 2015
791.4302'3—dc23

2014049331

CONTENTS

Acknowledgments ix

Introduction Jon Lewis 1

1. **THE SILENT SCREEN,** 1895–1927 Mark Lynn Anderson 15

2. **CLASSICAL HOLLYWOOD,** 1928–1946 Joanna E. Rapf 36

3. **POSTWAR HOLLYWOOD,** 1947–1967 Saverio Giovacchini 63

4. **THE AUTEUR RENAISSANCE,** 1968–1980 Jon Lewis 86

5. **THE NEW HOLLYWOOD,** 1981–1999 Douglas Gomery 111

6. **THE MODERN ENTERTAINMENT MARKETPLACE,** 2000–Present

Bill Grantham and Toby Miller 131

Academy Awards for Producing 151

Notes 157

Selected Bibliography 177

Notes on Contributors 183

Index 185

ACKNOWLEDGMENTS

As the editor of this volume and of the *Behind the Silver Screen* series, the ambitious history of Hollywood craft to which this book on producing contributes, I have worked closely with Leslie Mitchner, editor-in-chief and associate director of Rutgers University Press. We are, at this writing, over two years into the project, enough time for me to fully appreciate her considerable editorial, intellectual, and practical contributions to the series. Leslie is a smart and careful editor with a keen understanding and appreciation of film history. She is also a warm and considerate person. Throughout this project I have enjoyed a stimulating relationship with her.

For this book, I was either lucky or smart or both in my selection of contributors. Beginning with the very first drafts, the scholarship has been first rate. And throughout the venture all of the contributors have been willing to revise and redraft to suit the series guidelines and my own fairly aggressive line editing. So, big thanks here to Mark Anderson, Joanna Rapf, Saverio Giovacchini, Douglas Gomery, Toby Miller, and Bill Grantham. I would welcome the opportunity to work with any and all of you again.

The staff at Rutgers University Press has been terrific. Thanks here to Lisa Boyajian, Marilyn Campbell, and Anne Hegeman for their editorial, production, and design expertise, and to Eric Schramm for the careful copyediting.

Finally, I acknowledge the considerable contributions of Martha Lewis, first for her design help: the series logo is hers, as is the cover design for this book. For this volume and others in the series, all sorts of design and production decisions were run by and through her. These significant contributions are a lovely bonus in what has been a thirty-year love affair that has made life and work and whatever else there is so much fun for so long.

PRODUCING

INTRODUCTION Jon Lewis

Of all the job titles listed in the opening and closing screen credits, "producer" is certainly the most amorphous. There are businessmen producers (and businesswomen producers), writer- director and movie-star producers; producers who work for the studio or work as a liaison between a production company and the studio; executive producers whose reputation and industry clout alone gets a project financed (though their day-to-day participation in the project may be negligible); and independent producers whose independence is at once a matter of industry structure (as the studios no longer produce much of anything anymore) and only and always relative, as they are dependent upon the studios for the distribution of "their" product into the marketplace. Some producers are credited—though the credits themselves tell us little, as titles like producer, executive producer, and associate producer often overlap and are used interchangeably. Producer credits may appear above the title or under it. Through much of the classical era, those employed by the studio's production department were not credited at all even if they shepherded a project from development through release. The job title, though, regardless of the actual work involved, warrants a great deal of prestige in the film business; it is the credited producers, after all, who collect the Oscar for Best Picture. But what producers do and what they don't or won't do varies from project to project.

For example, the Best Picture winner at the 2014 Academy Awards ceremony was *12 Years a Slave,* for which the producers Brad Pitt, Dede Gardner, Jeremy Kleiner, Steve McQueen, and Anthony Katagas received Oscars. Two of the names in that list were familiar to a casual filmgoer watching the Oscar show on television: the movie star Brad Pitt and the film's director Steve McQueen. While at least part of their job during the production was something we could safely guess at—Pitt acted in the film and McQueen directed—what exactly got them a producer's credit is something about which we can only venture an educated guess. So, making such an educated guess, we begin with Pitt's willingness to play an onscreen role in the film and what this appearance means at the so-called favor bank that governs industry operations. His onscreen presence no doubt helped attract financing and got the prospective filmmakers an audience at the studios, even with such a risky commercial venture as *12 Years a Slave.* McQueen's creative role from development through release was likely significant, but, here again making an educated guess, it was the contract negotiated by his agent (who got thanked in McQueen's acceptance speech, quoted below) that secured for the filmmaker the producer's credit.

A little research into the other credited producers tells us a bit about who they are, but not about what they did on the film. Gardner works for Pitt's production company, Plan B, and has received production credit for most of Pitt's films since 2007, beginning with *The Assassination of Jesse James by the Coward Robert Ford* (Andrew Dominick). Kleiner is also an executive at Plan B, and he became the company's co-president (with Gardner) after production on *12 Years a Slave* was complete.[1] Katagas is not a Plan B employee. His production expertise ranges over sixty films, mostly for boutique independents, films made for the art-house studio subsidiaries Miramax (owned by Disney), Focus (owned by Universal), as well as IFC (which is a subsidiary of the conglomerate AMC Networks). While we again have to guess at what Katagas did to "produce" the film, his inclusion in the production team—and *team* is a key term here—suggests that the picture was targeted at least in part at the art-house audience served by the companies with whom Katagas had established relationships.

In an industry in which ego plays such a significant role, screen credit today is mostly a matter of contract. The names that run at the end of every feature speak to the elaborate network of union or guild-contracted agreements that guarantee cash and credit for a proper day's work. The lone exception to such contracted agreements remains the producer, for whom screen credit may not indicate much about what or how much of the movie he or she "produced." The precise role played by the various members of the production team for *12 Years a Slave,* for example, was never elaborated in the press generated around the film. This omission was very much by design and followed a tradition within the production community dating back to the classical or studio era, when a film's success was first and foremost a matter of the studio's accomplishment as a whole, as a

process, as a mode of production and a business plan. In 2014, conspicuous in their absence on stage at the Dolby (formerly the Kodak) Theater on Oscar night was anyone from the Twentieth Century Fox Film Corporation, the studio that distributed the picture worldwide. But in the larger scheme of the film business today, *12 Years a Slave* nonetheless contributed to the greater glory of the studio, again because the specifics of production are so amorphous, and because the Fox logo at the start of the picture signals the studio's ownership of the title (and copyright) and thus trumps all and sundry claims to its creative production.

Predictably, Pitt was first in line to make an acceptance speech at the Oscar ceremony: "Thank you all. Thank you for this incredible honor you bestowed on our film tonight. I know I speak for everyone standing behind me [McQueen, Gardner, Kleiner, and Katagas] that it has been an absolute privilege to work on Solomon's story. And we all get to stand up here tonight because of one man who brought us all together to tell that story. And that is the indomitable Mr. Steve McQueen." Gracious as Pitt's remarks may be in giving credit to the director of the film, to whom the movie star quickly relinquished center stage and the microphone, the carefully scripted remark regarding the "one man who brought us all together" also serves to obscure McQueen's sole authorship and his role as one of the movie's producers. What McQueen brought together was a production team, after all, headed initially by Pitt's Plan B, and the story they tell is Solomon's, that is, the man who spent twelve years as a slave, Solomon Northup, whose published account (as told to David Wilson) is the source and inspiration for the film.[2]

McQueen's comments further obscure credit for the production, as he too emphasizes the collaborative process, one that can be traced back to his childhood:

> There are a lot of people for me to thank. . . . My wonderful cast and crew, Plan B, Brad Pitt, who without him this film would just not have been made. Dede Gardner, Jeremy Kleiner, and Anthony Katagas. River Road, Bill Pohlad, New Regency, Arnon Milchan and Brad Weston. Film4, to the great Tessa Ross. And Fox Searchlight, Steve Gilula and Nancy Utley, and their fantastic team. . . . My publicist Paula Woods, I'm sorry about this, for her hard work. April Lamb, and my magnificent agents. I have to say this to all these women, I have all the women in my life and they're all the most powerful. And my mother, obviously. Maha Dakhil—I can't even pronounce it. Maha, I'm nervous, I can't pronounce your name, you know who you are—Beth Swofford, Jenne Casarotto, and Jodi Shields. I'd like to thank this amazing historian, Sue Eakin, whose life, she gave her life's work to preserving Solomon's book. I'd like to thank my partner, Bianca Stigter, for unearthing this treasure for me. Finally, I thank my mother. My mum's up there. Thank you for your hard-headedness, Mum, thank you. And my children, Alex and Dexter. And my father, thank you. . . . The last word: everyone deserves not just to survive, but to live. This is

the most important legacy of Solomon Northup. I dedicate this award to all the people who have endured slavery. And the 21 million people who still suffer slavery today. Thank you very much. Thank you.[3]

Tucked into this otherwise deferential and humble acceptance speech is an explicit affirmation of the collaborative process, for without the help of collaborators whose contributions range from the professional to the personal, what turned up on the screen would not have been possible.

Film scholarship in cinema studies depends upon the spirit if not the letter of the auteur theory that acknowledges the director's authorship as a first step toward recognizing cinema as an art form (like literature, painting, and so on). But film production is so complex and collaborative that such a formulation has proven to be little more than a convenient and necessary fiction. André Bazin acknowledges this complexity when he celebrates the genius of the auteur in his formative essay "La politique des auteurs": "And what is genius anyway if not a certain combination of unquestionably personal talents, a gift from the fairies, and a moment in history." It's a moment in history, Bazin implies, that must be seized in a system rigged against the director, in a system in which such a *carpe diem* is temporary, relative, and partial.[4]

Indeed, while it's fashionable in film histories to counterpoint Bazin's formulation for auteurism (and, by extension, that of the journal he edited, *Cahiers du Cinéma*) with Thomas Schatz's groundbreaking *The Genius of the System—* because the latter challenges auteurism to acknowledge the production (and studio) system—at bottom both Bazin and Schatz recognize the significance of collaborative effort.[5] As Schatz writes in an essay on Warner Bros. in the classical era: "Ultimate authority belonged to the owners and management executives, of course, whose primary goal was to make movies as efficiently and economically as possible. But the impulse to standardize and regulate operations was countered by various factors, especially the need for innovation and differentiation of product, the talents and personalities of key creative personnel."[6] In the very act of recognizing the struggle inherent to movie production, both Bazin and Schatz, albeit to different ends, problematize credit for production, and in doing so set up the fundamental challenge for the contributors to this book: what do producers produce, exactly? And why is it important to film scholarship to tell their (hi)story?

What Producers Produce

Film scholars as well as popular movie reviewers routinely affirm the division of labor in film production according to a simple dialectic; that film production is rigidly divided between financial and creative tasks, and while the director

supervises the art of the motion picture, the producer manages the industrial, commercial enterprise. Such a reductive assumption rather diminishes the complexity of the producer's work. Producers raise money and supervise development, production, and/or post-production; they procure a script or book or "pre-sold property" (like a popular comic book or young adult novel); and they are on hand at the beginning and then not at the end, or join the project late and work with the studio to help get the film into theaters in the United States and abroad.

If producers are a necessary evil, then we need to recognize that they are at the very least necessary. And while producers have historically struggled with directors to produce what we see onscreen, as Schatz affirms, that struggle in and of itself speaks volumes on a production process that is pinned upon the give and take between the creative and the practical, the artistic and the institutional.

So here at the start we begin with the following formulary: moviemaking can appear complex and fundamentally disorganized—spend a little time on a movie crew, spend a few minutes on a city sidewalk, and watch what goes into a single on-location take—but it is nonetheless a process in which most of the crafts or jobs are by union agreement and by tradition narrowly defined. The writer writes. The actor acts. The cinematographer lights the set. What distinguishes producers from the ranks of such delineated crafts is that he or she may be involved in and may be responsible for several aspects of the movie project at once. A producer on *12 Years a Slave* may have performed tasks quite different from what a producer of a previous Best Picture winner did, while still receiving the identical screen credit.

The challenge, then, for this volume is to assess what producers actually do, or, more to the point, what producers actually *did* during each of the six eras covered in the chapters that follow. Of interest are trends and customs in industry production, as well as a wide range of production tasks and job descriptions under the same rather flexible job title.

During the first twenty years of American moviemaking, the producer was the person who either invented or controlled the patent on the equipment used to produce and exhibit movies. The advent of studio production later in this era brought with it the first wave of producer-moguls. In the classical era, producer-moguls solidified control over industry production and thus established so-called studio styles, which adhered not to the particular talents or tastes of director-auteurs, but to executives' larger notions of what composed commercially and artistically successful moviemaking. While this was the era in which studio production was more organized than ever before or since, and also the era in which studio producers had significant roles in a project's progression from development to exhibition, most of these production executives opted not to take screen credit for their work, thus complicating the task of historicizing the role of movie producer. Irving Thalberg, for example, "produced" nearly 100 titles, but declined to take screen credit as producer for any of these films.

The role of the producer during Hollywood's so-called transition era (1947–1967) changed yet again as the studio system unraveled in the wake of two significant destabilizing events: the Blacklist and the Paramount Decision. While studio fare faltered at the box office, a cast of independent, international producers moved the industry toward greater conglomeration and globalization. The following decade saw a sea change in the public image of the producer as the industry briefly embraced the auteur theory, not so much as film scholars viewed it—as a historical principle—but instead as a merchandising strategy. As directors gained in prestige and power, studio producers appeared to take a back seat. But despite this temporary shift in power from the institutional to the independent and creative, the producer in 1970s Hollywood still played a significant role in movie production.

As the industry moved into the blockbuster era, and as high-concept, pre-sold properties remade Hollywood into a producer's industry once again, the producer him- or herself became an auteur of sorts. Moreover, the studios had by 1980 all become subsidiaries of diversified conglomerates or had become, in and of themselves, entertainment industry conglomerates, headed by executive teams that viewed films as no different from other consumer products. And in the twenty-first century Hollywood has seen a shift away from American studio-bound filmmaking into an industry better suited to a global and globalized market. Producers in this era are no longer industry players per se, but talented middle-men who view movie production as just one iteration (one format, one aspect) in a complex engagement and agreement struck between media conglomerates and their subsidiaries and partners in parallel industries in the United States and overseas. The successful producer in this era is the man or woman who can negotiate an industry characterized by synergistic relationships between companies that may or may not have much filmmaking or film marketing experience, companies that may or may not be headquartered in the United States. Of interest, then, are not individual producers, but instead the larger system in which private capital and public money is complexly used by these intermediaries to support a system of manufacture that complicates the very notion of cultural production.

How Producers Produce

The job title of film producer dates to the turn of the twentieth century, an era in which movie production was an extension and an expression of the age of invention as well as a manifestation of its rapid accommodation by American enterprise and industrial manufacture. In 1891, after securing the patent for his kinetograph, the photographic apparatus that produced "moving pictures," and his kinetoscope, the "peep-show" viewing machine that exhibited the crude new

FIGURE 1: Thomas Edison's 1893 moving picture *Blacksmith Scene.*

visual medium, Thomas Edison became the industry's formative producer and its first celebrity. It was his apparatus or invention that first attracted crowds to the Brooklyn Institute of Arts and Sciences in May 1893, the place and date of the first public exhibition of moving pictures. Attendees viewed a number of short kinetoscope programs, including *Blacksmith Scene,* which showed three men, all Edison employees, hammering on an anvil for approximately twenty seconds. It is important to note here that the demonstration of the new technology eclipsed the attraction of the movies it produced. And Edison, the inventor and entrepreneur, was the event's one true star, not the actors or the men who photographed them. The producer credit here was aptly termed; he was the man who conceived of and supervised the invention, the man who owned the company and the patent, the man who stood to profit from the corporate enterprise.

A photograph run in a number of American newspapers in 1893 provided a formal announcement for the invention. It shows Edison seated behind two tables on which rested an Edison-prototype movie camera and an assortment of lenses. In the photograph, Edison looks back at the photographer and half-heartedly appears to be operating the machinery. A close look at the newspaper photograph today tells a more complex story. A signature at the bottom of the image reveals the photograph's producer, the photographer who took the picture: W.K.L. Dickson, an Edison employee and a primary creative force behind the development of moving picture technology. Dickson would later produce movies in addition to staging and photographing several Edison-produced short subjects, but he was

FIGURE 2: The industry's first producer, the inventor and entrepreneur Thomas Edison, appearing here in the Edison Manufacturing Company short film *Mr. Edison at Work in His Chemical Laboratory* (1897).

never granted credit as these films' producer. Edison took credit for the invention, which many contend was in large part Dickson's as well, because, like Henry Ford, a fellow turn-of-the-twentieth-century entrepreneur, he owned the means and thus the mode of production. Later Edison would take credit for the device's eventual productions, though Dickson, William Heise, and James White were the hands-on producers while Edison was the company figurehead of the aptly named (in the spring of 1894) Edison Manufacturing Company. As the name makes clear, Edison's business model focused on the making and selling of his kinetoscope and kinetograph equipment, not on any form of cultural or artistic production.

In 1894, about the time the first kinetoscope parlors opened in the United States, two brothers in the photographic equipment business in France, Auguste and Louis Lumière, patented their motion picture camera. The Lumière's cinematographe was a more portable and practical machine than Edison's. It combined camera, film processor, and projector in a single unit, and ran at 16 frames per second (fps), the eventual standard for silent film. In March 1895, the Lumière brothers showcased their cinematographe to an invitation-only audience in Paris. Nine months later, they rented out a basement room in the Grand Café on the Boulevard des Capucines in Paris and in doing so became the first filmmakers to screen a program of projected motion pictures to a paying audience. Two months after the Lumière's Grand Café show, the British-born engineer Robert

Paul, using a projector of his own design, exhibited his first motion pictures in London. With cameraman Birt Acres, Paul produced a series of documentaries that captured quintessentially English events and scenes: *Oxford and Cambridge University Boat Race, The Derby* (a popular horse race), and *Rough Sea at Dover* (all 1895). The birth of the film producer was rooted internationally in industrial manufacture, with the products subsumed in the excitement generated by the inventions and by the inventors.

The first move toward a consolidated, modernized movie industry in the United States came in 1908 when a cartel headed by Edison—the Motion Picture Patents Company, or MPPC—exploited certain industrial patents to monopolize the production and distribution of American movies. The MPPC tried to make cinema fit Fordist principles of standardization and efficiency, but in the end the trust's membership failed to understand and appreciate the medium's audience. By the middle of the second decade of the twentieth century, the MPPC had already lost its control over the industry and in its place arose another cartel, a group of first-generation immigrants, men quite like the audience they served, who ventured west and "invented" Hollywood. They too adopted a Fordist mode of production, organizing labor to accommodate an increasingly large, complex, and collaborative workforce. The studio or contract system that film historians now refer to as classical Hollywood was designed primarily to enable production of such an expensive and complicated product as feature films.

In the classical era, movies were still fundamentally viewed as industrial products or productions, so credit for a given work privileged industrial and copyright ownership over individual creative inspiration. However important to the final product a studio assembly-line worker like a costume designer or film editor might have been to a complete moving picture, the company these workers worked for took primary credit. The moving picture logo showing Leo the lion, for example, identified MGM as the studio producer of a film, although neither the lion nor the studio moguls who ran the studio actually made the movie.

With the evolution of studio styles—Warner Bros.' gritty realism, the opulent musicals at MGM, the ensemble comedies at Paramount, for example—came an affirmation, within Hollywood at least, of the creative input of the movie producer. What he (and it was almost exclusively men in the classical era) produced was up there on screen, but how exactly he did what he did—well, that was subsumed in "the magic of the movies." And the magician never divulges how his trick is performed. Indeed, fostered during this era was the aura of the businessman, a tycoon who somehow kept the whole picture (here meant literally and figuratively) in his head.

When the American writer F. Scott Fitzgerald tried to capture the essence of the studio-era producer in *The Love of the Last Tycoon,* he created the character

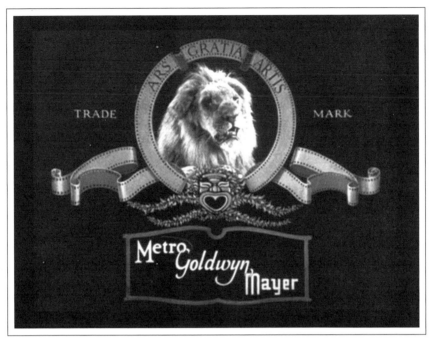

FIGURE 3: The MGM logo affirmed industrial and copyright ownership as the film unspooled. Collaborative credit for production was implied. The film was "produced" by the studio for which individual artists and artisans all worked under contract.

of Monroe Stahr, a man of little formal education but uncanny instinct. Stahr was based on Irving Thalberg, MGM's so-called boy wonder, with whom Fitzgerald had rubbed elbows in Hollywood in the late 1920s. One particular encounter in the commissary at Metro stuck with Fitzgerald, and it's worth recounting here because of how well it defines the public image of the classical Hollywood movie producer. Fitzgerald highlights the connection between business acumen and creative enterprise, that peculiar combination of talents deemed essential to the successful Hollywood producer in the classical era. Fitzgerald recalled Thalberg's commissary monologue as follows:

> Scottie, supposing there's got to be a road through a mountain—a railroad and two or three surveyors and people come to you and you believe some of them and some of them you don't believe; but all in all, there seems to be half a dozen possible roads through those mountains each one of which, so far as you can determine, is as good as the other. Now suppose you happen to be the top man, there's a point where you don't exercise the faculty of judgment in the ordinary way, but simply the faculty of arbitrary decision. You say, "Well, I think we will put the road there," and you trace it with you finger and you know in your secret heart and no one else knows, that you have no reason for putting the road there

rather than in several other different courses, but you're the only person that knows that. You don't know why you're doing it and you've got to stick to that and you've got to pretend that you know and that you did it for specific reasons, even though you're utterly assailed by doubts at times as to the wisdom of your decision because all these other possible decisions keep echoing in your ear. But when you're planning a new enterprise on a grand scale, the people under you mustn't ever know or guess that you're in any doubt because they've all got to have something to look up to and they mustn't ever dream that you're in doubt about any decision. Those things keep occurring.[7]

Over half a century later, the movie producer Lynda Obst seemed to channel Thalberg and Fitzgerald's Stahr when she opined that 1980s-era producers "tend to have decisive personalities for no other reason than they need to be expedient more often than most other people. Decisive personalities are attracted to power and these personalities tend to err on the side of preemptive decision making, as in: Any decision is better than no decision at all."[8] While Obst offers little clarification on *what* producers actually do, *how* they do (what they do) comes down to the same peculiar business and creative confidence Thalberg lauded to Fitzgerald, the same basic methodology: decide on a course of action and stick to it to the bitter end. It is a business mantra certainly suited to such a speculative industry and, not incidentally, also à propos to a peculiarly American trait frequently extolled in a medium that loves decisive heroes who "shoot from the hip."

Such heroic figures may well have become obsolete in twenty-first-century Hollywood, in an industry that adheres to a business model in which producers primarily mediate relationships between the private and public sectors, between and among parallel industries, venues, and formats. What exactly producers produce has never been more difficult to discern. If iconic models such as those Thalberg and Obst describe above persist at all in contemporary Hollywood, it is at the margins of the industry, in the boutique studios and conditionally independent film outfits like Focus and Miramax, epitomized by James Schamus and Harvey and Bob Weinstein.

A Book on the History of Movie Producing

In the chapters that follow, we begin with producer-inventors (Edison), then work through producer-moguls (Darryl Zanuck, Carl Laemmle, Louis B. Mayer), producer-entrepreneurs (Walt Disney), producer-showmen (David O. Selznick, Joseph E. Levine), producer-industry players (Lew Wasserman, Robert Evans), and producer-independents (Samuel Z. Arkoff, Julia Phillips, Dino De Laurentiis,

Stacey Sher). Each of the chapters independently defines and redefines the role of the producer in the moviemaking process. As Mark Lynn Anderson points out in the opening chapter, "To study the producer is to study the industry itself—the industry understood as an expression of a calculating intelligence." Such a "calculating intelligence" leads significantly away from individual contribution—which, with regard to the producer, is often uncertain and routinely debated among those laying claim to a picture's successes and failures—and toward that "genius of the system" Thomas Schatz writes about. The role of the producer within that system is at once amorphous and crucial—a challenge that all the contributors to this volume have taken on.

So, to be clear: the chapters here all focus on producing movies. And they go about that project with varying degrees of attention to specific producers. Anderson's opening chapter establishes an important historical frame for producing movies at a moment when films were quite clearly the products of a newly invented, speculative business. So far as credit for movie productions was affixed at all, corporate ownership and/or the control of patents and copyrights were the determining factors. The transition from producer-owners to producer-managers in the 1910s and 1920s maintained these corporate-based distinctions and emphasized, especially in industry public relations, the acumen of the men and women who seemed to be uniquely capable of balancing the complex financial and creative aspects of this industrial art.

As Joanna E. Rapf notes in the second chapter, the history of producing in the classical era was very much the history of studio producers, so-called moguls who viewed screen credit for their work as at once unnecessary and a bit unseemly. Studio styles attested to these producers' abilities to manage a vast workforce to create a consistent product. The particular tasks these moguls performed as movie producers began in the development stage and ended in exhibition, framed by the monopoly system over which they presided.

The unraveling of the studio system after the Second World War fundamentally unsettled movie production. In 1947, the hearings conducted by the House Committee on Un-American Activities and the Blacklist that followed destabilized the industry workforce. And the Paramount Decision the following year forced the studios to divest their strategic financial interests in exhibition, and in doing so undermined a half-century-old business plan. As Saverio Giovacchini elaborates in his chapter on this transitional era, as the studios got out of the business of producing films, creative showmen and presenters, independents, and self-styled industry outsiders like Joseph E. Levine came on the scene to fill that role.

It is one of the curious ironies of American film history that individual, even independent producers reemerged with celebrity and clout during the so-called auteur renaissance, that decade-long golden age for the Hollywood director. Despite the celebration of the auteur by critics as well as studio marketers in the 1970s, as I point out in the fourth chapter of this book, producers played

significant roles in production in part because the balance between artistic inspiration and financial responsibility had never in the history of American cinema been more crucial to the final product. Robert Evans, Paramount's head of production and hands-on producer during the auteur era, sets the scene: "It's the producer whose vision (which he then shares with others) eventually ends up on the screen. He's the one who hires the writer and director. When a director hires a producer you're in deep shit. A director needs a boss, not a yes man."[9] However self-serving such an account may be, it reveals how in the seventies auteurism restored the essential and, as Schatz suggests, contentious relationship between the director and the producer, a relationship that, in the 1970s, at least, was quite clearly organized along creative and commercial lines.

The advent of the modern blockbuster in the 1980s, Douglas Gomery notes in the next chapter, was defined and refined by the last of the old-school studio moguls, Lew Wasserman. But as Wasserman learned after corporate reshuffling and a few bad films cost him control over what had been his company, his earlier success came at a price. While the eighties and nineties saw a dramatic continuation of Hollywood's box office triumphs, the increasingly corporatized studios seemed to grope in search of a stable business plan. The producer-turned-studio executive David Puttnam tried to reinvent the studio process at Columbia and failed. Coca-Cola attempted to impose a more predictable, corporate production system at the same studio (emphasizing producing while diminishing the role of the producer), but soon thereafter sold the company and got out of the movie business forever. The producers worth noting in this era, Gomery contends, were those like Stacey Sher, who, following Wasserman's model as a former talent agent, packaged projects independently and then sold them to the studios for financing and distribution.

Toby Miller and Bill Grantham point out in the final chapter that as the investment in increasingly expensive movie blockbusters became the norm in Hollywood, the notion of the studio or independent movie producer as sole owner, manager, facilitator, and visionary became obsolete. To put things in perspective, the authors refer us to a provocative argument posed by Adam Davidson for the *New York Times* in June 2012: "For the cost of *Men in Black 3* [Barry Sonnenfeld, 2012], . . . the studio [Sony] could have become one of the world's largest venture-capital funds, thereby owning a piece of hundreds of promising start-ups. Instead, it purchased the rights to a piece of intellectual property, paid a fortune for a big star and has no definitive idea why its movie didn't make a huge profit. Why is anyone in the film industry?"[10] The answer to Davidson's question is there in the asking, so to speak; with greater risk comes greater reward. It is sobering, I think, to discover from Miller and Grantham's chapter that cinema history has come full circle. In the 2010s as in the 1910s, producing is a matter of corporate ownership, patent, and copyright control, access to private and public capital, and leverage on Wall Street and in Washington, DC.

A Last Word on Producers

Just as we must acknowledge the lack of specificity inherent to the title "movie producer," we need to recognize the role movie producers have played over the past century in the collective imaginary of Hollywood. Indeed, despite a lack of specificity or consistency in their roles in such a glamorous industry, a number of movie producers have become celebrities, larger-than-life "characters" in the many ways that word has come to be understood. One example was Don Simpson, who, with his partner Jerry Bruckheimer, became one of the premier action-film, high-concept producers in modern Hollywood.

In a tribute written after Simpson's sudden death in January 1996, the American novelist and screenwriter John Gregory Dunne, given the choice of celebrating the man or the legend, made clear that with regard to Hollywood producers the distinction is never so clear. "In the biographical narrative Simpson provided," Dunne writes, qualifying what follows as a certain fiction just as he repeats it, "he was the son of stern Baptist parents . . . he carried a flight bag holding a split of champagne, a stash of cocaine, and a loaded handgun . . . he dressed entirely in black, and claimed not to wear his Levis past the first washing . . . the classier Hollywood madams—Heidi Fleiss and Mme. Alex—were always ready to give him a character reference."[11] With such a story, who would want to quibble about fact and fiction?

Simpson produced *Flashdance* (1983), *Beverly Hills Cop* (1984), and *Top Gun* (1986). And while it would be careless to dismiss the contributions of the directors of these films (Adrian Lyne, Martin Brest, and Tony Scott, respectively), it would be equally irresponsible not to comment upon Simpson's apparent auteur signature as well. Precisely what Simpson did or didn't do on these films is debatable; and his legend, his Hollywood biography that celebrates an irresponsible and wild lifestyle, hardly supports the image of a careful fiscal manager or sensitive, introspective creative talent. But as with so much Hollywood history, as with so much of the history of movie production and its subset, the history of movie producers, the only truth is what's up there on the screen and, of course, in the black and white of the first weekend's box office figures. Under such criteria, Simpson is certainly a major figure in film history, even if we will never know exactly how or why.

1

THE SILENT SCREEN, 1895-1927 Mark Lynn Anderson

The notion of a motion picture "producer" was initially a default identity for manufacturers of early motion picture equipment, such as Thomas Edison and Siegmund Lubin, once they began making films on a semi-regular basis at the turn of the twentieth century. It was also a label used for popular artists and entertainers like J. Stuart Blackton and William Selig, who supplied the early theatrical and itinerant markets with motion pictures. These inventors and showmen would eventually found the first movie studios in the United States, as well as form the industry's first significant trade organization at the end of 1908, the Motion Picture Patents Company (MPPC).

In many ways, these early producers (inventors, showmen, cinematographic operators who screened short actualities) were the first recognizable motion picture personalities. During this period, the motion picture producer performed various types of work that would quickly become separate vocations in an emerging division of labor and in cinema's legibility for a fascinated public. Early producers might typically write scenarios, scout locations, procure costumes and properties, direct and edit films, process prints, write promotion, secure sales, ship prints, or even project motion pictures in large exhibition venues, all of this in addition to attending to budgets and the legal and financial concerns of the companies they operated. Furthermore, their very names

became the brands that created product differentiation for exhibitors and the public alike.

Movie Workers

The day-to-day work of the studio executive has been documented in various studies of the film industry and in the researched biographies of the more celebrated producers. However, the producer's job was also regularly represented in popular and educational literature, sources that can tell us much about the public's understanding of the industry and its appreciation of management's role. The creation and evolution of the film producer as a public figure has received little attention from historians of the industry, even among those who have sought to reveal the "real workings" of the studio system behind the myths. Many of the popular myths about Hollywood were just as much products of the industry as were its films and movie stars. Still, such depictions can tell us a lot about how the film producer came to be recognized as a specialized worker within the studio system by an interested audience.

In 1939, Alice V. Kelijer, Franz Hess, Marion LeBron, and Rudolf Modley wrote a slim book entitled *Movie Workers* in which they endeavored to explain the division of studio labor to school-age children. They described the work of the film producer in relation to that of the director:

> The producer and director are the ones who are responsible for all of the details of a movie production. The producer is the general manager. He takes care of the business, the purchasing, the advertising, the distribution, and the supervision of all departments working on the picture. The director is responsible for the making of the picture itself. He directs the actors, plans the camera work, guides the lighting, and is on the set to supervise all shooting of the movie. After a story is chosen for production the producer and director have story conferences to decide about details of changes and ways of screening the story.[1]

While the book's authors describe the contributions of the various studio departments to motion picture production, they significantly position the producer and the director as ultimately "responsible for all the details," with the director portrayed as the chief creative talent and the producer the principal managerial authority. This represents the ideal of the central producer system that was gradually introduced and refined during the late 1910s and 1920s.

Because the Hollywood studios became vertically integrated during the same period, the producer depicted in *Movie Workers* is also responsible for advertising and distribution. Here the producer is imagined as an executive with broad

authority over the entirety of a studio's operations, rather than as either an associate producer to whom an executive producer might delegate some of his own specific duties or as what we would now recognize as a unit manager who coordinates the talent and resources on a single production by implementing a predetermined work schedule.[2] The executive producer oversees the studio's full schedule of ongoing productions, as well as the distribution and promotion of all the firm's products. In this way, the executive producer is the agent of industrial organization whose vision is not divorced from the creative basis of motion picture art but forms the very possibility of that art's realization as entertainment for the masses. While the director might occupy the more romantically conceived position of an individual artist, the producer is more or less the personification of the studio as a unique business enterprise, one that is committed to a cultural mission of advancing and fulfilling the aesthetic aspirations of a moviegoing public.

Such a distinction between director and producer did not always exist. Consider this description of film production at the fictional Comet Film Company from Laura Lee Hope's 1914 juvenile novel, *The Moving Picture Girls at Rocky Ranch.*

> The scene in the studio of the moving picture concern was a lively one. Men were moving about whole "rooms"—or, at least they appeared as such on film. Others were setting various parts of the stage, electricians were adjusting powerful lights, cameras were being set up on their tripods, and operators were at the handles, grinding away, for several plays were being made at once.[3]

The author describes a bustling studio with a fairly advanced division of labor and with the various departments at work on several productions at once, a depiction of the "dream factory" that would become a routine representation of Hollywood filmmaking at the height of the studio system. However, none of the productions at the Comet Film Company have individual directors assigned to them. Instead, all these motion pictures are coordinated by a Mr. Pertell who, "once he had all the various scenes going[,] took a moment to rest, for he was a very busy man."[4] In the novel, Pertell is the ostensible owner of the film company, as well as its coordinating manager, and he personally directs the filming of the more elaborate feature productions, leaving individual camera operators to shoot the more conventional program fare.

Hope depicts camera operators as unit directors. In doing so, she describes a craft situation more indicative of the earliest days of American film manufacture, when, before 1907, as the film historian Janet Staiger notes, "the cameraman knew the entire work process, and conception and execution of the product were unified."[5] Hope's fictional account thus represents a blurring of early social and technical divisions of labor in the evolving film industry.

IN ONE SCENE ALICE AND RUTH HOLD THE STAGE ALONE.
The Moving Picture Girls. *Page 157.*

FIGURE 4: In Walter S. Rogers's illustration for Laura Lee Hope's *The Moving Picture Girls at Rocky Ranch* (1914), we can see that both Mr. Pertell, the studio manager, and cameraman Russ Dalwood are familiar with "the entire work process" at the Comet Film Company.

In Hope's series of seven novels featuring the Moving Picture Girls, written between 1914 and 1916, these operator/directors are subject to a central coordinating authority of a producer/manager, a production context more indicative of the increasing technical division of labor that emerged after the director's task had been firmly distinguished from the camera operator's and a director-unit system was implemented during the late nickelodeon era (in the early to mid-1910s).[6] Yet, in the Moving Picture Girls series, the camera operator's broad manufacturing expertise is repeatedly demonstrated. On those occasions when the company's youthful cameraman, Russ Dalwood, explains various aspects of film production to the novels' central characters—the two DeVere sisters who act for the company, as well as to the novels' young readers—these distinct albeit somewhat overlapping historical production models are combined. Through such means Hope is able to preserve the *impression* of studio manufacture as essentially a cottage industry, despite its increase in scale as the studios sought to exploit a mass entertainment market.

This notion of a filmmaking enterprise that preserves the family and familial relations within its ever increasing division of labor casts the producer/owner/manager in the role of a wise and watchful patriarch whose business success, which often results from outwitting unscrupulous competitors or from effectively adjudicating disputes between company employees, is the index of both his creativity and his fatherly beneficence. In Hope's novels Mr. Pertell is "a very busy man," indeed. This notion of the producer as a visionary protector of the family would become part of the enduring mythos of American film history, most easily recognizable in the silent period by those popular monikers

of "Uncle Carl" (Laemmle) and "Papa" (Adolph) Zukor given to the chief executives of Universal Film Manufacturing Company and Famous Players–Lasky, respectively.

Producing and Public Relations

The increasing refinement of the role of the producer in the early studios was driven by market forces that promoted increasing motion picture output to service the expanding demand from exhibitors and exchanges for fresh product. By the 1910s, the industry's ability to build and maintain an exploitable audience for motion pictures required the transformation of the experience of cinema: from viewing films as attractions on a mixed vaudeville bill or as a continuous program of short, one- and two-reel motion pictures screened in small, storefront theaters, to attending a sizable theater to see an advertised, multiple-reel motion-picture attraction whose featured player, genre, or subject matter constituted the principal reason for the purchase of a ticket. While managerial duties during the nickelodeon period varied from studio to studio, owners and their managers typically dealt with the oversight of the financial aspects of the business, overseeing accounts, payroll, and sales, while directors and camera operators coordinated and executed most of the preproduction, production, and postproduction processes. Relations between owners, managers, and directors could vary widely during this period, but the work of conceiving of motion pictures and then making them was one of the least formalized parts of the business, with directors and camera operators often pursuing and innovating their own methods and approaches on a day-to-day basis.

The Biograph Company was one of the most fiercely competitive studios of the nickelodeon era in terms of protecting its financial interest. It had successfully fought Edison's attempt to control the market through licensing agreements by strategically acquiring crucial camera-technology patents in 1908.[7] Biograph's ability to control patents guaranteed the company's eventual inclusion on its own terms in the MPPC, America's first film oligopoly. Nevertheless, when D. W. Griffith arrived at the studio in 1908, the production process at Biograph was staggeringly unorganized. Linda Arvidson, the famous director's spouse, described one aspect of this disorganization, the transient situation of acting talent during their first days at the studio in 1908.

> It was a conglomerate mess of people that hung around the studio. Among the flotsam and jetsam appeared a few real actors and actresses. They would work a few days and disappear. They had found a job on the stage again. The better they were the quicker they got out. A motion picture was surely not something to be taken seriously.

Those running the place were not a bit annoyed by the attitude. The thing to do was to drop in at about nine in the morning, hang around awhile, see if there was anything for you, and if not, beat it up town quick, to the agents. If you were engaged in part of a picture and had to see a theatrical agent at eleven and told Mr. McCutcheon so, he would genially say, "That's O.K. I'll fix it so you can get off." You were much more desirable if you made such requests. It meant that theatrical agents were seeking you for the legitimate drama so you must be *good!*[8]

While Arvidson seeks to describe a moment before screen acting held any social prestige, suggesting that the low character of film work created the conditions of an unmanaged workplace, she is also describing a moment just prior to the star system in which, because of a lack of standard practices, motion picture production was propping itself on and deferring to a theatrical labor market. Griffith himself, who came from the world of the theater, would shortly change this situation at Biograph when he formed a stock company of players with actors who had ongoing contractual obligations to work at the studio and to act in the company's films.

Mary Pickford recounts how Griffith, against the concerns of studio management in the spring of 1909, offered her a guaranteed contract at $40 per week against the standard $10 a day she had been earning as a featured player.[9] These and similar means of stabilizing the pool of acting talent for motion pictures were simultaneously implemented at other studios, often at the behest of directors who typically scouted and developed screen talent.

In this way, directors and director/producers were defining what would soon be a key task of the movie producer during the silent era and beyond, the contracting of a select group of screen talent whose rising salaries compensated not only for their hours of labor at the studio but also for their value as company assets, in other words, movie stars whose market value was presumably determined by popular demand. This became one of the first and most visible roles of the producer for a public increasingly interested in the working lives of the personalities they observed on the screen.

One of the most retold stories in American film history credits the independent producer Carl Laemmle with inventing the star system when he announced in early 1910 that he had placed Florence Lawrence under contract at his Independent Motion Picture Company (IMP). The promotion of IMP's acquisition of Lawrence's contract sought to publicly reveal and bank on the actress's name. The company at which she had risen to fame, Biograph, had maintained a policy, observed by many studios of the period, of not providing the public with the names of its regular performers. Previously known only as the "Biograph Girl," at IMP Lawrence was a key part of a publicity campaign in which the studio advertised not its films or its brand name, but its ability to lure a popular

performer away from the very company with which she was once so closely identified. According to the film historian Eileen Bowser, an early advertisement for Lawrence's new position, prior to the revelation of her name, featured only her portrait with the words, "She's an Imp!"[10]

While these developments are widely recognized as the basis for what would become the regular promotion of movie stars, they also illustrate how one of the central tasks of the executive producer was defined during this period and how it was intimately tied to the developing star system, that is, the control and crafting of the studio's public image. Whether the first movie stars appeared because of a public demand to know more about the screen performers they had come to recognize and admire or, conversely, whether the star system was principally an industrial strategy to standardize a product in order to guarantee an exploitable market of regular, recurring consumption, Laemmle's promotion of Lawrence represents the work of the producer as promoting both the quality of the company's products and its ability to provide the public with what they wanted and what they deserved at a cost they could afford. Thus, in addition to scheduling and overseeing the production process and managing the division of labor, the producer played a crucial role in public relations—the management of information about the company and the control over how such information is disseminated in order to shape public opinion and consumer habits.

Unlike most of the early manufacturers and inventors who headed the studios of the MPPC, the second wave of producers, such as Laemmle (who had operated nickelodeons in Chicago as early as 1906 and moved to production into 1909) came predominantly from the ranks of motion picture exhibitors and other amusements businesses, as well as from the retail trades. They were thus more familiar with the public as an exploitable market than the first manufacturers. But because many of them came to film production from the exhibition and distribution sectors, they were also predisposed to envision and eventually realize a vertically integrated film industry once the opportunity to control significant holdings in all branches of the industry—production, distribution, and exhibition—arose at the end of the First World War.

As early as 1912, Laemmle merged his IMP studios with five other producing companies to form Universal Film Manufacturing Company (with Laemmle serving as company president). Universal's executive offices were in New York, with its principal studio in nearby Fort Lee, New Jersey; yet Universal also acquired two early Los Angeles studios as a result of the consolidation. In 1915, Laemmle would permanently move his company's production to Universal City, a massive studio complex built on a ranch in the San Fernando Valley. While standard histories credit Laemmle himself with the longevity of the studio, at least until his retirement in the mid-1930s, the film historian Mark Garrett Cooper has described just how fraught and relatively unstable upper-level management at the studio was throughout the 1910s, with Laemmle remaining as president

of the company largely because of his ability to garner a majority of shareholder votes and because of his ongoing friendly relations with Robert H. Cochrane, Universal's first vice-president, who held a substantial share of voting stock.[11]

A business partner of Laemmle since the latter first entered the motion picture business, Cochrane had an extensive newspaper and advertising background. In 1927, the popular journalist Allenne Talmey suggested that Laemmle's reputation as a sagacious but kind-hearted captain of industry was largely the invention of Cochrane. "It is the aim of the advertising departments to personalize the tremendous organization by featuring only the president. It all happened, this wise advertising, because R. H. Cochrane, now vice-president of Universal, had the theory years ago that the best way to put over a company was to make patrons and exhibitors think of the paternalistic Carl Laemmle when they thought of the Universal Corporation."[12] Thus, it is important to understand that the early Hollywood producers not only performed and managed various types of public relations work, but were themselves, as idealized businessmen, part of the industry's self-promotion.

The Name above the Title: Producers in the Nascent Studio System

The early producers were increasingly represented to the public as businessmen who secured the services of popular movie stars. Industrial management signified the power of the producer to secure and develop these compelling personalities who appeared on the screen. The executive producer, like the star, was closely identified with both the film industry in general and with the particular company he presumably controlled. The producer was not a performer but a presenter, a role that would quickly establish the convention of placing the producer's name above a film's title and its stars, such as in the opening-credit formulation, "Adolph Zukor presents. . . ."

These types of attributions had become so important that, by the time Paramount ended its East Coast production in 1921, studio vice-president and head of Hollywood production Jesse Lasky was obliged to write Zukor in New York to assure the chief executive that he had given "instructions that the pictures made here should be presented equally by you and by me," a recognition that movies were indebted as much to New York financing and business strategies as they were to Hollywood studio manufacture.[13] The familiar name of the producer who stood behind the product marked a type of entrepreneurial authorship that helped promote popular appreciation not only of a particular motion picture or a particular company, but of the film industry itself as a media institution corporately organized with compassion and vision. This practice of fashioning producers as industrial authors helped create a widespread social respect for the authority of the corporate executive that endures today. Zukor is the executive

producer most often credited as the principal architect of the classical studio system, playing key roles in the consolidation of the star system, the move to feature-length films, the run-zone-clearance mode of distribution, and, most importantly, the vertical integration of the studio system.

A Hungarian Jew, Zukor immigrated to the United States when he was sixteen and began his professional career in the fur trade. He eventually became interested in amusements and invested in several arcades and small theaters. Marcus Loew, one of his early partners, would go on to control numerous theater chains, becoming one of the most important owners of prestige movie houses in North America. It was on this basis that in 1920 Loew would integrate—that is, expand corporate interest and control into other parallel aspects of the media—backward into production by purchasing Metro Pictures, only then to partner with Louis B. Mayer, Irving Thalberg, and attorney J. Robert Rubin in 1924 to form Metro-Goldwyn-Mayer (MGM), a major studio that exploited Loew's extensive holdings in film exhibition at his chain of metropolitan first-run theaters.

Zukor took a different trajectory toward vertical integration. In seeking to expand the audience as well as the social reach and prestige of motion pictures, he booked a celebrated multi-reel European production into various high-priced venues in 1912; for this purpose he formed the Famous Players Film Company and purchased the U.S. distribution rights for the French film *The Loves of Queen Elizabeth,* starring the internationally acclaimed stage actress Sarah Bernhardt in the title role. Zukor premiered the film at the Lyceum Theatre on Broadway in July and then successfully distributed the film on a state-rights basis; in other words, he sold the picture to regional exchanges or operators for exhibition in specific territories in lieu of access to national distribution.

The Lyceum was owned and operated by the Broadway producer Daniel Frohman, who helped finance and promote Zukor's nearly simultaneous move into feature film production at a studio on West Twenty-sixth Street. With Frohman's continuing assistance, Zukor's promotion of "Famous Players in Famous Plays" led him to purchase the rights to several successful plays and well-known novels. He also contracted popular stage celebrities such as James O'Neill, who performed in Zukor's five-reel production of *The Count of Monte Cristo* in 1913; the Shakespearean actor James Hackett, who played dual roles in *The Prisoner of Zenda* that same year; and the Broadway star Pauline Frederick, who made her screen debut in 1915 for Famous Players in an adaption of Hall Crain's best-selling novel *The Emerald City.*

In 1914, Zukor lured Pickford back to motion pictures from the Broadway stage by offering her a contract for $400 a week, a salary that would quickly increase by the beginning of 1915 to $2,000 a week, plus a percentage of her picture's profits.[14] Zukor participated in and helped to precipitate a rapid escalation of star salaries in the mid-1910s. This escalation resulted, in part, from the efforts of several motion picture producers to exploit popular performers of both stage

and screen. By offering them ever-increasing salaries, producers endeavored to make their performers' paychecks newsworthy and thus part of the publicity and promotion of the stars and the companies who could afford their services.[15] The producers who negotiated these sensational contracts understood the central importance of movie stars in guaranteeing a sizable if never quite determinable share of the box office market. Others in the industry believed that the inflated salaries of celebrity performers would eventually lead to an economic crisis in the industry, as when in 1916 *Photoplay* editor James R. Quirk decried "the cancerous salary" often demanded by undeserving talent. "Managers highly intelligent have fallen for the actors' graft like children. 'I didn't want to do it, but the other fellows made me!' is their favorite song."[16] Motion picture stars were thus sometimes viewed as selfishly damaging the industry for their personal gain by exploiting the competition among the different producers.

Several producers, including Zukor, attempted to move away from the star system in the late 1910s and early 1920s. By promoting important authors and screenwriters over lead actors, by producing multiple-star prestige pictures designed to stall the market command of any single actor, and by emphasizing the uniform quality of all the studio's releases despite their specifics of casting, producers sought new ways to secure audiences and to predict box office returns. These producers did not seek to do away with the lucrative star system so much as to use managerial authority to discipline it, bringing the star's labor, presumed professional interests, and public image more closely in line with the studio's corporate identity. This signaled a return to and synthesis of both the stock-company model of early narrative cinema and Laemmle's initial impulse to promote his company in 1910 by proclaiming Florence Lawrence to be "an Imp!" Because the studios were becoming increasingly figured in corporate terms as magical enterprises where art and commerce blended almost seamlessly—one of the earliest and most lasting mythologizations of Hollywood—stars were also encouraged to share management's perspective on the business of motion pictures by becoming producers themselves.

In 1916, Zukor was already moving toward vertical integration by gaining control of his studio's main distributor, Paramount Pictures, and then merging his production company with the Lasky Feature Play Company, naming Jesse L. Lasky and his director Cecil B. DeMille as principal executive officers in the newly formed Famous Players–Lasky Corporation (FPL). At the same time, Zukor created the Mary Pickford Film Corporation, paying the star $10,000 a week and a 50 percent share in her pictures' profits, as well as providing Pickford with her own company in which she had authority over virtually all aspects of production. While this production deal has been typically viewed as evidence of Pickford's increasing power over her employers, it represents, as well, the studio's passing along to its biggest star the work of the producer in budgeting each production and coordinating the studio's workforce. Thus, as

Pickford was ostensibly earning more and enjoying relative autonomy, she was also forced to contend with managing daily production schedules while still being dependent on the studio for her salary and for the effective distribution of her pictures.

This arrangement would soon become a point of contention between Pickford and Zukor, leading Pickford to break with the studio in 1918 to accept a million-dollar contract with FPL's chief competitor, First National, an organization of independent exhibitors who resented Zukor's manipulation of the market through the unfair stipulations and pricing that Paramount had placed on their most desirable star releases. Though Pickford's move into semi-independent production in 1916 might have been something of a first, there quickly followed other movie stars who formed their own production companies, usually with the help of an established producer who, whether independent or affiliated with a major concern, had enough experience with and access to distribution to profitably release the star/producer's productions.

Also in 1916, Lewis Selznick left World Film Corporation to distribute motion pictures manufactured by Clara Kimball Young's "own" company. Selznick would go on to handle the distribution of films made by several other independent stars such as Norma Talmadge and Alla Nazimova. Producer Louis B. Mayer would also leave Metro to finance the productions of Anita Stewart's company during this period.[17] While sometimes represented as a crisis of defection from the major studios by important producers, directors, and stars, this explosion of independent companies in the late 1910s and early 1920s was not so much a threat to the established studios as it was a further elaboration of the producer's role and his or—at this unique moment in American film history—her public profile. Such (relative) independence ultimately benefited the industry as a whole by further blurring distinctions between owner, producer, and creative talent, while never fully collapsing these vocational categories upon which the corporate management of centralized film production depended. While the major companies often ended up distributing the products of these independents, thereby realizing a substantial portion of the profits while suffering little of the financial risk, they also saw the work of the producer being attributed to a favorite star or a successful, well-known director.

What was demonstrated in these forays into independence was the non-exclusive nature of the producer's managerial function, one that was not antagonistic to the demands of art or to the public's tastes, but might instead be aspired to or at least appreciated by virtually anyone. Even though Richard Rowland, the head of Metro Studios, reportedly exclaimed when four of the most popular Hollywood creative personalities announced the formation of United Artists in the spring of 1919 that the "the lunatics had taken over the asylum," the idea that Charles Chaplin, Douglas Fairbanks, D. W. Griffith, and Mary Pickford could run a studio was anything but an aberrant occurrence in the development of a

studio system that was set on deifying the producer as the central player in the emergence of a mass industrial art form.[18]

Consolidation and Cooperation

The explosion of semi-independent producers in the late 1910s coincided with the industry's move toward further consolidation. With the most powerful companies owning established networks for national and international distribution, the most successful producers (such as Zukor) came to appreciate that control of distribution was the key to controlling the market. Whatever competition had existed in the early 1910s between, say, the MPPC and independent producers, or between the independents themselves, had given way by the end of the decade to a corporately organized industry, consisting of a handful of giant companies producing and distributing annual schedules of films in studios functioning under a central-producer system. While these studios might compete against one another to increase their relative share of both national and international markets, the major producing companies usually refrained from any sort of action that might endanger their collective control over national distribution and, after 1919, their dominance in world film distribution.

Cooperation among the so-called independent studios was formalized as early as 1916 with the National Association of the Motion Picture Industry (NAMPI), a trade organization for producers and exhibitors. NAMPI had grown out of the Motion Picture Board of Trade of America, a short-lived endeavor that had been proposed as early as 1914 by New York exhibitor-cum-producer William Fox to standardize trade practices and technologies; to compile, interpret, and disseminate information about industrial conditions; and to arbitrate conflicts within the industry. This Board of Trade had sought to represent the interests of the entire industry, but the producers quickly took control, with the majority of its officers representing the studios rather than the exchanges or theater owners. NAMPI continued the hegemony of the producers when William A. Brady, who was then head of production at the powerful World Film Corporation, became its first and only president, while Zukor, who had been a former business associate of Brady, served as one of its two vice-presidents.

Brady had a successful tenure as president of NAMPI, in part because his compelling personality and his oratorical skills effectively persuaded potentially divided industry players to act in accord with the presumed interests of the industry as a whole. Principally a producer-led organization, NAMPI sought to coordinate studio responses to developments such as labor organization in the crafts, rising star salaries, and industrial cooperation with the government (especially during World War I). NAMPI also played a key role in the ongoing public relations project of promoting a unified industry to the public and to various

elected and unelected public representatives by countering reformers' demands for greater regulation of the industry through censorship legislation.

Indeed, in response to growing concerns about the prevalence of "sex pictures," NAMPI formulated and passed in early 1921 one of the first industrial codes to regulate screen depictions, though its fourteen points were, like most of the industry's subsequent production codes, merely recommended guidelines rather than a strict formula to be followed.[19] These regulations sought to forbid explicit depictions of prostitution, nudity, "inciting dances," instruction in crime, and salacious intertitles (the brief descriptive textual comments inserted often on illustrated cards), while they cautioned against sexual suggestiveness and passionate love scenes, excessive bloodshed, and stories about vice and crime set in the underworld. The fourteen points also advised the careful handling of narratives containing themes of adultery and premarital sex, intoxication, and all religious depictions. While the fourteen points were initially represented as an industrial secret, the existence of self-regulation quickly became public knowledge as news of the system of self-censorship was "leaked" by the studios themselves.[20]

The eventual demise of NAMPI resulted in large part from Brady's failure to halt the passage of censorship legislation in New York State in April of 1921, when the governor signed into law a bill establishing a commission to license all motion pictures commercially exhibited in a state where many of the important first-run theaters (in New York City) effectively established the box office potential of new releases for a national market. While scores of movie censorship bills were regularly introduced in various state legislatures during the era, New York was the first to successfully establish a board of censors in the five years after the establishment of NAMPI. The organization's failure to defeat the New York legislation through its public campaigns and lobbying efforts was a significant setback for the studios and created further exhibitor dissatisfaction with the major producers.

One of the producers' strategies to counter censorship arguments during this period was to emphasize how the increasing centralization of the major studios under the producer system, as well as their functioning in tandem to control the international market for motion pictures, made censorship less necessary. The large-scale monopoly formation of the studios provided the most effective means of responding to public complaints and implementing industrial changes. For example, when a public hearing was held before the governor on April 26, 1921, in the New York State Capitol in Albany on the pending assembly bill to create a licensing commission, the executive committee chairman of Famous Players–Lasky, H. D. Connick, argued that the film industry did not require external regulation since it operated as an efficient large-scale monopoly in the interests of the wealthiest classes in America.

Connick maintained that Hollywood could easily agree and comply with the interests of the state since "the bulk of the pictures are made by four or five

concerns, as for instance Mr. Fox, who is here, he makes pictures, and Mr. Marcus Loew, he makes the Metro pictures, and a few others—these four or five men together could absolutely insure the quality of these pictures to any standard that might be agreed upon."[21] Connick maintained that Famous Players–Lasky was a "purely manufacturing" concern with three thousand stockholders, and that the company's directors were "some of the biggest financial men of the community," including the vice-president of Empire Trust Company, as well as prominent members of the DuPont family. While Brady had portrayed state film censorship as acting against the interests of working people at this same meeting, other representatives of the industry such as Connick portrayed Hollywood as an extension of Wall Street and the U.S. economy, attempting to suggest that the regulation of motion pictures was essentially an attack upon capital itself.

Such pronouncements by producers and producer organizations were not uncommon in the period, and they contradict the widely held assumption by many film historians that the principal operation of financial power in the movie industry was mostly invisible to the public, and that studio corporate officers "and their companies," to quote the movie industry historian Douglas Gomery, "rarely publicized themselves and their secrets of operating. Despite being publically operated companies, the corporate leaders kept the pictures in their heads, hardly interested in sharing them with others."[22]

The executive producer is frequently privileged in film history as the proper object of study for the analysis of the political economy of the studio system. This approach is built upon the notion of an industry run by a small number of men keeping "pictures in their heads," producers wielding enormous executive power because of their rare ability to intuitively inhabit a corporate understanding of how a global media industry works, particularly in relation to more powerful banking institutions and electronic corporations. Archival records of the day-to-day operations of the studios at almost any level of the work hierarchy inevitably lead us to reconstruct and appreciate the formerly oblique decision-making processes of this "handful of men"; however, such a historiography is entirely consistent with the studios' own promotion of their chief executives as highly talented businessmen whose keen abilities and instincts created the enduring structures of production planning, execution, and marketing that made the most efficient use of the enormous creative and technical talent at their disposal. The consistency between revisionist history and Hollywood's own self-promotion suggests that the film industry itself played a crucial role in determining the very protocols through which the story of the studio system might be told and remembered. This is why each consultation with surviving documents related to film manufacture needs to be related to the larger history of public relations (a history in which Hollywood played a central role) since the management of public opinion had become one of the principal tasks of the studios once the United States entered the First World War in 1917. Cooperation among the studios in the form

of producer organizations provided an effective means of shaping the public's perception of the industry's goals, commitments, and modes of operation.

NAMPI was replaced at the end of 1921 by the more widely known Motion Picture Producer and Distributors of America (MPPDA). When President Warren Harding's postmaster general, Will Hays, left his cabinet post to accept the studios' lucrative offer to head the MPPDA, the new trade organization was refashioned explicitly as an organ of industrial self-regulation. In the interim between the passage of the censorship bill in New York in April and the creation of the MPPDA, the Federal Trade Commission (FTC) issued a formal complaint against Famous Players–Lasky and its executive officers for restraint of trade, a federal action that the studio would easily weather over the ensuing years. The initial FTC investigation and hearings resulted in the accumulation of tens of thousands of pages of testimony and exhibits, with a final decision issued in the summer of 1927 that Famous Players–Lasky had used "unfair methods of competition" in order to achieve its dominance in the industry. On the basis of its findings, the FTC issued a federal order requiring the company to cease and desist all conspiratorial activities including the practice of block booking, or the forced selling of multiple pictures to exhibitors in an ensemble, and the building of theaters as a means of threatening uncooperative exhibitors with damaging and unfair competition in targeted markets. The studio formally disputed the FTC's findings, a development that led the Justice Department, in 1928, to launch its own investigations into the collusion of all the major studios to control the motion picture industry. The Justice Department's investigation made extensive use of the FTC archive and eventually resulted in its 1938 suit against the major studios, an action that would eventually result in the 1948 U.S. Supreme Court ruling in favor of the Justice Department's position, a decision that required the major studios to divest of their profitable first-run theaters.

During the original FTC investigation in the early 1920s, the industry also faced mounting public animosity after a series of sensational star scandals made international headlines and called into question the moral health of the industry as a whole. Thus, Hays was selected for the job of "film czar," in part as a means for Hollywood to appear responsive to both governmental and public concerns about the social worth of the studio system. Hays had served as the chairman of the Republican Party and was a deacon in the Presbyterian Church, credentials that positioned him as a guardian of core American values.

Although some viewed the creation of the MPPDA as just another public relations move by the producers to escape government scrutiny and public accountability, with Zukor and the others ultimately calling the shots, the organization provided the means for producers to cooperate in extending their control over some of the studios' most difficult employees—movie stars and big-name directors. In the process, producers could refigure their own identities as sober businessmen whose self-effacing commitments to industrial efficiency took

on a moral tenor that made their increasing corporate authority necessary for the sustainability and further development of screen art. With the introduction in 1922 of morality clauses into the standard contract, producers claimed the right to subject the private lives of their employees to a scrutiny from which they themselves were exempt. Furthermore, producers benefited from and participated in a popular discourse about how the increasing centralization of the production process was ostensibly stifling artistic expression, a complaint often voiced by the first generation of screen stars and directors who were, by the early 1920s, increasingly represented in both fan culture and popular journalism as old-fashioned and out of date.

For example, when Rudolph Valentino walked out on his contract with Famous Players–Lasky over creative disagreements in early 1923, he was easily represented in the popular press as a temperamental actor whose emotional excesses, while important to his onscreen appeal, nonetheless required the constraints of the rational business executive to make the most effective use of his flamboyant artistry. Indeed, during the decade of the 1920s the presumed artistic intensity of European-born (mostly German- and Scandinavian-born) actors and filmmakers was sought out and ingenuously exploited by Hollywood producers. The recurring complaints made by these imports about the rigidity of Hollywood production methods only validated that system's ability to transform such pretentious posturings into marketable entertainment for the masses.

The Central Producer System

Irving Thalberg, silent cinema's "boy wonder" credited with finally consolidating the central producer system at MGM in the mid-1920s, secured his legacy within a historical confluence of artistic extravagance and managerial discipline, a reputation tested by his professional relationship with the "difficult" director Erich von Stroheim. By the time he was twenty years old, Thalberg had made the transition from clerical worker at Universal's offices in New York to Laemmle's personal secretary to director general in charge of production at Universal City. Given his slight frame, his history of ill health, and his self-effacing manner (refusing to take screen credit for his productions throughout his career), Thalberg was repeatedly figured as something of an enigma, since he also had an uncanny ability to manage the studio's heavy production schedules and its workforce by insisting on the application of sound business and accounting practices in a manner that understood and appreciated the specific artistic requirements needed to make popular motion pictures.

A lengthy biographical piece on the producer that appeared in the *Los Angeles Times* in the fall of 1922 described Thalberg as having a "strange personality." "He is a driver, but those whom he drives have the assurance that he drives himself

GENIUS OF THE MOVIES IS ONLY 23

(By JACK JUNGMEYER)

HOLLYWOOD, April 10—All right, Sparks. Put the big white "spot" on Irving G. Thalberg, youthful prodigy of the movie industry!

Thalberg, who is 23, directs a film business grossing $400,000 a year, commands a personal income of over $100,000 and is proclaimed an organization genius.

He brings to the executive side of pictures a blending of personality and achievement ranking with that of the foremost stars in romantic interest, as well as a vision which should help rid the industry of much that is now stultifying.

Thalberg has just been given a substantial interest in the Louis B. Mayer studio. As vice president he will guide the destinies of that big concern. Prior to that he was three years director general of Universal, to which he came as assistant to the

ple whose lives would otherwise be drab! How it stimulates imagination. Builds dreams. Re-creates waning ambition. Fires now hopes. Stirring a nation with a new culture.

"Why, the fact that thousands of people heretofore inarticulate have been prompted by motion pictures to write, not only for the screen, shows its influence in quickening mental activity.

"Success," he said cutting back, "is the measure of one's vital relationship to the rest of the world, a relationship made up of an infinite number of sentimental reactions and their material coin of exchange.

"In this business you must have a great faith in the weight of emotions. You've got to be a sentimentalist to risk from $200,000 to $400,000 for a picture in the reasonable assurance that its sway upon human hearts will reimburse and profit you.

"You can readily see that motion pictures can't be based on cold-blooded finance like raising potatoes

FIGURE 5: News coverage of Irving Thalberg's move to MGM in 1923 emphasized his unique sensitivity and his good business sense: "He brings to the executive side of pictures a blending of personality and achievement ranking with that of the foremost stars in romantic interest, as well as a vision that should help rid the industry of much that is now stultifying." *Fitchburg* (MA) *Sentinel*, April 14, 1923.

even harder. He asks for twice as much as he can possibly expect from every man and, in consequence, gets every man's full effort."[23] Here the producer's strength has to do with thoughtful planning and efficiency, the perfect foil for von Stroheim's penchant for extravagance, waste, and decadence.

Von Stroheim had already modeled himself as something of a provocateur in both the studio and in American culture. Often portraying himself as a European aristocrat with an unnatural fetish for the details of lavish costuming and décor, he continually went over budget on productions by overspending on sets and excessively reshooting scenes. Thalberg had already confronted von Stroheim in 1920, when, after the film had been in production for almost a year, the young producer brought to a halt the shooting of Stroheim's million-dollar production of *Foolish Wives*. But it was Thalberg's firing of von Stroheim in 1923 during the production of *Merry Go Round* that has become the event most celebrated in the victory of the central producer system over the autonomous and, in this instance, autocratic director.[24]

In his recent biography of the producer, Mark A. Vieira describes the event's significance:

With this bold act, Thalberg established the precedent of the omnipotent producer. . . . For the time being, though, its significance was that of a David-and-Goliath story. A frail, untutored youth had bested a powerful, worldly man. It was incredible that Thalberg should dare do this, let alone succeed. Where did he get the will, the courage? Only a handful of people in Los Angeles knew the wellspring of his ambition. It was his

inescapable realization that time was running out. After staring down
death for years, he would not be cowed by a strutting poser.[25]

Vieira's description registers an important transformation in the representa-
tion of the film producer that was enacted during the first half of the 1920s and
remains a legacy for us today. Here the unbreakable spirit of economic efficiency,
informed as it is by an existential insight into the conditions of morbidity and
death, is defined and admired as a sort of hard-won health, a soundness of judg-
ment and mind that overcomes the frivolity of artistic narcissism.

What such a refiguring accomplished was the removal of the producer from
the conditions of popular inspection that attended the public's attention to movie
stars and other types of celebrity personalities. While it was still possible to ask
who a producer was in terms of what informs his personality and his way of see-
ing the world, this type of interest was already being carefully distinguished from
a popular interest in film stars. Star reception sought to explain not universal,
abstract qualities such as the rationality of self-reflection but instead the idio-
syncrasies of emotional life, erotic feeling, and suffering. For Thalberg, suffering
became a means of calculating the value of work, whereas suffering remains
merely the condition of the troubled movie star.

Any proper historical understanding of the producer will therefore require an
approach and an archive different from the study of other movie personalities.
To study the producer is to study the industry itself—the industry understood as
an expression of a calculating intelligence. While the details of an individual life
may count for something in a historical explanation of the producer, those details
will never be valued apart from appreciating the individual's contributions to the
manufacturing process. Studio records are valued as more telling than personal
letters or journalistic impressions. The producer represents a commitment to the
transparency and truth of the production process.

Writing the History of Early Film Producers

Consider another celebrated architect of the central producer system, Thomas
Ince. Between 1912 and 1913, Ince began separating his production into different
units shooting simultaneously, but he maintained control of the units through
prepared shot-by-shot continuity sheets with all the many details of the produc-
tion determined beforehand. Within a year, Ince was no longer writing scenarios
or directing films but instead working as central producer with the help of an
efficiency expert who served as his production manager. As Kristen Thompson
and David Bordwell point out, "Today he is remembered primarily for having
contributed to the move toward efficiency in studio filmmaking, particularly the
use of the continuity script to control production."[26]

In a recent monograph on Thomas Ince, the film historian and Library of Congress archivist Brian Taves seeks to dispel longstanding rumors about the famous producer having been murdered by William Randolph Hearst while sailing on the latter's yacht in late 1924; in doing so, Taves calls for a more accurate accounting of Ince's significance in the silent era. One prevalent version of the murder story has Hearst shooting Ince after mistaking him in the dark for Charles Chaplin, whom Hearst believed was his rival for the romantic attentions of Marion Davies. Taves devotes the entire first portion of his study to the would-be scandal, contending that the final truth of Ince's death has to be settled before the proper work of studio history can legitimately begin.[27]

The rigor of the historian in proving such rumors groundless—so that film history might proceed free of gossip—illustrates well, I believe, how much current film historiography on early Hollywood effectively if not intentionally reproduces the industry's own prior promotion of movie executives and the disciplining of interest in their work and lives. The trouble with the rumors about Ince is not so much the content of the stories as the types of people who might find them useful, insightful, or pleasurable. Most historians continue to ignore Mark Garrett Cooper's observation that archives exist "not to 'save' the past, but to pervert the present," pursuing instead archive-dependent projects of recovery that render irrelevant what might be or has already been said or written about the historical subjects to which the freshly consulted archival documents presumably bear witness.[28] In other words, the personal and business records of studio executives are used as a means to correct and discipline any misguided understandings of the film industry that have not had proper recourse to the archive, thereby presuming that the archival record itself is free from any previous and continuing historicizing function. As Taves himself remarks, "Sadly, possible Hollywood scandals always evoke a prurient interest, and legends are immortalized and retold in any number of turn-a-fast-buck gossip books. Looking beyond the façade of *Hollywood Babylon* and the like to the contemporary sources reveals little conflict as to the actual events that occurred around Ince's death."[29]

Taves's research does well to restore Ince's legacy, not only as one of the pioneers of the central producer system and the founder of Inceville, a studio that in its heyday had a staff of 700 and a facility sporting over 200 dressing rooms, as well as assorted stables and corrals. Ince is often thought of and as such had his reputation and significance diminished as the producer primarily of early film westerns, due in part to his work with the cowboy movie star William S. Hart. But as Taves points out, Ince produced films in many genres, often featuring the era's best-known stars, including John Gilbert, Lon Chaney, and Sessue Hayakawa.

Producers helped provide an impression of unity and coherence to both the operation of the industry and its depiction to the public, a depiction that

continues to the present. When Lasky was asked "what stands behind the Paramount standard of production" for a promotional exposé of the film industry written in 1920 for *Leslie's Weekly,* the producer responded by describing the organic unity of thought and purpose among the managerial heads of the studio:

> Well, there is so much to say; and while I feel the subject very deeply, I believe there is another man in our organization who can better visualize the true aims in our productions and the methods of attaining them. Mr. de Mille, our director general in charge of all our productions, represents the whole thought and spirit of our institution. He interprets our every ideal in motion picture making. My thoughts and Mr. Zukor's thoughts are his thoughts. He expresses every hope and aspiration that we cherish. I believe it would be better to have Mr. de Mille convey to your readers through you the thoughts that lie behind every Paramount Picture.[30]

Here a producer performs studio publicity by recommending that another producer/director would be a more effective communicator of the company's values, about which they are in complete accord. So while Lasky's response has the appearance of being a coy deferral of public relations work, it represents one of the key achievements of early Hollywood public relations, that the unity of the managerial force of modern industry, despite its lack of transparency, is itself a demonstration of the universal harmony of rational thought, a Kantian insight that was presumably manifesting itself in almost every aspect of cinema. As DeMille himself would put it later in the same article, "The motion picture is the greatest medium of thought transference that has been invented and developed since the printing press. I believe that *the motion picture is destined to become the greatest single power in the world.*"[31]

DeMille is expressing the now familiar but widely discredited idea that motion pictures constituted a universal language that might serve centrally in the promotion of world peace, a hope that gained emotional appeal if not credibility in the wake of the First World War. Yet DeMille is grounding the possibility of this peaceable kingdom in the vision and organizational work of the producers who are the models of rational agreement and who are principally responsible for the growing effectiveness of this new system of communication (a mode of communication with the potential of creating a world of one mind). While the myth of a universal language has been routinely interrogated and analyzed, the almost seamless relation between the motion picture producer and the rational organization of industrial manufacture is often a working presumption of film history.

Thus, when the film historian Thomas Schatz published his seminal account of golden age Hollywood production, *The Genius of the System,* in 1989, he sought to participate in a revisionist historical practice by making the production system itself the central object of inquiry while privileging company records and

FIGURE 6: By the late 1920s, Adolph Zukor had achieved the status of a business leader whose influence on public affairs was of global significance. *Time* magazine, January 14, 1929.

internal memoranda as the principal evidence upon which a new appreciation of the studio system could be secured. Like other revisionist historians of the period, Schatz was wary of both auteurism and histories of exceptional individuals, though he nonetheless posed individual producers as unique talents whose very agency rested on their ability to have an intuitive intellectual command of the very system of which they were only seemingly an integral part.

Unsurprisingly, Schatz approvingly cites F. Scott Fitzgerald's unfinished, posthumously published novel about a Hollywood producer, *The Last Tycoon,* whose narrator observes, "Not a half a dozen men have been able to keep the whole equation of pictures in their heads." Schatz finds Fitzgerald's representation of managerial exclusivity to be a "concise statement of our objective here: to calculate the whole equation of motion pictures, to get down on paper what Thalberg and Zanuck and Selznick and very few others carried in their heads. After digging through several tons of archival materials from various studios and production companies, I have developed a strong conviction that these producers and studio executives have been the most misunderstood and undervalued figures in American film history."[32]

Though Schatz immediately qualifies this elevation of "a half a dozen men" to an exceptional historical agency by pointing out that the studio division of labor extended well into the highest ranks of studio management, his naming of names recapitulates the equation of the studio executive's intellection with the mystified value of the production system, an identity that Lasky and DeMille were professing as early as 1920. Even if the studio executive is rarely glamorized like the movie star or venerated like the film director, the film producer has continued to accrue a type of respect typically accorded to great statesmen or founding fathers who are seen as both the architects of a social good and the very embodiment of its enduring value.

2

CLASSICAL HOLLYWOOD, 1928-1946 Joanna E. Rapf

F. Scott Fitzgerald first came to Hollywood in 1927 to write a comedy for United Artists that was never made. He returned in 1931 when Irving Thalberg hired him at MGM, where again he was unsuccessful as a screenwriter but, significantly, absorbed all he could about the workings of the studio. In 1937, when he was hired a second time by MGM, he began working on a Hollywood novel, *The Love of the Last Tycoon,* pumping everyone around for inside information, including my father, Maurice Rapf, and his best friend, Budd Schulberg, two college-educated producers' sons. These two, along with Louis B. Mayer's daughters, Edith and Irene, are combined in Fitzgerald's narrator, Cecelia Brady, daughter of a fictional studio head, Pat Brady.[1]

Fitzgerald's novel covers many days, during which we see Monroe Stahr, a character based on Thalberg, go over scripts with writers, shots with directors, lighting with cameramen, cutting with editors, emotional problems with actors, censorship issues with the so-called Breen office (the Production Code Administration or PCA that enforced the industry's censorship code, headed by Joseph Breen), union threats, and financing. The film historian Matthew Bernstein has aptly observed that the work of the producer during this period "was by far more complex and constructive than the myth [of studio Hollywood] has allowed,"[2] and to Fitzgerald's credit, in *The Love of the Last Tycoon,*

there is a vivid description of this complexity and the constructive day-to-day, hands-on work of the movie producer at a major Hollywood studio in this era. For example, in a meeting with the writers and the director on a picture he is supervising, Fitzgerald's Stahr gives specific instructions on the script, page by page:

> "In the third sequence have him hit the priest," Stahr said.
> "What!" Wylie cried, "—and have the Catholics on our neck."
> "I've talked to Joe Breen. Priests have been hit. It doesn't reflect on them."[3]

During this script conference, the film's director, John Broaca, nostalgically remembers the old days, before the studio system, "when writers were gag men or eager and ashamed young reporters full of whisky—a director was all there was then. No supervisor—no Stahr."[4] But in the classical era Stahr has the last word, even on directing and cutting. To one of his editors, the "oracle" speaks: "Sometimes ten feet can be too long—sometimes a scene two hundred feet long can be too short. I want to speak to the cutter before he touches this scene—this is something that'll be remembered in the picture." With so many diverse tasks involved in making a film, a visitor to the studio wonders, "What makes the unity?" Stahr replies simply, "I'm the unity."[5]

The years between 1928 and 1946 saw the transition from silent pictures to sound, and from an economic crisis that ushered in the Great Depression to the end of World War II. During this era the motion picture industry became a powerful force in American life with the producer as king, the primary shaping force behind the pictures being released. This corporate structure would alter after the war with the end of vertical integration (studios owning both the means of production and exhibition) and changes in income tax laws making it more advantageous for producers, directors, and stars to form their own production companies. But during this so-called "Golden Age," as the film historian Thomas Schatz has observed, "the chief architects of a studio's style were its executives."[6] The producer's role was not simply to oversee the budget and keep a businesslike eye on the free-spirited vagaries of stars, writers, and directors; they were, as Fitzgerald illustrated so well, actively involved in the creative process from the inception of a film through its distribution.

Production was dominated by the five "majors" in Hollywood—Loew's/MGM, Paramount, Warner Bros., RKO, Twentieth Century–Fox—and, to a lesser extent, the three "minors"—Columbia, Universal, and United Artists (then only a distribution company). There were also successful independent companies during this period such as Samuel Goldwyn Inc., Selznick International Pictures, and Walt Disney Productions, and low-budget studios such as Monogram and Republic. What distinguished the majors was the integration of production,

distribution, and exhibition. Indeed, it was the majors' ownership and control over the theater side of the business that tended to be the most lucrative. By the 1940s, Paramount, with more than 1,200 theaters, was the most profitable studio; Twentieth Century–Fox had 600, Warner Bros. 175, Loews's/MGM 150, and RKO 100.[7] For each of the majors, the real bosses were not the heads of production in Hollywood but the corporate executives on the East Coast.

Nevertheless, as Schatz notes, it was the men who oversaw production on the West Coast who shaped a studio's style, and although each one's particular contributions varied from one studio to another, this house style became more and more recognizable by the end of the 1920s. Of the five majors, MGM, boasting "more stars than there are in heaven," was the wealthiest, and also the glossiest, with high-budget productions designed by its influential art director, Cedric Gibbons, who was with the studio from 1924 to 1956. Paramount was more cerebral, with a soft-focus, low-light style influenced by technicians recruited from UFA in Berlin and Sascha-Film in Vienna. Warner Bros. was less European and more working class, noted not only for its gangster films, but also for pictures of social interest such as *I Am a Fugitive from a Chain Gang* (Mervyn LeRoy, 1932). Twentieth Century–Fox, as John Belton notes, was "jokingly referred to by rival studios as '16th Century–Fox' because of all the period and costume pictures it produced."[8] Tightly run on the West Coast by Darryl Zanuck, it also had a rural appeal unlike the more urban focus of Warner Bros., and during this period it featured more folksy stars such as Will Rogers, Shirley Temple, Stepin' Fetchit, Henry Fonda, the Olympic ice skater Sonja Henie, and, in the 1940s, Betty Grable. RKO was more eclectic, corresponding to the many different heads of production during the 1930s and 1940s, including David O. Selznick, Merian C. Cooper, George Schaefer (who oversaw *Citizen Kane* [Orson Welles, 1941]), Charles Koerner, and Dore Schary.

As the industry grew, studios began adopting a tiered production format, with a studio head on top and producers in charge of their own units under him. Because there were so many producers making so many films in the period between 1928, when *Wings* (William H. Wellman, 1927, associate producer B. P. Schulberg) won the first Oscar for "Outstanding Picture," and 1946, when *The Best Years of Our Lives* (William Wyler, 1946, producer Samuel Goldwyn) won the nineteenth, this chapter discusses the roles, careers, and working methods of just a select few of the prominent producers at the five majors.

MGM

During this period, MGM, under the leadership of Louis B. Mayer, was the dominant studio among the majors. It garnered the most Best Picture awards (five): *Broadway Melody* (Harry Beaumont, 1929, uncredited producer Harry

FIGURE 7: Louis B. Mayer signs in at the premiere of MGM's 1932 prestige picture *Grand Hotel* (Edmund Goulding), one of the studio's five Best Picture Oscar winners between 1929 and 1942.

Rapf [my grandfather]), *Grand Hotel* (Edmund Goulding, 1932, uncredited producer Irving Thalberg), *Mutiny on the Bounty* (Frank Lloyd, 1935, uncredited producer Irving Thalberg), *The Great Ziegfeld* (Robert Z. Leonard, 1936, producer Hunt Stromberg), and *Mrs. Miniver* (William Wyler, 1942, producer Sidney Franklin).[9]

When MGM was founded in 1924 with the merger of the Goldwyn Company, Metro Pictures, and Louis B. Mayer Productions, a story headlined "Merger Chief Picks Clever Associates" began: "The destinies of Goldwyn-Metro-Mayer, the recently merged film interests, rests in the hands of three men. Those men are Louis B. Mayer, vice president in charge of production, and his two associates, Irving G. Thalberg and Harry Rapf."[10] This trio was affirmed in a front-page story in *Film Daily* for October 19, 1924, when Marcus Loew announced there would be no shake-up at the Metro-Goldwyn Studios: "Louis B. Mayer will resume his duties here upon his return from Italy, with Irving Thalberg and Harry Rapf continuing as his assistants." Hunt Stromberg was added to the team in 1925. A newspaper story announcing his addition reads in part, "But the strength of this three link circle is in the ascendant, and the names of Mayer, Thalberg, and Rapf already loom large in the bright galaxy of film fame. The successful 'big three' is now augmented by the presence of Hunt Stromberg."[11] At the time of the merger Thalberg and Rapf earned the same salary of $650 a week and had adjoining and equal-sized offices in a building next to the main gate to the Culver City studio.

Their secretaries shared outer offices, and the two men had a joint projection room that could be reached by a ramp between their building and the building where the editing was done. During the formative years of MGM they were close associates, read each other's scripts, attended each other's previews, and, for at least the first year of the company's operation (1924–25), were responsible for the entire program of forty-eight films promised to exhibitors. As the structure of the studio evolved, more producers were added to the team. Thalberg had assistants Paul Bern, Albert Lewin, and Bernie Hyman; Rapf had Jack Cummings, Larry Weingarten, and, in 1926, David Selznick. Thalberg, in general, supervised the bigger-budget pictures. Those made for under $500,000 were supervised by Rapf, although this differentiation was not clear-cut. The line between so-called A- and B-pictures was a fluid one. Of the forty-eight features, only twelve were big budget, including a select group known as "Specials," such as *The Big Parade* (King Vidor and [uncredited] George W. Hill, 1925, producer Irving Thalberg), which were designed to have longer runs at the Astor in New York. Most MGM films opened at the Capitol, and the average run was about two weeks. At this time, as Bosley Crowther wrote, "Thalberg was Mayer's productive right hand; Rapf was his left."[12]

MGM was the last of the major studios to switch over completely to sound, and its first two big successes in this new technology were both produced by Rapf: *The Broadway Melody* and *The Hollywood Revue of 1929* (Charles Reisner). With his background in managing vaudeville acts, these all-star singing and dancing extravaganzas were a natural for Rapf; he was able to bring back many old friends such as Gus Edwards, Bessie Love, Ukulele Ike, Dane & Arthur, and Marie Dressler. Thalberg oversaw the more "serious" films, such as *Hallelujah* (King Vidor, 1929), a look at the life of a Southern cotton picker who becomes a preacher; the prison drama *The Big House* (George W. Hill, 1930); and Greta Garbo's first "talkie," an adaptation of Eugene O'Neill's *Anna Christie* (Clarence Brown, 1930). It is clear the styles and interests of these two producers were different, but they complemented each other and supervised without animosity the kinds of productions for which each was best suited.

In addition to musicals, Rapf specialized in sentimental comedy. He had always had a fondness not only for dogs (Rin Tin Tin was his discovery when he started at Warner Bros. in 1921), but also for the oppressed man, woman, or child who triumphs over adversity. These are the kinds of films on which he focused at MGM in the early sound era, and they were some of the studio's most successful: *Min and Bill* (George W. Hill, 1930, for which Marie Dressler won an Academy Award), *The Sin of Madelon Claudet* (Edgar Selwyn, 1931, for which Helen Hayes won an Academy Award), *The Champ* (King Vidor, 1931, for which Wallace Beery and screenwriter Frances Marion won Academy Awards), *Emma* (Clarence Brown, 1932), and *Tugboat Annie* (Mervyn LeRoy, 1933). It was his idea to pair Beery and Dressler, and, as the producer of their major pictures at this

time, Rapf clearly played a role in establishing them as the number-one box office draws in the first two years of the 1930s.

A look at the production file on *Emma* reveals exactly how painstaking and detailed the work of the classical era producer was.[13] The film is based on an original three-page story by Frances Marion, and she had her good friend Dressler in mind for the lead for the screen adaptation. The development of the script took place during the spring, summer, and fall of 1931, with a number of writers, as was customary at MGM, working on it, including Leonard Praskins, Del Andrews, Max Lief, and Zelda Sears. Each revision had to be approved by Rapf. There are a number of such revisions in the files, dating from June 8 to October 17. The film was shot in November. But the creative role of the producer did not end there. Revisions continued to be made in dialogue and continuity, usually involving retakes.

The transcript of a conference on *Emma* that took place on Monday, December 7, 1931, between Mr. Rapf, Mr. Praskins, Miss Marion, and two other rewrite men, a Mr. Brown and a Mr. Davies, reflects exactly the kind of detailed contribution a producer would make on a film at this time. They are discussing Emma's trial and her lines at the end of the film. Praskins finds her words to the children, "God bless you," to be sentimental "pulp." But Rapf defends the emotion:

> RAPF: I like this other one here. I don't think this might turn out bad, as it is, when she says: "But my work's finished here, dear. You're all grown up—you're all fine big men and women—and I'm proud of you."

However, he wants to cut the line, "You mustn't ask me to stay any longer," and instead go straight to, "'But I've got to go,' then she turns around—'Be Happy.'" Praskins disagrees and thinks there will be a logical gap without that line, but Davies supports Rapf: "She would say: 'Oh I'm all right . . . I've got to go.'" They go on talking about the dialogue in this scene word by word. Rapf likes the line, "Emma, we want to take care of you," and argues that it leads in naturally to her saying "God bless you":

> RAPF: For their expressions of affection,—they want to take care of her,— she says: "God bless you all," then "I'm a work horse." I think that coming from Dressler is marvelous.

Rapf goes with his feelings and his ideas prevail. As producer, he understood the intricacies involved in shooting a film and maintaining continuity. In that December conference on *Emma*, for example, he shows exactly how well he understands filmmaking:

> RAPF: Now we go to the court room scene. The continuity will read this way: We open up with a long shot of the court room. The druggist

is on the stand. Marie is up on the stand. Requires no retake there. We cut to the airport. Ronnie's arrival and his leaving. We cut back to the ante-room of the court room during recess. We start the scene with the District Attorney and Assistant. Now we will have to retake it from there, because she won't be at the window at this time.

This is the same kind of eye for detail that Fitzgerald attributed to Monroe Stahr. With Rapf and Thalberg at MGM, the producer was indeed "the unity." It should not be surprising, then, that MGM's output changed when both Rapf and Thalberg suffered heart attacks in 1932, Rapf at the beginning of the year and Thalberg at the end. The ill health of these two pioneers marked a complicated switch of power at the studio. Rapf stayed on, but in a diminished capacity, until his death in 1949. Thalberg died in September of 1936. Among the tributes in *Film Daily* were those from Selznick: "Irving Thalberg was beyond any question the greatest individual force for fine pictures that we have ever known—the world's greatest producer"; and Darryl F. Zanuck: "The loss of Irving Thalberg to the motion picture industry is irreplaceable. More than any other man, he raised motion pictures to their present world prestige. I am sad at the thought of losing him as a friend, but am proud that the industry in which I belong has produced a man of such notable stature."[14]

By 1941, Louis B. Mayer was still vice-president in charge of production, but immediately under him there was now a large executive staff of vice-presidents

FIGURE 8: The "three link circle" atop MGM (left to right): Irving Thalberg, Louis B. Mayer, and Harry Rapf. From the personal collection of the author.

that included not only Rapf, but also Al Lichtman, Sam Katz, and Eddie Mannix. Production operations were overseen by an Executive Committee of nine: the five men above, along with Stromberg, Benny Thau, Bernie Hyman, and Larry Weingarten.

In this year all the studios began reorganizing production in order to meet the terms of the Consent Decree (the agreement made to temporarily settle the federal government's suit against the studios' practice of "block booking," in which exhibitor access to desirable titles was tied to an agreement to license other less popular films distributed by the same studio). A story in the *Hollywood Reporter* for January 20, 1941, indicates a record number of films going into production, with "big-budgeted shows" outnumbering "program pictures" about three to one. The story goes on: "A new portent shows up in a look over the stages this week, a move which may prove radically to alter existing production before the 1940–41 season is written off to the home office accountant books. It is the slant toward unit production, which would seem to be taking hold by leaps and bounds."

With the expansion of the unit system in which different producers oversee different productions with others working under them, the power dynamics at MGM changed. For example, as Schatz notes, the "Seitz unit" (run by George B. Seitz) was in charge of the Andy Hardy pictures starring Mickey Rooney.[15] Rapf, on the other hand, who had been supervisor of MGM's shorts department since the silent era, was in 1941 put in charge of the "Rapf/Schary unit" (working with Dore Schary, who in 1948 became head of production at MGM). The August 22 issue of the *Hollywood Reporter* announced the formation of the unit: "The newly set up production unit at MGM, headed by Harry Rapf and Dore Schary, will turn out a minimum of twelve pictures a year, according to present plans. So far, three producers—Samuel Marx, Irving Asher, and Jack Chertok—have been assigned to the unit, but others may be added."

During its two years of operation the unit made over twenty-four films, including the World War II drama *Journey for Margaret* (W. S. Van Dyke and [uncredited] Herbert Kline, 1942) and *Lassie Come Home* (Fred M. Wilcox, 1943). Producers in these units were still closely involved in preproduction (story and script development), the hiring of directors, and postproduction (cutting, dubbing, scoring after previews and retakes). In 1937 Mayer hired Mervyn LeRoy from Warner Bros. to become head of production. And it was he who convinced the studio to make *The Wizard of Oz* (Victor Fleming et al., 1939). Arthur Freed was the (uncredited) associate producer on *The Wizard of Oz* and then went on to create what is probably MGM's best-known division, "the Freed unit," which produced its major musicals during this time, including *Strike Up the Band* (Busby Berkeley, 1940), a patriotic celebration of Americana with Mickey Rooney and Judy Garland; *Cabin in the Sky* (Vincente Minnelli, 1943), an all-black musical with Lena Horne in her only starring role at MGM; and *Meet Me in St. Louis* (Vincente Minnelli, 1944). But as the war ended, MGM's top-heavy

management-by-committee, where the number of producers expanded while the output diminished, put the studio in perilous financial shape. As a result, the New York office, long headed by Nicholas Schenck, contemplated replacing the formidable Mayer, a shake-up that indeed transpired in 1948 when Dore Schary took over.

Paramount

The man behind Paramount in this era was Adolph Zukor who, with Jesse Lasky, merged three companies in 1916, Famous Players, the Lasky Corporation, and Paramount. Zukor built the Publix Theatres Corporation, with nearly two thousand theaters nationwide, and ran two production studios, one in Astoria, Queens, New York, and one in Hollywood. Because of the success of the theaters, in 1930 the company became simply "Paramount."

Walter Wanger was head of production at the East Coast studio from 1924 through 1931. The studio was closed for a year in 1927, then reopened in 1928 to make sound films, and under Wanger's leadership a number of Broadway actors were recruited, including the Marx Brothers and Maurice Chevalier. In 1926 Zukor hired Ben (B. P.) Schulberg to run the West Coast operation, which he did until 1932. There was a rivalry between the East Coast and West Coast, although both studio heads, Wanger and Schulberg, were thoughtful and educated men.[16] In 1931 the Astoria Studio closed again and Wanger joined Columbia.

There was also an intense in-house rivalry between Schulberg and David O. Selznick, who joined Paramount in 1927 after starting his career as Harry Rapf's assistant at MGM. He was appointed Schulberg's executive assistant to help oversee the transition to sound films. In 1929, as the film historian David Thomson reports, with the Schulberg family away on a vacation in Italy, Selznick began to deluge Lasky with ideas for reorganizing the studio. When Schulberg came back he rightly felt "resentful and suspicious." Publicly, Selznick defended Schulberg, who was in trouble with the studio for his affair with the actress Sylvia Sidney, but his real feelings came out in one of his famously caustic memos in which he described the producer as "a really great mill foreman." As the industry changed, Thomson writes, "and as the public became more selective, and as the method of selling pictures changed, the assembly-line method of making pictures obviously became outdated and destroyed its adherents."[17]

Selznick left Paramount in 1931, working first at RKO, where he produced, among other films, *A Bill of Divorcement* (George Cukor, 1932), the film that brought Katharine Hepburn and George Cukor to Hollywood (see RKO, below). Though he helped make her a star, Hepburn's perspective on Selznick was dismissive and snide: "He was like a wonderful, brand-new, beautifully designed and very expensive shoe—he wasn't creative, but he was a piece of work."[18]

Against the advice of his wife (Selznick had married Louis B.'s daughter Irene Mayer in 1930), the producer left RKO and rejoined his father-in-law's studio in 1933 with his own production unit. "The son-in-law also rises" became a catch phrase around town. With Thalberg's heart attack, Selznick was seen, if not as a successor, at least as a back-up. His films at MGM included *Dinner at Eight* (George Cukor, 1933) with Jean Harlow, John Barrymore, Wallace Beery, and Marie Dressler, and *Dancing Lady* (Robert Z. Leonard, 1933) with Joan Crawford and Clark Gable. Harry Rapf's son Maurice watched some of the rushes for *Dinner at Eight* with Selznick:

> He was *fantastic* in the projection room. . . . He'd sit there and he'd see things that I didn't see at all. Including minor things, but they were impressive to me—that he could notice that somebody's pocket was turned up or something. I said, Jesus! I was interested in movies in those days . . . but I could never be as perceptive as he. . . . He would be snap. It was quite extraordinary. . . . I think a lot of it was just, if you're going to be a boss, you'd better act like one.[19]

Selznick was skilled at taking a film from preproduction through production and finally into release; and, like father Lewis J. Selznick, a pioneer in the business, he had no shortage of confidence. As Thomson writes in the biography, "It is a test of any great producer or artist to suffer failure in the morning and then step into something like perfection after lunch. There must be no loss of confidence or momentum."[20] Working under the supervision of the MGM studio bosses was not ideal for a man with so many creative ideas of his own, so he left in 1935 to form an independent company, Selznick International Pictures. Between 1936 and 1939 he continued to film literary classics, such as *Little Lord Fauntleroy* (John Cromwell, 1936), *The Prisoner of Zenda* (John Cromwell, 1937), and *The Adventures of Tom Sawyer* (Norman Taurog, 1938).[21] He also made *A Star Is Born* (William Wellman, 1937), the first color film to be nominated for an Academy Award.[22] Selznick was noted for his frequent use of Technicolor, rare in the late 1930s, and used most impressively in his crowning achievement, *Gone with the Wind* (Victor Fleming, 1939).

With his own company, Selznick International, the producer had the kind of control he was not allowed at MGM. As he told Art Buchwald in 1957, "I am interested in the thousands and thousands of details that go into the making of a film. It is the sum total of all these things that either makes a great picture or destroys it. The way I see it, my function is to be responsible for everything."[23] When Selznick died at the age of sixty-three, the *New York Times* obituary noted that at "the peak of his career, Mr. Selznick was voted for 10 successive years as the No. 1 producer of box-office successes by motion-picture exhibitors of the country."[24]

FIGURE 9: Working under the supervision of the MGM studio bosses was not ideal for David O. Selznick, so he left in 1935 to form his own independent company, Selznick International Pictures.

Both Selznick and Wanger left Paramount in 1931. In 1932, Schulberg also was forced out, and the company, in dire financial straits, filed for bankruptcy and went into receivership in 1933, from which it eventually recovered. While at Paramount, however, Schulberg was a powerful and influential player; he had founded his own production company, Preferred Pictures, in 1919, and was noted for discovering and promoting Clara Bow, the "It" Girl, who starred in *The Plastic Age* (Wesley Ruggles, 1925), written by an ambitious young screenwriter, Frederica Maas. In her autobiography, Maas described Schulberg as "one of the few literate minds in motion picture production at the time." He "had a retentive memory, read the classics, and quoted from them often."[25] "Schulberg," she wrote, "with the full confidence of his boss, Adolph Zukor, had a free hand to put Paramount on top. There would be none of the waste, pompousness, stalling, or posturing of studios such as MGM. Schulberg ran the show, working long hours, overseeing all aspects of production, keeping control over everything. He was a just man, sensitive and compassionate, an executive you could talk to anytime you had a problem that had to be resolved."[26] John Baxter, in his book on Josef von Sternberg, also says that Schulberg was not the typical "mogul," who read little and thought mostly in terms of the bottom line. He was, according to Baxter, "aligned with East Coast leftist culture rather than the gold-rush mentality of California."[27] No doubt in these early years his wife, Adeline Jaffe Schulberg, was a big influence. She had been active in the suffrage movement as a young woman and was a committed socialist. In Hollywood,

she promoted birth control clinics and helped found a progressive school based on the teachings of John Dewey. After her divorce from Schulberg in 1933, she founded a talent agency and eventually had a successful literary agency in New York. It was Adeline who convinced her husband to hire von Sternberg in 1927.

Although Schulberg reportedly called the script of *Blonde Venus* (von Sternberg, 1932) "the goddamndest piece of shit I've ever read in my life," he generally had a reputation for spotting excellent material. Like Selznick, Schulberg actually read scripts and he also had a talent for promoting promising stars and directors.[28] Paramount, according to Matthew Bernstein, gave directors more autonomy than other studios, and so it was really the directors and writers rather than production executives that helped to define the studio style.[29] But two good examples of Schulberg's influence are the cases of the director Dorothy Arzner and the actress Mae West, who is often credited with saving the studio in the worst of the Depression years.

The *Straits Times* (November 4, 1934) reported a story in which Schulberg takes credit for bringing Mae West to the screen but, oddly, over his initial reservations. The author of the story described the producer as "a remarkable man" for admitting that he did not want to hire West. This willingness to recognize his mistakes "is because his record for successes has been so long that he can afford to be more candid than most men are in Hollywood." The playful story, illustrative of a producer's conference at Paramount, reads as follows:

"I remember that I distinguished myself by sneering and scoffing," he says, "when they first brought Mae's name up.

"When I was production head at Paramount I had a cabinet of advisors. There were two types of men in the cabinet. The seasoned showmen, experienced playwrights and clever directors made up one group. The other consisted of relatives, men sent out by the banks and long-hairs who had been hired in moments of blindness on the part of various executives. I had a great advantage with such a cabinet. If an idea sounded good to the second group (which I always thought of as the 'know nothing party'), I could be fairly certain it was wrong.

"Well, we took up the matter of casting a picture called 'Night After Night.' It was to star George Raft and we were eager that it should go over. . . . We began to cast about for someone to play the part of the tough beauty shop owner.

"I referred the question to my cabinet and, as usual, the 'Know Nothing Party' was the first to make a suggestion. I was used to hearing them make bonehead proposals, but I wasn't used to the one they made this time. They proposed Mae West.

"I tried to be tolerant with them. I explained with some patience that Mae West was too large to photograph well. I also pointed out she had been gaoled in New York for plays that were considered indecent. I further

mentioned that she had written several books and plays on subjects that certainly would alienate the sympathy of women audiences. I took the trouble to present the facts about Mae West in a ten-minute summary. I desired to dismiss the subject once and for all. When I got all through I asked for any other suggestions. One came from one of the long hairs.

"'But this Mae West is funny,' he said, 'and this is a funny part.'

" . . . It didn't take long to show we were deadlocked. The showmen didn't want Mae and the dummies did. Usually I would step in and end what seemed to me to be a futile argument. But, with the representative of bankers and the relatives of executives' wives, it is better to be tactful than arrogant. I said I would telegraph Mae West and make her an offer.

"I kept my word. I sent her an offer that named so little money I was sure she would turn it down. To my amazement she accepted. That's how Mae West got into the movies, on the vote of a bunch of men who never had made a sound suggestion before, and, as far as I know, never have made one since. The geese once saved Rome, they tell me, and the geese in my office that afternoon saved Paramount."[30]

Arzner started her film career as a stenographer at Paramount but rapidly moved on to become a writer and editor. In 1927 she was offered a chance to direct at Columbia. When she went to Schulberg to announce her departure, their conversation played out as follows,

SCHULBERG: "We don't want you to leave. Why don't you stay in our scenario department?"
ARZNER: "I don't want to go into the scenario department. I want to direct."
SCHULBERG: "What if I said you could direct here at Paramount?"
ARZNER: "Not unless I can be on a set in two weeks with an A picture."

With that Schulberg left, saying, "Wait here." He was back a few minutes later with an assignment for her first picture, *Fashions for Women* (1927).[31] Arzner later directed Schulberg's protégée, Clara Bow, in her first talkie, *The Wild Party* (1929), which was the third-highest grossing picture of 1929, and also, in some accounts, the feature on which the boom mike was first used.

Warner Bros.

The Warner brothers, Harry, Albert ("Abe"), Sam, and Jack, started out in the nickelodeon business. In the late teens, they got into film production, and by 1928 there was a clear division of labor among them, with Harry managing the financial

side of the company in New York (he moved to Los Angeles in 1935), Abe the head of the theatrical division, and Jack running the Warner studios on Sunset Boulevard.[32] Their first big hit was *The Jazz Singer* (Alan Crosland, 1927), and with the success of the first all-talking feature, *The Lights of New York* (Bryan Foy, 1928), the studio geared up for full-scale sound production. The studio also expanded its production facilities that year by acquiring First National Pictures, and Jack Warner put young Darryl F. Zanuck in charge there. In the *Film Spectator* for July 21, 1928, Zanuck ably supported the company's audacious business model:

> If the Warner Brothers, in their entire career, have never done anything for the motion picture industry heretofore, they deserve the greatest appreciation we can give them for sponsoring talking pictures. After two years of ridicule and an expense of four million dollars, they may now sit back and rest on their laurels while the rest of the industry scrambles frantically in an effort to catch up. The day of the "silent picture" is a day far past. The black shadow of Al Jolson in *The Jazz Singer* was the well-known "hand-writing on the wall."[33]

Zanuck produced forty-three of Warner's eighty-six features in 1929 under the First National banner. By the early 1930s, he was overseeing most of the studio's important pictures, including the 1931 gangster classics *Little Caesar* (Mervyn LeRoy) and *Public Enemy* (William Wellman) and *I Am a Fugitive from a Chain Gang* (Mervyn LeRoy, 1932). W. R. Wilkerson in the *Hollywood Reporter* for August 5, 1932, extolled the success: "In the first place, Warners has the greatest showman producer in our business in the person of Darryl Zanuck. That man knows story values as does no other Hollywood executive. His ideas for the most part are new, original; always with plenty of wallop and he is able to inspire those around him, his writers, his directors, his artists on the merits of the ideas, thereby getting a cooperation that is otherwise unknown, in this cinema village." He ran the studio "like an assembly line. . . . He had a huge chart the size of his desk divided up into fifty-two weeks of the year. In the left-hand column of the chart he'd list fifty-two stories and on the right side the major stars at the studio. Then he'd get together all of his writers and say: 'Okay, this year gimme three Bogarts, four Bette Davises, four, no make that five Cagneys . . . I need a George Raft by Christmas. . . . ' Then the writers would go back to the Writers' Roost and create original stories around the actors' names."[34]

Zanuck left Warners in 1933 to form an independent company, Twentieth Century Pictures (see below). Milton Sperling, Cass's father and Harry Warner's son-in-law, explains one of the reasons why:

> In the early 1930s I knew that Darryl would never be given the studio, although at the time, he was confident he was next in line. He was the

wonder boy, the dynamic executive with the energy and bubbling ideas that had carried Warners into the new era of talking pictures. He felt he *was* Warner Bros. Then he began to realize that Jack Warner had no intention of making him the heir. Jack would have cut off his right arm, even his head, rather than hand over the studio to anyone. That included his brothers.[35]

Hal Wallis, who had been in charge of the publicity department, replaced Zanuck, while Jack Warner continued to run the studio as "the Chief." Warner supervised the selection of screen properties and acquired talent, and was most actively involved in production during the editing process. According to Rudi Fehr, a film editor, at least twice a week he and Warner would stay until 1:30 A.M. watching the rushes.[36]

Jack Warner's legendary frugality could frustrate creative talent on the lot. For example, he complained to the director Michael Curtiz after a long day's shooting on the set of *Casablanca,* "I can't understand why a fifty-four-second take must be started seven times."[37] Warner Bros. was an economically and efficiently run studio. Jack Warner had the reputation of regularly prowling the premises to make sure no unnecessary lights were on and that everyone was working. He was quoted as saying, "I'm running a factory. Making movies is like any other kind of factory production requiring discipline and order rather than temperament or talent."[38]

A day in the life of this producer, as described by his assistant, Bill Schaefer, sounds very much like Thalberg's or Rapf's, or B. P. Schulberg's:

> J. L. [Warner] would arrive between 11:30 and noon and would first go through the mail, then talk to the production head, Hal Wallis, or Mel Obringer, who was head of the legal department, or Ed DePatie, the business manager, who, with Harry Warner around, had become a very important cog in the wheel. Then we waited around to go to lunch. . . .
>
> After lunch J. L., accompanied by Wallis, would go to the projection theater and look at the dailies from the previous day's filming. I'd sit next to J. L. in the theater and make notes of his comments. He had what was called a fader, a control that he turned to raise or lower the sound.[39]

"After watching the rushes, Warner would go back to his office and if he didn't have an appointment," Schaefer relates, "he would read the trade papers, then the newspapers, from which he occasionally got story ideas."[40] Later, he would go to his private barbershop for a shave and manicure, and if he planned on running a film at the studio in the evening, Schaefer would "order a steak and baked potato and some kind of vegetable from the Brown Derby and have one of our drivers pick it up. I'd make him a pot of coffee somewhere between 7:30 and 8 P.M., and

he'd say, 'Well, Bill, you can go home.' Sometimes Jack Warner wouldn't get home until midnight."[41]

In addition to gangster pictures, Warner Bros. also made musicals like *42nd Street* (Lloyd Bacon, 1933) and *Footlight Parade* (Lloyd Bacon, 1933), and, after the Motion Picture Producers and Distributors of America (MPPDA) founded the Production Code Administration in 1934, melodramas, swashbucklers, and historical dramas. The studio also famously made cartoons, although Jack Warner didn't take animation seriously. All he knew about it was that it was important for distributors, who wanted a full program of news and animated shorts along with features. The first Warner Bros. Looney Tunes short, "Sinkin' in the Bathtub," made its debut on May 6, 1930, and starred a Mickey Mouse knock-off named Bosko.[42] The animation division was founded in 1933 initially as Leon Schlesinger Studios, a separate producing company whose films were released by Warner Bros. Schlesinger sold the animation studio to its parent organization in 1944, which continued to operate it as Warner Bros. Cartoons Inc. Its popular series—Looney Tunes and Merrie Melodies—featured Bugs Bunny, Daffy Duck, Porky Pig, Wile E. Coyote, and the Road Runner.

In the late 1930s, Warner Bros. was more political than the other major studios. Although both Harry and Jack were Republicans, they were also strong supporters of FDR, in large part because they rejected the isolationist policies embraced by many Republicans in Hollywood at the time. As such, Warner Bros. produced one of the first Hollywood films to dramatize the rise of Hitler, *Confessions of a Nazi Spy* (Anatole Litvak, 1939). Four years later, with the United States having entered the war with the Soviet Union as its ally, the studio made *Mission to Moscow*. Screenwriter Howard Koch was reluctant to take on the picture, but Harry and Jack convinced him that it was his patriotic duty and that FDR himself wanted the film made. Koch's reservations proved to be prescient, however: after the war, in the anticommunist hysteria of the Blacklist era, what had initially been seen as a patriotic film came to be considered un-American.

Except for Twentieth Century–Fox, the major studios were all run by Jews who wanted to steer clear of anything that might encourage antisemitism, particularly directed toward Hollywood. Hostility toward Jews in Hollywood dates back to the silent era and the fear that immigrants (like the studios' management) threatened the idyllic life of small-town Protestant America. People resented the preponderance of foreign-born Jews in the industry, and Will Hays, hired in 1922 to become the first president of the MPPDA and to help clean up the image of Hollywood, was regarded by some as "the hired man of a bunch of rich Jews." Henry Ford reputedly had a sign in one of his plants that read:

JEWS TEACH COMMUNISM
JEWS TEACH ATHEISM
JEWS DESTROY CHRISTIANITY

JEWS CONTROL THE PRESS
JEWS PRODUCE FILTHY MOVIES
JEWS CONTROL MONEY

Joseph Breen of the PCA, who worked closely with the studios on the content of their pictures, was also an antisemite. In a letter, he called a Warner Bros. Philadelphia district manager "a kike Jew of the very lowest type," and went on: "These Jews seem to think of nothing but money making and sexual indulgence. . . . They are, probably, the scum of the scum of the earth." Following a congressional subcommittee that determined in 1931 that 70 percent of Communist Party members in the United States were aliens, "and that most of these aliens were Jews," Breen worried about communist propaganda infiltrating the movies, adding that "most of the agitators are Jews."[43]

Between 1938 and 1944, Congressman Martin Dies headed the House Committee Investigating Un-American Activities, prefiguring the more famous postwar HUAC hearings. Dies believed that the Jews were dupes of a larger communist conspiracy and, because most Hollywood producers were Jews, they were influenced by communist ideology in the making of their pictures. In 1941 a Senate subcommittee, convened by Burton Wheeler of Montana and Gerald Nye of North Dakota, similarly investigated the idea that Hollywood had become a propaganda machine run by Jews. Nye specifically suggested that Harry Warner and MGM's Nicholas Schenck, because of their ethnic background, wanted the United States to intervene in the ongoing war in Europe. In their defense, Wendell Willkie, who the previous year was the Republican nominee for president, brilliantly argued that it was not the movies that shaped public attitudes, but movies that responded to public attitudes. Zanuck, then head of Twentieth Century–Fox, reminded the committee that he had been born in Nebraska and that his parents and grandparents were all native-born and lifelong members of the Methodist church. "Senator Nye, I am sure, will find no cause for suspicion or alarm in that background."[44] Zanuck was outspoken on the subject; he resisted when the PCA suggested that he should consult the German consul on the script for *The House of Rothschild* (Alfred L. Werker, 1934): "I do not think it would be a good idea to send it to a representative of the German government at this time. In the first place, I am told that the present government of Germany does not look with favor upon American moving pictures, especially Hollywood producers they have classed as Jews."[45]

Concessions made by Jewish producers were otherwise frequent, for example Warner Bros.' cooperation with the PCA in 1936 during the production of *The Life of Emile Zola* (William Dieterle, 1937), as the story might have been perceived as an indirect criticism of Hitler's Germany. For example, the word "Jew" was mentioned four times in the original script; all but one were cut, and the one is just an appearance of the word on a printed page indicating Alfred Dreyfus's religion.

Once the United States entered the war, the studios were encouraged (by the Office of War Information) to make films to support the war effort. The most famous film made in support of this mission is Warners' *Casablanca,* produced by Wallis, whose recent run of success at the studio included *The Petrified Forest* (Archie Mayo, 1936) with Bette Davis and Humphrey Bogart; *Dark Victory* (Edmund Goulding, 1939), also with Davis and Bogart; and *The Maltese Falcon* (John Huston, 1941), again with Bogart. In January of 1942 Wallis signed a four-year independent production deal. *Casablanca* was the third feature made under the "Hal Wallis Productions" banner.[46]

The development of *Casablanca* began in a routine manner when Jack Warner, at the urging of Irene Lee, who headed the story department at the studio, bought the rights to an unproduced play by Murray Burnett and Joan Alison entitled *Everybody Comes to Rick's.* When Wallis read it he called it "a potboiler," but he saw some good cinematic values in the story. On April 2, Warner sent a note to Wallis: "What do you think of using [George] Raft in *Casablanca?* He knows we're going to make this and is starting to campaign for it." Wallis, who had already made several pictures with Bogart, replied, "Bogart is ideal for it, and it is being written for him, and I think we should forget Raft on this property."[47] Interestingly, Wallis initially wanted to change Rick's jazz-pianist sidekick Sam to a woman but changed his mind.

In her detailed study of *Casablanca,* the film historian Aljean Harmetz argues that Wallis was the "creative force" behind the film, making decisions on the

FIGURE 10: The creative force behind *Casablanca* (Michael Curtiz, 1942), the Warner Bros. producer Hal Wallis.

quality of the lighting, the details of costumes, the use of music, and even, with respect to sets, an insistence on a live parrot outside the Blue Parrot Café. For example, Wallis wrote to cinematographer Arthur Edeson on June 2, 1942, that he wanted more contrast in the first scenes in Rick's Café: "I am anxious to get real blacks and whites, with the walls and the backgrounds in shadow, and dim, sketchy lighting." Regarding Rick's drunken reverie that leads into the Paris flashback, Wallis wrote to his director, "The general lighting in the Café should be turned out when we dissolve into the room from the Ext. Sign, and the Café should be almost in darkness with the exception of a couple of lamps on the lights on the tables." On costumes, he nixed the tuxedo that Laszlo (Paul Henreid) was to wear and decided instead on a "very well tailored tropical suit."[48]

Wallis told Curtiz to reshoot Rick's dialogue with Captain Renault (Claude Rains) after Ilsa (Ingrid Bergman) and Laszlo leave. "This should be delivered with a little more guts . . . a little more of the curt hard way of speaking we have associated with Rick. Now that the girl is gone I would like to see Rick revert to this manner of speaking."[49] Wallis also wrote the famous last line himself—"Louis, I think this is the beginning of a beautiful friendship"—and he wrestled with aspects of the script throughout the shoot, hiring his favorite writer, Casey Robinson, to improve the love story. With screenwriter Howard Koch, Wallis reworked the ending, telling Curtiz in a memo on July 6, 1941, "I think you will find that it incorporates all of the changes you wanted made, and I think we have successfully licked the big scene between Ilsa and Rick at the airport by bringing Laszlo in at the finish of it all."[50]

Everyone who worked on *Casablanca,* and especially director Michael Curtiz, gave Wallis credit for shaping the film. Biographer Charles Higham states unequivocally, "The film reflected his precision in looking at life as a series of blacks and whites. The crisp, clear-cut approach to a moral dilemma was Wallis."[51] But when the film was announced as the 1942 Academy Award winner for Best Picture, it was Jack Warner who ran to the stage to accept the award ahead of Wallis, leaving the film's hands-on producer just getting out of his seat. An angry Wallis responded, "*Casablanca* had been my creation; Jack had absolutely nothing to do with it."[52] The consolation for Wallis was that for the second time, he was given the Thalberg Award "for the most consistent high quality of production by an individual producer, based on pictures he has personally produced during the preceding year."[53]

As the war entered its final months, Harry Warner began to think about the future: "The motion picture industry would be shamefully remiss if it were not looking ahead to its task in the postwar world. The essence of the task can be stated in a single phrase, 'To interpret the American way.' We at Warner Bros. have sought for more than a decade to combine entertainment with a point of view. We have tried to say on the screen things about America and democracy and Fascism that needed to be said."[54] *Casablanca,* as Harmetz has written, "was

the beneficiary of Harry Warner's stubborn anti-Nazi stance and his insistence that the studio combine good citizenship with entertaining movies."[55] But the changes in the industry during the postwar years made for an uneasy future, and "the American way" became tangled in a web of anticommunism, witch-hunting, and a climate of fear in Hollywood.

RKO

RKO was formed in October of 1928 with the merger of the Radio Corporation of America (RCA), the Keith-Albee-Orpheum theater chain, and Joseph P. Kennedy's Film Booking Offices of America (FBO). The corporate history of RKO is complex; as Rick Jewell has written, the studio "existed in a perpetual state of transition from one regime to another, from one set of production policies to the next, from one group of filmmakers to an altogether different group. Being less stable than its famous competitors, the company never 'settled down,' it never discovered its real identity."[56]

William LeBaron, who had been head of production at FBO, assumed that role for the new studio. He was replaced by David O. Selznick in 1931, who hired as his assistants Merian C. Cooper and Pandro S. (Pan) Berman. With his previous experience at MGM and Paramount, Selznick was able to recruit some much-needed talent, including the director George Cukor and the actress Katharine Hepburn, who made her screen debut in Cukor's *A Bill of Divorcement* for the studio. However, after only fifteen months at RKO, a dispute with corporate president Merlin Aylesworth in 1933 prompted Selznick's departure, and Cooper took over. Shortly thereafter, RKO fell into receivership, but the studio continued to produce noteworthy films throughout the 1930s, due largely, according to Jewell, to decisions made early on by Selznick, including support for Cooper's personal project, *King Kong* (Merian C. Cooper and Ernest B. Schoedsack, 1933), and the Cukor-directed *Little Women* (1933, starring Hepburn).

Cooper's tenure was also distinguished for the pairing of Fred Astaire and Ginger Rogers, who ranked fourth on the list of the "biggest moneymaking stars of 1934–1935," a first for any RKO performer.[57] Their musicals helped define the mid-1930s "studio style" with the suave Art Deco influence of Van Nest Polglase, who headed the design department and did for RKO what Cedric Gibbons did for MGM. Because there were so many diverse personalities behind the scenes at RKO, and "production philosophies were in constant flux," its house style was shaped less by its producers than by its contracted artists and special-effects personnel.[58]

Unlike producers such as Selznick, Cooper's method was not to micromanage, leaving his associates to oversee individual productions. He focused mostly on pre-production, especially script development, hoping to eliminate the shooting

of unnecessary scenes, thereby keeping costs down. In a memo to Selznick on November 2, 1933, on the success of *Little Women,* he made clear that he regarded the director, in this case George Cukor, as the "author," not the producer. As for his own role, he took credit for not letting anyone "bother Cukor regardless of how many days he was behind shooting time. . . . The chief credit in any picture basically goes to the director and the writers, and certainly no one could have done a better job than George."[59]

When Cooper left RKO in 1935, the new production chief, Samuel Briskin, lasted only two years. His key contribution to the studio was the signing of Walt Disney to a distribution deal in 1936 that included the release of the first full-length animated feature, *Snow White and the Seven Dwarfs* (1937), and then *Pinocchio* (1940). Previously, Disney cartoons had been distributed by Columbia and then United Artists, but Briskin knew Disney and his brother Roy from his days at Columbia. When the deal was announced, Disney said, "In looking to the future, and that includes television, we believe our association with RKO offers greater opportunities for the broader and more expansive fields of development."[60]

Pandro S. Berman replaced Briskin in 1937, but he clashed with studio president George J. Schaefer who, after Berman's exit, became head of production himself. Schaefer was not a hands-on film person and left production to independents like Samuel Goldwyn and, famously, Orson Welles. In 1942, Charles Koerner took over for Schaefer and served as an efficient production head until his death in 1946. Koerner emphasized entertainment rather than prestige pictures, so that during the box office boom of the war years, RKO revived financially, becoming the first studio to create a television subsidiary, RKO Television Corporation. More than the other majors, under Koerner RKO emphasized its low-cost B-picture unit, which included Val Lewton's enormously popular horror films, such as *Cat People* (Jacques Tourneur, 1942), *I Walked with a Zombie* (Jacques Tourneur, 1943), and *The Body Snatcher* (Robert Wise, 1945), as well as the Tarzan series.

Lewton had been a story editor for Selznick and was hired by Koerner at the suggestion of Breen. He was offered his own production unit on the condition that he make low-cost horror "programmers," and that he use titles that had been developed through market research. Lewton, however, had his own ideas. "They may think I am going to do the usual chiller stuff which'll make a quick profit, be laughed at, and be forgotten, but I'm going to fool them. . . . I'm going to do the kind of suspense movie I like."[61] As a writer/producer, Lewton came up with the ideas for his films, researched them himself, and worked collaboratively with his production team that included writers, art directors, and directors. The writer on *Cat People,* DeWitt Bodeen, recalls that sometimes during story conferences Lewton would "move to the light switch of his office, turn off the lights quickly, and continue recounting the story in the darkened room."[62] He would then sit down at his old Royal typewriter and, with two fingers, rewrite the script during the early hours of

the morning. As screenwriter Ardel Wray recalls, "We'd work late, go to dinner at the Melrose Grotto, back to the studio, work some more, then walk out, enjoying and talking about the eerie, half-sinister quality of an empty lot at night."[63]

As for the production itself, director Jacques Tourneur remembers that Lewton knew what he wanted. "If you make the screen dark enough, the mind's eye will read into it anything you want. We're great ones for dark patches."[64] In Lewton's films, horror is suggested rather than shown. On *I Walked with a Zombie,* actress Elizabeth Russell recalled that Lewton was always on the set, "and had a worried look all the time. He was always in there, perfecting the script the night before."[65]

Lewton's films saved RKO when it was nearly bankrupt, but a combination of factors, including poor health, led to his departure from the studio in November of 1946. In that same year, RKO released the Samuel Goldwyn production of *The Best Years of Our Lives* (William Wyler), which won the Oscar for Best Picture. The film was also a harbinger of change industry-wide, as Sarah Kozloff has observed: "The best years of the Hollywood studios had come to a close."[66]

Twentieth Century–Fox

The Fox Film Corporation, under the leadership of William Fox, had been in business since 1904, the year of Fox's first nickelodeon. When Marcus Loew, who owned theaters on the East Coast as well, died in 1927, Fox saw the opportunity for an advantageous merger and in 1929 acquired a controlling interest in Loew's. However, the stock market crash and the economic collapse that followed put the corporation into receivership and William Fox himself was forced out of management in 1930. In August 1935, the struggling Fox Film Corporation merged with a new company, Twentieth Century (founded in 1933 when Zanuck left Warner Bros. and went into partnership with Joseph Schenck). Zanuck's company had no production facilities and no theaters, but it did have a distribution deal with United Artists. The merger with Fox thus brought Twentieth Century exactly what it needed.

Zanuck came from the rural Midwest. He started his film career as a gag writer for Mack Sennett, but he moved to Warner Bros. where he established himself as an especially prolific screenwriter. In 1924 he was promoted to producer and, in 1926, to supervisor of production for the whole studio, regarded as "the greatest showman producer" in the business and working directly under Jack Warner. According to the historian Peter Lev, there is a discernable Zanuck style: "[His films] were tightly written, with an emphasis on plot and conflict rather than symbolism or speech making. . . . [His pictures are] convincingly grounded in contemporary reality."[67]

On April 15, 1933, a front-page headline in the *Hollywood Reporter* announced, "Zanuck out of Warners." Zanuck turned in his resignation, according to the

official release, "due to a disagreement of policy in company management."[68] Zanuck promptly went into partnership with Schenck, president of United Artists, to make twelve pictures a year under the Twentieth Century Pictures banner. In another front-page story, this one in the *Hollywood Filmograph* two weeks later, under the headline "Darryl Francis Zanuck Announces Plans of New Company," the producer explained the origin of the name. "The reason for selecting TWENTIETH CENTURY PICTURES, INC. as the name of the new company, was because it seems to exemplify the type of pictures we intend to produce. Our stories, with but few exceptions, will be modern headline types of stories packing a punch aimed at the box office. In short, TWENTIETH CENTURY PICTURES, INC. intends to carry to the box-office of the theaters of the world, a spirit as modern and as vital as its name."[69]

Twentieth Century was successful for Zanuck, releasing an impressive number of films between 1933 and 1935 (when it merged with Fox). Another story in the *Hollywood Filmograph,* this one headlined "Darryl Francis Zanuck Is Busiest Man in Hollywood," describes the producer's load:

> Any producer in any of Hollywood's big studios can put forth evidence to fully substantiate the fact that they are very busy men, toiling from early morning to hours that are often long past midnight.
>
> As to the "busiest" of all these producers, at the present moment, however, there can be no doubt is—Darryl Francis Zanuck, vice-president in charge of production for Twentieth Century Pictures.
>
> He has faced the task of translating into actual fact the agreement made between Joseph M. Schenck to produce twelve pictures in the coming season for United Artists release.
>
> In the history of United Artists which was formed to release the productions of the screen's foremost personalities, no single member organization has attempted so ambitious a program. . . . In a short space of time—Darryl Zanuck, with that indefatigable zeal so often characteristic of the man who is small in stature but a giant in spirit, has perfected an organization which is ready to spring into action and carry to full completion the vast production plan he has undertaken.[70]

Due to personal and financial conflicts, in 1935 Schenck and Zanuck began looking for a new home for their company. At the same time Fox needed a stable production base on the West Coast. The merger resulted in Twentieth Century–Fox, with its East Coast president, Sidney Kent, overseeing the areas of distribution, exhibition, advertising, and government relations, while on the West Coast there were briefly two studio heads, Zanuck and Winfield Sheehan. Sheehan was soon forced out, leaving Zanuck, at the age of thirty-three, in charge of production, with Schenck, the titular executive, focusing on more general industry-wide issues.

Zanuck brought to Twentieth Century–Fox a production style he had developed at Warner Bros.: well-written, fast-paced scripts frequently set in the Midwest or the West, since the majority of the Fox theaters were in this area. Warners' gritty urbanity had no place here; however, Zanuck brought from his former studio the idea that films should educate as well as entertain, making such classics as *The Story of Alexander Graham Bell* (Irving Cummings, 1939), *Young Mr. Lincoln* (John Ford, 1939), *Stanley and Livingston* (Henry King and Otto Brower, 1939), *The Grapes of Wrath* (John Ford, 1940), and *Wilson* (Henry King, 1944). Sounding a lot like Harry Warner, Zanuck said he regarded *Wilson*, about the former U.S. president Woodrow Wilson, as the most important he ever made: "I am gambling $3 million in an effort to prove that audiences are ready to accept something more than straightforward entertainment. I am making one mighty bid to try to open the floodgates of production toward the making of entertaining films that are enlightening as well."[71] *Wilson* was nominated for Best Picture (losing to Leo McCarey's *Going My Way*), but it did not do well at the box office. Although Bosley Crowther wrote in his review in the *New York Times* that the picture "should inspire millions of people throughout this land to renewed appreciation of its subject's ideals and especially of his trials, which may be ours," few outside of New York City found its almost two and half hours of running time worth watching.[72]

Fox's biggest successes were not political films; Shirley Temple, featured in heart-warming family comedies such as *The Little Colonel* and *The Littlest Rebel* (both David Butler, 1935), was the top moneymaker in America between 1935 and 1938. Also popular was the folksy Oklahoman Will Rogers, who helped define the populism that characterized Fox in the later years of the Depression. Olympic figure-skating champion Sonja Henie was signed in 1938, and, shortly after that, the down-to-earth Henry Fonda. During the war years, Fox's top female stars were Betty Grable, Linda Darnell, and Gene Tierney.

The B-picture unit at Fox was headed by the mercurial Sol Wurtzel, a producer radically different from his boss. According to Frederica Maas, Wurtzel had contempt for anything he did not understand or did not want to understand. He was not literate and hated reading (and so did not read the scripts or books brought to him). Everything had to be synopsized in plain simple English. Ben Schulberg, Maas says, coined the phrase that summed up the man: "From bad to Wurtzel."[73] His unit was nonetheless important to the studio, turning out B-westerns and musicals and also the popular Charlie Chan series.

At Fox, Zanuck was intensely involved in preproduction and postproduction, although he left much the actual work on the set to his directors. There were exceptions, especially when the pace of production seemed slow. In a memo written during the production of *Swamp Water* (1941), he wrote to its director, Jean Renoir: "You are going entirely too slow. . . . We have changed cameramen and now you have a photographer who can keep up to a fast pace, yet we are getting

no more film than we did with the other cameraman." And he goes on to make eight specific suggestions, including:

1. You are wasting entirely too much time on non-essential details in your background.

2. You are moving your camera around too much on the dolly or on the tracks. . . .

7. You used four different angles to get over the action with the sheriff on the porch. This could have been covered with one or two angles at the most.[74]

Today Renoir is noted for his use of deep focus and the telling details in his backgrounds, but Zanuck, with a producer's eye for budget as well as a filmmaker's eye for technique, kept a tight rein on the French director's work at the studio. In another memo, detailing yet more criticisms, Zanuck forcefully concludes, "In closing, I want you to know that I am behind you and I am going to see you through on the picture—but, by the same token, I expect you to play ball my way."[75]

Since he had started his career as a writer, Zanuck was an excellent script doctor and read every draft of every script, working collaboratively with his writers. Even though his story conferences were often transcribed as monologues, the writers with whom he worked, such as Nunnally Johnson and Phillip Dunne, found their collaboration with him productive and stimulating.[76] In a memo to Dunne and director William Wyler on December 6, 1940, Zanuck described himself as "not the type of producer who stands on the side-lines and hires people to express their views for him and takes the screen credit. I expect every picture that I have been associated with to equally represent the views of the writer, the director and myself."[77]

Johnson called Zanuck "the best cutter" of films in Hollywood."[78] He screened the rushes, first cuts, and fine cuts with his primary postproduction assistant, the pioneering film editor Barbara "Bobbie" McLean, with whom he worked until her retirement in 1969. McLean won an Academy Award for her editing of *Wilson* and was nominated for six others, including *All About Eve* (Joseph L. Mankiewicz, 1950). Robert Wise, who edited RKO's *Citizen Kane* in 1940, described the experience of cutting *Two Flags West* (1950), the first feature he directed for Zanuck: "During the projection Zanuck was completely silent, but when the screening was over he spoke at great length about every scene. Zanuck's off-the-cuff lecture showed both a prodigious memory and a concern for analyzing the film-in-progress as a whole."[79]

Essentially, Zanuck, unlike his former bosses at Warner Bros. and more like Selznick, was involved in every aspect of film production, from scripting to

casting to set direction to the hiring of directors to editing and even to scoring. In "Problems of Producer Cited by Darryl Zanuck," in *Film Daily* for January 15, 1935, he elaborated his role:

> Ten million dollars cannot make a good picture unless the producer knows what to do with it. . . . The producer's worries start before the film is made and do not end until the picture has been run in the last theater in which it will play—perhaps years later. . . . As if all these burdens were not enough, the producer has both labor troubles, which occur in any industry, and temperamental difficulties which rarely crop up in other fields. Stars, directors and writers work under tension. They must be driven hard for delays are costly.[80]

At Fox, Zanuck worked with John Ford on three of the director's most important films: *Young Mr. Lincoln, The Grapes of Wrath,* and *How Green Was My Valley* (1941). He also produced films by Henry Hathaway, Elia Kazan, Joseph L. Mankiewicz, and Otto Preminger. His relationship with Preminger is especially interesting. Preminger had started at Fox in the B-picture unit in 1935 and had been fired by Zanuck for refusing to finish the direction of a film based on Robert Louis Stevenson's novel *Kidnapped* (the director's credit went to Alfred L. Werker in 1938), a film Zanuck himself had written. While Zanuck was in North Africa in 1942 for the Signal Corps producing a forty-minute color documentary about the Allied campaign entitled *At the Front in North Africa,* William Goetz, who was temporarily running the studio, rehired Preminger. After several wartime projects done in Zanuck's absence, Preminger began work on *Laura* (1944). When Zanuck returned, he kept Preminger on that project as producer, but hired the more experienced Rouben Mamoulian to direct. When Mamoulian didn't work out, Preminger took over again, directing a film that established his career at Fox and earned him an Academy Award nomination for direction. Preminger continued to work for Zanuck at Fox until he went into independent production in the 1950s. While they had had their flare-ups, Preminger called Zanuck "one of the fairest men I have ever met."[81]

After Pearl Harbor, all the Hollywood studios focused on films with war-related themes. Many were done cheaply, as studio personnel were actively involved in the war effort and supplies and equipment were limited. Fox's pictures in support of the war included *A Yank in the R.A.F.* (Henry King, 1941), with Tyrone Power and Betty Grable; *To the Shores of Tripoli* (Bruce Humberstone, 1942), with Maureen O'Hara and Randolph Scott; *Crash Dive* (Archie Mayo, 1943), also with Tyrone Power; and *The Purple Heart* (Lewis Milestone, 1944), with Dana Andrews and based on a story by Zanuck. On February 16, 1944, Zanuck wrote to Jack Warner concerning *The Purple Heart.* In the letter, Zanuck, who was not Jewish, mentions that the character of Sergeant Greenbaum was put in the story

not for propaganda purposes "and certainly not as a favor to my Jewish associates and friends. I put him in because the character fitted, and believe me, that is the only kind of propaganda that can ever be useful."[82]

The war years were profitable ones for the studios. But the end of the war brought major changes (to be discussed in the next chapter in this volume). In 1944, as the end of the war was finally in sight, Zanuck remarked that he made *Wilson,* whose subject spearheaded the formation of the League of Nations after World War I to foment international dialogue and cooperation, "as a positive contribution to the postwar situation," so that the isolationism that caused America's disarmament after World War I would not happen again. He again emphasized his belief in films that have something important to say, films such as *Wilson* that can "show how the world has shrunk," and "how the nations of the world have become dependent on one another."[83]

The words of fictional producer Monroe Stahr effectively sum up the role of the producer during Hollywood's Golden Age: "I'm the unity." With the exception of RKO, it was the producers who defined the studios' styles and from script to screen shaped the films made there. These producers had a remarkable ability to multitask: revising scripts, hiring directors and actors, supervising lighting, art direction, costumes, and camera placement, suggesting editing choices, music, and, of course, dealing with budgets and issues of censorship.

In 1949 Harry Rapf, in a retrospective for the house organ at MGM, *The Distributor,* wrote that his many years at that studio involved a "broad expanse of picture production and executive operation to paint in words." I have felt the same way in writing this chapter. Classical Hollywood was undoubtedly the heyday of the producer, and, as my grandfather concluded, "it [had] a romance of creation that can never be erased."[84]

3

POSTWAR HOLLYWOOD, 1947–1967 Saverio Giovacchini

In his 1941 history of American cinema, *Hollywood the Movie Colony, the Movie Makers,* Leo C. Rosten contended that, generally speaking, movie producers—and he was mostly talking about studio production executives—were fundamentally misunderstood. Many Americans, Rosten observed, fell back on a deep-seated xenophobia, regarding the (perceived to be) foreign-born studio executives as unschooled and ignorant, as un-American hangers-on who profited from the labor of the more attractive and talented folks who actually produced Hollywood movies. Rosten countered such an assumption with what for many filmgoers and film buffs were surprising facts: after screenwriters, producers were the Hollywood group with the highest percentage of college graduates, 85.6 percent. And most of them—86 percent—were born in North America.[1] Nearly thirty-five years later, the film historian Robert Sklar reflected back on Rosten's observations regarding such a fundamental xenophobia, reminding his readers that if we trace the etymology of the moniker "mogul," which was used by journalists and filmgoers alike to refer to the mostly Jewish American executives and producers, we find that the term is of Persian/Mongol origin, identifying these producers as "part splendid emperors, part barbarian invaders."[2]

Producers were unquestionably a powerful cohort; they were in the 1930s the bosses of Hollywood, commanding the highest salaries in town. As Rosten

confirms, many such executives earned "glittering figures" in the neighborhood of the mid-$200,000s, with Louis B. Mayer topping everybody at nearly a million dollars per year.[3] Rosten believed that these salaries were justifiable; the producers were in charge, and, as Rosten concludes, "to preserve our balance of judgment, it is necessary to observe that in Hollywood, as in other sectors of our society, the most convenient target for all sorts of psychological hostilities is 'the boss.'"[4] And these moguls were most certainly the bosses of Hollywood.

In 1947, MGM chief Dore Schary could still argue with some measure of cockiness that "in essence a producer is a man who starts with an idea or hope and ends with a completed picture ready for the screen. . . . He is the 'head man' of a given film enterprise."[5] But Schary would soon back off this lofty claim. An essay he wrote for the *New York Times Sunday Magazine* in 1950, three years after the advent of an industry-wide blacklist (of film workers with supposed Communist Party ties), feverishly tried to dispel the notion that Hollywood, and *in primis* its producers, were not ordinary Americans. This widespread misconception, he noted, was in part the producers' own doing. In the past, producers, or "their publicity departments," had cultivated an image of glamor, but it was mostly phony. Rather than fancy top dogs, Schary claimed that film execs were normal people: ordinary Americans, film industry people who "spend their vacations with their families and they are concerned where their youngsters go to school" and "they can't get drunk any more than a grocer in Kansas City, because they have to work hard the next day too."[6]

Schary's assertions in 1950 reveal that, when the House Un-American Activities Committee (HUAC) attacked Hollywood in 1947, producers by necessity cultivated a different public image than they had in 1940. By the time HUAC took on Hollywood, the industry had been tested by a protracted, organized labor struggle between Herb Sorrell's radical Conference of Studio Unions (CSU) and Roy Brewer's more conservative AFL affiliate, the International Alliance of Theatrical and Stage Employees (IATSE). This struggle ended up confirming IATSE's dominion over studio labor, but it also convinced HUAC's Cold Warriors that Hollywood needed some form of reprimand.[7] Indeed, by 1953 Schary was spending quite a bit of time and his considerable writing skills fending off attacks on Hollywood by moralists and, as he described them to the *New York Times,* "happy undertakers who stand ready to bury the motion picture industry."[8]

Fall from Grace

After a prewar period of relative stability that in *Movie-Made America* Sklar famously termed "the golden age of order,"[9] the American film industry faced the challenges of World War II and then a postwar period of change and uncertainty. The great Hollywood self-portraits of the early 1950s, Billy Wilder's *Sunset Blvd.*

FIGURE 11: MGM studio boss Louis B. Mayer told the director Billy Wilder at the premiere of *Sunset Blvd.* (pictured here, as Norma Desmond, played by Gloria Swanson, makes her final entrance) that he should be "tarred and feathered and run out of Hollywood." The sentiment revealed less about Wilder than the emerging new Hollywood.

(1950) and Vincente Minnelli's *The Bad and the Beautiful* (1952), are fraught with images of death, as well as moral and physical decay. The story goes that Louis B. Mayer told Wilder at the premier of *Sunset Blvd.* that he should be "tarred and feathered and run out of Hollywood."[10] The sentiment revealed less about Wilder than the emerging new Hollywood.

For producers and other film workers, the principal postwar "problem" concerned the Blacklist. HUAC became a permanent congressional committee in 1945. In May 1947, its new chair, J. Parnell Thomas, along with four other members of the committee (congressmen John McDowell and John Wood and investigators Robert E. Stripling and Louis J. Russell), took residence in the plush Biltmore Hotel on Pershing Square in downtown Los Angeles.[11] The committee began interrogating friendly witnesses, most of them supplied by the anticommunist Motion Picture Alliance for the Preservation of American Ideals (MPAPAI). Several producers were among the early respondents to the anti-Hollywood, anticommunist witch hunt, with James K. McGuinness of MGM and Henry Ginsberg of Paramount voluntarily giving information to the committee.[12] So did Jack Warner, who also thanked the committee and committed himself to continue to tell the investigators "whatever I may know about subversive elements" in the industry.[13]

The producers' behavior in May 1947 foreshadowed their even more accommodating stance later in the year, when the going got tougher and the stakes got higher. In September 1947, fortified by the Cold War (now fully embraced by Congress and Josef Stalin's Soviet Union), the Thomas committee issued forty-three subpoenas to a group of producers, actors, and writers, comprising older and newer

generations of Hollywood: former moguls like producers Louis B. Mayer, Samuel Goldwyn, Jack Warner, and Walt Disney, and promising members of the younger generation like the RKO *wunderkinder* Adrian Scott and Schary, before the latter left for MGM.[14] In October the Thomas committee deposed several friendly witnesses and went on to schedule hearings for nineteen so-called "unfriendlies." As is well known, the committee adjourned after hearing only eleven of them, including, in a public hearing, the so-called Hollywood Ten (the screenwriters Alvah Bessie [*Objective Burma!*, Raoul Walsh, 1945], Herbert Biberman [*Together Again*, Charles Vidor, 1944], Lester Cole [*Blood on the Sun*, Frank Lloyd, 1945], Ring Lardner Jr. [a 1943 Oscar for his script *Woman of the Year*, George Stevens], John Howard Lawson [a 1939 Oscar nomination for his screenplay *Blockade*, William Dieterle], Albert Maltz [a 1946 Oscar nomination for his screenplay *Pride of the Marines*, Delmer Daves], Samuel Ornitz [*It Could Happen to You*, Phil Rosen, 1937], and Dalton Trumbo [the 1941 Oscar-nominated script *Kitty Foyle*, Sam Wood], along with the director Edward Dmytryk and the producer Adrian Scott) and the playwright Bertolt Brecht in closed session. On November 25, 1947, at the Waldorf Astoria in New York City, Eric Johnston, the president of the Motion Picture Association of America (MPAA), pledged, in the notorious words of the declaration, that Hollywood producers would "not knowingly employ a Communist."[15]

The outcome of the HUAC hearings was a blow to producers and their status, in the eyes of both the left and the right. For the progressives, the spectacle

FIGURE 12: The producer Samuel Goldwyn was one of over forty Hollywood producers, directors, writers, and actors subpoenaed by HUAC in the fall of 1947. A year earlier Goldwyn had given the Red-baiting committee chair Martin Dies the cold shoulder, but after the Waldorf Statement was drafted in the late fall of 1947, Goldwyn went along with the industry's Blacklist

of Warner—a "clown," according to blacklistees Maurice Rapf and John Wexley[16]—and Mayer defending themselves and then committing their firms to blacklisting and political repression was at best disgraceful and at worst a crime against American principles. For the reactionaries, the producers had proved that indeed Hollywood was awash in all kinds of sins. Hollywood producers had kowtowed to the FDR administration and produced pro-Soviet films, employed communists, and—as in the case of one of the Hollywood Ten, Adrian Scott—been communists themselves.[17]

On the surface, the old guard and the younger guns had behaved differently. The old producers had squirmed but ultimately bowed to the committee with the partial exception of the Twentieth Century–Fox mogul Darryl F. Zanuck. According to the historian Haden Guest, Zanuck shielded Samuel Fuller from the witch-hunters' onslaught.[18] And he also resisted sacking the screenwriters Ring Larder Jr. in 1947 and Abraham Polonsky in 1951 when they came under fire. Ultimately, however, Zanuck was not willing to jeopardize his studio to defend either man, finally caving in and letting both of them go.[19]

The "young gun" Schary, RKO's liberal-minded executive, had initially voiced doubts about the committee's claims. Communists had little influence in Hollywood, Schary told the *Los Angeles Times* at the end of October 1947, and studios had no power to hire or fire people because of their political opinions.[20] However, by the end of November, even Schary participated in the formulation of the Waldorf Statement and in the main supported it.[21]

Independents did not fare much better. After voicing some objections in New York, Walter Wanger, together with Samuel Goldwyn, did not oppose the resolution, and neither did the president of the Society of Independent Motion Picture Producers (SIMPP), Donald M. Nelson.[22] In particular, Wanger, a good Hollywood liberal, did not publicly respond to any of the charges leveled against him or his direct collaborators, but he later promoted his Eagle-Lion films as "tools in the anti-Communist fight."[23] When his friend and associate, the writer Carl Foreman, came under the committee's fire in 1951, Stanley Kramer—a politically liberal independent producer—repudiated the screenwriter. He later bought out Foreman's partnership in their production firm, Screen Plays, Inc.[24]

It is easy to be critical of the studio producers in this era. But their collapse before HUAC needs to be seen within the context of the collapse of the Hollywood studio system itself. Studios were being besieged from all sides. After the war, U.S. attorney general Tom Clark had resurrected the antitrust lawsuit that had been dormant since 1938. An early mid-war court case, the Crescent Decision of 1943, while not directed at the studios precisely, had already questioned the legality of large, unaffiliated theater circuits using their quasi-monopolistic powers to harass small, independent exhibitors.[25] The Crescent Decision seemed a precedent in the postwar years, when efforts were renewed by the attorney general to dismantle the studios' control over U.S. exhibition. In the Paramount

FIGURE 13: When the screenwriter Carl Foreman became a person of interest for HUAC, his production partner Stanley Kramer (left, next to Columbia Pictures executive Harry Cohn) sold him out. Such were the treacherous politics of Blacklist-era Hollywood.

Decision of May 1948, eight months after the Waldorf statement, the Supreme Court ordered studios to divest their interests in exhibition. In addition, the government also castigated the unaffiliated large theater circuits that had long strangled independent movie venues working in conjunction with the studios.

The court could not have rendered its opinion in the Paramount case at a less propitious moment in the studios' history. After the World War II bonanza and record revenues and profits in 1946, the studio balance sheets revealed a more somber spectacle. Attendance was in decline and by 1949 the increase in ticket prices could do little to mask the downturn.[26] The reasons for this downturn are multifaceted and their relative importance and causal imbrication vary, but it is certain that motion pictures had more and more competition for Americans' entertainment dollars. During the 1930s movie tickets had amounted to 20 percent of the average American's recreational expenses. By 1950, however, Hollywood was able to snare only 12 percent.[27] Television was part of the reason, of course. Between 1947 and 1948 ownership of TV sets increased by more than ten times to 175,000 sets.[28] A 1948 Gallup poll revealed that film attendance in households with TV sets had decreased by 10 percent.[29] People were ready to trade film entertainment for the suburban dream. When they could, Americans bought TV sets as well as new homes outside the cities, and both purchases kept them away from the downtown movie palaces. The mostly white middle classes moved to the suburbs, depriving urban theaters of many of their customers, a loss that the boom in drive-in construction and ticket sales could only partially remedy.

The Corporatist Environment

Always a Hollywood booster, in 1952 Schary argued, despite so much evidence to the contrary, that TV was not a problem for Hollywood. He had convened in Los Angeles a group of one hundred now independent exhibitors to show them what the studios were readying for release. "Seeing Is Believing" was the motto of the convention. There were "constant factors that remain in the human mind in terms of interest" that brought people to prefer theaters to TV. The "end of the theaters was an absurd predictio[n]." "If we ma[ke] our pictures good enough and big enough," Schary insisted, "TV will start worrying about us."[30]

No doubt Schary was aware of bigger problems for the industry than television. And the solution to these problems involved a tricky spirit of cooperation with the federal government. The soft stance that studio executives took before HUAC in late 1947 was in part motivated by their increasing dependency on the government's brawn to help sell their movies abroad. There was simply too much to lose in antagonizing Washington. The historian M. Todd Bennett has recently analyzed what he terms the "corporatist partnership" that Washington and Hollywood developed during the Second World War. While at war with the Axis and their allies, the government had come to rely more and more on Hollywood to disseminate its "strategy of truth"[31] inside the United States, among its allies, and in the liberated areas. In turn, having lost a large chunk of its overseas market after September 1939, Hollywood depended on Washington and its armies to navigate the troubled waters of a world at war. If Hollywood produced politically useful films, the government would make sure that they would reach an audience inside and outside of the country.[32] As Bennett recognizes, this partnership had been rocky at times but it had worked well enough during the war, especially in the case of the British market, the largest venue for Hollywood products.

The end of the Second World War did not interrupt the construction of the corporatist environment for the production and distribution of American films. Already in 1944 one of the leaders of the Psychological Warfare Division of the U.S. Army in France, L. W. Kasner, had written to Robert Riskin, the famed screenwriter for director Frank Capra who had become a producer at MGM in 1942,[33] that "the French are planning all kinds of restrictions against . . . American films and I am very much afraid that unless someone from the [MPAA] as well as a film attaché from the American embassy is sent over rapidly they will try to push through their nefarious plans and beat us to it."[34]

In 1945 Hollywood executives decided to create a branch of the MPAA that was devoted to building and securing foreign markets.[35] In a partnership with the government, this branch, called the Motion Picture Export Association (MPEA), was directly charged with the exportation and distribution of American films

in the territories of the former Axis powers.[36] The corporatist *pas de deux* was expected to be even more coordinated in the aftermath of the conflict. Indeed, Assistant Secretary of State Adolf Berle circulated a document that argued that "the [State] Department desires to cooperate fully in the protection of the American motion picture industry abroad" and "expects in return that the industry will cooperate wholeheartedly with this government with the view to insuring that the pictures distributed abroad will reflect credit on the good name and reputation of this country and its institutions."[37] In this environment, the federal government was a Janus-faced presence for the studios. The federal government, a nemesis of their practices at home, supported Hollywood's overseas penetration. Its judicial branch condoned the very studios' practices overseas that it actively dismantled at home.[38]

It was, however, an environment that could be quite useful for the studios, especially as they projected themselves out of Southern California and into the wild, wide world of the Cold War. The Cold War against Soviet and domestic communists called on Hollywood to make movies that could be used in the fight to win the hearts and the minds of the Europeans. In January 1948 Congress passed the Smith-Mundt Act by a large bipartisan majority. This act of Congress is well known because it ensured the expansion of Voice of America, but it also authorized the federal government to favor the dissemination of "information about the United States through press, radio, motion pictures, information centers and instructors operating abroad." By the middle of 1948, *Variety* estimated that the studios were going to earn an extra $3 million from the Smith-Mundt Act, which had made $28 million available to private firms supplying material deemed educational by the U.S. Information Agency.[39]

Mimicking the collaboration between Hollywood and the Office of War Information during World War II, Smith-Mundt promised something for everybody. In the words of one of the two Republican sponsors of the bill, Senator Alexander Smith of New Jersey, Hollywood was to make an effort to "maintain the highest possible quality of production (for export)." In return, Smith promised to throw the full support of the federal government behind the studios, even to the extent of "relieving the producers of the embarrassment of foreign currencies which they received for their services."[40] What Smith proposed was for the government to establish a flow of dollars into European countries to aid the spread of favorable information about the United States. This injection of American currency would make it possible for the studios to extract more of their revenues out of dollar-starved Western Europe.[41]

The European Reconstruction Plan (ERP), better known as the Marshall Plan, also directly and indirectly benefited Hollywood pictures. By pumping $13.5 billion into Europe, ERP assuaged the shortage of dollars.[42] The studios believed that the MPAA could lobby effectively to get at least $5 million directly out of the ERP pot of money, to aid film companies that "have money frozen abroad

by currency restrictions."[43] And finally, the Marshall Plan enlarged the studios' take in Europe simply by making Europeans richer. CIA director Allen Dulles remarked that "the [Marshall] plan presupposes that we desire to help restore a Europe which can and will compete with us in the world markets and, for that very reason, will be able to buy substantial amounts of our own products."[44] People who were better off went to see more movies more often, and nothing proved this better than ticket sales. While in the United States the number of tickets sold kept shrinking from 1946 through 1972, the European market surged. In Italy the number of movie tickets sold during the calendar year jumped from 411 million in 1946 to 819 million in 1955. By 1960 Italy sold the largest number of tickets in Europe, while Italian GNP, aided in no small part by the ERP, followed the same upward direction.[45]

Hollywood, Washington, and the Quest for Foreign Markets

With the shrinking of the domestic box office, the foreign markets became of paramount importance for the studios' survival. During the 1930s around 35 percent of Hollywood revenue was gathered outside the United States.[46] In 1949 the percentage had risen to 39 percent[47] and reached 53 percent in the early sixties. As *Variety* calculated in 1957, "Far more than most American industries, films are dependent upon export—up to 50% of total revenues. Overseas box-office helps U. S. films hold their own at home against television."[48]

Given the growing importance of the foreign markets, the producers of 1950s blockbusters tried to give these movies what John Izod calls "universal appeal."[49] Since the 1920s the "worldwide hegemony of classical Hollywood cinema" had been achieved because, to cite the film historian Miriam Hansen's justly famous line, they had provided the world with "a sensory-reflexive horizon for the experience of modernization and modernity."[50] But this had been due less to serendipity than to the producers' awareness of the financial importance of the "over there" markets.

In 1955 the former Office of War Information (OWI) analyst Dorothy Jones revealed how economic concerns had shaped *Bengal Brigade* (1954), directed by Laszlo Benedek and produced by Ted Richmond at Universal. Eager to please non-American (especially the massive Asian Indian) audiences, Richmond had the script evaluated by film offices in London and Bombay to make sure the picture would not offend local sensibilities.[51] Confronted with a stagnant U.S. market, *Variety* noted that most companies had realized "the still growing potential of the overseas box-office."[52] Arthur Loew Sr., the son of one of the founders of MGM and the president of Loew's Inc., told *Variety* in 1956: "For many, many, years we all know that certain pictures were almost specifically made to get back their real gravy in the foreign markets."[53]

Western Europe accounted for a larger market share than any other part of the globe. In 1947 Great Britain, the closest ally of the United States during the war, was remitting $70 million in rentals to Hollywood, thus contributing more than 50 percent of the entire foreign market revenue to the studios. The British and the American film industries were deeply intertwined: in 1946 J. Arthur Rank had orchestrated the merger between Universal and his International Pictures; in 1947 Eagle-Lion bought a controlling interest in Producers Releasing Corporation.

The intentions of the Hollywood producers notwithstanding, the economic recession and the onset of the Cold War made things more complicated for the MPEA. The sense of economic malaise that enveloped Western Europe after the war was, perhaps, more a perception than a reality—the "gloom" Tony Judt wrote about in his magisterial *Postwar: A History of Europe since 1945*—but economic expectations do make an economy tick.[54] The strong box office of Hollywood films in Europe and the weak take of European films in the United States contributed to unbalanced trade relations. The Cold War climate polarized attitudes regarding American cultural imports. No longer was American cinema the product of an exemplary antifascist democracy, the "spices and the gold from across the Ocean" to be treasured and promoted as an antidote to fascist tendencies and realities.[55] For the leftists in Europe, American culture was tainted by reactionary, anti-Soviet, and pro-capitalist propaganda. American cultural productions, commented Italian communist and prominent literature scholar Carlo Salinari in the mid-1950s, "are completing the work of destruction by reducing great sectors of our culture to the rank of a colonial culture."[56]

As important as it was in harnessing the power of the federal government to Hollywood producers' foreign ambitions, the corporatist link between Hollywood and Washington could now be an embarrassment as well. The Washington-Hollywood collaboration exposed American films to accusations of propaganda, and producers were often the focus of the anti-Hollywood realignment of the European left. To prove their point, as soon as he had stepped down as secretary of state, stalwart anticommunist James F. Byrnes was hired by the MPAA to strengthen Hollywood's anticommunist image and to open overseas markets to American films.[57] In the popular daily of the Italian Communist Party, *L'Unità*, Ugo Casiraghi saw the MPAA as a front for the most violent among Hollywood's anticommunist bashers (*mangiacomunisti,* literally, "communist eaters"). *L'Unità* depicted "club-wielding producers" ("produttori-bastonatori") inciting the onslaught against Hollywood progressives. Hollywood became a bastion of conservative propaganda, and Byrnes fit right in.[58]

By 1948, pushed by postwar gloom and spurred on by cultural and political anti-American protectionism, Great Britain, France, and Italy had all enforced some sort of anti-Hollywood regulations. Great Britain enforced the most drastic measure. To continue buying so many American movies meant thwarting British

domestic production and depleting the country's reserves of hard currencies. In 1947 the Board of Trades overcame the objections of studio executives as well as those of domestic exhibitors and distributors and imposed a whopping 75 percent tax on all earnings of American films in the British market. In retaliation, the American industry boycotted British films. The U.S. State Department intervened and the tax was lifted. The new regulation allowed $17 million in revenues to be reexported by the studios back to the United States, a figure that was to be augmented by the same amount of dollars that British pictures garnered in the United States—an obvious encouragement to American distributors to give a fair chance to British films.[59]

France and Italy also tried to stop the ingress of Hollywood films. In 1946, France renegotiated the so-called 1936 Accord Marchandeau that legislated a maximum yearly contingent of 150 American films into the French market (out of 188 import licenses for foreign films).[60] The accord had become untenable because after five years of war a good number of theaters in France were either in trouble or in rubble. Facing the possibility of a draconian protectionism and even a boycott of their product, the studios appealed to the State Department. The situation was favorable to the Americans, as the French badly needed economic help especially in terms of coal, wheat, and currency. The resulting film agreement was, in fact, a mere two-page addendum attached to a larger commercial agreement between the two nations negotiated by the French special envoy (former Popular Front prime minister Léon Blum) and the U.S. secretary of state (Byrnes).

The brawn of Washington won Hollywood favorable terms. The so-called Blum-Byrnes agreement replaced the contingent system with a quota that initially allotted four weeks (five in 1948) per quarter to French films, in essence leaving the rest to Hollywood production. Given the studios' opposition to quotas, the increased economic and political might of the United States, and the enormous backlog of the studios, Blum and his negotiator, Pierre Baraduc, figured they got as good a deal as they could get.

Italians, too, wanted to set some limits on the Hollywood onslaught. To protect its cinema from American competition, the Italians reverted to protectionism: in this case the antidote to Hollywood was an admixture of "compulsive exhibition" (*programmazione obligatoria*) of Italian films,[61] and government's fiscal and financial aid to domestic products (see below).[62]

In all these cases the collaboration between Hollywood and Washington was crucial. For Hollywood to succeed overseas, studios and the federal government needed to dance the corporatist *pas de deux*. In the aftermath of Blum-Byrnes, the *Los Angeles Times* quoted MPAA chief Eric Johnston: "Revenue from foreign distribution is the lifeblood of the American motion picture industry." Johnston also announced the opening of MPEA offices in New York City, headed by the Twentieth Century–Fox executive Irving Mass.[63]

Hollywood Outside of Hollywood

The corporatist environment could not, however, solve all issues. Beside the shrinking of the domestic audience and the challenge of television, with regard to protectionist measures there was only so much that Washington could do to help its partner. Between the end of the 1940s and the beginning of the following decade some American producers figured out a way to exploit this situation.

Aid from the collaboration with the federal government notwithstanding, studio executives realized that some of the profits could not be taken back to the United States. Hollywood firms thus decided to reinvest in Europe. The Italian mechanism is exemplary of the process, and *grosso modo* the other major European markets produced only slightly different versions of the same story. In Rome as in all other European capitals, the government was limiting the profits that could be reimported to the United States. In addition, from 1949 on, the American studios were offered compulsory loans (*prestito forzoso*) from the Italian state for each film they exported into Italy. In exchange, studios received a certificate of deposit redeemable after ten years. Producers could, however, immediately redeem their certificate if they reinvested the funds in Italian productions. The mechanism was strengthened by a 1951 agreement between the American producers, again represented by the MPEA, and the Italian ANICA (Associazione Nazionale Industrie Cinematografiche e Affini): Americans were now free to export 50 percent of their profits back across the ocean. In return, they agreed to reinvest at least two-fifths of the remaining 50 percent in Italian film production (the remaining three-fifths could be invested in any other local enterprise).[64]

Prompted by these accords, Hollywood producers began taking their productions to Europe. Italy was a good location because first-class facilities were available in Rome, in Cinecittà, and at the Pisorno studio.[65] Like the rest of Europe, Italian labor was willing to accept lower wages. In 1949, the producer Sam Zimbalist at MGM shot Mervyn LeRoy's adaptation of Henryk Sienkiewicz's novel *Quo Vadis?* in Rome. Setting the film in the real *urbs* (the ancient walled city) was less a nod to historical accuracy (the film was in fact mostly shot in the Cinecittà studios)[66] than a quest for savings. Many producers followed Zimbalist and LeRoy's example, and in 1952 *Variety* concluded that "with possibly one-sixth of Hollywood's output this year being made abroad," it was clear that American producers were more and more often taking their projects overseas. Independent producers were leading the trend, but producers at major studios soon followed. The ability to use otherwise frozen funds was of paramount importance, *Variety* reported, but "cheaper production costs and the desire to limn fresh foreign backgrounds has led to the increased utilization of American dollars for these junkets."[67]

The Blacklist, fiscal policies, and the rising importance of foreign markets all buoyed the move overseas. Recent scholarship has highlighted how Hollywood

producers employed talent in Europe they had persecuted, or failed to defend, in California. Zanuck, for example, hired blacklisted director Jules Dassin to make *Night and the City* (1950) in London using Hollywood stars Gene Tierney and Richard Widmark.[68] After 1951, a new tax ruling exempted American citizens earning an income abroad from paying American taxes for up to eighteen months, making many Hollywood stars eager to work overseas.[69]

In addition, the growing importance of the European markets made European locations and stars more appealing to Hollywood producers. In 1949, Zanuck defended his choice to have *Night and the City* shot in London so as to make "dramatic use of London as an integral foreground" of the story.[70] When Robert and William Wyler produced and directed *Roman Holiday* in 1953 for Paramount, they paraded the European-ness of the film's setting and of one of its stars. As the credits announced, "This film was photographed and recorded in its entirety in Rome, Italy" and "introduc[ed]" Audrey Hepburn, a British theater and film starlet (born in Belgium from a Dutch mother and British father), fresh off her Broadway debut in *Gigi* (1951), next to their American star, Gregory Peck. Hepburn and Peck mélanged with Roman landscapes, moped rides on Vespas, and benign views of monarchical traditions to create a film that could appeal to both American and European ticket buyers. Such films also foreshadowed a new role for Hollywood whose task was now, in the words of the British historian Stephen Gundle, "to transcend national boundaries, create a common cultural currency, and help to imagine and to bring about a future Europe that was peaceful and integrated."[71]

The inaugural motion picture at the 1953 Venice Film Festival, *Roman Holiday* earned strong receipts on both sides of the ocean.[72] Not all admixtures, however, were so balanced. Following the success of the Wylers' film, Twentieth Century–Fox producer Sol C. Siegel supervised Jean Negulesco's shameless exploitation of the cosmopolitan charms of Rossano Brazzi and Gian Lorenzo Bernini's Roman fountains in the Cinemascope-infused *Three Coins in a Fountain* (1954).[73] And Kramer no doubt held his nose when he went to Francisco Franco's Spain to save on sets and extras for *The Pride and the Passion* (1957). The film had huge sets and thousands of extras and, as Kramer told a reporter during production, "it would have cost twice that much if we'd made it anywhere else."[74] Ultimately, the casting of Cary Grant (as the British naval captain Anthony Trumbull), Frank Sinatra (as the Spanish patriot Miguel), and Sophia Loren (as the Spanish firebrand Juana), along with the use of an international crew, did not gel and the film "was more than a bomb—it was a bust."[75]

The physical structures and the production facilities of Hollywood were inexorably shrinking. Squeezed between pulls to produce overseas and the pushes of the increasing costs of producing in Southern California, Hollywood studios began to slowly evacuate their soundstages. Especially after the Paramount Decision, Hollywood producers came to see their work as not entirely encompassed

by Southern California studios, which pink-slipped many among their contract personnel, produced fewer and fewer movies, and began leasing their facilities to television crews or independent film projects, generally providing refinancing and distribution.[76] In 1957, Hollywood studios released 291 features, of which 170 (58 percent) were produced by independents.[77] The old Hollywood may not have fully died out,[78] but studios were literally "thinning out," slowly becoming not necessarily less powerful or influential but more disassembled, disembodied, more immaterial. In the 1960s and 1970s, studio lots were sold to be turned into Culver City and Century City real estate developments.[79]

After the Paramount Decision, Warner Bros. producer Hal Wallis abandoned his job at the old studio, where his relations with Jack Warner had deteriorated, and began producing independently at Paramount and Universal.[80] Stanley Kramer, when his career at Columbia ended rather bitterly in 1955, moved to United Artists, where he became a producer-director in the "studio without a backlot." His first film in this capacity for United Artists was *Not as a Stranger* (1955), which he shot in the old Chaplin Studio on La Brea Avenue and the smaller California Studios on Melrose Avenue (then mostly used for television).[81]

In 1964 Katharine Hamill, the groundbreaking societal and financial analyst at *Fortune,* wrote that "producers . . . have become in effect entertainment companies rather than simply makers of movies."[82] Studio executives became managers of studio facilities that opened their doors to unaffiliated, independent filmmakers, as creative agents took more and more of a producing role. In his study of Hollywood agents, Tom Kemper has documented the slow progression into production of the important 1930s and 1940s agents like Charles Feldman and Myron Selznick. Since the 1940s, Feldman had begun to pair some of his star clients, resurrecting the careers of John Wayne and Marlene Dietrich.

This "strategic merging of his production company and his talent agency" had been particularly visible in the making of Howard Hawks's *Red River* (1948).[83] With the collapse of the studios, creative agents like Feldman and agencies like William Morris and MCA began putting together packages of stars, intellectual properties, and directors, which they then sold to studios or directly to banks. For example, realizing that Columbia wanted the services of his client, Dean Martin, for the film *Who Was That Lady?* (George Sidney, 1960), MCA's Lew Wasserman packaged Martin with Tony Curtis and Janet Leigh, whom MCA also represented, with their option on the rights to the source play.[84] "By the sixties," the film scholar Tino Balio writes, "it was estimated that of the 125 or so films made each year, about 80, or nearly two-thirds, were prepackaged by agents for their clients."[85]

Regarding the role of the new Hollywood producer in this new and less localized world, the film historian Ian Jarvie has written:

[1949] is when Hollywood began to develop a wholly new set of strategies to deal with the decline of the domestic market and to maximize profits and minimize risk by increasing its direct involvement with the flourishing film business of much of the rest of the world. But this development, and the fact that the restructured United States audience no longer demanded *only* Hollywood movies, meant that the survival of a large central factory town and its methods had lost priority as an industrial aim.[86]

Joe Levine

Joseph E. Levine was an impressive man trapped in an unimpressive appearance. Stocky, overweight,[87] bald, perpetually hot and sweaty, with a thick Boston accent, Levine did not look the part of the most important and innovative American producer of his generation. And yet, in a profile in *Fortune* magazine in 1964, Katharine Hamill cast his importance as follows: "When Hollywood gets around to doing a movie about the triumphs and heartbreaks of this transition period (as it inevitably will), the picture may well be entitled *The Joe Levine Story*."[88]

Born in 1905 in relative poverty in Boston's West End, Levine quit school at fourteen and spent much of his youth pursuing an array of careers, including selling clothes, managing a café, and peddling statues of the African American preacher Daddy Grace. In the late 1930s, Levine took ownership of the Lincoln Theater in Boston, and later he added a small circuit of New England theaters. Two decades after this first foray into the film business, Levine founded Embassy Pictures Corporation. Unhappy (as an exhibitor) with domestic production that was running short of demand, Levine purchased the distribution rights for the eastern United States of a Japanese monster film about a prehistoric creature brought to life by radiation, *Godzilla* (Ishirō Honda, 1954).

Levine was a showman, a presenter. He understood that American filmmakers had rarely made their money on production, that the money was in distribution and exhibition. This had become even clearer after the Paramount Decision when the studios scaled down the number of films they were willing to produce. In his book on horror films and the American movie business, Kevin Heffernan succinctly summarizes these changes, noting that the major studios "now focused on maximizing profits through fewer and costlier releases [and] began an aggressive new move into new technologies like widescreen projection, stereo sound, and 3-D both to compete with television and to profit from the sale of equipment to exhibitors."[89] Theaters, however, were still in need of films. Levine understood that and reimagined the "overseas" market from a place where Hollywood films were screened to a place where "Hollywood" films were also produced.

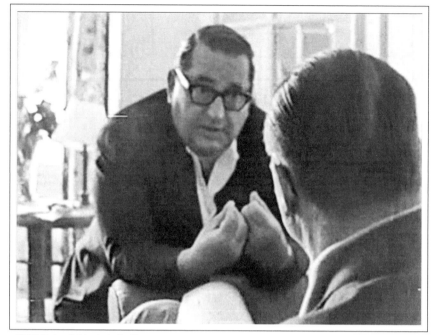

FIGURE 14: Joseph E. Levine in the Albert and David Maysles documentary *Showman* (1963).

The marketing of *Godzilla,* his first major success, shows Levine's talents and foresight. In handling the films he "presented," he never hesitated to reedit and to add production value. To distribute *Godzilla,* Levine, with Ed Barison and Harry Rybnick, two Los Angeles producers, founded TransWorld Releasing Corporation. The company hired an experienced director/editor, Terry O. Morse, who cut some of the original footage and in Los Angeles shot several new scenes, introducing an American character, the reporter Steve Martin (Raymond Burr). TransWorld then retitled the film *Godzilla, King of the Monsters* (1956).[90]

Godzilla, King of the Monsters was a much-altered film with a running time sixteen minutes shorter than the ninety-six-minute original Japanese version.[91] Levine purchased the rights to distribute the film east of the Mississippi for a paltry $12,000,[92] while Barison and Rybnick maintained the rights to distribute the film on the West Coast. *Godzilla* opened in 400 theaters, 150 in New England alone, supported by a promotion and advertising campaign managed by the veteran publicist Terry Turner for which *Variety* coined the term "saturation," a full twenty years before Universal's release of Steven Spielberg's *Jaws* (1975) rather perfected the strategy.[93] *Godzilla* was a sensation; two months into its initial release the film was still playing in 250 theaters.[94]

Bosley Crowther gave the film an abysmal review in the *New York Times,* calling it an "incredibly awful film." But *Variety*'s review was more telling; the trade magazine noted that the film was going to net the usual "box-office excitement

in houses geared to bally product" but would also gather some attention among "deluxers harassed by the current product shortage."[95] Levine was not the first producer/distributor to launch a saturation distribution campaign. Producer David O. Selznick had used a similar strategy in 1946 for *Duel in the Sun* (King Vidor, 1946), also after early bad reviews.[96] Turner, the former RKO producer whom Levine hired to help him with *Godzilla,* had previously masterminded the TV and radio deals for RKO in 1956 ahead of the re-release of *King Kong.*[97] Levine similarly tied the sale of television rights to the first run of *Godzilla.*

Levine understood that the film business in the transition era was a buyers' market where spectators had to be lured into theaters via distribution strategies exploiting the collaboration of exhibitors and the trade press. The former were to be wined and dined into renting a film; the latter would receive substantial pay-offs for advertising his wares. The game plan was to become increasingly global, contracting films outside of the United States and then finding American movie-goers willing—after some expensive coaxing—to pay to see a film whose original budget may have been accounted in yen rather than dollars. A 1956 survey of exhibitors showed that 76 percent of all theaters—and a remarkable 64 percent of small-town theaters—had exhibited at least one foreign picture during 1955–56.[98]

Levine understood that aggressive marketing, what was then often termed "ballyhoo" (hence the trade term "bally product"), was crucial to make his mov-ies stand out. Cinema was once "a daily habit" (*un'abitudine*), declared Federico Fellini, rather than a conscious act of volition targeting a particular movie.[99] Pre–World War II and pre-television, people just "went to the movies." But after the war this changed. As Tino Balio has noted, in postwar America and certainly by 1960, American audiences "had become [more] selective. . . . Motion pictures became special events, which had the effect of widening the gap between com-mercial winners and losers."[100]

In 1958, Embassy bought the Canadian and U.S. distribution rights for *Attila the Hun* and *Hercules* (both directed by Pietro Francisci and released in the United States in 1958). The latter title proved to be an astonishing success. Levine purchased the rights to *Hercules* for $120,000 and, following the strategy he had used with *Godzilla,* reedited the film and dubbed it into English. Using the saturation release strategy that had worked so well for the Japanese horror film, Levine opened *Hercules* in 600 theaters. He spent $1.5 million in public-ity, roughly ten times the negative cost, including $250,000 in television tie-ins, $350,000 on newspaper ads, and $40,000 for a single banquet at the New York Waldorf Astoria for 1,200 exhibitors and journalists.[101] He advertised in niche markets, for example placing ads in body culture magazines, many of which catered to the subterranean gay culture of late 1950s America.[102] The campaign was hugely successful: *Hercules* took in $20 million at the box office.[103]

All of the major studios tried to establish strategic relationships in the televi-sion industry in the 1950s, but the Federal Communication Commission (FCC)

FIGURE 15: Steve Reeves and Sylva Koscina in Petro Francisci's *Hercules* (1958). Joseph E. Levine purchased the rights to the film, reedited and dubbed it, and grossed nearly 200 times his investment.

prevented them from making any significant corporate investment in the parallel medium.[104] At Twentieth Century–Fox, for example, Zanuck considered TV's influence beneficial as it compelled moviemakers to go back to storytelling and stop betting just on star appeal; viewers watched TV, Zanuck thought, for the stories and did not "care who's in it."[105] Producers in the 1950s and 1960s consistently promoted to exhibitors and filmgoers what movies offered *in addition* to the TV experience. Levine was from the start aggressive in exploiting the possibilities of television.[106] Talking to the *New Yorker*'s Calvin Tomkins in 1966, Levine remarked, "We now have to examine what the possibilities of television are before we make a film, because that's our insurance—we know that even if the picture does not do well in the theatres we'll at least get our money back from television. You have to figure that there will be four fewer film companies in existence today if it weren't for television—mine included."[107]

Levine was a new kind of producer, and Embassy in many ways foregrounded the New Hollywood. He understood that producing movies on an actual soundstage in Southern California had become obsolete. He readily admitted that he was a producer without a (physical) studio. As Tomkins wrote in the *New Yorker:* "Embassy owns no production equipment—not so much as a movie camera. And Levine plans to keep it that way."[108]

As a producer, Levine presented films to a transnational audience whose largest constituency was in the United States. For him, the protectionist practices enacted by European countries represented a possibility rather than a constraint. Key here was a conservative notion of what defined "national." For instance, in Italy, in order to qualify as "national," a film needed to be shot in Italian studios, or, if shot on location, post-produced in Italy; its cast and crew needed to have a majority of Italian actors but the stars could be mostly foreign-born. If these conditions were met, the film received fiscal aid from the Italian state and could

qualify for a prize if it met certain vaguely defined quality requirements. Finally, its producer was allowed to import one foreign film without paying the tax on dubbing. Meeting these requirements was fairly easy for Levine, who partnered with the most modern of Italian producers, Carlo Ponti and Dino De Laurentiis. The idea was to make films that could be reexported into the American market, either in the commercial circuit or in the blossoming art circuit that by 1966 included close to 700 movie houses in the United States.[109]

The outcome was a boon to the Italian film industry; in 1967, Italy was producing more films than Hollywood.[110] When in 1963 Levine and Ponti struck a deal to produce and distribute four movies together—*Casanova 70* (Mario Monicelli, 1965), *Ieri oggi e domani* (*Yesterday, Today, and Tomorrow*, Vittorio De Sica, 1963), *La noia* (*The Empty Canvas*, Damiano Damiani, 1963), from the novel by Alberto Moravia, and Jean-Luc Godard's *Il Disprezzo* (*Contempt*, 1963)[111]—the communist daily *L'Unità* reported the news in a positive way. In a smart piece of promotion, Levine emphasized to *L'Unità* the considerable art and commerce of the Italian cinema: "I am not sure I understand how anybody may venture [the notion] that Italian cinema is in a crisis when it features directors like Vittorio de Sica and Federico Fellini. *La Ciociara* [*Two Women*, 1960] and *Boccaccio '70* [1962] are currently being exhibited on American screens and their box office is great. In its six month run at the 'Paris' in New York *Divorzio all'Italiana* [*Divorce Italian Style*, Pietro Germi, 1961] has garnered \$335,000."[112]

By 1967 Levine had produced one hundred and fifty films.[113] On a transnational scale his role was surprisingly similar to the one Balio describes at United Artists after the company was taken over by Arthur Krim and Robert Benjamin, a move that "ushered the industry into a new era."[114] In return for distribution rights, Levine provided local producers and talent with a share of the production financing, complete control over production, and a share of the profits.[115]

Consider as an example the financing, production, and distribution of *Italiani Brava Gente* (originally *Italiano Brava Gente,* Giuseppe De Santis), released in Italy in 1964 and in the United States in 1965 as *Attack and Retreat.* The film told the story of the Italian invasion of Russia from the perspective of the invaders.[116] *Italiani* was coproduced by an Italian company, Galatea, which received \$350,000 from Embassy for the distribution rights of the film outside the peninsula. Levine knew he was investing in a reasonably safe property. The director of the film was a known quantity in the United States and Europe. His *Riso Amaro* (*Bitter Rice*, 1949), was a considerable hit in the United States, in no small part because of the frequent focus on Silvana Mangano's naked legs.[117]

The thawing of the Cold War in the early sixties helped Levine's global production strategy become broader, less encumbered by political obstacles. Ironically, after the 1950 McCarran Internal Security Act, some of the crew members working on *Italiani* would not have been granted entry visa to the United States because they were members, or known fellow travelers, of the Italian Communist Party

(PCI). In addition, the thaw made it easier for American stars to work and be accepted abroad.[118] The Italian and Soviet Communist Parties were both involved in the *Italiani* project. By the late summer of 1962, the Soviet filmmaker Grigorij Ciukhrai was collaborating, uncredited, on the script. A decorated World War II veteran, Ciukhrai's had become well known in the Western art circuits after his *Story of a Soldier* (1959) had garnered the Lenin Prize, a special Jury Prize at the 1960 Cannes film festival, and an Academy Award nomination for Best Original Screenplay. In September 1962, Ciukhrai sent a draft of the script to De Santis from Moscow, via Gian Carlo Pajetta, a former partisan, prime minister, and prominent member of the PCI's Central Committee, who confirmed also that the Soviets were ready to front financing for some of the location expenses.[119]

An undated, circa 1962 letter from Giuseppe De Santis to "Nano" recounts the intricate production and financing for the film. After Nello Santi had sold Levine ("quel Jon or Jonne Levine") the distribution rights for $350,000, the producer went to the main source of financing for Italian movies, the Banca Nazionale del Lavoro, and received a credit of 500 million liras, because the film was reputed to enhance Italian art and culture. At this point, De Santis noted, the Italian producer was already in the clear financially: the budget of the film was around 300 million liras, and since the Soviets were going to pick up the production costs in Russia where most of the shooting would take place, everybody was poised to make money.[120]

The condition that Levine had set was that *Italiani* needed to appeal to a transnational audience. The producer demanded that at least two of the leads be American to ensure the film's strength on the U.S. market. Without consulting De Santis, he hired Arthur Kennedy and Peter Falk, who were both marketable, relatively cheap, and willing to work on a film shot in the Soviet Union. De Santis thought that neither actor was right for his role: the thirty-five-year-old Falk was cast as a young and dashing Italian medical officer who was to die a hero's death while helping a Soviet partisan. Kennedy's role as the fascist heavy, Ferro Maria Ferri, was too small to warrant such an established American actor. De Santis protested and even proposed to write a different role for Falk, but Levine was adamant.[121]

Levine's instincts proved correct. Kennedy, a four-time Academy Award nominee, played the challenging role of the unlikeable fascist black shirt convincingly, and Falk, a leftist Brooklyn-born Jew of Russian descent, was happy to go to Russia just to see the country.[122] Most of the problems for Levine and De Santis came from the Soviet officials who were invested in the Great Patriotic War and had tried to get a more heroic role for the Soviet Union in the film.[123]

By the summer of 1964 there were high expectations for *Italiani*. In August, the *New York Times* reported that *Italiani Brava Gente* was one of the new crop of films coming from the "Italian movie masters," in this case De Santis. "The reports on the film are excellent," the paper concluded.[124] *Italiani* premiered

at the 1965 San Francisco Film Festival where, as predicted, it garnered (albeit cautiously) positive reactions.[125] But the movie ultimately did not do well in the United States. In Italy, where it collected many glowing reviews, it had only average box office.[126] One of the champions of neorealism in the United States, the *New York Times* film reviewer Bosley Crowther, agreed with De Santis and found Falk "implausible." He and De Santis, however, concurred about little else. While acknowledging that "the direction of Mr. de Santis has reality and vitality," he thought that "for the most part [*Italiani*] is lurid and in the theatrical style of fake war films."[127] Crowther later lambasted the film in the Sunday edition of the newspaper, where he termed the film an example of the "implausible."[128]

Crowther and many other reviewers missed what made *Italiani* extraordinary, however. In a 1964 interview in the *Los Angeles Times,* Levine explained that Hollywood was not solely about the United States any longer; "our business is now sixty percent foreign." the producer declared. *Italiani Brava Gente* had been his most ambitious project yet to move in that direction, "an American-Italian-Russian co-production deal," and the best thing (from an American producer's point of view) was that "the only portion we had to pay was the salary of Arthur Kennedy and Peter Falk."[129]

Conclusion

Levine was an extreme case of a generalized phenomenon. Many of the most ambitious and successful Hollywood producers in this era disengaged their careers from the Southern California environment that had nourished and sometimes constrained the professional developments of their predecessors. As Kramer, the studio veteran, remembered: "When I left the dubious shelter of Columbia studios to make movies my own way, independently, the whole industry was going through an evolution so rapid, far reaching and perilous, it might be better described as a revolution."[130]

Compared with their precursors, transition era producers were less easily identified with a Hollywood studio or even the real, tangible, Hollywood itself. Although still relying on the majors for distribution, financing, and on occasion production facilities, independent producers emerged as the largest single contingent among Hollywood's creative executives. By 1960 more than half the pictures the studios distributed were made by independents.[131] Some of these independents, like Kramer himself, produced films that focused on the important domestic social and political issues of the postwar era: Kramer's *The Defiant Ones* in 1958 or *Guess Who's Coming to Dinner* in 1967. But there was still a global project at work; several of Kramer's films, by way of example, were about international issues, like *Judgment at Nuremberg* (1961), a film that had profound consequences outside the United States. Kramer's *The Pride and the Passion*

FIGURE 16: Precisely what Joseph E. Levine "produced," here as elsewhere in his career, is subject to question. He was a throwback, a showman, as he affirmed in the opening credits of *The Graduate* (Mike Nichols, 1967).

(1957) did not do well in the United States, but it was a very important film for the stabilization of Francisco Franco's regime in Spain.[132]

More and more Hollywood producers worked in Europe, some of them building entire careers out of overseas deals. Kramer produced films most notably in Nuremberg and West Berlin, and in 1968 he went to Italy to shoot *The Secret of Santa Vittoria* (1969) with an international cast headed by Anna Magnani and Anthony Quinn. Levine worked all over Western Europe. Samuel Bronston produced hits like *El Cid* (Anthony Mann, 1961) and *The Fall of the Roman Empire* (Anthony Mann, 1964) in Spain, the latter in his own giant studio in Las Matas, close to Madrid. After Bronston fell out with his principal financier, Pierre du Pont, the torch of Hollywood production in Spain was picked up by Philip Yordan.[133]

Some producers brought the "overseas" to Hollywood, like Hal Wallis, who launched Magnani's American career (she received the 1956 Academy Award for Best Actress for *The Rose Tattoo,* directed by Daniel Mann, a film that was targeted at audiences both in the United States and in Italy, by then the second largest market for American films in the world).[134] "Hollywoods" were routinely built outside of Hollywood. In 1962, film critic Vincent Canby quipped that "American investment in British production has made it almost impossible to define a 'British' film."[135] In the mid-1950s William Murray, the son of Magnani's English interpreter and confidante Natalie Murray, described "Hollywood on the Tiber" in his novel *The Fugitive Romans.*[136] In 1968 Almeria, Spain, proclaimed itself the "movie capital of the world" with eight Hollywood movies shooting there at the same time—one more than in Southern California.[137]

At the end of the 1960s, President Richard Nixon's fiscal policies encouraged the consolidation of American production back in the United States and created what Robert Sklar termed "Hollywood's revival."[138] But the changes of the

immediate postwar decades were bound to stay. The tangible Southern Californian studios that had contributed so much to make the United States "modern" in the first half of the twentieth century were, to use Marshall Berman's fortunate expression, "melting into air."[139] Hollywood producers, however, survived the melting of the California studios and followed the new Hollywood to a myriad of new facilities that stretched from the Hudson River to Almeria in Spain, to the Tiber in Italy, and beyond.

4

THE AUTEUR RENAISSANCE, 1968-1980 Jon Lewis

In an industry in which perception is more important than (if not itself funda-
mentally) a reality, the perception of the auteur-director gaining power in the
1970s signaled a diminution of power for the movie producer. As a consequence,
the principal challenge for producers in this era involved a short-term suppression
of ego—itself a monumental thing—in order to facilitate a long-term transforma-
tion of a moribund marketplace.[1] The producer's necessary indulgence of creative
talent was complicated by a coincident necessity to indulge a new breed of indus-
try executive who answered to the management and ownership of increasingly
corporatized studios.

Auteurism took root during a particularly destabilized era in Hollywood. The
studios had been broken up per the Paramount Decision in 1948. The unrav-
eling of the studio system and the various betrayals of the Blacklist period
fundamentally changed the how management contracted with Hollywood labor.
The necessary skill set for movie producers in the auteur era, then, by necessity
involved diplomacy and patience, decidedly long-term strategies as the industry
transitioned through the last years of a lingering box office slide. As the movie
producer Lynda Obst (*Flashdance*, Adrian Lyne, 1983; *Sleepless in Seattle*, Nora
Ephron, 1993) suggests in her memoir *Hello, He Lied: And Other Truths from the
Hollywood Trenches,* the successful producers in the modern era have benefitted

from a Zen-like philosophy: "When you can do nothing, what can you do?" and "If you sit by the river long enough, the body of your enemy will float by."[2] These Zen koans, paradoxes pitting reason against some future enlightenment, Obst contends, guided the tasks of the producer in auteur-era Hollywood.

Most histories of this so-called auteur renaissance predictably focus on the aptly named movie brats,[3] the directors who embraced a film school catechism built upon the writing of André Bazin and the filmmaking of his disciples in the French New Wave.[4] Mostly ignored in this history are the producers who enabled them, production executives like Robert Evans at Paramount, who supervised the development, production, and post-production of *The Godfather* (Francis Ford Coppola, 1972), studio-hired producers like Al Ruddy (who got the principal production credit on Coppola's film), independent, entrepreneurial producers like Julia Phillips and JoAnn Carelli (who produced *Taxi Driver* [Martin Scorsese, 1976] and *Heaven's Gate* [Michael Cimino, 1981], respectively); and the legendary B-movie impresario Samuel Z. Arkoff, all profiled below. These producers ably balanced the conflicting goals and aspirations of the creative and financial players in the modern filmmaking process and, in doing so, merit recognition, if not as auteurs themselves, then certainly as creative collaborators in an evolving modern filmmaking process.

Robert Evans

> It is curious that the film that put Coppola on the celebrity map, that gave him the magic adjective "bankable," is also extremely problematic in terms of authorship.
>
> —*Jeffrey Chown, Coppola biographer*

The auteur era took off with the success of one film: *The Godfather* (1972). For its director, Francis Ford Coppola, the picture realized the film-school dream of an auteur Hollywood in which a director might apply his or her artistic signature to a studio-genre film. For the studio, Paramount Pictures, and its hands-on head of production Robert Evans, the film was significant as well, as its success seemed to unsettle longstanding relationships between directors and producers and by extension the relationship between art and commerce that had characterized the medium since its inception.[5]

To fully appreciate the story behind the production of *The Godfather*, we need to track back to 1968 when Paramount Pictures was owned by the mining conglomerate Gulf + Western. Paramount had by then suffered a two-decade box office slide, and when the parent company's famously irascible CEO Charles Bluhdorn's decided to hire Evans, a failed actor whose executive experience was limited to a brief stint at the family clothing business, Evan-Picone, it seemed to

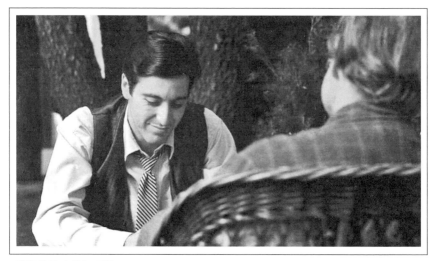

FIGURE 17: *The Godfather* (1972), directed by Francis Ford Coppola, launched Hollywood's auteur renaissance. The movie made Coppola the most famous movie director in the United States. Paramount's head of production Robert Evans received no screen credit, but the role he played in the film's development and production was undeniably significant.

many in the industry a sure sign he was scuttling the company. The trades bluntly regarded the hiring of Evans as "Bluhdorn's folly," or "Bluhdorn's Blow Job."[6]

In 1969 Paramount ranked ninth in box office revenues behind the other six major studios and also two independents, National General and Cinerama, both of which would soon go out of business. In an effort to either transform or fully decommission Paramount, Bluhdorn tried to sell the studio's trademark asset, the West Hollywood studio lot. But the deal fell apart in the eleventh hour when the developers failed to get an adjacent property, a cemetery, rezoned.[7]

Evans was undaunted by the unsettled situation at Paramount, and as production chief he began implementing a fairly simple but nonetheless inspired plan to turn things around. He had his first big success with the film adaptation of Ira Levin's best-selling novel *Rosemary's Baby,* which earned roughly five times its production budget in the summer of 1968. Then Evans put into production the adaptation of another best seller, *Love Story* (1970). Both novels were optioned by Evans before they were best sellers, and he used strategic relationships among Gulf + Western subsidiaries in parallel media to engineer the success of the novels first and the films afterward. He promoted the films as "pre-sold properties," movies based on source material familiar to the mass audience, before the term or the strategy became a marketing cliché in the industry.

Love Story was written by Yale professor Erich Segal and was initially seen by its publisher, Harper & Row, as a fairly minor title. Evans advanced $25,000 to Harper & Row to support a more ambitious first press run. Then, barely nine months after the novel hit bookstores and in time for the holiday season of 1970, Paramount released the film version directed by Arthur Hiller, starring Evans's

FIGURE 18: Bluhdorn's folly? Paramount chief Robert Evans, whose hiring by Gulf + Western CEO Charles Bluhdorn was questioned from the start, supervised the development and production of *Love Story* (Arthur Hiller, 1970), *The Godfather*, and *Chinatown* (Roman Polanski, 1974).

then wife, Ali MacGraw. The picture grossed in excess of $50 million in North America alone, earning nearly three times as much as the number two film for the year, *Little Big Man* (Arthur Penn), accounting for roughly a third of Paramount's total box office for the year.

Evans's purchase of an option on Mario Puzo's *The Godfather* preceded his expert handling of *Love Story*, and in retrospect we can see that a simple pre-sold strategy was in play here again. As Evans tells the story, in 1968 Puzo came to him with "fifty or sixty rumpled pages" of a book titled *Mafia*. Puzo, again according to Evans, owed some scary characters approximately $10,000 he didn't have.[8] The option check, then, was signed over to the very sort of characters depicted in the book.

Coppola biographer Peter Cowie tells a different version of the option story. According to Cowie, Puzo was already under contract to publish the novel with G. P. Putnam before he contacted Paramount. Hoping to pre-sell the movie rights, he showed those same sixty pages to a story editor at the studio, George Weiser, who liked what he saw because "it read like a Harold Robbins best seller."[9] Following Weiser's (and Cowie's) more likely version, Evans was at first uninterested; the studio had just lost money on Martin Ritt's *The Brotherhood*, a 1968 film that told a similar story about the son of a prominent gangster who returns home from war and reluctantly gets drawn back into the family business. But Weiser persisted and Evans finally gave in.

In either scenario, the same basic facts hold. Evans paid just $12,500 for the option on Puzo's novel (later retitled *The Godfather*) and produced the film for Paramount for a relatively modest $6 million. After its initial run, the film

earned over fifteen times its production budget and the auteur renaissance officially began.

Though uncredited as the film's executive producer,[10] Evans's work on the project began with optioning the novel (before it was a novel) and continued well after the film was "in the can." One of his first tasks after the book was published was to hire an appropriate director. His short list did not include Coppola. First choice was Richard Brooks, best known for his adaptation of *In Cold Blood* (1967) and *Blackboard Jungle* (1955). Brooks turned down the offer because he thought the book glorified organized crime. Evans was then turned down by Constantin Costa-Gavras, Elia Kazan, Arthur Penn, Franklin Schaffner, Fred Zinnemann, Lewis Gilbert, and Peter Yates.

Complicating the struggle to hire a director was a behind-the-scenes drama involving Burt Lancaster, who had offered to participate in the financing of *The Godfather* and the selection of its director in exchange for the role of Vito Corleone. Evans, however, lobbied against turning the project over to Lancaster because he didn't want to share production control or future box office revenue.

It was Evans's right-hand man, Peter Bart, who first suggested Francis Coppola, describing him as an extraordinarily bright person who wrote fabulous screenplays.[11] And in a Hollywood increasingly sensitive to identity politics, Bart argued Coppola's last name and ethnic heritage would also deflect the public criticism that awaited yet another film about Italian gangsters. Under increasing pressure to keep Lancaster out of the picture, and wanting to maintain the fiction of political correctness, Evans made an offer to Coppola, who astonishingly turned Evans down because he was not interested in directing a mainstream genre picture. A conversation with George Lucas later changed Coppola's mind and a deal was struck.

Evans's role in the production was complicated. He was from the start caught between the senior Paramount executives Stanley Jaffe and Frank Yablans and his young director, who audaciously proclaimed before the production began: "[*The Godfather* is] not a film about organized gangsters, but a family chronicle. A metaphor for capitalism in America."[12] Evans's job was to satisfy management and talent while keeping the film on budget, on message, and on time. A first compromise was necessary during development; executives at Paramount wanted the film updated and they wanted to shoot the entire film in Los Angeles, mostly on the studio lot. Coppola instead envisioned a period piece set in the 1940s and argued for extensive and expensive location work in New York and Sicily. Accommodating Coppola added to the cost of the film, but Evans made the argument to the studio brass that Coppola's version was necessary to satisfy the book's devoted readership.

Though he would intercede with the studio executives on behalf of his auteur director on a number of occasions, Evans and Coppola had fundamentally different concepts of the movie they had contracted to make "together." This, too,

complicated Evans's role as producer. He viewed the picture as a potential "event film"; it was for him, well before such terms had much traction in the business, a pre-sold, high-concept project. Coppola saw *The Godfather* instead as an opportunity to place his artistic signature on a studio genre film. Years later, the two would continue to regard the process of working together with acrimony and bitterness, but the film nonetheless satisfied the ambitions of both.

During the development phase, Coppola and Evans struggled over the casting of the two lead actors. Coppola wanted Al Pacino to play Michael Corleone. Pacino was a little-known New York actor at the time with only one significant film role to his credit—the lead in Jerry Schatzberg's *The Panic in Needle Park* (1971), a gritty-realist film about heroin addicts. Evans argued that Pacino was too short and pointed out that his three *Godfather* screen tests were awful.[13] The studio wanted to cast Ryan O'Neal, the more bankable (albeit Irish American) star of their 1970 hit, *Love Story.*

Coppola persisted and Evans dutifully contacted Pacino's agent, who declined the offer because his client had a scheduling conflict; Pacino had already signed to appear in the MGM adaptation of Jimmy Breslin's *The Gang That Couldn't Shoot Straight* (1971). In a relationship business it pays to have powerful friends, and Evans had one very powerful friend: the mob attorney Sidney Korshak. MGM was at the time owned by the corporate raider and Las Vegas hotel magnate Kirk Kerkorian and run by James Aubrey, one of a new breed of foul-mouthed bean counters at the studios. As Evans tells the story, he asked Korshak to help negotiate a deal that might free Pacino from his obligation to MGM. The "negotiation" took all of twenty minutes, after which Aubrey called Evans on the telephone: "You no-good motherfucker, cocksucker. I'll get you for this . . . the midget's yours." Evans later asked Korshak what he had said that so quickly convinced Kerkorian to release Pacino. Korshak replied: "I asked him if he wanted to finish building his hotel."[14]

Evans also opposed casting Marlon Brando, who was Coppola and Puzo's first choice. As Coppola reflected in 1997:

You have to remember that they were [at this time during the film's development] very seriously considering if they had the right director, and I brought up Marlon Brando. . . . I was told by one of the executives—I shouldn't say which one[15]—"Francis, Marlon Brando will never appear in this picture, and I instruct you never to bring him up again." At which point I fainted onto the floor. . . . My "epileptic fit" was obviously a gag, and they got the point. Finally, they recanted and told me that they would consider Brando if I could meet three criteria: one was that he would do the film for "nothing," one was that he would personally post a bond to insure them against any of his shenanigans causing overages, and the third was that he would agree to a screen test. And I agreed, even though I didn't even know Brando.[16]

Coppola shot a screen test on the pretense of working out costumes and make-up and Evans made the deal.

Evans's supervision and his necessary mediation persisted into the production phase. For example, his relatively inexperienced director clashed early on with the veteran cinematographer Gordon Willis. The director allowed his actors time and space to improvise; Willis's lighting depended upon the actors precisely hitting their marks. Evans stepped in to smooth things over, managing egos and negotiating compromises.

A second struggle emerged between Puzo and Coppola. Puzo complained to Evans that Coppola's script was nostalgic and soft. When Coppola heard that Puzo had met with Evans behind his back, he had the novelist banned from the set. Evans supported the ban and in doing so inadvertently lent support to Coppola's claim of authorship.

While Evans worked mostly behind the scenes, Jack Ballard was Paramount's eyes and ears on the set. After the crew wrapped the restaurant scene during which Michael guns down the crooked police captain McClusky and the drug lord Solozzo, Aram Avakian, the film's editor (with *The Miracle Worker* [1962] and *Mickey One* [1965], both directed by Arthur Penn, to his credit), at Ballard's urging, sought out Evans, and told the producer that the film "wouldn't cut," that

FIGURE 19: The restaurant scene during which Michael Corleone assassinates Solozzo and McClusky proved to be a turning point in the production of The Godfather. After Francis Coppola shot this scene, Aram Avakian, the film's initial editor—at Paramount employee Jack Ballard's urging—sought out Evans and told the producer that the film "wouldn't cut." Evans wisely resisted firing his young director and instead fired Avakian. Pictured here: Coppola (left), cinematographer Gordon Willis (foreground, right), and actor Al Pacino (center)..

Coppola had no idea about continuity. Ballard had his own agenda, of course, and he had to know that he was giving Evans an excuse to fire Coppola. But Evans was cautious about unsettling the delicate balance of egos and agendas on the set. So he stalled Ballard.

Protecting the film from bad production-stage press, behind closed doors Evans asked Peter Zinner (the editor of *In Cold Blood* [1966] and *The Professionals* [1967], both for Richard Brooks) to take a look at the dailies. Zinner examined the work and told Evans that the footage was terrific. So Evans instead fired Avakian and hired Zinner and then added William Reynolds, a long-time Hollywood veteran (*Algiers* [John Cromwell, 1938], *Bus Stop* [Joshua Logan, 1956], and *The Sound of Music* [Robert Wise, 1965], for which Reynolds won his first of two Oscars), to supervise the editing.

In the day-to-day grind of producing the picture, Evans proved to be an able behind-the-scenes facilitator of Coppola's directorial signature. But as Paramount's chief production executive, he took a more public and less sympathetic position regarding auteur directors. On February 3, 1971, under the *Variety* page-one headline "Cut Directors Down to Size," Evans characterized ambitious directors as spoiled children and announced his (and Paramount's) intention to "become [more] involved in the product on a creative basis," to "be close[r] to the script development, the casting, and the final cuts." If writers and directors didn't like Paramount's way of doing business, Evans bristled, "they should stay away."[17] Evans's fellow production executives at the time could read between the lines: they knew that such rhetoric was necessary but meaningless; the relative "size" of movie directors at the time had never in the history of Hollywood been bigger.

Postproduction has historically been the stage in filmmaking when confrontations between directors and production executives are most problematic, and indeed this is where and when Evans's and Coppola's dispute over authorship of *The Godfather* became the most contentious. In a 1984 interview, Evans quipped that Coppola's final cut of *The Godfather* "looked like a section out of [the television show] *The Untouchables*." It was so bad, Evans remarked, that he had to cut and "[change] the picture entirely."[18] Bart, Evans's assistant at the time, tells much the same story: "*The Godfather* was a seminal experience, in that Evans was dissatisfied with Francis Coppola's cut and spent months working around the clock with him on the film, even postponing the release date. Now the gossip in town was that Evans was intruding on the prerogatives of young filmmakers. The reality was quite the opposite: I watched as a superbly shot but ineptly put together film was transformed into a masterpiece."[19]

Coppola predictably disputes Evans's and Bart's accounts. So despite the film's success, there were hard feelings on both sides after *The Godfather* reached the screen. When Coppola signed with Paramount to direct *The Godfather: Part II*, his contract with the studio stipulated that Evans would have virtually no input.[20]

Recalling in his memoir a dispute during their ill-fated 1984 *Cotton Club* coproduction, Evans quotes from a telegram sent by Coppola. Twelve years after its release, the post-production of *The Godfather* remained a sore subject: "Dear Bob Evans, I've been a real gentleman regarding your claims of involvement in *The Godfather*. I've never talked about your throwing out the Nino Rota music, your barring the casting of Pacino and Brando, etc. Your stupid babbling about cutting *The Godfather* comes back to me and angers me for its ridiculous pomposity."[21] In the memoir, Evans cites the following reply: "Thank you for your charming cable. I cannot imagine what prompted this venomous diatribe . . . the content of which is not only ludicrous, but totally misrepresents the truth." A second exchange of telegrams took place when the two men disagreed over the casting of Fred Gwynne as Frenchy Demange in *The Cotton Club*. Again, the subtext was their work together on *The Godfather*. First, Coppola: "This is not *The Godfather*, Evans. I've had it! Fed up with you. Tired of your second guessing." Evans quips in his memoir: "How could a guy I plucked from near obscurity to superstardom vent this vitriolic hatred?" The answer was there in the asking, as Evans concludes, musing to the readers of the memoir: "No mistake about [Coppola's eventual take-over of Evans's production of *The Cotton Club*]—it was an ingeniously conceived, ten year festering come shot, a royal fucking by Prince Machiavelli himself."[22]

What we know for sure—which is to say that in this instance Coppola and Evans tell the same story—is that Coppola's first cut was quite a bit shorter than the film Paramount released in the spring of 1972. And it was at Evans's behest and with his help, working with senior executives at the studio, that Coppola restored approximately fifty minutes to the release cut, including the lengthy sojourn in Sicily.[23] For Coppola, the Sicily sequence provided an essential backstory. For Evans, the longer running time pushed the film into epic territory, a move that helped him to promote the film as an event like *Gone with the Wind* (Victor Fleming, 1939).

It is also Evans's ending, not Coppola's, that we find in the final cut. Coppola shot a scene to match the closing scene of the novel showing Kay in church lighting a candle for Michael's sins. The film ends instead with what was in the original script, the penultimate scene: we see Michael's office door slowly close on Kay; first we get a glimpse of Michael's lieutenants kissing his ring and then Kay's look of futility and despair. The church ending in the Coppola version gives closure to the film's thematic conflation of family and religion and Michael's betrayal of both in the series of murders that cement his authority. But Evans's neater and simpler ending accounts only and rather cynically for Michael's seizure of power and as a consequence Kay's increasing irrelevance in his life.

Moviemaking is a collaborative process. But as we can see here, for a film to "work" the collaboration between producer and director need not be amicable. *The Godfather* made Coppola the industry's most famous director, and he

exploited that notoriety through the end of the decade. The film's unprecedented success at the box office also went a long way to cementing Evans's reputation as the industry's top production executive. *The Godfather* was produced for just $6 million, which even by 1972 standards was astonishingly cheap. The film grossed (at less than two dollars per ticket) over $80 million domestically. Worldwide box office after this first run totaled approximately $150 million. In 1974, when NBC contracted for a two-night airing of the film, the network paid Paramount $10 million, the most ever for a single showing of a movie. An estimated 100 million viewers, almost 40 percent of everyone with TV sets on, watched the movie at home. For his colleagues at Paramount and his boss at Gulf + Western, Evans's crowning achievement was that, when *The Godfather* became the highest grossing film to date, the studio owned over 84 percent of the picture.

Al Ruddy

> *[I would like to thank] Frank Yablans for having the courage and imagination to sell this film and make my mother rich.*
> —Al Ruddy, Oscar acceptance speech, 1973

When *The Godfather* won the Academy Award for Best Picture in the spring of 1973, the Oscar went to Albert S. Ruddy, the film's credited producer. Evans, who had hired Ruddy, went uncredited and did not get a statuette. Ruddy was an unlikely Oscar winner; he was before 1972 a teleplay writer known primarily for the comedy series *Hogan's Heroes,* which he co-created. His two feature film credits as producer were for a low-budget road picture *Wild Seed* (Brian G. Hutton, 1965), which he produced for Marlon Brando's Pennebaker Productions and Universal, and *Little Fauss and Big Halsey* (Sydney J. Furie), a film about motorcycle racers starring Robert Redford and Michael J. Pollard, distributed by Paramount in 1970. As Ruddy remarked in an interview in 2012, Paramount chose him because they had been recently stung at the box office with the poorly conceived musical *Paint Your Wagon* (Joshua Logan, 1969), and Evans in particular figured that Ruddy was someone he could trust to control costs on *The Godfather.*[24]

Given such criteria, Ruddy did precisely what he was hired to do: he managed the production and kept the show's spending within range of Evans's $6 million budget. And he also served as the studio's front man, its public face on the production. In the process of satisfying that role, he had to take a public relations hit for the team (so to speak) when things got dicey on location in New York City.

When the *Godfather* production team arrived in New York's Little Italy in the spring of 1971 to prep production, Ruddy was confronted by the Italian-American Civil Rights League. The group insisted that before a single frame could be shot, before the production could access key New York City locations and contract for

Teamster transportation of equipment, a deal would have to be struck, injecting a dose of reality to the notion of deals one cannot afford to refuse. Indeed, Ruddy had little choice—extensive location work had been by then rather carefully planned—so he made a deal. As reported in the March 20, 1971, edition of the *New York Times,* the Civil Rights League granted its permission for Ruddy and Coppola to shoot on their turf and to use what were in reality their trucks, so long as Coppola and Puzo agreed to eliminate the words "Mafia" and "Cosa Nostra" from the screenplay.[25]

After a subsequent *Times* story revealed that the League's negotiating team had been headed by Anthony Colombo, mob boss Joseph Colombo's son, Evans and the rest of Paramount's executive team predictably ran for cover, leaving Ruddy to take the brunt of the public relations fallout. An unidentified Paramount executive told a *Variety* reporter that the negotiations between Ruddy and the League were "completely unauthorized,"[26] a nonsensical notion since Evans had hired Ruddy and the studio had pressured him to make the deal.

Julia Phillips

> JACK VALENTI: I'm not suggesting for one minute that there aren't plenty of crooks, cheats, and charlatans in Hollywood. I am saying that the vast majority are people of probity and integrity who care very much about their public reputations.
>
> INTERVIEWER: Is it worse than in any other business?
>
> VALENTI: I don't know. Of course, it's not like any other business.

About a year after Steven Spielberg's *Jaws* (1975) made Universal over $100 million, the producer Julia Phillips agreed to take on the director's follow-up project, *Close Encounters of the Third Kind* (1977). Like Spielberg, Phillips was on a roll; she was the first female producer to receive a Best Picture Oscar (for *The Sting,* directed by George Roy Hill in 1974) and, two years later, with her husband Michael Phillips and Phillip Goldfarb, she produced *Taxi Driver* (Martin Scorsese), a legendary auteur picture.

Her first task while developing the *Close Encounters* project was to assemble a production team to work with Spielberg and the film's studio distributor, Columbia. For the managerial role of line producer, the on-set manager of the "show," Phillips began by sorting through (in her words) a list of some "aggressively non-creative money-watching types." So she considered first her ex-business-partner and ex-husband, Michael Phillips. In her tell-all memoir, *You'll Never Eat Lunch in This Town Again,* Phillips recounts his decision (he turned her down)

by reminding us that in a relationship business, occasionally the professional and the personal overlap uncomfortably. As Phillips writes: "Michael has made it clear he ain't doin' it; he's planning to go around the world in search of a soul he doesn't have."[27]

Next, Phillips considered the editor Verna Fields. But, according to Phillips, Spielberg nixed Fields because she had taken too much credit in the press for the expert postproduction work on *Jaws*. She then turned to the producing partners Bill Sackheim and George Shaw, but their personalities clashed with hers. "Sackheim seemed like a Nixon plumber," Phillips colorfully recounts, and Shaw just didn't seem interested. Absent a viable alternative, she took the lead, banking on something Spielberg said to her off the cuff: "All great movies are the product of one person's obsession."[28]

Spielberg was right, of course; to take a project from development through distribution, it takes someone to facilitate the creative vision; it takes a committed producer. With *Close Encounters of the Third Kind*, Phillips proved to be just that, a persistent facilitator out in front of the inevitable obstacles to the production. For example, when Phillips met Spielberg's pick for the complicated special visual effects, Douglas Trumbull, who had famously designed the space-travel sequences in Stanley Kubrick's *2001: A Space Odyssey* in 1968, it was clear from the start that his proposed budget of $3 million was about $2 million more than Columbia executives were willing to pay. Phillips knew that she had to somehow please both of her masters (Spielberg and Columbia), or at least convince them that she was committed to protecting their conflicting interests.

Spielberg insisted that he needed Trumbull. Trumbull insisted that he needed $3 million. The executives at Columbia had parsed out their budget based on market projections, and the visual effects line in that budget was just under $1

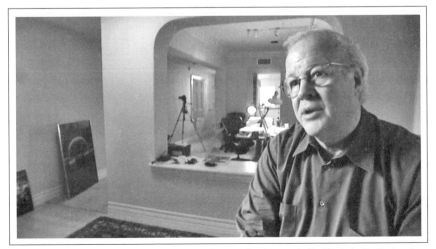

FIGURE 20: The special visual effects expert Douglas Trumbull (pictured here) proposed a $1 million budget for his planned work on *Close Encounters of the Third Kind* (1977) based on assurances from producer Julia Phillips that she would get him an additional $2 million once the film was under way.

million. At such an early stage in the development of the project, Phillips had to be careful not to undermine the market-driven budget. Moreover, she knew that it would be far easier for the studio to back out of the project before the principal photography had begun. So she convinced Trumbull to underbid, assuring him that if he bid $1 million she would get the additional $2 million once the film was under way. Phony special visual effects budget in hand, Phillips went to the studio and did what any good producer would do: she lied. And then, when the production was under way, she figured out a way to get Trumbull the money he needed. It was by then too late for Columbia to turn back.[29] Reflecting upon the development of the film, Phillips quipped that the fundamental challenge in producing *Close Encounters of the Third Kind* was "keeping the money and the movie maker as far apart as possible."[30] Such a strategy seems, in retrospect, a primer for producing in the auteur era.

Taxi Driver, which opened on February 8, 1976, was a critical and financial success. It won Scorsese the Palme d'Or at Cannes, received four Oscar nominations (including Best Picture for Michael and Julia Phillips; they lost out to the production team for *Rocky*, directed by John G. Avildsen), and grossed a very respectable $21 million in its initial playoff, roughly sixteen times its production budget. But the film, which tells the story of a mentally disturbed loner (Robert De Niro) who plots a political assassination and then settles for a violent, vigilante rescue of a teen prostitute, was, at the risk of understatement, hardly a likely scenario for a successful Hollywood movie. Its realization required producers who could see past the bloody epiphany (which initially got the film an X rating) and the story of (in the screenwriter Paul Schrader's words) a "psychopath's Second Coming."[31]

Schrader's first draft script found its way to Julia and Michael Phillips through his friend the director Brian De Palma. The producers were initially turned off by the script's cynicism, its violence, and its unlikable protagonist, but at De Palma's urging they optioned the script for a modest $1,000 and promised to try to find financing from one of the studios. Given the problematic script and the absence of a name actor or director attached to the project, Phillips failed to find a buyer. But she still held on to the option. A couple of years passed, and while Schrader's revised script was still unrelentingly bleak, the talent Phillips had attached to the project had in the meantime become quite successful and famous. De Niro had won an Oscar for his performance as the young Vito Corleone in *The Godfather: Part II* (Francis Coppola, 1974), and Scorsese's feature *Alice Doesn't Live Here Anymore* (1974) was a box office success and featured an Oscar-winning performance by Ellen Burstyn. Despite the fact that he too hated the script, Columbia Pictures president David Begelman greenlighted *Taxi Driver* because it was so well packaged by Phillips.[32]

In the memoir, Phillips recalls her first go-round with Schrader's screenplay, which was only one of several projects she was juggling at the time: "I had found nothing really attractive about *Taxi Driver* when I first read it, except

for its sociology. Travis was a nut case . . . but Schrader was too."[33] What kept her working on its behalf was De Niro, whose performance as Johnny Boy in *Mean Streets* (1973) suggested that he might be the one actor who could make the script work.

De Niro's professional relationship with Scorsese was not at first a selling point. When Phillips first shopped the script around, she interviewed a number of other, better-known directors, including Irvin Kershner (who would later direct *The Empire Strikes Back,* 1980) and Lamont Johnson, who had directed the excellent TV movie *The Execution of Private Slovik* in 1974. She rejected Kershner because he wanted major rewrites, "the kind that indicate that he doesn't want to do [the film],"[34] and then when her relationship with Johnson cooled she showed the script to John Milius, who considered further developing the script's vigilante right-wing subtext. Milius had been the script doctor on *Dirty Harry* (Don Siegel, 1971), after all. It was Spielberg who spoke up on behalf of Scorsese, eventually offering his services to Phillips should Scorsese not work out.

Phillips began developing *Taxi Driver* after her first encounter with De Palma and first read-through of Schrader's script. She persevered through the successful packaging of De Niro and Scorsese with the project, and then stayed on through contentious post-production negotiations with the Classification and Rating Administration (CARA), which saddled the rough cut of *Taxi Driver* with an X rating. After CARA rendered its verdict, Begelman, the studio executive from whom Phillips had secured production and distribution financing, took the predictable position: he reminded the producer that Scorsese was contractually obliged to cut the picture to get an R rating. If the director refused, Begelman could hire someone else to supervise the final cut. As the film's producer, Phillips

FIGURE 21: The producer Julia Phillips was instrumental in securing an R rating for *Taxi Driver* (1976), which was initially saddled with an X rating because the MPAA ratings board was shocked by the violence of the film's bloody climax.

had to protect the picture from the industry censors, from Begelman, and to an extent from Scorsese, who, true to auteur credo, saw no good reason to compromise his artistic vision to suit a handful of anonymous, prudish parents working for CARA.

Serving several masters yet again, Phillips requested specific notes from the CARA board (needed to secure an R) and then, armed with those notes, endeavored to convince Scorsese to make changes that seemed to both of them arbitrary—for example, cutting the sound of Travis's zipper from the effects track in his scene with the underage prostitute Iris (and the underage actress, Jodie Foster, playing her). Cutting the sound was easy enough and, as creative compromises go, inoffensive, so Scorsese complied. Their real problem was the film's violent climax, a scene that was so pervasively bloody it seemed impossible to fix. Absent a specific playbook from CARA, Phillips understood that her role in this situation was to impress upon Scorsese that he needed to at least appear to make appropriate concessions to the censorship board. And she got the director to do just that; he cleverly executed technical as opposed to content changes. He asked the lab to re- and de-solarize the footage, essentially making the blood less red. Phillips then told the board in vague terms about the director's significant changes spurred by their comments on the rough cut. The CARA board watched the sequence again, and though the content was mostly unchanged they gave the "new" version of the film an R.

Phillips's role in the development, production, and post-production of *Taxi Driver* may not have been necessarily "creative," but the film's creative success was very much the product of her strategy and diplomacy. She never much liked Schrader's script, but she optioned it anyway and then despite all sorts of obstacles got the movie produced and released. Though *Taxi Driver* is quite likely the film for which she will be remembered as a producer, it was a project about which she felt ambivalent. But to her credit as a producer, she did her job anyway, and the reward for that commitment is up there on screen.

Phillips was an important and successful movie producer in the 1970s and a savvy industry player. She was also one of a rather select minority of women operating in such a powerful role in Hollywood.[35] Sadly, her ability to be an effective producer was short-lived. Though her track record as the producer of critically appreciated and financially successful films at the time was unassailable, the very sort of personal hiccups (drugs and alcohol abuse) that only briefly derailed the careers of male producers at the time (Mike De Luca comes to mind) played a decisive role in the sudden end to her career in 1977.[36] Eleven years would go by between her screen credit for Spielberg's sci-fi classic and her next film, the micro-budgeted adaptation of Paul Mones's off-off-Broadway play *The Beat*. Her final screen credit—Phillips died in 2002—came in 1991 for the B-comedy *Don't Tell Mom the Babysitter's Dead* (Stephen Herek), a far cry from the sorts of films she produced in the seventies.

JoAnn Carelli

Nobody really controls a picture right now; the director is on his own, even if he's insecure, careless, or nuts. There has always been a megalomaniac potential in moviemaking, and in this period of stupor, when values have been so thoroughly undermined that even the finest directors and the ones with the most freedom aren't sure what they want to do, they become obsessive and grandiloquent—like mad royalty. Perpetually dissatisfied with the footage they're compulsively piling up, they keep shooting— adding rooms to the palace.

—*Pauline Kael, film critic*

The auteur era is bookended by two films: *The Godfather* and *Heaven's Gate* (Michael Cimino). The former embodied and exemplified the possibilities of an auteur Hollywood; the latter, which got two showcase screenings at the end of 1980 and a very limited general release in 1981, rather confirmed the worst fears of the studio executives and producers who had wearied of dealing with the often tiresome movie brats.

It is a bit cynical but nonetheless accurate to conclude in retrospect that *Heaven's Gate* was the film the whole industry was waiting for, the very auteur box office nightmare that would finally restore production control to the financiers and studios. It was the executive team at United Artists that took the big hit—somewhere in the neighborhood of $40 million[37]—but someone had to. Their bad news (in the decided short term) was good news (in the long term) for the studio industry; after *Heaven's Gate* every demanding auteur was a potential Michael Cimino, and every ambitious creative enterprise another *Heaven's Gate.*

In August 1978, when the western that would become *Heaven's Gate* was greenlighted at UA, the industry was abuzz with news about an audacious new Vietnam War film, *The Deer Hunter,* directed by an astonishing new talent, Michael Cimino. The film was not due out until December, but prints were circulating and there was already talk about Oscars, which indeed materialized in 1979; the film won five, including Best Picture and Best Director. The publicity supporting the film and its auteur prompted the executive team at United Artists to contract Cimino's proposed next film, a western based on a struggle between corporate and family ranchers in Wyoming in 1892, the Johnson County War. Westerns were not particularly popular at the time, but that was beside the point. UA wanted to be in business with Cimino, no matter what he wanted to direct. In the history of American cinema, there is no clearer case of a studio indulging the auteur theory.

There was a lot not to like about the project as it was pitched to the studio. Steve Bussard, the head of UA's story department, was unimpressed with the script. But

he recommended making the deal anyway. Bussard put the situation in a perspective rather locked into the times: "If it were not for Cimino, I would pass."[38]

Complicating matters, the studio was struggling at the time with another auteur project, Coppola's *Apocalypse Now,* which the studio had greenlighted in 1976. The film had gone well over its initial production budget. One studio executive was so frustrated working with Coppola that he leaked to the press that the picture might never come out, dubbing the film, "Apocalypse Never." Just as the studio planned to scapegoat Coppola for what they perceived to be a bloated auteurist bomb and in the process come out from under their $30 million investment in his film,[39] they met with Stan Kamen, Cimino's agent at William Morris, and agreed to develop *The Johnson County War.* The risk of their deal with Kamen seemed minimal, in studio terms at least; all told, fees to move the film into development amounted to only $1.7 million in pay-or-play obligations to the director and the movie star Kris Kristofferson (another Kamen client), both of whom were obliged to free their calendars should UA make the picture. Kamen's principal selling point was the promise of Cimino's follow-up to *Deer Hunter* for a bargain price; Cimino's pre-release (and pre-Oscar) fee was just $500,000. The proposed budget for the film was $7.5 million, roughly a quarter of what *Apocalypse Now* had already cost the studio.

The Johnson County War, which would soon be retitled *Heaven's Gate,* was attractive in large part because the studio had wearied of Coppola and *Apocalypse Now.* But as things played out, the auteur movie box office disaster that UA executives feared when they saw the rough cut of *Apocalypse Now* was realized instead by *Heaven's Gate,* which grossed less than $2 million in its initial release while Coppola's film surpassed the $100 million mark.

In an astute observation on the industry, circa 1981, Coppola reflected on the predicament of the auteur at the dawn of the blockbuster era:

> I think what happened to *Heaven's Gate* has to do with much bigger, more fundamental problems with making a movie today. Traditionally, what happens is the director embarks on an adventure, and he's basically frightened of the so-called studio because he knows the people he's dealing with. . . . So what he does is use his strength as a viable director to get all the rights . . . the right of final cut. . . . As a result the studio is without much control. Realizing his life is going to be affected with one throw of the dice the director starts protecting himself by trying to make it beautiful, spectacular, and one of a kind—almost without regard for what were the original priorities of the piece.[40]

Coppola's notion that filmmaking is a high-stakes gamble was nothing new; the movie moguls in the classical era rather celebrated the notion that they were flying by the seat of their pants, risking vast sums on fundamentally unstable or

unpredictable products. But that the creative if not financial gamble would be the director's alone was something new, suggesting here that not only the megalomania of certain directors (as suggested by Kael, above) undid auteurism but that a failure of producers and executives to reign in these directors was to blame as well.

Four producers were credited on *Heaven's Gate:* Joann Carelli, Denis O'Dell, Charles Okun, and William Reynolds. Carelli supervised the day-to-day production. She was throughout the project Cimino's right-hand "man," having already executive-produced *The Deer Hunter*—and she would later produce Cimino's *The Sicilian* in 1987. Carelli's professional relationship with Cimino began at Madison Pollock and O'Hare, the advertising firm where Cimino shot commercials for Revlon, Pepsi-Cola, and United Airlines.

This relationship rather defined her role in the production. When the budget spiraled out of control, she kept the budget-conscious executives at UA away from Cimino, including but not exclusively the studio producer Lee Katz, whose concerns about cost overruns were expressed to his superiors in a memo referring cynically to Cimino and Carelli's "budget made with a crystal ball." Carelli responded by demonizing Katz and touting the auteur line: "[UA executives] want an important movie, right? Well, they'll get an important movie, but not if Mr. Cimino has to deal ever again with Mr. Lee ('crystal ball') Katz."[41]

For Carelli, her primary task was to protect Cimino from the studio, to keep the moneymen and the artist separate, so much so that the artist might never be concerned or hampered by financial details. When, for example, Katz drew attention to cost overruns generated by all the extras suddenly needed for the roller-skating scene (which, to be fair, is stupendous), he reported back to the studio, guessing at a figure: $100,000. Carelli attacked Katz for guessing, deliberately ignoring the essence of the warning that the scene would cost a lot more than

FIGURE 22: When the United Artist production liaison Lee Katz drew attention to cost overruns generated by all the extras needed for the roller-skating scene in *Heaven's Gate* (1980), the producer JoAnn Carelli responded by demonizing Katz and touting the auteur line: "[UA executives] want an important movie, right? Well, they'll get an important movie, but not if Mr. Cimino has to deal ever again with Mr. Lee ('crystal ball') Katz."

initially budgeted. As to other budget estimates about the roller-skating scene, Katz submitted figures that should have alarmed the executive team at UA: props up from $151,000 to $386,000; wardrobe up from $268,000 to $510,000; set construction up from $410,000 to $1.08 million.[42] Katz's point was that the numbers were changing dramatically and that this was a very bad sign. But Carelli took the position that if the studio wanted an "important film," they were going to have to trust Cimino and fire Katz.

Okun, who had also worked with Cimino at Madison Pollock, adopted a different strategy. He tried to use his relationship with Cimino to forge a compromise between the moneymen (including Katz) and the moviemaker. Cimino and Carelli viewed Okun's communications with Katz as fundamentally "clandestine," when to be fair they fell more into the category of standard operating procedure.[43] They publicly regarded Okun's "betrayal" as a challenge to the director's high-stakes gamble on the film and forced his exit mid-production.

Of all the credited producers, O'Dell had the most experience; during the British New Wave, he coproduced Richard Lester's *A Hard Day's Night* (1964) and *Petulia* (1968). So it is, in retrospect, a pity that he had a relatively a small role in the production. O'Dell worked as the production manager on the prologue, which was set and shot in Oxford, England, and had little else to do with the film.

Reynolds was the film's supervising editor, a role he also played on *The Godfather*. His producer's credit was added in post-production after he helped the studio reduce the film's running time from over five to three and a half hours (the first, final cut) and then to two and a half hours (for general release). For the vast majority of the production, the least experienced producer, Carelli, was in charge. She was fiercely loyal to Cimino. And it shows in all of the several available versions of the film.

According to Steven Bach, the former UA senior vice-president whose book *Final Cut* chronicles the development, production, post-production, and release of the film, there was never any doubt of the film's technical brilliance: "It was an orgy of brilliant pictorial effects, and no one [among the UA executives] who sat in the theater [for the rough cut screening] would ever question again where the money had gone." But however much they might have been pleased to see how their money had been spent, Andy Albeck, UA's president, summed up the studio's post-screening sentiment rather bluntly: "No way this company's going to release a movie that's five hours long."[44]

When *Heaven's Gate* finally opened at three and a half hours in November 1980, it played on only two screens. A few months later, when Reynold's further abridged version opened on 810 screens, it grossed a disappointing $1.3 million. "It's as if somebody called every house in the country," Paramount sales executive Jerry Esbin told the *Los Angeles Times,* "[and said] there will be a curse on your family if you go see this picture."[45]

When *Heaven's Gate* realized the very auteur-blockbuster disaster *Apocalypse Now* had only hinted at, many of the critics who had celebrated the auteur renaissance seemed anxious to mark its final gasp. In conversation with Bach, the *Wall Street Journal's* Joyce Gould Boyum seemed to speak for her fellow reviewers when she wrote: "The industry has to an extent abdicated to its directors. This is a victory those of us who care about films have always wished for, but it turns out not be precisely what we had in mind."[46]

Samuel Z. Arkoff

SAMUEL Z. ARKOFF: I like the business. I like the people in the business. It's a business of rogues. I say it nicely. But it's a business of rogues.

INTERVIEWER: And you're a rogue?

ARKOFF: No, I'm the only one who's not.

The auteur era was good for creative independence, but it was not so good for creative independents. The studios serially altered their business model through the 1970s, transitioning out of production to focus more exclusively on distribution; by the end of the decade, the studios produced less than 20 percent of the films in general release but still distributed over 95 percent. Such a model was hardly practical or even possible for smaller, independent distributors. Making matters worse, by 1980 the studios and theater chains had begun exploiting a loosening of anti-trust regulations to collectively and coercively exert more control over the licensing and exhibition of feature films, leaving the smaller independents with significantly restricted access to the marketplace. Lower-budget independent producers, who had made a living supplying the indie distributors with content, were struggling as well. Just as production and distribution costs had significantly increased, short-term interest rates used to finance movie production reached 20 percent. As a new Hollywood loomed, the average feature film budget reached $18 million with another $6 million for advertising and distribution, costs non-studio players could not afford.

In the spring of 1980, the legendary B-movie producer Samuel Z. Arkoff turned to the trades to complain about the new market conditions. "The industry is entering a different period," Arkoff told *Variety*. "People are not interested in lesser pictures, so the picture business is becoming the province of well-funded companies. The independents that can't keep up with the escalating costs of production and marketing will get hurt savagely in the marketplace."[47] In the last years of the auteur era and the first years of the new Hollywood, his prediction proved correct as Arkoff's American International

Pictures (AIP), Filmways, Weintraub, Cannon, De Laurentiis, New World, Lorimar, Vista, New Century, and the Atlantic Releasing Corporation all went out of business.

By the time AIP went under, Arkoff had been a hugely successful Hollywood B-movie producer for nearly three decades. At AIP his production credits include over 500 titles, most notably *The Fast and the Furious* (Edward Sampson and John Ireland, 1954), *The Day the World Ended* (Roger Corman, 1955), *Hot Rod Girl* (Leslie Martinson, 1956), *I Was a Teenage Werewolf* (Gene Fowler Jr., 1957), *The Cool and the Crazy* (William Whitney, 1958), *Machine Gun Kelly* (Roger Corman, 1958), *The Pit and the Pendulum* (Roger Corman, 1961), *The Raven* (Roger Corman, 1963), *Beach Party* (William Asher, 1963), *Dementia 13* (Francis Coppola, 1963), *Summer Holiday* (Peter Yates, 1963), *The T.A.M.I. Show* (Steve Binder, 1964), *The Wild Angels* (Roger Corman, 1966), *What's Up Tiger Lily?* (Woody Allen and Senkichi Taniguchi, 1966), *The Trip* (Roger Corman, 1967), *Wild in the Streets* (Barry Shear, 1968), *3 in the Attic* (Richard Wilson, 1968), *Bloody Mama* (Roger Corman, 1970), *The Abominable Dr. Phibes* (Robert Fuest, 1971), *Boxcar Bertha* (Martin Scorsese, 1972), *Blacula* (William Crain, 1972), *Dillinger* (John Milius, 1973), *Return to Macon County* (Richard Compton, 1975), *The Little Girl Who Lives Down the Lane* (Nicholas Gessner, 1977), and *Rolling Thunder* (John Flynn, 1977).

Throughout his B-movie career, Arkoff operated under a short-term model that hearkened back to the 1930s and the mode of production on Poverty Row. That model, emphasizing speedy production and efficient distribution, was no longer possible in the late 1970s as the wait for box office payoffs had become slow and uncertain and the cost of money (hovering at 20 percent) had become unmanageably high. The key to the box office appeal of Arkoff's movies also dated to the 1930s; he produced and distributed exploitation films that promised (but seldom fully delivered) an alternative to the strict regime of content censorship enforced by the Production Code Administration. With the advent of the new Voluntary Movie Rating System in 1968, an industry event that helped launch the spirit of independence upon which the auteur renaissance was built, the salacious promise of exploitation was significantly blunted.

Arkoff recognized that the industry was changing and that he had to change with it. After 1968 he cut back significantly on the number of films produced at AIP, and while he continued to make exploitation-style films targeted at teen audiences, he moved cautiously upmarket. When it became clear that AIP was undercapitalized to realize such a strategy, he merged with the slightly larger, self-described "mini-major" Filmways to gain access to their borrowing power and cash reserves. Given the market conditions at the time, the merger seemed to make good business sense. But unfortunately for Arkoff, it wasn't long before he and the Filmways' CEO Richard Bloch clashed over the sort of films the combined companies should make.

Bloch was an Arizona real estate tycoon before he succeeded the former television producer Martin Ransohoff at the helm of Filmways; he was very much a new Hollywood player, a film executive who readily confessed that he not only knew little about but rarely even went to the movies. The ideological impasse between Arkoff and Bloch embodied the philosophical differences between the old, entrepreneurial Hollywood in which Arkoff began his career as a producer and the new, post-industrial model that was taking shape in the late 1970s.

Before merging with Filmways, Arkoff tried to survive on his own. And he appeared to be on the right track with his last three AIP-produced films: *Love at First Bite* (Stan Dragoti, 1979), *The Amityville Horror* (Stuart Rosenberg, 1979), and *Dressed to Kill* (Brian De Palma, 1980). All three films made money, in large part thanks to Arkoff's canny production and promotion. The development of the parody *Love at First Bite* provided a model for Arkoff's move upmarket. Production values were improved to suit a less easily satisfied teen audience, but costs were otherwise controlled by clever casting, with the leads played by the television star Susan St. James and the supermarket tabloid celebrity George Hamilton. Both actors had terrific name recognition, yet both worked for considerably less money than movie stars.

The Amityville Horror, released a few months after *Love at First Bite,* seemed even at the time just a bigger budget B-picture, an adaptation of a best-selling book (*The Amityville Horror: A True Story,* by Jay Anson) based on one of the juiciest tabloid stories of the previous year, about a haunted house on suburban Long Island. The picture was released with characteristic dispatch and reached theaters while the story was still in the news and the book still a best seller.

Dressed to Kill, officially the last film produced by Arkoff at the helm of AIP, sported an auteur-film director, De Palma, and A-picture production values.[48] But while the rest of the industry seemed to be wildly investing in the apparent marketability of the auteur, a business strategy that got the studios both *The Godfather* and *Heaven's Gate,* Arkoff took a hard line when it came to De Palma's budget accountability. The production deal for *Dressed to Kill* committed AIP up to $6 million: a lot for them, but less than half the major studio average at the time. All expenses over that amount were the responsibility of De Palma and his producer George Litto, who, in an ironic twist of fate, became the head of the film division at post-AIP Filmways.

With *Dressed to Kill* Arkoff showed how old-school B-movie marketing techniques might be used to promote an A-feature. For example, when CARA saddled the film with an X rating, Arkoff did what he had to do to achieve a compromise R, but he used the publicity generated by the news to position the film as a "hard-R," as a film somehow more intense, more pervasively erotic, more disconcertingly violent than the usual R-rated studio fare. Then, when women's groups objected to the film's graphic depiction of sexual violence, Arkoff exploited the picture's notoriety and its objectionable content. To this day, it is difficult to know just how many

of the women picketing outside venues screening the film were actual protestors and how many were actors on Arkoff's payroll. The ratings board controversy and the organized protests against the film paid off: *Dressed to Kill* grossed over $31 million, nearly five times its $6.5 million production budget.

In order to close the production deal for *Dressed to Kill,* Arkoff had to offer De Palma and Litto points on the film's gross revenues. Arkoff had never before shared the profits with "talent," but here again he proved willing to adapt to new market conditions. As fate would have it, by the time the film turned a profit, Arkoff and AIP were no longer on the hook; indeed, when Litto and De Palma filed suit in 1990 to retrieve over $1.5 million, their shares of the accumulated profits over the years, the suit named a variety of players not involved in the initial deal: Orion Pictures Corporation (thus involving Orion's former distribution partner Warner Bros. as well), Orion Distribution Corporation (the 1989 version of the soon-to-be defunct mini-major), and (the long defunct) AIP.[49] Exactly who owed or, more pointedly, who had the money to pay Litto and De Palma wasn't the only question at hand; management at Orion astonishingly claimed that the film was still in the red. Over the years, the various permutations of Filmways and Orion had sold off the film's theatrical and television rights in complex package deals with as many as fourteen other former AIP and Filmways titles, films that never made anyone any money. In frustration, Litto and De Palma's attorney, J. Michael Crowe, turned to the trades and characterized his clients' case as yet another bad new Hollywood story: "The issues we are focusing on are the reasonable expenses that can be taken [by Orion]. It is our contention that Orion has not done [the accounting] the way it should have. I think all of us are concerned in L.A. with the way in which creative people are dealt with by the large production companies."[50] He was right, of course, but being right didn't get his clients paid.

In retrospect, we can see how with a new slate of films—*Love at First Bite, The Amityville Horror,* and *Dressed to Kill,* along with AIP's final "negative pick-up,"[51] *Mad Max (1979)*—Arkoff had managed to change the market position of the "typical" AIP product without (much) changing his production methods or the product itself or his creative marketing. But in the emerging new Hollywood, Arkoff believed he needed Filmways to sustain a more upscale, upmarket product line. When the deal was finalized in March 1979, AIP's credit ceiling was $10 million, Filmways' $25 million. Arkoff was a major stockholder but ostensibly an independent producer for the combined companies. This likely sounded about right to Arkoff, at least until the unfriendly Filmways' executive team began rejecting his requests for production financing. After less than a year, Arkoff resigned and relinquished his seat on the Filmways board. In March 1980, Bloch announced the retirement of the AIP name.

The new Filmways got off to a decent start, cashing in on the three films produced by Arkoff: *Love at First Bite, The Amityville Horror,* and *Dressed to Kill.* Bloch and Ralph Etkes, the president and CEO of the Filmways Film Division,

planned to simply get these films out of the way as they developed a slate of prestige films. The first three films produced for the new Filmways fit this new model: Arthur Penn's *Four Friends* (1981), De Palma's *Blow Out* (1981), and (with the producer Dino De Laurentiis) Milos Forman's *Ragtime* (1981).

In the early stages of production at Filmways in 1980 were Ridley Scott's *Blade Runner*, Sergio Leone's *Once Upon a Time in America,* and Lee Grant's *Tell Me a Riddle.* In development were such interesting projects as *The Gangs of New York* (to be directed by Martin Scorsese), *Links* (with Diane Keaton, to be directed by Arthur Penn), *Huey* (a biopic of Huey Long, scripted by Gore Vidal), *Fire on the Mountain* (to be directed by Tony Scott), *Good Company* (to be directed by John Avildsen), and remakes of Leo McCarey's *An Affair to Remember* and *A Woman's Place.* It is hard to argue that any of the major studios had a more promising lineup at the time.

But the advent of the mini-major proved brief and unhappy. To finance the development of a prestige lineup of films, the new Filmways CEO Robert Grundburg had to sell off the AIP film library, its most secure and valuable asset. In protest, Arkoff sold his stock to Tandem Productions, at the time owned and run by the television producers Norman Lear, Bud Yorkin, and Jerry Perenchio. Regarding Filmways' use of his film library to finance prestige films (at the very moment the industry was rather given over to the blockbuster), Arkoff told the trades that he was "genuinely relieved" to be through with the company "where I spent my time giving them advice they now realize they should have taken."[52]

Arkoff's remarks indeed proved prescient. In 1980, Filmways posted fourth-quarter losses totaling over $66 million and a stock-price decline of $11.71 per share. Filmways eventually sold out to Orion in 1982, which was forced to sell off the many promising Filmways projects just to stay afloat.

After the demise of American International Pictures and Filmways, Arkoff received offers to become a major studio producer. But he turned them down. Instead, though he had little chance of success, he formed a new, severely underfunded independent film company, first calling it the Samuel Z. Arkoff Company and then Arkoff International Pictures (a second AIP). He got back in the business doing what he had always done, producing low-budget exploitation films, the first of which was *Q: The Winged Serpent* (Larry Cohen, 1982), about a giant flying lizard nesting on the rooftops of New York City skyscrapers. In his memoir, Arkoff recalls a conversation with the critic Roger Ebert after the release of the film, an exchange that speaks volumes on Arkoff's production model:

EBERT: Sam . . . I just saw *Q* (aka: *Q: The Winged Serpent*)! What a surprise! That wonderful method performance by Michael Moriarty, right in the middle of all that dreck!

ARKOFF: Why thank you . . . the dreck was my idea.[53]

In addition to the films and the AIP trademark (which always meant something above the title of a film), it is worth stopping here to acknowledge the number of contemporary auteur-era directors, writers, and actors who got their start in the latter days of AIP: Francis Coppola, Martin Scorsese, Peter Yates, Woody Allen, Robert Towne, Jack Nicholson, and Charles Bronson. As Ebert notes in a publicity blurb for Arkoff's memoir, "Sam Arkoff has produced more films by Hollywood's best directors and brightest stars than anyone else—and he did it before they were the best or the brightest, which isn't as easy as waiting until everybody else discovered them."

As we look back—and most film historians look back fondly—to the auteur renaissance, it is at once ironic and illuminating to discover Arkoff's role in its earliest iteration. Well before the studios' brief flirtation with auteurism began, a new American cinema in which young cineastes made genre films with relative autonomy emerged amidst the cheapskate economy at Arkoff's AIP. The intellectual roots of the auteur era are no doubt firmly entrenched in the film school experience and in the catechism promulgated by Bazin, *Cahiers,* and the French New Wave. But its practical trial run is found in the fertile soil of American exploitation, where producers like Arkoff and Roger Corman were anxious to indulge a production model pinned on the resourcefulness and creativity of the movie director.

5

THE NEW HOLLYWOOD, 1981–1999 Douglas Gomery

There were three key types of producers during the 1980s and 1990s: producers able to greenlight projects at a studio, producers working for a studio submitting projects to be approved by a corporate board, and producers working at small, unaffiliated independent companies packaging film projects and then successfully pitching them to a distributor-studio to be greenlighted for worldwide distribution. During this era, Lew Wasserman of Universal Studios was a unique figure—a studio boss who also owned a major share of "his" company. He had the authority to greenlight films for worldwide distribution in theaters, through cable and satellite TV, and sales on tape and DVD. Wasserman was hugely successful; he supervised the first modern blockbuster in 1975 with *Jaws* (Steven Spielberg), then in 1982 produced *E.T. The Extraterrestrial* (Spielberg, 1982), the highest grossing film to that date. Wasserman hired and fired all the talent involved in both projects and watched daily rushes. As with all the films he greenlighted, he supervised production and postproduction. During Wasserman's long tenure at Universal, several corporate and management regimes came and went.

At Columbia Pictures during this era, the Coca-Cola Company departed from the hands-on film management model and instead tried (and failed) to marry soft drink creation and moviemaking, basing their management structure on specialized MBA-run divisions. There was no single producer assigned to projects, but

instead a series of committee heads who created feature films in the same way that the Coca-Cola Company created and distributed Coke or Diet Coke.

When the Coca-Cola Company first purchased the Columbia Pictures studio in 1982, the plan was to streamline the producing phase—to follow a business model like making and selling a standardized product. Ownership sought to place specialists in positions of power to systematically make hit movies. But this potential corporate revolution failed, and Coke abandoned its film studio project after just six years. The experiment seemed to prove that producers didn't need an MBA, but training on the job.

In 1988 Coca-Cola sold Columbia Pictures to Sony, and the newly named Sony Entertainment returned to the producers model of Hollywood-trained personnel who developed projects and then reported to the board of Sony USA. A studio executive was given the power from the CEO of Sony and a board of directors to greenlight films. Unlike the system at Universal under Wasserman, at Sony no project could proceed to production without an agreement from the parent corporation to distribute it globally. Under such a system, funding was tied to worldwide distribution. Producers created projects within this system and then used what power they had to convince management to finance and develop the project. The greenlight, in such a system, came to signify a conviction on the part of the board of directors and company CEO that the project somehow matched corporate policy. In such a system, producers come and go with regularity while corporate management remains stable.

Independent producers, the third type under examination here, developed packages of stories, stars, and special effects on their own and then pitched them to one or another of the major studios for distribution. Independent producers were as close to the daily creative process as was Lew Wasserman of Universal and thus needed knowledge of what was required of each crew member, the salary of each person in the production, and the union rules that governed the creative process. The most important task, however, was to provide an expert eye and solid creative judgment at every stage of the film's development. The ranks of independent producers capable of fulfilling all these functions were few in number. The best producers spent long hours with writers—coddling, inspiring, and correcting a script. They achieved a rapport with directors—advising, planning, casting, and sharing in the creative process, careful not to take away the director's prerogatives but enhancing them in different ways. These independent producers knew the rules of the road on the set. They mediated disputes and cut down waste that could accumulate as a production moved along (due to alternating whims of cinematographers, directors, stars, and/or production designers on set). These independent producers also understood the finishing process of the film, how dedicated footage might be woven into a popular motion picture with an integrated sound track and special effects—the filmic choices that make for a popular film.

Prior to the 1980s, independent producers apprenticed with more experienced producers. But as the new Hollywood studios transitioned out of on-site and in-house production, more independent producers were needed to develop projects to be pitched to studio executives cum decision-making producers. In 1981, with a $1 million gift, long-time independent producer Ray Stark started the Peter Stark Producing Program at the University of Southern California to teach newcomers the skills necessary to become independent producers. In 1992, when Jersey Films fashioned *Pulp Fiction,* its coproducer was a 1985 graduate of the USC program, Stacey Sher. Sher served notice to the Hollywood industry that university film school–educated independent producers could create moneymaking, cutting-edge films.

These three case studies—of the most successful producer of the era, Universal's Wasserman; of the failed Coca-Cola ownership of Columbia, in which the corporate parent tried to reduce film producing to a skill any MBA could master; and finally of Stacey Sher, the first independent producer to emerge from a graduate program and make a significant impact in the industry—provide a telling compendium of the period. We begin with the producer and film executive most clearly tied to Hollywood's transition from the halcyon studio era to the new Hollywood: Lew Wasserman.

Lew Wasserman

Lew Wasserman, the former chairman and chief executive of the Music Corporation of America (MCA), was the most powerful and influential decision maker in Hollywood from 1962 to 1994, spanning his three-decade run as the top man at Universal Pictures.[1] He was at the zenith of his power from 1970 to 1994, able to greenlight a motion picture on his own.

Although the focus of this essay is the 1980s and 1990s, the Wasserman era fully took shape in June 1975 when Wasserman as top executive and part owner of Universal initiated the era of the Hollywood blockbuster with *Jaws.* Spielberg's film earned more than $100 million at the U.S. box office in six months, easily becoming the all-time Hollywood box office champ by the end of the summer season. Although Twentieth Century–Fox's *Star Wars* became the new champ in 1977, Wasserman and Universal's *E.T.: The Extra-Terrestrial* (1982) went on to top it. In 1994 Wasserman developed and put into production the next top grosser in Hollywood history, *Jurassic Park* (Spielberg). *Jaws* proved that one film under careful guidance from its distributor could precipitate a national pop culture event and make millions of dollars in profit for a single studio with a single film. *Jurassic Park* certainly proved that point as well.

Wasserman opened *Jaws* in 409 North American movie houses in June 1975 after Universal fully saturated prime-time television with promotional ads.

FIGURE 23: Lew Wasserman opened *Jaws* in 409 North American movie houses in June 1975 after Universal fully saturated prime-time television with promotional ads, creating "the summer of the shark." The film, starring Roy Scheider, broke box office records, and the stock price of Universal's parent company, MCA, doubled.

Universal purchased at least one thirty-second ad on every television network during primetime—then only ABC, CBS, and NBC—and on every evening TV program over the three days preceding the film's release. So successful was this advertising campaign that it became standard operating procedure in the film business thereafter.

Gone were the days of a glamorous New York City or Hollywood premiere, critical reactions, and then a gradual release across the country. With *Jaws* and *E.T.* Wasserman convinced Hollywood studio owners that television should be the centerpiece of the launch of any blockbuster. With *Jaws,* Wasserman turned June, July, and August 1975 into the "summer of the shark"; his film inspired false sightings, pop songs, and millions of dollars in ancillary sales of posters, T-shirts, beach towels, and shark-tooth pendants. The stock price of Universal's parent company, MCA, doubled—solely based on *Jaws.* A new era for industry practice had begun: since then, studios have looked for that single film that could convert a poor year into a record one. In the process, movies became special pop-culture attractions.

Wasserman was by nature an obsessive micro-manager. While he took no credit as a producer, Hollywood as a filmmaking community knew that no significant decision at Universal could be made without his approval. Spielberg may have gotten credit as *Jaws'* filmmaker, but it was Wasserman who reinvented the system as a powerful studio head and top producer.

One of the more important decisions for a producer lies in the choice of a release date; summer (middle May through early September) is best; Christmas (middle November through early January) runs a close second. In this game of

bluff, the six majors seek an exclusive for their weekend releases. The goal for an exclusive is to gain at least two thousand screens, preferably three thousand, for simultaneous release. Most sought-after dates (in order) are Memorial Day weekend (the last Monday in May), Independence Day weekend (around the Fourth of July), Thanksgiving Day weekend (the last Thursday in November), and Christmas Day weekend. Wasserman's up-front distribution planning was picked up by the six mega-studios: Paramount, Warner Bros., Universal, Fox, Disney, and Sony-Columbia, all with vertically integrated operations, made possible initially by lax enforcement by the Federal Trade Commission (FTC) and Federal Communications Commission (FCC) in compliance with President Ronald Reagan's policies of deregulation. These six companies controlled almost 80 percent of the movie business in the United States and approximately half the market around the world. The Big Six club was exclusive in part because few filmmaking enterprises could afford the true cost of a blockbuster.

In the 1980s, studio producers began to use price discrimination—releasing a film so as to maximize the revenues from each separate market window, a practice still employed today. Basically, this means that the Big Six release films in the following order: theaters, home video, pay-per-view, and pay cable (all three introduced in the late 1970s and made widely available in the early 1980s), and finally network/basic cable television. This release lineup is for the United States and all other nations. Each window in this sequence is opened to draw out the maximum amount of revenue, and then shut. A new window is opened only when all the value of the previous window has been fully captured. Many have predicted the end of the theatrical window. But opening a blockbuster in a multiplex is still vital, and television, rather that killing it, assists in its exploitation.

The key challenge for a producer begins in the development stage in the process of finding the right project to back. Blockbusters are very expensive, so choosing the right project is vital. By the end of the twentieth century, a blockbuster was defined by how well it did in theaters during its first few weeks. Indeed, the goal of the two-month marketing campaign is to make a film a "first-choice." If not judged a blockbuster after three weeks, another potential blockbuster is released to replace it.[2] Even Lucas and Spielberg have had their blockbuster busts: while *Star Wars* (1977) minted money and *E.T.* set records, Lucas's *Howard the Duck* (1986) and Spielberg's *1941* (1979) quickly faded into obscurity. There is always risk. So to minimize risk, all six of the major studios function as vertically integrated media conglomerates. These conglomerates have stakes in all media that play movies.[3]

Through the 1980s and into the 1990s, MCA/Universal—Lew Wasserman's creation—stood at the apex of a renewed Hollywood moving image business. Tall, gaunt, with white hair, oversize black-rimmed glasses, and his usual dark suit, Wasserman inspired love, fear, respect, and loathing in Hollywood. "He is so sharp that he would call me with matinee figures on opening day and then

accurately project the film's ultimate performance" at the box office, Spielberg told *Variety* in 1986. As of 2013, *E.T.* still held the records for the most weeks at #1 (16), and most weekends at #5 (27). Wasserman was a studio head and owner, yet he was also the consummate hands-on producer, always keeping track of the details of the making of each of the films he developed and produced.

The best example of Wasserman's producing skills was *E.T.*, which he green-lighted in September 1981. The project was filmed under the cover name *A Boy's Life*, as Spielberg did not want anyone to discover and plagiarize the plot. The actors had to read the script behind closed doors and everyone on the set had to wear an ID card. The shoot began with two days at a high school in Culver City, and the crew spent the next eleven days moving between two locations in Northridge and Tujunga, near Los Angeles. The next forty-two days were spent at Culver City's Laird International Studios, mostly for the interiors of Elliott's home. The production's last six days were spent at a redwood forest near Crescent City. The shoot was completed in sixty-one days, four days ahead of schedule.[4]

Over the years, critics, pundits, and journalists alike have dissected, explicated, and second-guessed the reasons for *E.T.*'s broad, unparalleled success. Many contend that the movie transcended mere entertainment and reflected a restless alienation that troubled millions in Ronald Reagan's version of the United States of America. The most favored explanation was that the country's divorce rate had hit the 50 percent mark by the early 1980s, and *E.T.*'s underlying or B-story was one of divorce.[5]

On page one of MCA/Universal's 1982 annual report to shareholders and ahead of photographs of the corporate officers, the board of directors, and even Wasserman himself, we find a photo of MCA's Creature of the Year: E.T. Holding a bouquet of roses, the bug-eyed, pug-nosed visage smiles shyly at the camera with a caption telling stockholders all they needed to know: that Spielberg's *E.T.* has been received with acclaim by audiences around the world.

During 1982, MCA netted a record $176.2 million on revenues of $1.59 billion. Losses from Spielberg's failure with *1941* disappeared from all conversation. Wasserman did all in his power to keep Spielberg shackled to MCA, allocating $6 million to build the lavish adobe hacienda headquarters of Spielberg's Amblin Entertainment on the Universal lot. Spielberg gets credit as an auteur, but he needed Wasserman to handle the producing details.

After the successful release of *E.T.*, Wasserman began to think of selling his company. But it was not until September 1990 that he opened talks with Matsushita Electric Industrial Co., the world's largest television manufacturer (under the brand names Panasonic, Technics, and Quasar) and the world's twelfth-largest corporation. He mistakenly believed that in the coming decade Universal could not prosper unless it was allied with a larger enterprise. And Matsushita seemed a good fit.

The nickname in Japan for Matsushita was "Maneshita," or copycat. The nickname derived from Matsushita's reputation for introducing new products only after competitors had tested the market. Sony had purchased a Hollywood film studio, Columbia, in 1989. Matsushita, true to its nickname, paid in excess of $6 billion for MCA/Universal in November of the following year.[6] MCA was an attractive purchase for the Japanese conglomerate and, given the strategic importance of Hollywood films in world entertainment markets, promised to help Matsushita advance its plans for global expansion.

In 1989, the year before the studio sale, MCA reported the highest revenues ($3.4 billion), operating income, and earnings per share in the company's history. But Matsushita failed to build on the studio's best year ever and soon sold out without bothering to inform Wasserman, still very much a force at the company. In April 1995 Matsushita finalized its sale of MCA to the Seagram Company, the conglomerate controlled by the Bronfman family of New York and Montreal. Wasserman's former company, MCA, was renamed Universal Studios by its new president, Edgar Bronfman Jr.

The highlight of the Matsushita era at MCA/Universal came on June 11, 1993, with the release of *Jurassic Park*. Wasserman bid for rights to the yet unpublished novel by Michael Crichton before he sold the company to Matsushita, then paid Crichton an additional $500,000 to write the screenplay. It was from the start Wasserman's project. But by the time the film was readied for release, Matsushita was preparing to oust Wasserman, then eighty years old. *Jurassic Park* proved to be his final and biggest blockbuster, surpassing *Jaws* and *E.T.* in its theatrical gross revenues in the United States.[7] Contrary to Matsushita's impatience with the executive/producer, the industry trades continued to celebrate his acumen. In the March 17, 1993, issue, under the headline "Lew Wasserman at 80: A Firm Hand at the Helm," *Daily Variety* proclaimed that Wasserman was, despite his age, still at the peak of his power.[8] But things were about to change dramatically. *Jurassic Park* was a box office hit, but *Waterworld* (Kevin Reynolds, 1995), a subsequent Wasserman project with a similarly huge budget, was widely (though inaccurately) publicized as a box office disaster.[9] As a consequence of the widely held assumptions about *Waterworld,* when Matsushita sold out to the Seagram, Wasserman was pushed to the margins of what was once his company, reduced to the role of a $1 million-a-year consultant. His days as the ultimate studio greenlight producer were over.

Columbia Pictures

Wasserman, in many ways Hollywood's last real movie mogul, seemed to many in the business in the 1980s to be a relic from the classical Hollywood production system. So when Coca-Cola took over Columbia Pictures in June 1982,

purchasing the studio for $692 million, they endeavored to create a more modern system, one that moved away from the single, all-powerful executive at the top as at Universal. They believed that moviemaking was too haphazard, that it needed to be systematized into a modern MBA model.

In January 1982, Coca-Cola's Atlanta-based owners and managers began to show interest in Columbia Pictures and its several attractive assets: an extensive film library, a thriving television division, five TV stations, and twelve radio stations. From Columbia's stockholders' point of view, being a subsidiary of a multi-billion-dollar company had its advantages: first and foremost, there would no longer be the threat of a hostile takeover (like the one initiated by the corporate raider Kirk Kerkorian two years earlier). Later in 1982, Columbia's shareholders embraced Coke's offer of $75 per share—almost twice the market value.

Coca-Cola was in the early 1980s an ambitious company bent on expansion. On March 4, 1981, Coke chairman Roberto C. Goizueta presented "The Strategy for the 1980s" to Coke's board of directors, a document that defined "the future self-definition of the Coca-Cola Company." In that document, Goizueta proclaimed, "The world is our arena in which to win marketing victories as we must." In 1982 Coca-Cola was the world's largest manufacturer and distributor of soft drink syrups and concentrates, and these products produced the overwhelming majority of Coke's revenues (85 percent). That said, in 1981 soft drink sales were slowing, and by entering other business areas Coke believed it could increase its overall earnings substantially. Goizueta explained, "You can't be a national force in soft drinks without a syrup plant, and in entertainment, you need a movie company—that's the turbine, the locomotive." Goizueta promised that the company would not stray from its traditional areas of strength but would aim through expansion to maximize the returns on shareholder investments. "In choosing new areas of business, each market we enter must have sufficient inherent real growth potential to make entry desirable."[10] But trying to apply standardization principles to film production did not work.

Coke's billion-dollar assets gave Columbia an advantage that no other studio had, and at the start Coca-Cola's ownership proved beneficial to Columbia in the marketing and promotion of its films. The company's ability to buy large chunks of TV airtime at volume discounts (because of its soft-drink advertising) helped gain a 5 percent stake in network TV advertising for Columbia's ads. The studio and soft drink divisions were able to swap TV ad time within the blocks Coke had purchased in advance.

Coca-Cola installed Peter Sealey, manager of Coke's marketing operations, at Columbia Pictures so he could apply Coke's marketing techniques to film distribution. Also, Coke reorganized Columbia, making the future major league baseball commissioner Fay Vincent Columbia's chairman and CEO. Coke's board of directors increased Vincent's authority when it voted him senior vice-president of Coca-Cola as well as president of the Hollywood production unit.[11] From

the start, Coke management believed that its addition of an entertainment business sector to the company's other segments was a good fit. As it informed its stockholders: "The acquisition of Columbia emerged from our careful search for a high-growth business that was compatible with the central strengths of the Company. . . . In Columbia we have an excellent complement to our traditional businesses—an almost ideal fit with what we are—and a perfect partner to join with us in becoming what we want to be."[12]

Coke instituted a committee of decision makers. These MBA studio managers turned down Ray Stark's proposal of film versions of Neil Simon's *Brighton Beach Memoirs* (1986) and *Biloxi Blues* (1988), which Stark then took to Universal, where Lew Wasserman greenlighted them. Stark had long been an independent producer affiliated with Columbia, but under Coke's ownership, such longstanding relationships were deemed unimportant. Moreover, there proved to be little cooperation among production, distribution, and marketing at the studio. For example, in 1987 the production schedule was doubled, resulting in a glut of films. There were too many films for any of them to be marketed properly. As a consequence, none of the films became hits, even those with major stars attached: *Ishtar* (Elaine May, 1987), for example, became one of the decade's biggest box office disasters despite Dustin Hoffman and Warren Beatty, the film's two stars. The film emblemized for Coca-Cola the disappointing vagaries of the film business, which was not quite the same as creating soft drinks.

Like United Artists' *Heaven's Gate* (Michael Cimino, 1980) earlier in the decade, *Ishtar*'s failure was widely interpreted as a symptom of poor management, though unlike *Heaven's Gate* it did not lead to a management shake-up. Following the *Ishtar* debacle—a major loss during the summer of 1987 and the continuing soft performance of Columbia—Coke retained management but decided to reorganize its entertainment business sector to produce an even more efficient operation.

After multiple experiments, in June 1986 Coke executives hired the British independent producer David Puttnam to run the studio. But from the start there was no meeting of the minds between Coke management and the new studio head. Puttnam eschewed old-school, Wasserman-style hands-on management. And he also dismissed efforts to marry or target dissimilar films for different market segments. Indeed, Puttnam fashioned for producing one of the oddest chapters in Hollywood corporate history, antagonizing the parent company and many other major Hollywood producers (including Wasserman).

In 1998, Puttnam (with Neil Watson) published a history of cinema called *Movies and Money,* in which he describes his personal take on making movies and managing commercial constraints "as never so sharply dramatized as during the fifteen-month period from June 1986 to September 1987" when he was studio head of Columbia Pictures. Puttnam ascribed his hiring to Coke's interest in expanding its movie market outside the United States: "Coca-Cola's managers believed that a European with extensive experience of the international market

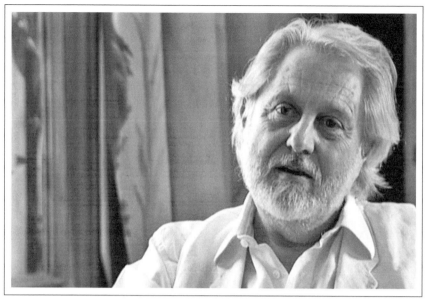

FIGURE 24: The producer David Puttnam took home an Oscar when *Chariots of Fire* (Hugh Hudson, 1981) won Best Picture in 1982. Puttnam's subsequent Hollywood experience running Columbia Pictures from June 1986 to September 1987 was far less happy.

would ideally be placed to achieve such a goal." Puttnam appreciated that the strategy stemmed from the fact that Coke had "been so successful in expanding its [soft drink] exports to Europe and elsewhere during the postwar period, some 65 percent of Coca-Cola's total revenues came from abroad, compared with only 30 percent of Columbia's."

"It was clear from the beginning," Puttnam further remarked,

> that my conception of cinema differed from that of most traditional studio bosses. Before I went to Coke headquarters in Atlanta to discuss the job, I wrote a long creed about what cinema represents to me, about what I saw as the responsibilities and duties of the filmmaker. In the course of the meeting, I handed this document, which really amounted to my personal filmmaking manifesto, to Coke's late chairman, Roberto Goizueta, and then president, Don Keough. In it I argued: "The medium is too powerful and too important an influence on the way we live, the way we see ourselves, to be left solely to the 'tyranny of the box office' or reduced to the sum of the lowest denominator of public taste." I went on to say: "Movies are powerful. Good or bad, they tinker around inside your brain. They steal up on you in the darkness of the cinema to inform or confirm social attitudes. They can help to create a healthy, informed, concerned, and inquisitive society or, alternatively, a negative, apathetic, ignorant one—merely a short step away from nihilism."[13]

The MBAs who ran Coke's Columbia experiment from 1982 to 1986 did not know what they were doing. Neither did Puttnam, who was an independent producer trying to be the head of production at a multi-million-dollar studio. As Puttnam wrote in *Movies and Money*: "Naturally, I wanted Columbia to concentrate on making films that I felt reflected the concept of cinema to which I was committed. Many of these were films aimed at a somewhat older audience than was being targeted by Hollywood at the time." Puttnam's opposition to the new blockbuster mentality was notable if also naïve. He hated the studio strategy of turning out second-rate action pictures for teenage boys while ignoring the larger, more sophisticated, and varied audience elsewhere. As the Baby Boom generation born in the late 1940s and the 1950s grew older, they were establishing new patterns of moviegoing: "To satisfy them [the boomers] required new stories and new marketing strategies, but simply to ignore them seemed to me absolute folly."[14]

Puttnam's success as an independent producer of films like *Midnight Express* (Alan Parker, 1978, which won for the film's screenwriter, Oliver Stone, his first Oscar), the Best Picture–winning *Chariots of Fire* (Hugh Hudson, 1981), and the critically acclaimed *The Killing Fields* (Roland Joffe, 1984, which received seven Oscar nominations and won three) had made him attractive to Columbia. But he proved a terrible fit and marked the end of Coke's movie studio experiment. Puttnam intended to run Columbia as a 1940s kind of studio by following a classical-era division of labor, setting up specialized units (à la Arthur Freed's musical unit at MGM and Val Lewton's horror unit at RKO). Puttnam may have admired both, but this was not the business model Coca-Cola wanted at Columbia. During his brief stay at the studio, Puttnam showed no interest in sequels; for example, he passed on a sequel to the Columbia hit *Jagged Edge* (Richard Marquand, 1985), featuring Glenn Close and Jeff Bridges, and he opposed the development of *Ghostbusters II* (Ivan Reitman, 1989), which was, despite his objections, produced and distributed by Columbia two years after his exit.

Independent producers who had been successful before his arrival at the studio—like Stark, David Melnick, whose *Roxanne* (1987) gave Columbia a modest success, and Norman Jewison, whose seven-picture deal with the studio was permitted to expire even though Jewison's productions generally made money—found working with Puttnam's Columbia discouraging. Puttnam wanted to make each film special, a work of art. He considered himself an artist, not a producer. Indeed, he held the financial side of producing in contempt.

After a string of failures in 1986—*A Fine Mess* (Blake Edwards), *Violets Are Blue* (Jack Fisk), *Armed and Dangerous* (Mark L. Lester), *Jo-Jo Dancer, Your Life Is Calling* (Richard Pryor)—led some Wall Street analysts to wonder how long Coca-Cola would stay in the entertainment business, Puttnam publicly proclaimed: "I'm not the head of production." But that was what the Coke MBAs had hired him to be.

Puttnam's short reign ended when Coca-Cola announced it would separate its entertainment business sector from its soft drink operations—as *Variety* put it, the company severed "showbiz from fizz."[15] While numbers seemed to mean little to Puttnam, they meant a lot to Coca-Cola. The thirty-three pictures at Columbia associated with Puttnam had production and advertising costs totaling $432 million, but at the time of his ouster the films had grossed just $112 million.[16]

By early 1989, rumors began circulating that Coca-Cola was planning to rid itself of Columbia. Equally strong were reports that Sony was studio-hunting and that Columbia was a likely prospect. Sony's attraction to Columbia was more than speculation; the electronics conglomerate was looking for a studio with television interests, and Columbia Television, despite the film division's struggles, had become a major force in network programming.

In November 1989 Coke sold Columbia Pictures to Sony for $3.4 billion. In its 1989 annual report Coca-Cola did not even mention filmed entertainment. Instead, Coke announced that its achievements for the 1980s lay in the growth of Coke's market share of global soft drink sales from 38 to 45 percent. Sony, in turn, hired the experienced and industry-trained Peter Guber and Jon Peters. Guber was the hands-on producer, aspiring to be an old-style production head in the model of Lew Wasserman.

Educating New Producers: Stacey Sher and the USC Peter Stark Producing Program

In September 1979, the University of Southern California started the Peter Stark Producing Program leading to a Master of Fine Arts in film producing. The Stark Program was introduced as a two-year (four semesters), full-time graduate program designed to prepare students for careers as independent film producers. It featured a mixture of tutoring by current producers with MBA-like courses. In other words, the program was designed to combine the Wasserman–like producer's role with the structure of what Coke had tried at Columbia, plus some basic, academic/business training.

The first group of twenty-five Stark Program students was taught to place equal emphasis on the creative and the managerial sides. The program assumed that producing was an artistic practice subject to the constraints that Hollywood was a business. The model was again Lew Wasserman, who had, earlier in his career (before the modern-era blockbusters *Jaws* and *E.T.*), produced the Alfred Hitchcock classics *Rear Window* (1954), *Vertigo* (1958), *Psycho* (1960), and *Marnie* (1964). USC hired veteran *Variety* reporter Art Murphy in 1979 to administer the program. Long-time independent producer Ray Stark himself headed the program's advisory board. Using his connections Murphy brought in Hollywood insiders as adjunct lecturers, with an eye on creating a new generation of

independent producers. Additionally, adjuncts were encouraged to hire "Starkies," as graduates of the program came to be known.

According to Murphy, for the inaugural year USC received 107 applicants for the Stark Program, accepting 17 men and 3 women, in proportion to the number of men and women who had applied. In line with the program's status as a collaboration between USC's graduate cinema and business schools, Murphy, along with one senior professor from each of those schools, made the selections. Consistent with other MBA programs, the median age of the entering group was twenty-five; their median grade point average was 3.5. Each aspirant had to write an application essay as to why they wanted to be a producer.

As of 2000, the end of the era covered in this chapter, the program's most famous and successful graduate was Stacey Sher. She had by then produced the cult classic *Pulp Fiction* (Quentin Tarantino, 1992) and *Erin Brockovich* (Steven Soderbergh, 2000), a blockbuster with a liberal message and an Oscar-winning star, Julia Roberts.

Full disclosure: I experienced the Stark Program application process with Sher. In September 1981, I was hired by the University of Maryland to teach film history and media economics in the Radio, TV, and Film (RTVF) division of the Department of Communication Arts. Starting in January 1982, I taught a course entitled "Understanding Hollywood as an Industry," and early in every term I explained what the various workers and executives did. Then a junior, Sher followed me to my office one day after class and asked me how she could become a producer. I suggested the Stark Program and showed her an ad in *Variety*. During her senior year at Maryland (1982–1983) Sher worked as an intern in the D.C. area for Columbia Pictures and got marketing experience. She applied for the Stark Program class that would enter in September 1983 and was accepted.

After Sher completed the program in June 1985, she was hired to read and evaluate scripts by Hill/Obst, a production company headed by Debra Hill (*Halloween* [John Carpenter, 1978] and *Escape from New York* [John Carpenter, 1981]) and Lynda Obst (*Flashdance* [Adrian Lyne, 1983]), located on Paramount's studio lot. Less than a year after leaving USC, on February 28, 1986, Sher was hired as a development executive for Hill/Obst. At Hill/Obst, Sher worked (as associate producer) on *Adventures in Babysitting* (Chris Columbus, 1987—a moderate hit), *Heartbreak Hotel* (Chris Columbus, 1988—a dud), and *The Fisher King* (Terry Gilliam, 1991—a moderate hit and cult classic).

In 1989 Obst left the independent company to become the head of Columbia Pictures (in the interim period before Sony completed its purchase of the studio). Obst then left Columbia to work as an independent producer and looked for a new independent group to join as a partner. After serving as associate producer on a series of films for Hill/Obst, Sher became senior vice-president at Lynda Obst Productions in 1991.

Less than a year later, Sher joined with Danny DeVito and Michael Shamberg to create Jersey Films. Sher's mission statement at Jersey Films sounds very much like something written by a film school grad:

There's nothing we [Jersey Films] wouldn't do, but you've got to find a personal hook or something that's fresh. We're not really interested in doing the ninth version of something that's been done before. What we try to do is find fresh voices and we've been incredibly fortunate. You can't believe the number of people that I meet to interview for jobs who don't know who Orson Welles is, as frightening as that sounds. If people want to choose this as their path, they should know about the arts that they're working in and know about the history of films and have actually seen [works by] the great filmmakers. How can you judge or have a point of view if you haven't read about or seen stuff? So see movies—old and new, but especially old.[17]

Sher put *Pulp Fiction* (1992) into production, and the film put Sher and Jersey Films on the map. To develop it she took a calculated risk on independent director Quentin Tarantino. It all started at a premiere of *Terminator 2* (James Cameron) in early autumn 1991, where the two met. A few weeks later, Tarantino signed a development deal with Jersey Films. After Tarantino delivered his script for what at the time was loosely described as a follow-up to *Reservoir Dogs,* Sher set up a meeting with Sony-TriStar chief Mike Medavoy. But the veteran executive had reservations about the script. Medavoy grilled Tarantino over the scene in which Vincent (to be played by John Travolta) shoots up heroin. Medavoy was dissatisfied with the script (and Tarantino's answers to his questions) and at the end of the meeting TriStar passed. Jersey, Sher, and Tarantino still needed a distributor.

Having *Pulp Fiction* rejected by TriStar proved beneficial. Sher changed the pitch and revised the production budget. They took the revised pitch to Miramax—the same company that had picked up the U.S. theatrical rights to *Reservoir Dogs* two years earlier. Miramax chiefs Harvey and Bob Weinstein had absolutely no doubt that *Pulp Fiction* would be a commercial success after the enormous earnings of *Reservoir Dogs* in markets outside the United States. Harvey Weinstein believed he could get enough foreign pre-sales on *Pulp Fiction* to cover the movie's entire $8 million budget before the film even went into production. No one seemed in the least bit bothered that Miramax had been bought by Disney the previous April and that, in effect, the ultimate family movie studio was about to invest heavily in a violent, black comedy set among Los Angeles lowlife.[18]

During the development stage of the picture, Sher's big coup was to get John Travolta to participate in the film for a mere $100,000. Jersey Films gave Tarantino the freedom to write and direct *Pulp Fiction,* albeit supervised by Sher. The

FIGURE 25: Quentin Tarantino lining up a shot for *Pulp Fiction* (1992), a huge hit for the producer Stacey Sher and Jersey Films.

film's principal shooting began on September 20, 1993, and ended on November 30. It then went into postproduction for an anticipated summer 1994 release. The release was later postponed to October so it would not be up against summer blockbusters.

Pulp Fiction was unveiled to the public in May 1994 at a Cannes Film Festival midnight screening and caused a sensation. It later won the Palme d'Or, the festival's top prize, generating a further wave of publicity. *Variety*'s late May/early June report on the 1994 Cannes Film Festival started with *Pulp Fiction*. After listing Sher (with DeVito and Shamberg) as producer, the *Variety* writer Todd McCarthy hailed the film: "A spectacularly entertaining piece of pop culture, *Pulp Fiction* is the *American Graffiti* of violent crime pictures. . . . This will be a must-see among buffs and young male viewers. Film buffs will have a field day with the . . . numerous references to past film classics. The camerawork reminds one of Sergio Leone."[19]

Over the next few months *Pulp Fiction* played at smaller festivals around Europe—Nottingham, Munich, Taormina, Locarno, Norway, and San Sebastian—building up more positive PR. On September 22, 1994, *Pulp Fiction* opened the New York Film Festival; after the screening, Janet Maslin, writing for the *New York Times,* called the film a "triumphant, cleverly disorienting journey."[20]

On October 14, 1994, *Pulp Fiction* went into general release in the United States. It was "platformed," opening in 1,100 theaters and was the top-grossing film at the box office its first weekend, edging out a Sylvester Stallone vehicle, *The Specialist* (Luis Llosa), which was in its second week and playing at more

than twice as many theaters. Against its budget of $8 million and about $10 million in marketing costs, *Pulp Fiction* grossed $108 million at the U.S. box office, making it the first "indie" film to surpass $100 million. In terms of domestic grosses, it was the tenth biggest film of 1994, even though it played on substantially fewer screens than any other film in the top twenty. Worldwide, it took in nearly $213 million.

By the end of 1994 the film had achieved cult status. The response of major North American movie reviewers was widely favorable. Roger Ebert described it as "so well-written in a scruffy, fanzine way that you want to rub noses in it—the noses of those zombie writers who take 'screenwriting' classes that teach them the formulas for 'hit films.'"[21] Overall, the film attained exceptionally high ratings among U.S. reviewers: a 95 percent score at *Rotten Tomatoes.*

In the wake of the film's success, *Variety* described Sher as a top-notch "script grunt." Such "grunts" were the young producers who were perpetually on the lookout for new, hot stories. Their goal was to recognize potentially hot scripts before anyone else. Accordingly, Sher provided her partners with a daily "hot sheet," a compilation of what might be possible to produce and then preliminary outlines on how to package the product and pitch it to a studio for international distribution.[22]

As 1995 began, *Pulp Fiction* was named Best Picture by the National Society of Film Critics, National Board of Review, Los Angeles Film Critics Association, Boston Society of Film Critics, and Southeastern Film Critics Association. In February, the film received seven Oscar nominations—Best Picture (Lawrence Bender, producer); Directing (Tarantino); Actor in a Leading Role (Travolta); Actor in a Supporting Role (Samuel L. Jackson); Actress in a Supporting Role (Uma Thurman); Writing (Screenplay Written Directly for the Screen) (Tarantino and Roger Avary); and Film Editing (Sally Menke). Travolta, Jackson, and Thurman were each nominated as well for the first Screen Actors Guild Awards, presented on February 25, but none took home the honor.

In 1996, the British Film Institute (BFI) initiated a series of books called "BFI Modern Film Classics," as part of the institute's commitment to the promotion and evaluation of contemporary cinema. In the BFI book on *Pulp Fiction,* the film scholar Dana Polan highlighted the role of the film's producers, writing that *Pulp Fiction* was not so much a film as a phenomenon (winning major prizes, giving rise to an immense culture of obsessive fandom, generating countless wannabes, promoted by its director and producers as an intensely authored work). There is no message nor any political position evident in the film, Polan writes, but instead sheer cinematic spectacle, a funhouse experience of vibrant sights and sounds.[23]

The film became something of a *cause célèbre* in the late 1990s, a symbol or symptom of a new Hollywood. For example, during the 1996 U.S. presidential campaign, the Republican nominee Bob Dole attacked Hollywood in general,

mentioning *Pulp Fiction* in particular. Echoing a concern first voiced by Medavoy during the development stage, he asked if the use of heroin by the Thurman character was what most Americans wanted from Hollywood.

One of the distinguishing characteristics of *Pulp Fiction* and one of the reasons why it seemed so different and new in 1994 was its story/script structure. Tarantino starts episodes and lets them come to what feel like commercial breaks or interruptions caused by channel surfing—a mode of narrative Sher and Tarantino deliberately conceived.[24] But the structure of the film was not as new as it seemed at the time. Indeed, it was familiar to any (cable) television viewer. Everyday Americans are quite at home with stories that come to a rest, stories divided into segments to be interrupted by other stories only to resume again. The interruptions are called commercials, and increasingly they are commercials for other stories both on television and in the movies. Channel surfing also segments the stories we watch.

It took six years for Sher to have her second big hit at Jersey Films: *Erin Brockovich.* The film is based on the true story of a young and poor single mother with three children who convinces a local attorney to take on a huge electric utility. The film was released in March 2000 without much fanfare. Director Steven Soderbergh got most of the credit when McCarthy, writing for *Variety,* praised *Erin Brockovich* as an indie hit.[25]

The film was indeed a hit with audiences and critics alike. But the indie tag is debatable; when Jersey Films needed $50 million to fund a film starring the likes of Julia Roberts, it inked a deal with two major studios: Universal released it and obtained sales rights for cable TV and DVD domestically, while Columbia Pictures distributed it theatrically worldwide and on cable and DVD outside the United States. As Oscar season started in January 2001, Sher remarked to Tom Doherty for *Cineaste:* "Julia Roberts creates empathy for a person who sees herself one way but the outside world sees her differently. It's a combination of her intelligence, her tenacity, and her down-to-earth likability." The remarks serve to highlight how the film was marketed and why by the end of 2000 the film had become a true blockbuster.[26]

Just before the Oscar announcements, *Newsweek* magazine invited a cadre of Hollywood's most acclaimed producers to a hotel room in Beverly Hills for a discussion of movies, money, and trophies. What follow are excerpts of the producer's discussion, in particular the contributions of Stacey Sher:

NEWSWEEK: So who can tell me what it is that you people do for a living? Are you mostly on the phone all day long?

STACEY SHER: Oh, that was so cheap! Mostly on the phone all day long. That's the problem. That's the perception. Producing is probably the most undervalued job. It's the credit that's given away the quickest because

it's really hard to define. But it's all-encompassing. For every movie it's a different thing. Producers have to be willful, clearly. They have to keep pushing to get movies made when the studios keep saying no.

QUESTION: What is a fake green light?

SHER: It's very conditional. If you get this star. If you hit this [budget]. It's basically, "Bring me the broomstick of the Wicked Witch of the West!"

QUESTION: What about initial weekend results?

SHER: The head of distribution calls everybody, and you get a fax. . . . The nice thing about going from theater to theater on opening night is, you get the movie back—you get to hear people actually talk about it for the first time. I love that.[27]

Jersey Films' final negative cost for *Erin Brockovich* came to what was an average Hollywood production cost of $51 million. As awards season 2001 started, the box office for *Erin Brockovich* in the United States had already reached $126 million and nearly $260 million worldwide. The film earned an additional $100 million in sales on DVD. Its sell-through topped the *Star Wars* installment, *The Phantom Menace* (George Lucas). By that time, Julia Roberts had established herself as an early Oscar front-runner. When the Oscar nominations were announced in February 2001, *Erin Brockovich* was nominated for Best Picture (DeVito, Shamberg, and Sher, producers), Actress in a Leading Role (Roberts), Actor in a Supporting Role (Albert Finney), Directing (Soderbergh); Original Screenplay (Susannah Grant); Score (Thomas Newman); and Film Editing (Anne V. Coates).

At the Academy Awards ceremony on March 25, 2001, a decade of box office hits finally paid off for Roberts when the world's best-paid female star finally added an Oscar to her impressive resume. Roberts had been nominated twice before, but her rambling, giddy acceptance speech suggested she intended to savor every instant of her triumph. "You're so quick with that stick," she cautioned orchestra conductor Bill Conti. "But why don't you sit, because I may never be here again." In the next few minutes, Roberts's breath fluttered as she rattled off a list of thank-you's, including the "sisterhood" of fellow nominees (Sher included) and "everyone I've ever met in my life." Pausing to survey the crowd, she beamed: "I love it up here! I love the world!"

Reflecting on her role as the film's producer—after all, she had developed the project and the talent—Sher remarked: "What's fascinating about this case is that what really happened was always more interesting and dramatic than anything you could have made up." Though few filmgoers knew this at the time, one of the challenges for Sher was that all the plaintiffs from the case at the heart of

the film in Hinkley, California, where the water was contaminated by chemicals from a Pacific Gas & Electric plant, had to be composite characters with made-up names. Reason? The settlement included a gag order. Brockovich and her real-life boss, attorney Ed Masry, signed no such agreement, so the movie was free to dramatize their personal lives. Because so much of the film was produced in concert with the gag order, Jersey Films weathered no storm of objections and accusations over factual issues. The Jersey Films–*Brockovich* team didn't hear a peep. "PG&E never contacted us," said Sher.[28]

In the March 23, 2001, edition of the *Los Angeles Times,* the critic Patrick Goldstein focused on Jersey Films' three producers: "They have classic taste, but they're interested in tomorrow's culture, so they tell the story and cast the material in a cutting-edge way. And that makes them a magnet for smart, creative people." What distinguished Jersey Films in this era was that they never made the kind of genre movies, such as an *Austin Powers* or a *Lethal Weapon,* that can be turned into sequel-style franchise films. Indeed, in the late 1990s, while continuing to seek the cutting edge in films such as *Feeling Minnesota* (Stephen Bagelman, 1996), *Living Out Loud* (Richard LaGravenese, 1998), and *Man on the Moon* (Milos Forman, 1999), Jersey Films hit a slump. But its reputation for creative product rarely suffered, because, as Shamberg put it, "If you aim high and you miss, you can still hold your head high. If you aim low and miss, you're [in trouble]. Our Jersey team aimed high, but not so high that its movies go over everybody's head."[29]

About a year after the release of *Erin Brockovich, Daily Variety* headlined a special section entitled "Jersey Films at 10" to celebrate the decade-long success of the small indie company. The actor Danny DeVito had started the company in 1991 to produce *Hoffa* (also directed by DeVito), but it was *Pulp Fiction* that built its reputation. *Variety*'s special section provided a brief biography of Sher, who acknowledged that her family was movie-obsessed and that she shared a love of movies with her father: "When *E.T.* opened, my dad took [all of us kids instead] to see Brian De Palma's *Obsession*."[30]

Conclusion

Lew Wasserman died in 2002. By then he had become a legend as a producer and as the head of a studio (that he part-owned). As a producer he had more power than anyone else in Hollywood in the 1980s and 1990s. He had learned the system as Alfred Hitchcock's agent for *Rear Window, Vertigo* (named the greatest film of all time in *Sight and Sound*'s poll in 2012), and *North by Northwest* (1959). He effectively produced many more great films without taking screen credit. When the films came out, the credits inevitably named someone else, someone Wasserman hired to handle the daily problems on the set.

Wasserman saw his job as simply one of getting films made and released. He dictated to others how to sell the films he produced. As president of Universal, he rarely gave interviews because he knew the box office would not increase with studio PR about himself. Indeed, to the public he was invisible, even as he controlled everything at Universal.

David Puttnam was the anti-Wasserman; he was always in the news (albeit as a failure). In 2013 Puttnam turned seventy-two, but because of a chronic disease that taps his energy, he has done little since leaving Columbia in the late 1980s. Puttnam was a success as an independent producer in England, but he is known in the United States as a creative producer who was crushed by the Hollywood system. In May 2006 he was made an Honorary Fellow of the Royal Society of Arts, remaining in England after his disappointing experience in the United States in the 1980s.

In 2013, having just turned fifty, Stacey Sher was still an active producer, proving that in Hollywood women producers with advanced degrees can be successful. The Peter Stark Producing Program gave her access to the margins of blockbuster Hollywood—as did her experience working with producers Debra Hill and Lynda Obst. After half a dozen years working for Hill/Obst, Sher thrived at Jersey Films and later at Double Features, Inc.

As a Peter Stark Producing Program success story, Sher was invited to give the June 2013 commencement address at USC. (The Stark Program had by then been integrated into the USC TV-Cinema program.) Delivered a year before she had her greatest box office success (producing *Django Unchained* [Tarantino, 2012]), Sher told the throng of graduates the lessons Hollywood has taught her, lessons well worth considering for future Hollywood producers: 1. Determine priorities in life. 2. Recognize potentials and opportunities. and 3. Learn from failures and mistakes.

6

THE MODERN ENTERTAINMENT MARKETPLACE, 2000–PRESENT

Bill Grantham and Toby Miller

The Producers Guild of America (PGA) has an official timeline for the period covered by this chapter.[1] Though far from a detailed narrative or analysis, the timeline discloses some relevant common-sense themes about changes in producing and references to important developments in the labor process, race and gender, technology, and genre. The PGA's history of the first decade of the twenty-first century begins at the moment of its 2001 merger with the American Association of Producers, which had covered associate producers of TV for the previous two decades. That transformation indicates both the weakening of boundaries between old, middle-aged, and new media and the sense that the various categories of producer, which range wildly and widely from the powerful and the moneyed to the desperate and the novitiate, can be accommodated within the same interest group.[2]

The PGA calls the 2001 merger "the most radical shift in the Guild's membership and direction since the 1960s." Why? Because of the desire to lump all producers into the same ownership class, and the recognition that Hollywood is inexorably tied to television in terms of production hours, commercials, overseas sales, and much of the revenue that eventually comes from what we misleadingly call "cinema."

The following year, technological challenges prompted the formation of a New Media Council. Once more, the development involved class consolidation, along with a minimization of the barriers between genres and formats. In 2005, the PGA trumpeted a decision by the Motion Picture Academy of Arts and Sciences to use its eligibility standards and arbitration process to govern nominations for Best Picture. The Guild was clearly becoming a gatekeeper for "full" producer credit, thereby determining who qualifies for awards. This shift created difficulties when negotiating producer deals, particularly with financiers who appear to fall outside the PGA's criteria for eligibility.

In 2006, a Diversity Committee introduced workshops for "aspiring producers of diverse films and television programs," a reform in response to decades of critique that Hollywood powerbrokers were almost all white men. The issue of diversity also led to an active role for the organization in labor relations. In 2007, the Guild "intervene[d] on behalf of producing team members working under illegal conditions at E! Entertainment Television, negotiating a settlement with the network that restore[d] overtime pay." The official history concludes two years later with word of a new annual conference.[3]

The timeline is a useful starting point here, as revealing for what is excluded as for what is featured. But a chronology can't get at the fundamental question: why produce films (at all) in the twenty-first century? As Adam Davidson mused in the *New York Times* in June 2012: "For the cost of *Men in Black 3* [Barry Sonnenfeld, 2012], . . . the studio [Sony] could have become one of the world's largest venture-capital funds, thereby owning a piece of hundreds of promising start-ups. Instead, it purchased the rights to a piece of intellectual property, paid a fortune for a big star and has no definitive idea why its movie didn't make a huge profit. Why is anyone in the film industry?"[4] One answer could be that *Men in Black 3*'s worldwide film-theater receipts exceeded $550 million—before we factor in TV sales, digital video discs, Blu-Ray, and streaming.[5] Or we might stress that costs were offset by product placement and merchandising,[6] helping Sony cope with massive losses in its technology business;[7] that those involved loved what they were doing; or what critical management studies and industrial sociology have demonstrated over seventy years: that bottom-line logics are frequently alibis for the exercise of power.[8]

The distinction between economic and cultural analyses of Hollywood has rightly been problematized within film studies,[9] but the latter nevertheless tends to ignore research by sociologists, management scholars, geographers, anthropologists, and psychologists, *inter alia*.[10] Taking our touchstone from stakeholders as diverse as these, plus medical academia, animal liberation, neoclassical economics, institutional analysis, critical political economy, participant observation, and environmentalism, in this chapter we plumb other areas with the same fervor as those signposted by the Guild.

Pricing Production

In 2005, the average expenditure on a fiction feature film made by a major studio was $96 million—a fourfold increase in two decades. For pictures produced by smaller project-based firms affiliated with the studios, the average was $39 million.[11] These figures cover production, duplication, promotion, and distribution.[12]

Mainstream movies are governed by two principal accounting categories: negative costs, which cover production, studio use, negatives, and capitalized interest; and print and advertising (P&A), which include duplication, distribution, and publicity. Taken together, these items comprise theatrical cost. They have shifted in importance over time. In 1985, negative costs averaged 72 percent of expenditure. Twenty years later, P&A had risen sharply while negative costs had diminished to 62 percent of the total because investment in promotion had increased dramatically.[13]

The price of film prints can be two thousand dollars as opposed to a hundred for digital discs, and comprehensive domestic satellite distribution is close at hand. In an effort to reduce costs, the studios have embarked on a strategy of no longer releasing movies on film stock in the United States.[14] Although the switch to digital high definition in production is almost complete, exhibition presents some difficulties, due to the cost of installing digital projectors in cinemas. The big domestic distributors are subsidizing this conversion. For now, the cost gap between analog (film) prints and digital versions isn't as great as it might be, since the subsidy cost is recouped from the box office as P&A. However, in territories where theatrical digitization is not extensive, producers must deliver films from digital copies so that analog prints can be made. Even for digital text, there remains a physical delivery cost, because studios, citing piracy concerns, generally shy away from using satellites, landlines, or the Internet to circulate digital copies (though they have occasionally done so). Delivery via encrypted hard drives using courier services is more typical.

Sources of film financing have shifted over the last thirty years, with retained earnings and bank loans of diminishing importance.[15] In a social network analysis of risk management in the film industry, Jade L. Miller contends that in the past third of a century, the industry has been increasingly reliant on dispersed and external financing, particularly bank financing, to spread risk and minimize the possibility of losing "everything" on any one production. Large studios often maintain revolving lines of credit with banks, usually based on a guarantee that the studio will market and distribute each film.[16] Many pictures are now coproductions between affiliated or independent production companies and major studios.[17] The company that is the titular head of a movie may only exist for the life of that project, in keeping with the nature of its labor force and the quasi-entrepreneurial character of production.[18] In Europe, Canada, and Australia, for instance, coproductions are subject to bilateral or multilateral treaties that

regulate tax and other matters. In Hollywood, coproductions are usually marriages of convenience, although some tap into the European-style model by, for instance, rebadging output as Canadian.

As Simone Ferriani, Gino Cattani, and Charles Baden-Fuller write in their 2009 essay, "The Relational Antecedents of Project-Entrepreneurship: Network Centrality, Team Composition and Project Performance":

> Independent contractors coalesce for a relatively short period of time around one-off projects to contribute the organizational, creative, and technical talents that go into the production of a film. The inherent transience of this production system results in a high rate of tie formation and dissolution, and a continuous rewiring of the network. . . . Producers first identify and secure the rights for a story (script) with some potential and then hire the creative team (director, cinematographer, etc.) whose task is to bring the story to the screen. Filming begins once these individuals have signed onto the project and the team has secured the required financing.[19]

The effect of such an "inherent transience," according to Mark Lorenzen, an expert on globalization in the modern film industry, is that "most production companies are now in effect system coordinators, focusing upon the planning and finance of films and taking advantage of large pools of freelance labor and specialized suppliers for actual production of them. Mass market film producers . . . share this history of early horizontal integration and later disintegration of production processes."[20]

These mass market producers follow a loose set of procedures. First, small amounts of money are spent prior to principal photography in order to obtain an option on both script and crew. A speculative script may be optioned at low cost. But a commissioned one is usually expensive, particularly if it is subject to Writers Guild of America jurisdiction. Then talent has to be paid and equipment rented. Before material production can commence, producers running the relevant ad hoc company and their financial backers must decide whether to proceed: for example, the granting of the greenlight.

Producers may try to raise funds from investors, but these days that is uncommon. The true greenlight is tied to the issuance of a completion bond, which guarantees that the picture is fully financed and will be delivered on time and on budget. "Costs to a producer" are really costs to a production company or, more properly, that company's financiers. Most producers propose projects at this stage to executive boards, identifying, evaluating, and promising to minimize monetary risks.[21] And "risk" is the word.

If modernity was initially about producing and distributing goods in a search and struggle for the most effective and efficient forms of industrialization, without thought for safety or the environment, today's wealthy societies enumerate

and manage such dangers. And rather than being an occasional, scary interruption to the everyday, risk is now a constitutive component of private and public life that can be sold, pooled, and reconfigured. This later modernity is characterized by ever-more sophisticated mechanisms for measuring risk, even as its range and impact become less controllable.[22]

The United States is *the* risk society, with 50 percent of the population participating in stock-market investments. Risk is brought into the home as an everyday ritual, an almost blind faith (sometimes disappointed) in mutual funds patrolling retirement income. In 2005, U.S. residents spent $1.1 trillion on insurance—more than they paid for food, and over a third of the world's total insurance expenditure. Insurance companies' global revenues exceed the gross domestic product of all countries excepting the top three. At one level, this represents a careful calculation of risk, its incorporation into lifelong and posthumous planning—prudence as a way of life. At another, it is a wager on hopelessness and fear. As dangers mount, safeguards diminish.

So whether we are discussing nuclear power plants or genetically modified foods, the respective captains of industry argue that they pose no risks, but insurance companies decline to write policies on them for citizens—because they are risky. Much of this corporate practice relates to the deregulatory intellectual and policy fashions of the last four decades, which have facilitated a historic redistribution of income upward by opposing the universalization of Medicare, reducing labor protection, and ideologizing against collective action other than in the private sphere—all this while at the same time the population confronts spiraling health costs and multiplying economic changes.[23]

Hollywood talks about risk all the time.[24] Some players, such as the banks that make production loans, can reduce risk to quite low levels. Others factor in risk by charging more for their money. For example, a subordinated lender (whose repayment does not begin until the senior or bank lender has been fully repaid with interest) may charge between 10 and 20 percent annual interest on its loan, plus facility fees, whereas a bank lender may only charge 3 or 4 percent at current rates and lower fees.

On a number of films, the risk-mitigation structure unravels, sometimes catastrophically, but this is usually because somebody breaks the rules, either through failing to observe the usual standards (which is fairly common) or by acting fraudulently (which is less so). Risk is fetishized across the industry as a core component of cultural work: "Relative to all other media products, cinema and television entertainment requires by far the highest amount of initial investment per unit, most of which is high risk. Investors often adopt a venture capital model, financing a portfolio of productions, of which only a few are expected to be successful."[25]

Although the overall insecurity of particular projects is borne by producers, all people working in Hollywood seem haunted by risk. They are members of

either the cognitariat or precariat, depending on whether they work above or below the accounting line that divides the price of skilled versus unskilled labor.[26] Increasing opportunities to draw on the New International Division of Cultural Labor see producers seeking state subsidies, able workers, new technology, and industrial pliancy across the globe.[27] The project basis that governs labor in the industry is the anticipated acceptance by the Global North's middle class that life-long employment is over. That said, from labor's point of view, the principal factor mitigating risk is the role of Hollywood's unions, which are effective in getting their members paid. Wages and residuals from nontheatrical use model a post-industrial, project basis for workers' rights, just as they modeled an end to full employment.

The figure attracting the greatest calumny in Hollywood, the locus of uncertainty and risk, is often the producer, who is also, as we saw above, subject to these pressures. This conflictual status represents a certain continuity with an earlier era, when producers embodied the full power of the studio system.[28]

Why this carryover across such different moments in employment history? Because the word "producer" signifies control and money via the dreaded bureaucratic "suit," whether that refers to male power uniforms or female power dressing, 1940s executives or noughties independents, stately studio statuary or boutique effects-houses. Consider the venerable history of scriptwriters complaining about producers, a tendency that the novelist and screenwriter Raymond Chandler both derided and expressed in his remorselessly dialectical way: "The personal qualities of a producer are rather beside the point. Some are able and humane men and some are low-grade individuals with the morals of a goat, the artistic integrity of a slot machine, and the manners of a floorwalker with delusions of grandeur."[29] There is a further irony: critics of producers sometimes want to *become* them. Chandler again: "A writer has no real chance in pictures unless he is willing to become a producer, and that is too tough for me. The last picture I worked on was just one long row."[30]

Producers can be entrepreneurs, managers, and artists all at once, and are frequently the only people heavily involved in pre- and post-production as well as production.[31] Because they straddle the relationship between art and commerce, proletarian and bourgeois, bourgeois and petit bourgeois, producers are marginalized by both auteurism's discourse of artistry and the studios' discourse of finance, even as they enable those very elements and sometimes achieve an alchemical personal apogee of them. Consider the combinatory *mestizo* figures of George Lucas, Steven Spielberg, and Aaron Sorkin, men whose word is both lore and law. They are culturally significant, financially successful, and organizationally capable, able to combine signature connotative themes with relative industrial autonomy. These qualities are embedded in both authorial ingenuity and monetary muscle and animated by teams who do their masters' bidding.

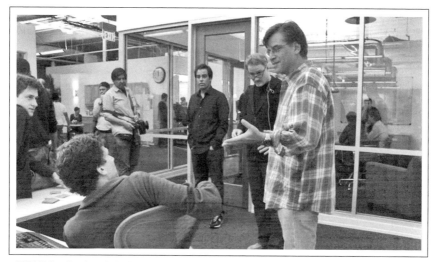

FIGURE 26: One of modern television's premiere writer-producer-"showrunners": Aaron Sorkin (far right) on the set of *The Social Network* (2010). To Sorkin's right is the director David Fincher, and seated, facing away from the camera, is the film's lead actor, Jesse Eisenberg.

Today's "showrunner" phenomenon sees television writers *as* producers, and vice versa. And it's not only writers who simultaneously desire and deride the category—the same can be said of many people along Hollywood TV's global commodity chain. Writers are essentially forced to become producers or executives because television is structured that way. In film, writers become producers to develop their own projects in the (usually forlorn) hope of controlling them.

Blockbusters and Coproductions

> *Banks are more likely to feel comfortable funding large-budget
> productions with higher blockbuster potential, while smaller budget
> movies that take more artistic risks—the kind that may lead to awards
> and praise—find bank funding more difficult, as potential profits are
> judged to be smaller.*[32]
>
> —*Jade L. Miller, media scholar, 2011*

According to the Organization for Economic Co-operation and Development (OECD), "average costs have soared over the past 20 years, driven largely by the 'blockbuster' phenomenon, where a large share of capital is invested in a small number of productions. Average costs have risen across the board, but much of the increase is in advertising and distribution, which now account for 30–40% of total costs for major studios."[33] Blockbusters generally rely on already-popular, ensemble, multi-generic formats with built-in, tested appeal.[34] As Davidson points

out in his accounting of the film industry published in the *New York Times,* "Eighteen of the all-time 100 top-grossing movies (adjusted for inflation) were sequels, and more than half of those were released since 2000."[35] Studios get about half of blockbusters' theatrical receipts, frequently based on high percentages from opening weeks. Exhibitors benefit as time passes. Driven by the global lingua franca of spectacle, testosterone, adventure, and multicultural casting, blockbusters minimize character development, narrative complexity, and dialogue. Again deferring to the OECD: "Films that require no obvious connection with an identifiable actor or with a specific language or cultural context (e.g., special effects or animated films) may be more accessible to a global audience and offer more direct links to subsidiary markets for computer games, merchandising and so forth."[36]

Studios generally take 40 percent of DVD and other consumer rentals and sales. This take amounted to more than $650 million for *Avatar* (James Cameron, 2009), for example, an "event" film of the kind that people still want to "own."[37] Merchandising brings in money through licensed toys, games, and posters, inter alia, amounting to 10 percent of income. Then comes television, which is a source of money through a range of venues: videoondemand, followed by premium cable, then broadcast. TV prices are based on theatrical success or failure and are responsible for approximately 11 percent of domestic revenue.[38] Streaming is a new source of income, but the oligopoly of Netflix and Amazon keeps licensing fees low.

The process of making blockbusters begins with serious investment. The desire to spread the risk they pose is understandable, and big new investors are often interested. For example, in 2009, Steven Spielberg received over $800 million from Reliance Big Pictures, an Indian-based venture, and 2014 found the Singapore-based Indus Media announcing a large fund for South Asians to invest, mostly in Hollywood.[39]

Where does all this money go? Rights to a best-selling book vary between $500,000 and $2 million. Adaptation is equally expensive: leading screenwriters can cost as much as $2 million per project. Top directors may command $10 million per film and a percentage of profits. Prior to the fiscal crisis, actors in the front rank expected a sign-on fee of between $10 and $20 million in addition to a percentage of the box office. This has decreased since the crash of 2008, and top actors trim their demands according to the type of film they're making: say, a million dollars for a $12 million film, $3 million or more for a $50 million film.

Computer-generated imagery can double overall costs, amounting on its own to an expense of $100 million. In terms of music, a leading artist may charge a million dollars per new song. Producers also pay themselves, of course. At the leading edge of the industry, they receive less than headlining actors, but sometimes they earn more than $5 million a movie. Once a blockbuster is in the can, the largest single expense remains: marketing, which may cost as much as half the original budget.[40]

A blockbuster's domestic media coverage and post-release marketing depend a great deal on its opening weekend, when audiences are dominated by teenage boys. Producers calculate, and there are studies that back this up, that young men do not read press reviews but are susceptible to marketing.[41] For industry analysts, "personal income, the comedy-drama genre, and the PG 13 rating are the important positive factors in the financial success of a film when moviegoers know relatively little about a picture."[42] In an essay titled "A Blueprint for Success in the U.S. Film Industry," Stephanie M. Brewer, Jason M. Kelley, and James J. Jozefowicz contend that

> ex post regressions demonstrate that peak screens, the quadratic of stardom, film award nominations and positive word-of-mouth information sharing are all positive and significant determinants of film performance. The impacts of production budget, the gross of a prequel, positive critical reviews, and release dates during the summer and Thanksgiving/ Christmas seasons are robust across the models. The action-adventure and comedy genres were also consistently positive and statistically significant across the models.[43]

Many films are now released on the same day worldwide, or over two to three weeks. This strategy places even greater pressure on their opening weekends.

"Smaller" pictures, too, need a variety of funders, frequently via coproductions. As Jade Miller writes in her social network analysis of coproduction relationships in bigger budget U.S. films:

> Begun as a tool of resistance to the dominance of U.S. films, [European] film funds were initially designed to support "high quality" movies that provided an artistic voice for domestic auteurs, an outlet that could not be supported by the mass market. . . . Only the films that could not be supported in the mass market win funds [which] encouraged the development of a film industry in many of these countries that could never become self-sufficient, as the system values art films over those that could appeal to the mass market, and as it values "quality" and artistic expression over development of a sustainable domestic mass market industry. . . . In the past two decades, discourse has begun to support public film policy that, instead of supporting individual local auteurs, favors the grooming of a local film industry workforce and foreign direct investment into local facilities. . . . In this way, public film support, particularly in Europe, shifted to encourage foreign productions to shoot on location domestically and to partner with local production companies.[44]

The global system is now in full flight. Analyzing the rise of global coproductions, Norbert Morawetz, Jane Hardy, Colin Haslam, and Keith Randle detail the financial system underwriting this new Hollywood:

> Finance in the US and international film industry [i]s filled with soft money from Europe[:] co-producing (co-financing) US pictures directly (as happened in Germany), or by bringing US or international production to Europe by using the co-production structure in the case of the UK model. In both cases the extent of money diversion was considerable. In 2000 alone . . . approximately $3 billion or 20 per cent of the entire US expenditure in film and video production was sourced from media companies and private equity film funds listed on the German "new economy" stock exchange Neuer Markt. . . . Even after the Neuer Markt's collapse in 2000/2001, German private equity continued to flow into the US industry, with German film funds raising EUR 2.3 billion in 2002, EUR 1.76 billion in 2003 and EUR 1.5 billion in 2004. . . . The German government reacted to the abuse of the tax scheme at first with restrictions and finally closed it in 2005.[45]

Coproduction is also part of the new and restless quest for the Asian market (meaning China and India). Hollywood coproductions, as Azmat Rasul and Jennifer M. Proffitt point out in their essay on Bollywood, work with "local production houses that know the culture and taste of the people."[46] The process has become wonderfully cosmopolitan and multicultural.

Technology

Crucial to contemporary Hollywood is a technological determinism. In its dystopic and utopic forms alike, this discourse presupposes that new gadgets destabilize both art and its hierarchy. And indeed, Hollywood trembles in the face of what happened to middle management in the recorded music industry over the past fifteen years. The comparatively cheap and easy access to making and distributing meaning afforded by the Internet is thought to have eroded the one-way hold on culture that saw a small segment of the world as producers and a far larger segment as consumers. New technologies allow us all to be cultural consumers *and* producers (prosumers) without the say-so of media gatekeepers. The result is said to be a democratized media, higher skill levels, and powerful challenges to old patterns of expertise and institutional authority.[47]

What might comprehensive digitization of production and post-production do? According to the OECD, it will make for the following:

- Greater integration of the production and post-production segments
- Redefinition and possible relocation of the duplication function
- Redefinition of the distribution function
- Closer integration of the cinema and television environments
- Creation of a new "communication" value-added segment geared to exploiting new methods of interactive market research encompassing social networks[48]

In this cybertarian world, everyone and no one is a producer in the traditional, quasi-institutional sense, just as everyone is simultaneously an unpaid worker and a paying customer. Fans write zines that become screenplays. Interning graduate students in New York and Los Angeles read scripts for producers and then pronounce on whether they tap into audience interests. Precariously employed part-timers spy on fellow spectators in theaters to see how they respond to coming attractions and report back to moguls. End-user licensing agreements ensure that in signing on, players who are paying subscriptions sign away their rights to the things they do onscreen in the game, hence offering the corporations that own the games the use of each player's creativity.[49]

But there is no clear link between the emergence of new technologies, such as videocassettes or pay TV, and box office revenues.[50] As noted earlier, one less utopian assumption is that producers will gain from reduced costs of duplication and distribution while continuing to benefit from the protection afforded them by production costs, which, because the labor-intensive nature of high-level production necessitates access to major financing, restrict new participation in the market.[51] We can say with some confidence, however, that Hollywood's neurotic but adaptive reaction to new technology over the past century, from the advent of sound to the hovering cloud, has seen its institutional power ramified again and again.

Public Subvention: Hidden Producers

Up to now, the assumption in this chapter has mirrored that of the dominant discourse on Hollywood: namely, that the risks encountered in producing motion pictures are private and that the market operates unfettered by government control or participation. But despite deregulation, the state is still centrally involved in mainstream production. Producers study at colleges, as do many of their employees. If it was German money that funded a Hollywood film in the early twenty-first century, the chances are that it was stimulated by tax breaks for lawyers, doctors, and dentists. French money might have come from firms

with state subvention in other areas of investment, such as cable or plumbing, and that has subsidized U.S. studios. TV shows shot in Canada have relied on welfare to attract U.S. producers. And domestically, state, regional, and municipal commissions have offered producers reduced local taxes, free provision of police services, and the blocking of putatively public thoroughfares. This public funding of Hollywood, supposedly the acme of laissez-faire business success, is one of those spheres of life where neoclassical economics and radical political economy can agree on both a target and a way of attaining it: uncovering and problematizing state subsidies that enable affluent, indolent bourgeoisies to survive and thrive.[52]

The primary goal of neoclassical economics is to organize the resources that enable capitalism. In this view, there are three legitimate actors: consumers, companies, and the state, with the latter's role restricted to policing relations between the other two groups.[53] Because such economists meticulously hunt for subsidies and market distortions that prop up lazy members of the bourgeoisie, they are good at ferreting out state film policies designed to attract Hollywood via "soft" money. This is the term producers use to describe their holy grail—investors or bankers who won't claim equity or seek either interest or returns of any kind.

So on the right, John Northdurft, writing for the Heartland Institute, disparages subvention for "some of America's most-affluent businessmen at the expense of taxpayers."[54] In a publication from the Tax Foundation, Joseph Henchmen rails at "corporate welfare" that guarantees investors 15 to 20 percent returns on their investments and stimulates competition between states to provide more and more subsidies that are lapped up and then forgotten by Hollywood once alternatives beckon, leaving minimal if any ongoing benefit in their wake.[55] Complaints are made that claims for economic development do not stand up because film and TV are not as sizeable as automobile manufacturing and the preponderance of revenue from them lands in California pockets anyway.[56] When the Academy of Motion Picture Arts and Sciences announced its 2014 Oscar nominees for Best Picture, the impeccably reactionary Manhattan Institute issued a neat table highlighting the public subventions of each film (see Table 6.1).

Such policies also irk political economists on the left, who are concerned by state capitalism's undemocratic excesses and are driven by a desire for social justice rather than private enterprise, for redistribution rather than efficiency, for democratic control of the market rather than democratic control through it. Writing in the venerable left-wing film journal *Jump Cut,* Vicki Mayer and Tanya Goldman write: "The system of tax credits is like every other bloated financial system in the United States, moving capital between elites while workers live with exaggerated job insecurity, declining market value, and uncertain futures that make up the rest of the workforce."[57] Numerous

Table 6.1:

Movie	Budget (millions)	State Incentives	Location
American Hustle	$40	25% production and payroll credits; sales tax exemption	Massachusetts
Captain Phillips	$55	$300k Grant	Virginia
Dallas Buyers Club	$5.5	30% credit on expenditures; 5% payroll credit	Louisiana
Gravity	$100	25% credit on first $38m expenditures, 20% credit thereafter	United Kingdom
Her	$25	20% tax credit	California
Nebraska	$13	Eligible for funds from participating local economic development offices	Nebraska
Philomena	$5	25% credit on first $38m expenditures, 20% credit thereafter	United Kingdom
12 Years a Slave	$20	30% credit on expenditures; 5% payroll credit	Louisiana
Wolf of Wall Street	$100	30% tax credit	New York

State Tax Incentives for Oscar-Nominated Motion Pictures (2014)

Source: Budget estimates from IMDB and movieboe. State incentives from various government film offices.

studies are similarly skeptical about the benefits versus the costs of tax breaks for movies as opposed to other forms of longer-lasting job creation that do not have adverse effects on tax receipts or run the risk that filmmakers who would have come to particular locations anyway suddenly enjoy windfalls at ordinary citizens' expense.[58] Such issues duel in the bourgeois media with arguments about the glamour, tourism, and jobs that supposedly accompany films as positive externalities.[59]

The gullible states that engage in this largesse do so for a variety of reasons: creating jobs during film or TV shoots, engendering public awareness of their localities to boost tourism, cleaving glamor to sponsoring politicians, fulfilling the remit of "culturecrats," and satisfying the needs of powerful businesspeople. But there is no evidence that subsidies pay for themselves in terms of private-sector expenditure during production or the establishment of secure, ongoing film-making infrastructure. Such prospects are jeopardized by the constant bidding contests between states as they ratchet up the terms they offer Hollywood-based producers.[60]

If a movie or TV show is made in any particular state of the United States, the credits generally thank regional and municipal film commissions for subsidies

of everything from hotels to hamburgers. Accommodation and sales-tax rebates available to producers sometimes extend to constructing studios, as in North Carolina. The California Film Commission, for example, reimburses public personnel costs and permit and equipment fees, while the state government's "Film California First Program" covers everything from free services to wage tax credits.

In 2010, forty-three U.S. states sought to "attract" Hollywood at an aggregate cost of $1.5 billion.[61] The start of the second decade of the twenty-first century has seen a massive increase in subsidies, stimulated by Louisiana and New Mexico upping the ante. These states have moved from traditional methods, such as minimal credits against income tax, deductions based on losses, loan guarantees, free access to public services, and exemptions from hotel taxes, to much more expansive tax credits. Other states have followed suit, stimulating a new business in trading such credits. Transferability takes tax credits afforded by governments to producers and sells them to wealthy people who don't feel like paying their share of tax. This allows producers to get their money faster than they would via refunds. First introduced in 2009, transferability is at this writing a multi-million-dollar business.[62]

On average, producers receive twenty-five cents from each dollar of these subsidies, regardless of the success of their films. No matter where these projects are shot, most skilled labor is imported from the Northeast and Southwest, specifically New York, traditional home of network TV, and Los Angeles, traditional home of film. So the plum jobs go to people who spend most of their income and are levied most of their taxes outside the places where they briefly work. The locals get distinctly below-the-line positions, as caterers and hairdressers—frequently non-unionized jobs that hardly build careers.

That said, the impact on actual shooting in Los Angeles has been profound, even if above-the-line labor still mostly lives and pays taxes there. According to Film L.A. Inc.: "In 1997, the majority of large-budget studio features were produced in California, with many in L.A. By 2013, most high-value feature projects were made elsewhere; just two of the year's live-action movies with budgets above $100 million were filmed in L.A. Today, most local feature production is for small, independent projects that offer reduced employment and spending benefits."[63] Exactly what this means for shoots supported elsewhere, at sites other than Los Angeles, the journalist Rollins Saas explains in the *Economist*: "And public programs in the states *have* sometimes generated ongoing investment in new infrastructure—sound stages and skilled workers, for example—that provide ongoing attractions beyond temporary direct subvention, and are claimed as part of encouraging a 'clean' or 'environmentally friendly' industry."[64]

Finally, it is worth seeing how closely the fiscal fortunes of Hollywood are linked to the federal government. Section 181 of the Internal Revenue Code is a

tax break for individual (not corporate) investors in production. This tax break is subject to various restrictions and has a sunset clause, so it must be renewed annually. The scheme is probably less attractive than federal breaks for, say, real-estate investment trusts. But it is used, and it indexes a desire to incentivize the wealthy to invest in film production.

The federal government also sponsors Hollywood. Its various agencies are among contemporary Hollywood's newest "hidden producers." Today's hybrid of SiliWood (Silicon Valley and Hollywood) blends Northern Californian technologies, Hollywood methods, and military funds. The process has evolved since an initial articulation in the mid-1980s of Southern and Northern California semi-conductor and computer manufacture and systems and software development (a massively military-inflected and -supported industry) to Hollywood screen content, as disused aircraft-production hangars became entertainment sites. The links are as much about gadgetry, personnel, and collaboration on ancillary projects as they are about story lines. Spielberg boasts the Pentagon's Medal for Distinguished Public Service; Silicon Graphics designs material for use by the empire in both its military and cultural aspects; and virtual-reality research veers between soldierly and audience applications, much of it subsidized by the Federal Technology Reinvestment Project and Advanced Technology Program. This has further submerged killing machines from serious public scrutiny: they surface as Hollywood props.[65]

The CIA established formal liaison with Hollywood in 1995, making them another hidden producer of film content. Though the agency has few spectacular assets by contrast with the Defense Department's ships, guns, and planes, it encourages scripts that portray it favorably.[66] The *New York Times* headlined the fall 2001 TV drama schedule like this: "Hardest-Working Actor of the Season: The C.I.A.," with no fewer than three prime-time network dramas being made under the aegis of the agency.[67] And with the National Aeronautics and Space Administration keen to renovate its image, who better to invite to lunch than Hollywood producers, in the hope that they would portray it as benign and exciting? In the process, profound contradictions between pursuing profit and violence versus civility get washed away, their instrumentalism erased in favor of the dramatic reenchantment of a supposedly higher moral purpose, expressed in nationalism and valor.[68]

There is an equally sordid nexus between universities, producers, and the military. Colleges generate research designed to test and augment the recruiting and training potential of the culture industries to ideologize, hire, and instruct the population. The Center for Computational Analysis of Social and Organizational Systems at Carnegie Mellon University in Pittsburgh promulgates studies underwritten by the Office of Naval Research and the Defense Advanced Research Projects Agency (DARPA). DARPA refers to Orlando as "Team Orlando" because the city houses Disney's research-and-development "imagineers," the University

of Central Florida's Institute for Simulation and Training, the nation's biggest military contractor Lockheed Martin, and the Pentagon's Institute for Simulation and Training.[69]

In Los Angeles, the Institute for Creative Technologies (ICT) at the University of Southern California articulates communications scholars, Hollywood producers, and game designers to use military money and dramatic muscle to test out homicidal technologies and narrative scenarios. ICT was formally opened in 1998 by the secretary of the army and the head of the Motion Picture Association of America with $45 million from the military's budget, a figure that was doubled in 2004 and trebled in 2011. By the end of 2010, ICT products were available on sixty-five military bases.[70]

The institute has directly collaborated on major motion pictures, such as *Spider-Man 2* (Sam Raimi, 2004), and the set designer for the Star Trek franchise thought up its workspace. ICT also produces Pentagon recruitment tools (for example, the videogame *Full Spectrum Warrior*) that double as "training devices for military operations in urban terrain": what's good for the Xbox is good for the combat simulator. The utility of these innovations continues in the field: the Pentagon is aware that off-duty soldiers play games and wants to colonize their leisure time, weaning them from skater games toward what are essentially training manuals.[71]

Citizenship

After the 2000 presidential election, Wall Street investors transferred money away from the media in general and toward manufacturing and defense as punishments and rewards for the Supreme Court's Republican coup. Energy, tobacco, and military companies, 80 percent of whose campaign contributions had gone to George W. Bush in the presidential election, received unparalleled transfers of confidence. Money fled the cultural sector—a victory for oil, cigarettes, and guns over film, music, and wires. The former saw their market value rise by an average of 80 percent in a year, while the latter's declined by between 12 and as much 80 percent.[72]

Such revelations about investment in cultural production inevitably lead to the issue of citizenship. Quite apart from questions of economic efficiency and imperialism, it is fair to wonder which issues of social justice should be addressed in the context of taxpayer support, as quid pro quos. It is one thing to engage in the "gotcha" game of pointing out that a putatively laissez-faire industry is actually dependent on public subvention. But what is the next move, after luxuriating in this blindingly obvious revelation? Should we be problematizing the social, cultural, and environmental injustices meted out by Hollywood as externalities,

drawing on the discourse of citizenship to say, effectively, "We give you all this money from the public purse. Reciprocity can't just be about questionable multiplier effects as per alleged tourism benefits"?

What might such reciprocity entail in terms of how movie production imperils humans, animals, and the environment?[73] For example, consider reciprocity and subsidies with regard to tobacco use: "An estimated 1.1 million current adolescent smokers in the U.S. were recruited to smoke by tobacco imagery in films about 350,000 of whom will ultimately die from tobacco-induced diseases," writes Jonathan Polansky and Stanton A. Glantz for the Center for Tobacco Control Research and Education. "Two thirds of US developed, youth-rated film projects with tobacco imagery were filmed in the US, a rate typical of all films released by US studios over the past decade. Filmed in a dozen states now offering subsidies, these 35 movies contributed 71 percent of the 11.4 billion tobacco impressions delivered to US theater audiences by youth-rated films in 2008. . . . States awarded an estimated $830 million in public subsidies to films with tobacco, including $500 million to youth-rated films with tobacco. For comparison, the states budgeted $719 million for all tobacco control in 2009. . . . An estimated 62 percent ($830 million/$1.3 billion) of state film subsidies go to smoking films."[74]

The failure of voluntary compliance—self-regulation being a consistent aspect of the mode of Hollywood production—is made clear in a publication entitled "Smoke Free Movies: From Evidence to Action" from the World Health Organization:

> Voluntary agreements with the tobacco industry to limit smoking in movies have not and cannot work because the fiduciary interests of the tobacco industry are opposite to those of the public health community. In the United States, the Master Settlement Agreement (MSA) between states' Attorneys General and the major domestic tobacco manufacturers included a provision in which the manufacturers agreed to a prohibition on paid tobacco product placement in movies. However, evidence shows that smoking incidents increased in movies released subsequent to the MSA's 1998 implementation, peaking in 2005. . . . An analysis of more than 1300 feature films accounting for 96% of all ticket sales in the United States between 2002 and 2010 found that tobacco imagery permeated both youth-rated (G/PG/PG-13) and adult-rated (R) movies, with 62% of top-grossing films featuring tobacco imagery. More specifically, 81% of all R-rated movies included smoking, while smoking appeared in 66% of movies rated PG-13 and 27% of movies rated G or PG. Altogether, top-grossing movies of all ratings distributed in the United States between 2002 and 2010 contained approximately 7500 tobacco incidents.[75]

A focus of this World Health Organization study is the disconnect between sub-ventions/tax credits and the prevalence of tobacco-use imagery:

> From 2008 to 2010, 14 nations or their sub-units awarded an estimated $2.4 billion to producers of 93% of the 428 films, mainly developed by companies based in the United States, which achieved top box office sta-tus in Canada and the United States. Half of these films featured tobacco imagery. Over three years, subsidized with $1.1 billion in tax credits, these films delivered an estimated total of 130 billion tobacco impres-sions to theatre audiences worldwide. . . . Film industry representatives sometimes assert the need for smoking imagery in a movie to tell a story. The WHO FCTC certainly asserts that the implementation of a compre-hensive ban on tobacco advertising, promotion and sponsorship should not prevent legitimate expression. However, the presentation of smoking on screen is rarely realistic, generally showing images more consistent with cigarette advertising than with authentic representations of the dire health consequences of tobacco use. . . . Tobacco incidents . . . per youth-rated movie fell from 20 in 2005 to seven in 2010, a 66% reduction; the degree of improvement, however, varied substantially by movie studio. The three companies with published policies designed to reduce smoking in their films (Disney, Time Warner and Comcast's Universal) reduced tobacco incidents per youth-rated (G/PG/PG-13) movie by more than 90%, to an average of fewer than two incidents per movie by 2010. The other companies (Sony, News Corporation's Fox, Viacom's Paramount, and independent film companies considered as a group) had 26–63% reductions and six to 14 tobacco incidents per youth-rated movie in 2010. . . . Published company policies, adopted between 2004 and 2007, provide for review of scripts, story boards, daily footage, rough cuts, editing deci-sions and the final edited film by managers in each studio with authority for implementing the policies. As of June 2011, none of the studios had blanket policies against including smoking or other tobacco imagery in youth-rated films that they produced or distributed.[76]

A second consideration here is gender equity. In an interview for *Salon,* the pro-ducer Lynda Obst mused: "I think women make wonderful producers, because they're very nurturing, but at the same time, they feel things more. In this busi-ness, that's not necessarily a great thing, because you have to always say 'Next.' We tend to internalize things, so that's not good. I think in the long run it's not a bad business for women. It's not Wall Street. Creative instincts are rewarded. We have great women studio heads and role models and networking organizations. You can have a meeting with five women in it. There's not a lot of businesses you can say that about."[77] But if, as Obst contends, moviemaking is a good business

for women, consider the following: that men produced over 80 percent of the twenty highest-grossing Hollywood pictures released between 1985 and 2005. In 2012, women were just 18 percent of producers or other above-the-line, off-camera participants in Hollywood's top-grossing 250 motion pictures. The 18 percent figure was an increase of just 1 percent from 1998. Forty percent of associate producers are women, but the percentages decrease as prestige and power increased; women amount to just 17 percent of executive producers. An important sidebar here: where female producers are involved, the likelihood of women directors increases. Such imbalances are common in project-based industries as opposed to ones that are governed by uniform organizational policies affected by the discourse of equal opportunity or affirmative action.[78]

Third, Hollywood production has historically had a detrimental effect on the environment. There is a horrendous history of the abuse of animals across the industry's history that discloses a systematic barbarism on the part of producers. People for the Ethical Treatment of Animals (PETA) and its activists have disclosed such crimes, to the point where in 2013 the *Hollywood Reporter* finally paid heed.[79] PETA has guidelines for producers on this matter.[80]

And then there's the environmental impact of production. The first major scholarly study on environmental despoliation, conducted on behalf of the Integrated Waste Management Board from 2003 to 2005, concluded that the motion-picture industry was the biggest polluter in L.A. As a result of its massive use of electricity and petroleum, movie productions release hundreds of thousands of tons of deadly emissions each year. In California as a whole, film- and television-related energy consumption and greenhouse-gas emissions (carbon dioxide, methane, and nitrous oxide) are about the same as those produced by the aerospace and semiconductor industries.[81]

Conclusion

While the business model supporting film production in the United States has changed dramatically in the twenty-first century, the U.S. industry continues to be clustered in the Los Angeles area. As the OECD study discussed earlier in this chapter reveals:

> The economics of the film industry revolve around the need to protect large investments by managing risk. This involves aggregation, marketing and production strategies. The conventional way to control and co-ordinate production risks has been to aggregate production activities in one location. Thus, the US industry is clustered in Los Angeles. . . . But positive effects from clustering are now mostly confined to project development, financial, marketing and distribution. Many 'Hollywood' films

Table 6.2: Laissez Faire versus Welfare Hollywood

Laissez-Faire Hollywood	Welfare Hollywood
No state investment in training, production, distribution, or exhibition	Massive state investment in training via film schools and production commissions, major diplomatic negotiations over distribution and exhibition arrangements, and Pentagon budgets
No governmental content	
Copyright protection	Copyright protection as a key service to capital along with antipiracy deals
Monopoly restrictions	Monopoly restrictions minimized to permit cross-ownership and unprecedented concentration domestically and oligopolies internationally
Export orientation	Export orientation aided by plenipotentiaries
Market model	Market model but mixed-economy practice through state subvention
Avowed ideology of pleasure before nation	Ideology of pleasure, nation, and export of Américanité via imperialism

are no longer filmed in Hollywood—often taking advantage of location shooting incentives (tax breaks and subsidies), often in other countries. But arguably the markets for these films are still created in the Hollywood cluster.[82]

Two seemingly contradictory Hollywoods—two distinct modes of production—emerge in this era, "laissez-faire Hollywood" and "welfare Hollywood." Table 6.2 draws from the discourse of neoclassical economics.[83] Note how the state is magically airbrushed from view in the former model.

Although producers' working environments have changed over the decades, three appetites have remained constant: an appetite for risk, for public money, and for "efficiencies"—without due regard to human, animal, or environmental rights. We contend here, by way of conclusion, that the least we can expect of producers is that they work to meet their citizen responsibilities as well as their fiscal drives; a system that is as public as Hollywood, for all its claims to being free enterprise, owes us that much. Perhaps one day the PGA's official chronology will note moments when such rights took center stage.

ACADEMY AWARDS FOR PRODUCING

1927/28 OUTSTANDING PICTURE, Paramount Famous Lasky, *Wings*

- 1928/29 OUTSTANDING PICTURE, Metro-Goldwyn-Mayer, *The Broadway Melody*

1929/30 OUTSTANDING PRODUCTION, *All Quiet on the Western Front*, Universal

1930/31 OUTSTANDING PRODUCTION, *Cimarron*, RKO Radio

1931/32 OUTSTANDING PRODUCTION, *Grand Hotel*, Metro-Goldwyn-Mayer

1932/33 OUTSTANDING PRODUCTION, *Cavalcade*, Fox

1934 OUTSTANDING PRODUCTION, *It Happened One Night*, Columbia

1935 OUTSTANDING PRODUCTION, *Mutiny on the Bounty*, Metro-Goldwyn-Mayer

1936 OUTSTANDING PRODUCTION, *The Great Ziegfeld*, Metro-Goldwyn-Mayer

1937 OUTSTANDING PRODUCTION, *The Life of Emile Zola*, Warner Bros.

1938 OUTSTANDING PRODUCTION, *You Can't Take It with You*, Columbia

1939 OUTSTANDING PRODUCTION, *Gone with the Wind*, Selznick International Pictures

1940 OUTSTANDING PRODUCTION, *Rebecca*, Selznick International Pictures

1941 OUTSTANDING MOTION PICTURE, *How Green Was My Valley*, Twentieth Century–Fox

1942 OUTSTANDING MOTION PICTURE, *Mrs. Miniver*, Metro-Goldwyn-Mayer

1943 OUTSTANDING MOTION PICTURE, *Casablanca*, Warner Bros.

1944 BEST MOTION PICTURE, *Going My Way*, Paramount

1945 BEST MOTION PICTURE, *The Lost Weekend*, Paramount

1946 BEST MOTION PICTURE, *The Best Years of Our Lives*, Samuel Goldwyn Productions

1947 BEST MOTION PICTURE, *Gentleman's Agreement*, Twentieth Century–Fox

1948 BEST MOTION PICTURE, *Hamlet*, J. Arthur Rank-Two Cities Films

1949 BEST MOTION PICTURE, *All the King's Men*, Robert Rossen Productions

1950 BEST MOTION PICTURE, *All about Eve*, Twentieth Century–Fox

1951 BEST MOTION PICTURE, *An American in Paris*, Arthur Freed, Producer

1952 BEST MOTION PICTURE, *The Greatest Show on Earth*, Cecil B. DeMille, Producer

1953 BEST MOTION PICTURE, *From Here to Eternity*, Buddy Adler, Producer

1954 BEST MOTION PICTURE, *On the Waterfront*, Sam Spiegel, Producer

1955 BEST MOTION PICTURE, *Marty*, Harold Hecht, Producer

1956 BEST MOTION PICTURE, *Around the World in 80 Days*, Michael Todd, Producer

1957 BEST MOTION PICTURE, *The Bridge on the River Kwai*, Sam Spiegel, Producer

1958 BEST MOTION PICTURE, *Gigi*, Arthur Freed, Producer

1959 BEST MOTION PICTURE, *Ben-Hur*, Sam Zimbalist, Producer

1960 BEST MOTION PICTURE, *The Apartment*, Billy Wilder, Producer

1961 BEST MOTION PICTURE, *West Side Story*, Robert Wise, Producer

1962 BEST PICTURE, *Lawrence of Arabia*, Sam Spiegel, Producer

1963 BEST PICTURE, *Tom Jones*, Tony Richardson, Producer

1964 BEST PICTURE, *My Fair Lady*, Jack L. Warner, Producer

1965 BEST PICTURE, *The Sound of Music*, Robert Wise, Producer

1966 BEST PICTURE, *A Man for All Seasons*, Fred Zinnemann, Producer

1967 BEST PICTURE, *In the Heat of the Night*, Walter Mirisch, Producer

1968 BEST PICTURE, *Oliver!*, John Woolf, Producer

1969 BEST PICTURE, *Midnight Cowboy*, Jerome Hellman, Producer

1970 BEST PICTURE, *Patton*, Frank McCarthy, Producer

1971 BEST PICTURE, *The French Connection*, Philip D'Antoni, Producer

1972 BEST PICTURE, *The Godfather*, Albert S. Ruddy, Producer

1973 BEST PICTURE, *The Sting*, Tony Bill, Michael Phillips, and Julia Phillips, Producers

1974 BEST PICTURE, *The Godfather, Part II*, Francis Ford Coppola, Producer; Gray Frederickson and Fred Roos, Coproducers

1975 BEST PICTURE, *One Flew over the Cuckoo's Nest*, Saul Zaentz and Michael Douglas, Producers

1976 BEST PICTURE, *Rocky*, Irwin Winkler and Robert Chartoff, Producers

1977 BEST PICTURE, *Annie Hall*, Charles H. Joffe, Producer

1978 BEST PICTURE, *The Deer Hunter*, Barry Spikings, Michael Deeley, Michael Cimino, and John Peverall, Producers

1979 BEST PICTURE, *Kramer vs. Kramer*, Stanley R. Jaffe, Producer

1980 BEST PICTURE, *Ordinary People*, Ronald L. Schwary, Producer

1981 BEST PICTURE, *Chariots of Fire*, David Puttnam, Producer

1982 BEST PICTURE, *Gandhi*,Richard Attenborough, Producer

1983 BEST PICTURE, *Terms of Endearment*, James L. Brooks, Producer

1984 BEST PICTURE, *Amadeus*, Saul Zaentz, Producer

1985 BEST PICTURE, *Out of Africa*, Sydney Pollack, Producer

1986 BEST PICTURE, *Platoon*, Arnold Kopelson, Producer

1987 BEST PICTURE, *The Last Emperor*, Jeremy Thomas, Producer

1988 BEST PICTURE, *Rain Man*, Mark Johnson, Producer

1989 BEST PICTURE, *Driving Miss Daisy*, Richard D. Zanuck and Lili Fini Zanuck, Producers

1990 BEST PICTURE, *Dances with Wolves*, Jim Wilson and Kevin Costner, Producers

1991 BEST PICTURE, *The Silence of the Lambs*, Edward Saxon, Kenneth Utt, and Ron Bozman, Producers

1992 BEST PICTURE, *Unforgiven*, Clint Eastwood, Producer

1993 BEST PICTURE, *Schindler's List*, Steven Spielberg, Gerald R. Molen, and Branko Lustig, Producers

1994 BEST PICTURE, *Forrest Gump*, Wendy Finerman, Steve Tisch, and Steve Starkey, Producers

1995 BEST PICTURE, *Braveheart*, Mel Gibson, Alan Ladd Jr., and Bruce Davey, Producers

1996 BEST PICTURE, *The English Patient*, Saul Zaentz, Producer

1997 BEST PICTURE, *Titanic*, James Cameron and Jon Landau, Producers

1998 BEST PICTURE, *Shakespeare in Love*, David Parfitt, Donna Gigliotti, Harvey Weinstein, Edward Zwick, and Marc Norman, Producers

1999 BEST PICTURE, *American Beauty*, Bruce Cohen and Dan Jinks, Producers

2000 BEST PICTURE, *Gladiator*, Douglas Wick, David Franzoni, and Branko Lustig, Producers

2001 BEST PICTURE, *A Beautiful Mind*, Brian Grazer and Ron Howard, Producers

2002 BEST PICTURE, *Chicago*, Martin Richards, Producer

2003 BEST PICTURE, *The Lord of the Rings, The Return of the King*, Barrie M. Osborne, Peter Jackson, and Fran Walsh, Producers

2004 BEST PICTURE, *Million Dollar Baby*, Clint Eastwood, Albert S. Ruddy, and Tom Rosenberg, Producers

2005 BEST PICTURE, *Crash*, Paul Haggis and Cathy Schulman, Producers

2006 BEST PICTURE, *The Departed*, Graham King, Producer

2007 BEST PICTURE, *No Country for Old Men*, Scott Rudin, Ethan Coen, and Joel Coen, Producers

2008 BEST PICTURE, *Slumdog Millionaire*, Christian Colson, Producer

2009 BEST PICTURE, *The Hurt Locker*, Kathryn Bigelow, Mark Boal, Nicolas Chartier, and Greg Shapiro, Producers

2010 BEST PICTURE, *The King's Speech*, Iain Canning, Emile Sherman, and Gareth Unwin, Producers

2011 BEST PICTURE, *The Artist*, Thomas Langmann, Producer

2012 BEST PICTURE, *Argo*, Grant Heslov, Ben Affleck, and George Clooney, Producers

2013 BEST PICTURE, *12 Years a Slave*, Brad Pitt, Dede Gardner, Jeremy Kleiner, Steve McQueen, and Anthony Katagas, Producers

2014 BEST PICTURE, *Birdman, Or (The Unexpected Virtue of Ignorance)*, Alejandro G. Iñárritu, John Lesher, and James W. Skotchdopole, Producers

NOTES

Introduction

1 Dominick Patten, "Brad Pitt's Plan B Banner Promotes Jeremy Kleiner to Co-President," *Deadline Hollywood,* May 22, 2013, http://deadline.com/2013/05/jeremy-kleiner-named-co-president-of-brad-pitts-plan-b-entertainment-506343/.

2 Solomon Northup, *Twelve Years a Slave* (1853; reprint, Los Angeles: Graymalkin Media, 2014).

3 Jenn Selby, "12 Years a Slave: Brad Pitt's and Steve McQueen's Best Picture Oscars Acceptance Speech in Full," *The Independent,* March 3, 2014, http://www.independent.co.uk/arts-entertainment/films/news/12-years-a-slave-brad-pitt-and-steve-mcqueens-best-picture-oscars-acceptance-speech-in-full-9165040.html.

4 Andre Bazin, "La politque des auteurs," trans. Peter Graham, in *The New Wave,* ed. Peter Graham (London: Secker and Warburg, 1968).

5 Thomas Schatz, *The Genius of the System: Hollywood Filmmaking in the Studio Era* (New York: Pantheon, 1989).

6 Thomas Schatz, "'A Triumph of Bitchery': Warner Bros., Bette Davis, and Jezebel," *Wide Angle* 10, no. 1 (1988): 16.

7 Matthew J. Bruccoli, "The Last of the Novelists: Fitzgerald and the Last Tycoon," http://fitzgerald.narod.ru/tyc/bruccoli-lastnovelist.html.

8 Lynda Obst, *Hello, He Lied: and Other Truths from the Hollywood Trenches* (Boston: Little, Brown, 1996), 95.

9 Robert Evans, *The Kid Stays in the Picture* (New York: Hyperion, 1994), 325.

10 Adam Davidson, "How Does the Film Industry Actually Make Money?" *New York Times,* June 26, 2012, http://www.nytimes.com/2012/07/01/magazine/how-does-the-film-industry-actually-make-money.html?r=0.

11 John Gregory Dunne, "Bully Boy," *New Yorker,* February 5, 1996, 26.

1 The Silent Screen, 1895–1927

1 Alice V. Kelijer, Franz Hess, Marion LeBron, and Rudolf Modley, *Movie Workers* (New York: Harper and Brothers, 1939), 13.

2 I use the masculine pronoun here since the executive work of any producer in the studio system was by this point presumed to be an entirely male prerogative.

3 Laura Lee Hope, *The Moving Picture Girls at Rocky Ranch* (New York: Grosset and Dunlap, 1914), 8–9. "Laura Lee Hope" was a pseudonym under which a number of authors wrote juvenile series fiction for the Stratemeyer Syndicate after 1904. All seven volumes of the Moving Picture Girls series were written by Howard R. Garvis.

4 Ibid., 11.

5 David Bordwell, Janet Staiger, and Kristen Thompson, *The Classical Hollywood Cinema: Film Style and Mode of Production to 1960* (Madison: University of Wisconsin Press, 1985), 116.

6 Ibid., 113–127.

7 The best known of these patents was for the so-called "Latham loop," which reduced the tension on the film print in the projector. See Eileen Bowser, *The Transformation of Cinema, 1907–1915,* vol. 2 of *History of American Cinema* (Berkeley: University of California Press, 1990).

8 Mrs. D. W. Griffith [Linda Arvidson], *When the Movies Were Young* (New York: E. P. Dutton and Company, 1925), 32.

9 Mark Pickford, *Sunshine and Shadow* (New York: Doubleday, 1955), 70–71. See also Eileen Whitfield's discussion of Pickford's struggle with Griffith over daily versus weekly salary in *Pickford: The Woman Who Made Hollywood* (Lexington: University Press of Kentucky, 1997), 79.

10 Bowser, *The Transformation of Cinema,* 112.

11 Mark Garrett Copper, *Universal Women: Filmmaking and Institutional Change in Early Hollywood* (Urbana: University of Illinois Press, 2010), 29.

12 Allene Talmey, *Doug and Mary and Others* (New York: Macy-Masius, 1927), 114.

13 Letter from Jesse Lasky to Adolph Zukor, July 18, 1921, 2–3, Zukor correspondence, Margaret Herrick Library, Beverly Hills, California.

14 Ben Singer and Charlie Keil, eds., *American Cinema of the 1910s: Themes and Variations* (New Brunswick, NJ: Rutgers University Press, 2009), 21.

15 See, for example, Karl K. Kitchen, "What They Really Get," *Photoplay* 8, no. 5 (October 1915): 138–141, and Alfred A. Cohn, "What They Really Get—NOW!" *Photoplay* 9, no. 4 (March 1916): 27–30.

16 *Photoplay* 10, no. 6 (November 1916): 64.

17 See Karen Ward Maher's chapter on independent women producers in her *Women Filmmakers in Early Hollywood* (Baltimore: Johns Hopkins University Press, 2006), 154–178.

18 The earliest attribution of the quote to Richard Rowland that I know of is in Terry Ramsaye's *A Million and One Nights: A History of the Motion Picture through 1925,* vol. 2 (New York: Simon and Schuster, 1926), 795.

19 "Famous Players–Lasky Ban Sex Films by Fourteen 'Don[']ts' to Studio Officials," *Variety*, February 18, 1921, 46.

20 Lasky had quickly verified to the reporter from *Variety* the existence of the fourteen points as well as his studio's anticipated compliance with the new regulations, and he tried to convince Zukor that it was important to make public the producers' concerted efforts at self-regulation. See his letter to Zukor, February 25, 1921, Zukor correspondence, Margaret Herrick Library, Los Angeles, California. This letter also illustrates the importance of Brady's NAMPI leadership to executives at Paramount, as Lasky reports on his plan to hold a luncheon in Los Angeles for Brady so that Hollywood producers might be reassured of Brady's ability to represent and pursue their interests in the midst of a mounting public relations crisis regarding risqué pictures.

21 Transcript of hearing on April 26, 1921, 9, in Papers of Governor Nathan Miller, box 19, file 21, series A1429–72, New York State Archives, Albany, New York.

22 Douglas Gomery, *The Hollywood Studio System: A History* (London: BFI Publishing, 2005), 4–5.

23 Malcolm Stuart Boylan, "Great Executive Job Held by Boy of 22," *Los Angeles Times*, October 15, 1922, sec. 3, 37.

24 For the detailed account of this event see Richard Koszarski, *Von: The Life and Films of Erich von Stroheim* (New York: Limelight Editions, 2001), 108–133.

25 Mark A. Vieira, *Irving Thalberg: Boy Wonder to Producer Prince* (Berkeley: University of California Press, 2009), 14.

26 Kristen Thompson and David Bordwell, *Film History: An Introduction,* 2nd ed. (Boston: McGraw-Hill, 2003), 73.

27 By demonstrating how the repeated details of the scandal cannot be sustained by the historical record, a record about which Brian Taves is the indisputable authority given the depth of his research, the historian proves false all those repeated but colorful stories that the producer's death was a covered-up crime of passion. Taves's research reveals that Ince did not die at Hearst's hand, but instead of a thrombosis brought on by overwork, overall ill health, and alcohol abuse (he drank heavily on Hearst's yacht against doctor's orders). See Brian Taves, *Thomas Ince: Hollywood's Independent Pioneer* (Lexington: University Press of Kentucky, 2012).

28 Mark Garrett Cooper, "Archive, Theater, Ship: The Phelps Sisters Film the World," in *Researching Women in Silent Cinema: New Findings and Perspectives*, ed. Monica Dall'Asta, Victoria Duckett, and Lucia Tralli (Bologna: University of Bologna, 2013), 120–129.

29 Taves, *Thomas Ince: Hollywood's Independent Pioneer,* 5. Taves is referring to Kenneth Anger's notorious *Hollywood Babylon* (Phoenix: Associated Professional Services, 1965).

30 Felix Orman, "Looking behind the Movie Scenes," *Leslie's Weekly*, November 20, 1920, 652.

31 Ibid., 653. Emphasis in the original.

32 Thomas Schatz, *The Genius of the System: Hollywood Filmmaking in the Studio Era* (New York: Pantheon, 1989), 8.

2 Classical Hollywood, 1928–1946

1 F. Scott Fitzgerald, *The Love of the Last Tycoon,* ed. Matthew J. Bruccoli (New York: Scribners, 1994), 28. Here Cecilia refers to a paper she wrote at Bennington College called "A Producer's Day."

2 Matthew H. Bernstein, "Era of the Moguls: The Studio System," in *The Wiley-Blackwell History of American Film,* vol. 2, ed. Cynthia Lucia, Roy Grundman, and Art Simon (West Sussex: Wiley-Blackwell, 2012), 52.

3 Fitzgerald, *The Love of the Last Tycoon,* 43.

4 Ibid., 42.

5 Ibid., 58.

6 Thomas Schatz, *The Genius of the System* (New York: Pantheon Books, 1988), 7.

7 Peter Lev, *Twentieth Century–Fox: The Zanuck-Skouras Years, 1935–1965* (Austin: University of Texas Press, 2013), 102–103.

8 John Belton, *American Cinema/American Culture* (New York: McGraw-Hill, 2013), 78.

9 It is worth noting that in the early years of MGM, producers did not take credit. The power of the producer is reflected in Irving Thalberg's famous pronouncement, as quoted by Fitzgerald in endnotes to *The Love of the Last Tycoon,* 149: "If you are in a position to give credit to yourself then you do not need it." This policy changed after Thalberg's death in 1936.

10 Harry Rapf's scrapbook, in possession of the author's family.

11 Newspaper story by Florence Lawrence in the Harry Rapf scrapbook.

12 Bosley Crowther, *The Lion's Share: The Story of an Entertainment Empire* (New York: E. P. Dutton, 1957), 35.

13 The production file can be found at the USC library.

14 *Film Daily,* September 15, 1936, 7.

15 Schatz, *The Genius of the System,* 258.

16 In *Moving Pictures: Memoir of a Hollywood Prince* (New York: Stein and Day, 1981), 444. Schulberg's son, the writer Budd Schulberg, said of his father that "B. P. had the charm and intelligence to win a thousand arguments."

17 David Thomson, *Showman: The Life of David O. Selznick* (New York: Alfred A. Knopf, 1992), 96–97, 99, 115.

18 Ibid., 141.

19 Ibid., 178.

20 Ibid., 179.

21 Observing the youthful subjects of Selznick's films, Ben Hecht presumably commented, "The trouble with you, David, is that you did all your reading before you were twelve." Quoted in Ethan Morden, *The Hollywood Studios: House Style in the Golden Age of the Movies* (New York: Alfred A. Knopf, 1988), 205.

22 *A Star Is Born* won a special Oscar for the Technicolor cinematography by W. Howard Greene.

23 Quoted in Rudy Behlmer, ed., *Memo from David O. Selznick* (New York: Modern Library, 2000), xxv.

24 *New York Times,* June 23, 1965.

25 Frederica Maas, *The Shocking Miss Pilgrim: A Writer in Early Hollywood* (Lexington: University Press of Kentucky, 1999), 53.

26 Ibid., 146.

27 John Baxter, *Von Sternberg* (Lexington: University Press of Kentucky, 2010), 63.

28 Ibid., 154.

29 Bernstein, "Era of the Moguls: The Studio System," 39–40.

30 John C. Moffitt, "The Experts Derided Mae West," *Straits Times,* November 4, 1934, 4.

31 Kathy Huffines, "First Person Feminine," *Boston Phoenix,* May 1, 1984, 35.

32 Sam Warner died in 1927.

33 *The Film Spectator,* July 21, 1928, 7.

34 Cass Warner Sperling and Cork Millner, with Jack Warner Jr., *Hollywood Be Thy Name: The Warner Brothers Story* (Rocklin, CA: Prima Publishing, 1994), 166.

35 Ibid., 182.

36 Aljean Harmetz, *Round Up the Usual Suspects: The Making of Casablanca—Bogart, Bergman, and World War II* (New York: Hyperion, 1992), 28.

37 Ibid., 28.

38 Sperling and Millner, *Hollywood Be Thy Name*, 226.

39 Ibid., 216.

40 All the studios had story departments with dozens of readers who would comb through books, magazines, articles, and newspapers for ideas, then send one-page synopses to the studio heads.

41 Sperling and Millner, *Hollywood Be Thy Name*, 217–218.

42 Disney created Mickey Mouse in 1928.

43 Steven Alan Carr, *Hollywood and Anti-Semitism: A Cultural History up to World War II* (Cambridge: Cambridge University Press, 2001), 66, 84–85, 131, 156–157.

44 Ibid., 272.

45 Ibid., 204.

46 During the first year of his contract, Wallis made six films, but only three in the second when in 1944 the rivalry between him and Jack Warner resulted in the cancellation of the contract. Wallis spent the following twenty-five years working as an independent producer at Paramount. Among the first screenwriters with whom he worked there were the diverse personalities of liberal playwright Lillian Hellman and conservative guru Ayn Rand. Wallis made Rand's *The Fountainhead* (King Vidor, 1949).

47 Sperling and Millner, *Hollywood Be Thy Name*, 247.

48 Harmetz, *Round Up the Usual Suspects*, 29, 136, 167, 169.

49 Ibid., 238.

50 Ibid., 233.

51 Quoted in ibid., 234–235.

52 Sperling and Millner, *Hollywood Be Thy Name*, 249.

53 Harmetz, *Round Up the Usual Suspects*, 322.

54 Sperling and Millner, *Hollywood Be Thy Name*, 256.

55 Harmetz, *Round Up the Usual Suspects*, 24.

56 Quoted in Richard B. Jewell, *RKO Pictures: A Titan Is Born* (Berkeley: University of California Press, 2012), 10.

57 Ibid., 108.

58 Ibid., 120.

59 Ibid., 76.

60 Quoted in ibid., 120.

61 DeWitt Bodeen, "Val Lewton," *Films in Review* 14, no. 4 (April 1963): 210.

62 Ibid., 215.

63 Joel Siegel, *The Reality of Terror* (New York: Viking Press, 1973), 41.

64 Ibid., 32.

65 Gregory Mank, *Women in Horror Films, 1940s* (Jefferson, NC: McFarland & Company, 1999), 105.

66 Sarah Kozloff, *The Best Years of Our Lives* (London: Palgrave Macmillan, 2011), 28.

67 Lev, *Twentieth Century–Fox,* 17.

68 *Hollywood Reporter* 14, no. 2 (April 15, 1933): 1.

69 *Hollywood Filmograph* 13, no. 16 (April 29, 1933): 1.

70 *Hollywood Filmograph* 13, no. 18 (June 24, 1933): 3. In fact, the company succeeded in turn-ing out thirteen pictures during the 1933–34 season, including *The House of Rothschild* (Alfred L. Werker, 1934), which was nominated for Best Picture. The reference to small stature refers to the fact that Zanuck was only 5 feet, 6 inches tall.

71 George Custen, *Twentieth Century's Fox: Darryl F. Zanuck and the Culture of Hollywood* (New York: Basic Books, 1997), 275.

72 *New York Times,* August 2, 1944.

73 Maas, *The Shocking Miss Pilgrim,* 142.

74 Rudy Behlmer, ed., *Memo From Darryl F. Zanuck: The Golden Years at Twentieth Century-Fox* (New York: Grove Press, 1993), 51–52.

75 Ibid., 54.

76 Lev, *Twentieth Century-Fox,* 45.

77 Quoted in ibid., 46.

78 Matthew Bernstein, *Walter Wanger: Hollywood Independent* (Minneapolis: University of Minnesota Press, 2000).

79 Lev, *Twentieth Century-Fox,* 45.

80 *Film Daily,* January 15, 1935, 26.

81 Foster Hirsch, *Otto Preminger: The Man Who Would Be King* (New York: Alfred A. Knopf, 2007), 135.

82 Behlmer, *Memo From Darryl F. Zanuck,* 75–77.

83 Ibid.

84 Harry Rapf's scrapbook.

3 Postwar Hollywood, 1947–1967

1 Leo C. Rosten, *Hollywood the Movie Colony, the Movie Makers* (New York: Harcourt Brace, 1941), 230–280.

2 Robert Sklar, *Movie-Made America: A Cultural History of American Movies* (New York: Random House, 1994), 46.

3 Rosten, *Hollywood the Movie Colony,* 275.

4 Ibid., 278.

5 Dore Schary, *Case History of a Movie as Told to Charles Palmer* (New York: Random House, 1950), 11. The case study for this book was William Wellman's *The Next Voice You Hear* (1950).

6 Dore Schary, "Exploring the Hollywood Myth," *New York Times Sunday Magazine,* May 9, 1950, 5, 40.

7 See Gerald Horne, *Class Struggle in Hollywood 1930–1950: Moguls, Mobsters, Stars, Reds, and Trade Unionists* (Austin: University of Texas Press, 2001).

8 *New York Times,* September 5 1953, 7.

9 Sklar dated this golden age of order from 1935 to 1941. Sklar, *Movie-Made America,* 175, 187.

10 See Robert Sklar, "Hollywood about Hollywood: Genre as Historiography," in *Hollywood and the American Historical Film,* ed. J. E. Smyth (New York: Palgrave, 2011), 71–93.

11 *Los Angeles Times,* May 9, 1947, 1.

12 Ibid.

13 *Los Angeles Times,* May 16, 1947, 1 and 2.

14 Marsha Hunt thought that Adrian Scott was the "new Thalberg," and Schary was similarly anointed when Nicholas Schenck recruited him as a head of production at MGM in 1949. On Scott, see Paul Buhle and Patrick McGilligan, *Tender Comrades* (New York: St. Martin's Press, 1997), 318. On Schary, see Thomas Schatz, *Boom and Bust: The American Cinema in the 1940s* (Berkeley: University of California Press, 1997), 336–337.

15 See Rebecca Prime, *Hollywood Exiles in Europe: The Blacklist and the Cold War Film Culture* (New Brunswick, NJ: Rutgers University Press, 2013), 31–32.

16 Buhle and McGilligan, *Tender Comrades,* 497 and 712.

17 On Scott, see Jennifer Langdon-Teclaw, "The Progressive Producer in the Studio System: Adrian Scott at RKO, 1937–1947," in *Un-American Hollywood: Politics and Film in the Blacklist Era,* ed. Frank Krutnik, Steve Neele, Brian Neve, and Peter Stanfield (New Brunswick, NJ: Rutgers University Press, 2007), 152–169.

18 Haden Guest, "Hollywood at the Margins: Samuel Fuller, Phil Karlson, and Joseph H. Lewis," in *The Wiley Blackwell History of American Film,* vol. 3, *1946–1975,* ed. Cynthia Lucia, Roy Grundmann, and Art Simon (Oxford: Wiley Blackwell, 2012), 158–176.

19 See George F. Custen, *Twentieth Century's Fox: Daryl F. Zanuck and the Culture of Hollywood* (New York: Basic Books, 1997), 314–316.

20 *Los Angeles Times,* October 30, 1947, 1, 2.

21 Dore Schary, *Heyday: An Autobiography* (Boston: Little, Brown, 1979), 166–167.

22 *New York Times,* November 26, 1947, 1, 27.

23 Matthew Bernstein, *Walter Wanger, Hollywood Independent* (Berkeley: University of California Press, 1994), 227–228.

24 See Daniel Spoto, *Stanley Kramer: Filmmaker* (New York: G. P. Putnam's, 1978), 75–76. See also Stanley Kramer, with Thomas M. Coffey, *A Mad, Mad, Mad, Mad World: A Life in Hollywood* (New York: Harcourt Brace, 1997), 86–87.

25 Schatz, *Boom and Bust,* 323.

26 Ibid., 290.

27 bid.

28 Tino Balio, ed., *The American Film Industry* (Madison: University of Wisconsin Press, 1985), 401.

29 See Gallup data in Gene Brown, *Movie Time: A Chronology of Hollywood from Its Beginnings to the Present Time* (New York: Macmillan, 1995), 193.

30 *Variety,* May 14, 1952, 18. See also *New York Times,* May 9, 1952, 20.

31 See George Roeder, *The Censored War* (New Haven, CT: Yale University Press, 1993).

32 M. Todd Bennett, *One World, Big Screen: Hollywood, the Allies, and World War II* (Chapel Hill: University of North Carolina Press, 2012), 16–17.

33 *New York Times,* January 2, 1942, 25.

34 Cited in Ian Jarvie, "The Postwar Economic Foreign Policy of the American Film Industry, Europe 1945–1950," *Film History* 4 (1990): 279.

35 Schatz, *Boom and Bust,* 289.

36 David Ellwood, *The Shock of America* (Oxford: Oxford University Press, 2012), 312.

37 Cited in Jarvie, "The Postwar Economic Foreign Policy," 280.

38 The irony did not escape Thomas Schatz. See his *Boom and Bust,* 289.

39 *Variety,* April 7, 1948, 3 and 23.

40 *New York Times,* January 17, 1948, 1. On the Smith-Mundt Act see also Richard Pells, *Not Like Us* (New York: Basic Books, 1997), 62–63.

41 The currency issue was in fact crucial as foreign governments often objected to the repatriation of studios' profits abroad as it denuded their dollar reserve.

42 Tony Judt, *Postwar: A History of Europe since 1945* (New York: Penguin, 2005), 91.

43 *Variety,* April 7, 1948, 23.

44 Cited in Judt, *Postwar,* 94.

45 Christopher Wagstaff, "Italy in the Post-War International Cinema Market," in *Italy in the Cold War: Politics, Culture, and Society 1948–54* , ed. Christopher Duggan and Christopher Wagstaff (Oxford: Berg, 1995), 95.

46 Ruth Vasey, *The World According to Hollywood* (Madison: University of Wisconsin Press, 1997), 7.

47 Schatz, *Boom and Bust,* 303.

48 *Variety,* January 23, 1957, 1.

49 John Izod, *Hollywood and the Box Office 1895–1986* (New York: Columbia University Press, 1988), 158.

50 Miriam Bratu Hansen, "Fallen Women, Rising Stars, New Horizons: Shanghai Silent Film as Vernacular Modernism," *Film Quarterly* 54, no. 1 (Fall 2000): 10.

51 Dorothy B. Jones, "Foreign Sensibilities Are Even More Unpredictable than Foreign Quota and Currency Restrictions," *Films in Review* 6, no. 9 (1955): 449–451. See also Thomas H. Guback, *The International Film Industry: Western Europe and America since 1945* (Bloomington: Indiana University Press, 1969), 4.

52 *Variety,* November 16, 1955, 7.

53 *Variety,* March 14, 1956, 4.

54 Judt, *Postwar,* 86–90.

55 The quotation is from a 1943 essay by the Italian anti-Fascist intellectual Giaime Pintor, "La lotta verso gli idoli," in Giaime Pintor, *Il sangue d'Europa (1939–1943),* ed. Valentino Giarratana (Turin: Einaudi, 1950), 216.

56 Carlo Salinari, "La lotta dei comunisti per una cultura libera, moderna e nazionale," in *Per la costituzione democratica e per una libera cultura. Rapporti alla sessione del CC del PCI del 10–12 novembre 1952,* ed. Palmiro Togliatti, Luigi Longo, and Carlo Salinari (Rome: Partito Comunista Italiano, 1953), 112.

57 "Byrne Enters the Motion Pictures Producers Association as Counsel," *Variety,* June 3, 1947, 6.

58 *L'Unità,* March 5, 1948, 3.

59 Schatz, *Boom and Bust,* 299–300.

60 Jean-Pierre Jeancolas, "From the Blum-Byrnes Agreement to the GATT Affair," in *Hollywood & Europe: Economics, Culture, National Identity 1946–1996,* ed. Geoffrey Nowell-Smith and Steven Ricci (London: BFI, 1998), 47–59.

61 Italian and U.S. negotiators agreed that twenty days out of each quarter in the fall, winter, and spring (the summer months were not considered as they traditionally produced a very low box office) would be devoted to Italian productions. Wagstaff, "Italy in the Post-War International Cinema Market," 89–115.

62 The best account of this economic negotiation is Barbara Corsi, *Con qualche dollaro in meno. Storia Economica del Cinema Italiano* (Rome: Editori Riuniti, 2002).

63 *Los Angeles Times,* June 3, 1946, A1.

64 See Corsi, *Con qualche dollaro in meno,* 48–68. The best account in English is Wagstaff, "Italy in the Post-War International Cinema Market," 105–107.

65 On the film studios in Tirrenia much less is known than about Cinecittà. See Giuseppe Meucci, *La città dei sogni. Dalla Pisorno alla Cosmopolitan* (Pisa: Pacini, 2005).

66 Douglas Bankston, "Wrap Shot," *American Cinematographer* 81, no. 5 (May 2000): 152.

67 *Variety,* November 3, 1952, 18.

68 Prime, *Hollywood Exiles in Europe,* 59–82.

69 Ibid.

70 Stephen Watts, "Camera on *Night and the City* in London," *New York Times,* October 2, 1949, X5. See also Prime, *Hollywood Exiles in Europe,* 59–82. A fresh interpretation for the appeal of location shooting in runaway production is in Daniel Steinhart, "Paris . . . As You've Never Seen It Before!!!": The Promotion of Hollywood Foreign Productions in the Postwar Era," *Media* 3 (2013), http://inmedia.revues.org/633.

71 Stephen Gundle, *Glamour: A History* (New York: Oxford University Press, 2008), 212.

72 *L'Unità,* August 21, 1953, 3.

73 On *Three Coins in a Fountain* see Steinhart, "Paris . . . As You've Never Seen It Before!!!," 32.

74 Cited in Neal Moses Rosendorff, "Hollywood in Madrid: American Film Producers and Franco's Spain, 1950–1970," *Historical Journal of Film, Radio, and Television* 27, no. 1 (March 2007): 85.

75 See Donald Spoto, *Stanley Kramer: Filmmaker* (New York: G. P. Putnam, 1978), 187–197. Kramer is cited in Tino Balio, *United Artists,* vol. 2, *1951–1978: The Company That Changed the Film Industry* (Madison: University of Wisconsin Press, 2009), 143.

76 Thomas Schatz, "The New Hollywood," in *Movie Blockbusters,* ed. Julian Stringer (London: Routledge, 2003), 18–44.

77 Tino Balio, "Introduction to Part I," in *Hollywood in the Age of Television,* ed. Tino Balio (Cambridge: Unwyn, 1990), 10. Independents had produced 20 percent of the 234 pictures released by the eight majors in 1949.

78 See Wheeler Winston Dixon, *Death of the Moguls: The End of Classical Hollywood* (New Brunswick, NJ: Rutgers University Press, 2012).

79 On the sale of the TCF lots to William Zeckendorf, the developer of Los Angeles Century City, see *Los Angeles Times,* December 16, 1958, 21. On the sale of part of the MGM lot to James Thomas Aubrey and Culver City, see *Los Angeles Times,* June 5, 1970, 12.

80 See Hal Wallis, with Charles Higham, *Starmaker: The Autobiography of Hal Wallis* (New York: Macmillan, 1980), 113–114, and "Hal Wallis," in George Stevens Jr., *Conversations with the Great Moviemakers of Hollywood's Golden Age at the American Film Institute* (New York: Alfred A. Knopf, 2006), 590.

81 On Kramer's first contract at UA see Balio, *United Artists,* vol. 2, 141–143.

82 Katharine Hamill, "The Supercolossal—Well, Pretty Good—World of Joe Levine," *Fortune,* April 1964, 130. Also by Hamill, who was hired by *Fortune* as a research assistant in 1931: "Women as Bosses," *Fortune* (1956), http://0-features.blogs.fortune.cnn.com.library.ccb-cmd.edu/2012/09/23/women-as-bosses-fortune-1956/.

83 Tom Kemper, *Hidden Talent: The Emergence of the Hollywood Agents* (Berkeley: University of California Press, 2010), 219–220.

84 Edward Jay Epstein, *The Big Picture: The New Logic of Money and Power in Hollywood* (New York: Random House, 2005), 37.

85 Balio, "Introduction to Part I," 10.

86 Jarvie, "The Postwar Economic Foreign Policy of the American Film Industry," 286.

87 n 1965 *Esquire* joked about the producer's crash diet. See "Joe Levine's Crash Diet," *Esquire* 63 (January 1965): 99.

88 Hamill, "The Supercolossal—Well, Pretty Good—World of Joe Levine," 130–132 and 178–185. Quote comes from 130.

89 Kevin Heffernan, *Ghouls, Gimmicks, and Gold: Horror Films and the American Movie Business 1953–1968* (Durham, NC: Duke University Press, 2004), 5.

90 *Variety,* February 22, 1956, 18. See also Peter H. Brothers, *Mushroom Clouds and Mushroom Men: The Fantastic Cinema of Ishiro Honda* (Bloomington, IN: Authorhouse, 2009), 72.

91 See both versions in the *Godzilla* DVD released by Criterion in 2012.

92 The figure comes from Gay Talese, "Joe Levine Unchained: A Candid Portrait of a Spectacular Showman," *Esquire* 55 (January 1961): 65.

93 *Variety,* April 4, 1956, 21, and April 18, 1956, 13. On saturation opening see Justin Wyatt, *High Concept: Movies and Marketing in Hollywood* (Austin: University of Texas Press, 1994).

94 *Variety,* June 17, 1956, 4.

95 *New York Times,* April 28, 1956, 11; *Variety,* April 25, 1956, 6.

96 See Thomas Schatz, "The New Hollywood," in *Movie Blockbusters,* ed. Julian Stringer (London: Routledge, 2003), 18.

97 A. T. McKenna, "Joseph E. Levine: Showmanship, Reputation, and Industrial Practice, 1945–1975" (Ph.D. diss., University of Nottingham, 2008).

98 Heffernan, *Ghouls, Gimmicks, and Gold,* 115. On the success of foreign films in the United States, see Tino Balio, *The Foreign Film Renaissance on American Screens, 1946–1973* (Madison: University of Wisconsin Press, 2010).

99 Cited in Gian Piero Brunetta, *Buio in sala. Cent'anni di passione dello spettatore cinematografico* (Venice: Marsilio, 1989), 163.

100 Tino Balio, "New Producers for Old: United Artists and the Shift to Independent Production," in Balio, *Hollywood in the Age of Television,* 165.

101 *Variety,* December 10, 1958, 7; Gay Talese, "Joe Levine Unchained: A Candid Portrait of a Spectacular Showman," *Esquire* 55 (January 1961): 65–68.

102 See Levine's profile in the *New Yorker* where Levine boasts to have advertised the movie to thirty-six "beefcake mags," the kind "newsdealers sometimes carry hidden away beneath the counter." Calvin Tomkins, "Profiles: The Very Rich Hours of Joe Levine," *New Yorker,* September 16, 1967, 56.

103 The figure comes from *Fortune,* March 1964, 131. In 1977 *Hercules* was still among *Variety*'s "All Time Film Rentals Champs." *Variety,* January 5, 1977, 16ff.

104 Tino Balio, "Introduction," in Balio, *Hollywood in the Age of Television,* 20, and Timothy R. White, "Hollywood's Attempt at Appropriating Television: The Case of Paramount Pictures," in Balio, *Hollywood in the Age of Television,* 165, 184.

105 Cited in Custen, *Twentieth Century's Fox,* 318.

106 *Fortune,* March 1964, 131.

107 *New Yorker,* September 16, 1967, 102.

108 Ibid., 58.

109 Balio, "Introduction to Part I," 7. See also Balio, *Foreign Film Renaissance.*

110 Unesco listed 215 films for Hollywood and 258 for Italy. See Unesco, *Statistics on Film and Cinema 1955–1977* (Paris: Division of Statistics on Culture and Communication, 1981). Many of them were coproductions with the United States. See David Forgacs and Stephen Gundle, *Mass Culture and Italian Society from Fascism to the Cold War* (Bloomington: Indiana University Press, 2007), 142.

111 Though Levine helped market *Le mépris* (*Contempt,* 1963), he was likely the model for the quintessential American producer (played by Jack Palance) disparaged in the film.

112 *L'Unità,* February 23, 1963, 7. All translations are mine unless directly specified otherwise.

113 Tomkins, "The Very Rich Hours of Joseph Levine," 55–57.

114 Balio, *United Artists,* vol. 2, 1.

115 See Balio, "New Producers for Old," 168.

116 This was a bizarre proposition and the film ended up absolving Italy of most of the crimes committed by Italian troops in the invasion. On the mythology of the Italiano brava gente ("Italian nice folks") and its recent articulations, see my "Soccer with the Dead: *Mediterraneo* and the Myth of *Italiani Brava Gente,*" in *Re-picturing the Second World War,* ed. Mike Paris (London: Palgrave, 2008), 55–70.

117 On *Bitter Rice*'s success in the United States, see Balio, *Foreign Film Renaissance,* 59.

118 On the experience of blacklistees in Italy, see Giuliana Muscio, "Lista nera sul Tevere," *Acoma* 7 (Spring 1996): 50–62, and Prime, *Hollywood Exiles in Europe.*

119 Grigori Ciukhrai to De Santis, September 5, 1962, Giuseppe De Santis Papers, folder 16 (Italiano Brava Gente), Centro Sperimentale di Cinematografia, Cinecittà, Rome.

120 De Santis to "Nano," no date (probably1962), ibid.

121 Carlo Lizzani diary entry, dated July 19, 1963, in Carlo Lizzani, *Attraverso il novecento* (Turin: Lindau, 1998), 95.

122 Chris Chase, "Peter Picked a Pip," *New York Times,* November 28, 1971, D1.

123 De Santis to "cari amici," May 1963, and J. Raisman and N. Glagoleva to De Santis, no date, Giuseppe De Santis Papers, folder 16 (Italiano Brava Gente).

124 *New York Times,* August 30, 1964, X9.

125 *New York Times,* October 31, 1965, X13.

126 *L'Unità,* September 25, 7.

127 *New York Times,* February 2, 1966, 20.

128 *New York Times,* February 13, 1966.

129 *Los Angeles Times,* May 17, 1964, Y1.

130 Kramer, *A Mad, Mad, Mad, Mad World,* 121.

131 Balio, "New Producers for Old," 165. See also his *United Artists,* vol. 2.

132 Rosendorff, "Hollywood in Madrid," 85–87.

133 On Bronston's career in Spain see Rosendorff, "Hollywood in Madrid," 77–109. See also Mel Martin, *The Magnificent Showman: The Epic Films of Samuel Bronston* (Albany, GA: Bear Manor Media, 2007).

134 On Wallis's work in *Rose Tattoo* and *Wild Is the Wind* (George Cukor, 1957), the second film he made with Magnani, see Hal Wallis, with Charles Higham, *Starmaker,* 127–135.

135 Cited in Balio, *Foreign Film Renaissance,* 229.

136 William Murray, *The Fugitive Romans* (New York: Vanguard, 1955). But see also Hank Kaufman and Gene Lerner, *Hollywood sul Tevere* (Rome: Sperling & Kupfer, 1980).

137 Rosendorff, "Hollywood in Madrid," 96.

138 Sklar, *Movie-Made America,* 321.

139 Marshall Berman, *All That Is Solid Melts into Air: The Experience of Modernity* (New York: Penguin, 1988). Of course, the original phrase is in Karl Marx and Friedrich Engels, *Manifesto of the Communist Party,* trans. Samuel Moore (1848; Chicago: Charles H. Kerr, 1906), 17.

4 The Auteur Renaissance, 1968–1980

1 After sporting record profits of $120 million in the first full year after the war, studio profits fell steadily: to $87 million in 1947, $49 million in 1948, $34 million in 1949, and $31 million in 1950. This decrease in profits corresponded to a similarly steady box office decline: a 43 percent drop from a high of $1.7 billion in 1946 to a low of $955 million in 1961. In 1947, 90 million Americans went to the movies every week. By 1957 average weekly attendance had fallen to 40 million. The box office turnaround began in 1972 and seemed in full effect for all of the major studios by 1975.

2 Lynda Obst, *Hello, He Lied: And Other Truths from the Hollywood Trenches* (Boston: Little, Brown, 1996), 89, 142.

3 A partial list of auteur era histories that focus extensively on movie directors: Michael Pye and Lynda Miles, *The Movie Brats: How the Film Generation Took over Hollywood* (New York: Holt, Rinehart, 1979); Robert Kolker, *A Cinema of Loneliness* (Oxford: Oxford University Press, 1988); Robin Wood, *Hollywood from Vietnam to Reagan* (New York: Columbia University Press, 1986); Peter Biskin, *Easy Riders, Raging Bulls: How the Sex-Drugs-and-Rock-and-Roll Generation Saved Hollywood* (New York: Simon and Schuster, 1999).

4 Andre Bazin's essay "La politique des auteurs" first appeared in the April 1957 issue of the *Cahiers du Cinéma*. The essays argued that a rare few Hollywood directors were able to transcend the studio system by imposing their particular artistic signature on "their" films. Several editors and writers from *Cahiers* went on to become filmmakers who together formed the French New Wave: François Truffaut, Jean-Luc Godard, Jacques Rivette, Claude Chabrol, and Eric Rohmer.

5 See Jon Lewis, *The Godfather* (London: BFI, 2010). The argument presented in this earlier work is the basis here for the discussion of Coppola's and Evans's work on the film.

6 The phrase "Bluhdorn's blow job" was coined by Jack Rosenstein, the publisher and editor of the tabloid *Hollywood Close-Up*.

7 "Paramount Studio Buy Talks, But No Deal Yet into Focus; Realty Value Runs $29–32 Mil," *Variety,* April 8, 1970, 5.

8 Puzo contests Evans's account. In fact, when the book first came out, Puzo famously denied ever having met a gangster.

9 Coppola would later echo the comparison to Harold Robbins, though he and Weiser had very different impressions of Robbins's work. See Peter Cowie, "The Whole *Godfather,*" *Connoisseur* (December 1990): 90.

10 Complicating any history of producing in Hollywood is the inconsistent attribution of credit. Since Evans was Paramount's head of production, he did not seek a credit line on the final print. But by all accounts (including Coppola's), Evans supervised the production from development through distribution.

11 The latter remark was soon proven out: Coppola's screenplay for the recently released *Patton,* written with Edmund North, went on to win an Oscar in 1971.

12 Robert Evans, *The Kid Stays in the Picture* (New York: Hyperion, 1994), 220.

13 The screen tests can be seen in the DVD extras link on the 4-DVD "*Godfather* Collection." It's easy to see why Evans didn't much like them.

14 Evans, *The Kid Stays in the Picture,* 223–224.

15 Coppola may not want to name names, but he is most likely referring to studio president Stanley Jaffe.

16 Francis Coppola as quoted in Michael Sragow, "Godfatherhood," *New Yorker,* March 24, 1997, 48.

17 Gene Arneel, "Cut Directors Down to Size: Bob Evans: 'We Keep Control,'" *Variety,* February 3, 1971, 1, 22.

18 Julie Saloman, "Budget Busters: *The Cotton Club*'s Battle of the Bulge," *Wall Street Journal*, December 13, 1984, 22.

19 Peter Bart, in his introduction to *The Kid Stays in the Picture*, xiv.

20 In fact, Coppola was so weary of dealing with Evans, he initially turned down an offer to direct the sequel, recommending to the studio that they should hire Martin Scorsese.

21 The comment about "throwing out Nino Rota's music" is slightly exaggerated, but basically accurate. Evans had wanted to use the light-jazz composer Henry Mancini (most famous today for the *Pink Panther* theme). Bart had separately contracted with Nino Rota, and Coppola, who wanted to use Italian talent as much as possible, sided with Bart. Rota had worked previously with Luchino Visconti and Federico Fellini, both legendary Italian auteurs, credits that the former film student Coppola no doubt appreciated. Peter Biskind, *The Godfather Companion* (New York: Harper Perennial, 1990), 16.

22 Evans, *The Kid Stays in the Picture*, 338.

23 Coppola had cut the footage because his contract called for a running time under 125 minutes. If he failed to deliver a rough cut under this predetermined running time, the studio had the right to hire someone else to supervise cutting the film down to size.

24 "deadCENTER 2012: A Conversation with Al Ruddy," filmed at the deadCENTER Film Festival in Oklahoma City, June 20, 2012, http://www.youtube.com/watch?v=DqgC-uP7b2g.

25 "Yes Mr. Ruddy, There Is a . . ." (editorial), *New York Times*, March 23, 1971, 36. U.S. attorney general (and later Watergate conspirator) John Mitchell surprisingly announced that he would follow Ruddy's lead. He ordered the Justice Department to stop using the terms as well. As with the complex deals made between organized crime figures and politicians depicted in *The Godfather: Part II*, it is fair to wonder why a person in Mitchell's position would want to help buoy mob public relations. That said, for years, FBI chief J. Edgar Hoover had contended that the mob was a media concoction, that the Mafia didn't really exist. Rumor has it that he made such a ridiculous claim because the mob had proof (pictures!) revealing Hoover's secret indulgence for wearing women's clothes. Might we wonder what the mob had on Mitchell?

26 "Par Repudiates Italo-Am. Group v. 'Godfather,'" *Variety*, March 24, 1971. Evans makes reference to John Mitchell's decision, on behalf of the Justice Department, to stop using the terms "Mafia" and "Cosa Nostra" as justification for the Paramount deal with the Italian-American Civil Rights League.

27 Julia Phillips, *You'll Never Eat Lunch in This Town Again* (New York: Signet, 1991), 203.

28 Ibid., 204.

29 Ibid., 205.

30 Ibid., 284.

31 Paul Schrader, *Taxi Driver* (London: Faber and Faber, 1990), 86.

32 Amy Taubin, *Taxi Driver* (London: BFI, 2000), 11–12.

33 Phillips, *You'll Never Eat Lunch in This Town Again*, 231.

34 Ibid.

35 The next woman to win an Oscar as a producer would be Lili Fini Zanuck for *Driving Miss Daisy*, directed by Bruce Beresford in 1989, fifteen years after Phillips's win for *The Sting*.

36 Michael (Mike) De Luca was named head of production at New Line Cinema in 1993 at the age of just twenty-seven. A well-earned reputation as a "party animal" and a string of bad films led to his firing by Time Warner boss Gerald Levin. But unlike Phillips, after De Luca got his life under control he was welcomed back, and his second act as a Hollywood producer has been even more impressive than his first, including credits for producing David Fincher's *The Social Network* (2010) and Paul Greengrass's *Captain Phillips* (2013), both nominated for Best Picture Oscars.

37 The *Heaven's Gate* production budget is routinely reported at $44 million. Even the most generous accounting of the film's box office in its three separate limited releases is less than $4 million.

38 Steven Bach, *Final Cut: Dreams and Disaster in the Making of Heaven's Gate* (New York: New American Library, 1985), 123.

39 UA executives laid out a complex financial arrangement with Coppola, exchanging control of the film's copyright and responsibility for its costs (as part of a loan agreement with the studio) for domestic distribution rights. The deal was a big mistake; Coppola made a fortune on the film and UA looked dumb in backing out on such a terrific film.

40 Gay Talese, "The Conversation," *Esquire,* July 1981, 80.

41 Bach, citing Katz's memo and paraphrasing Carelli's response to UA executive David Field, in *Final Cut,* 243–244.

42 Ibid., 243.

43 Ibid., 326.

44 Ibid., 370, 371.

45 Paul Slansky, *The Clothes Have No Emperor,* VidLit Press e-book, http://www.theclothes-havenoemperor.com/index.php/read-first-chapter-2/.

46 Boyum, cited by Bach, *Final Cut,* 410.

47 Roger Watkins, "Arkoff Warns of 1969 Repeat," *Variety,* May 21, 1980, 34.

48 Like a lot of seventies *auteurs,* De Palma worked for Arkoff early in his career. De Palma's conjoined-twin horror picture *Sisters* was shot for AIP in 1973.

49 Orion acquired and liquidated Filmways in June 1982.

50 "De Palma, Litton Going to Trial in October with Orion over *Dressed to Kill,*" *Variety,* July 19–25, 1989, 12, 17.

51 Studios—even smaller studios like AIP—routinely purchase completed pictures for distribution. These films are termed "negative pick-ups" and to an extent benefit both parties; the studio gets to release a film that it has seen in its final form, and the producer(s) of the film get to sell off the distribution rights to the film in exchange for an immediate, no-risk payoff.

52 Stephen Klain, "Arkoff as Producer of Which Few Remain in Age Dominated by Deal Makers," *Variety,* May 27, 1981, 37.

53 Samuel Arkoff with Richard Trubo, *Flying through Hollywood by the Seat of My Pants* (New York: Birch Lane Press, 1992), 241.

5 The New Hollywood, 1981–1999

1 The subtle changes in the name of the studio, initially called the Universal Film Manufacturing Company when it was founded by Carl Laemmle in 1912 and known ever since under its shorthand moniker "Universal," are important in that they reflect serial changes in corporate ownership. In the era under examination here, the studio was known officially as Universal Pictures, the corporate designation adopted after the MCA takeover in 1962.

2 See Douglas Gomery, "Industrial Analysis and Practice," in *The Hollywood Blockbuster,* ed. Julian Springer (London: Routledge, 2003), 72–82.

3 Kathleen Sharp, *Mr. and Mrs. Hollywood* (New York: Carroll & Graf Publishers, 2004), 451. See also the documentary *A Look Back at Howard the Duck,* directed by Willard Huyck and Gloria Katz (2009).

4 David E. Williams, "A Exceptional Encounter," *American Cinematographer* (January 1983): 34–37.

5 The autobiographical implications of this B-story are worth mentioning here as well; Spielberg's parents divorced when he was a teenager and several of his films involve the complex dynamics of single-parent families.

6 *Matsushita Electrical Industrial Company, Ltd.,* Annual Reports, 1990 and 1991.

7 Joseph McBride, *Steven Spielberg* (New York: DaCapo, 1997), 416–434.

8 Richard Natale, "Lew Wasserman at 80: A Firm Hand at the Helm," *Variety,* March 17, 1993, 17.

9 The public and industry assumptions about the box office for *Waterworld* are contradictory. The film was (and is) widely assumed to have been a bomb, but a more sober accounting reveals that the film grossed in the neighborhood of $265 million worldwide against a production budget of $175 million. Assuming reasonable promotion and advertising costs, the film most likely broke even. *Jurassic Park,* by comparison, was a blockbuster hit: over $1 billion in worldwide box office against a production budget of just under $65 million.

10 Bernard F. Dick, *Columbia Pictures* (Lexington: University Press of Kentucky, 1992), 33–40.

11 Andrew Yule, *Fast Fade: David Puttnam, Columbia Pictures, and the Battle for Hollywood* (New York: Delacorte, 1989), and Charles Kipps, *Out of Focus: Power, Pride, and Prejudice—David Puttnam in Hollywood* (New York: Century, 1989).

12 "The Strategy for the 1980s," Coca-Cola Company, Form 10-K, 1982, 2.

13 David Puttnam, *Movies and Money* (New York: Alfred A. Knopf, 1998), 270.

14 Ibid., 31.

15 Charles Kipps, "The Rise and Fall of the Coca Cola Kid," *Variety,* May 18, 1988, 7.

16 Pat Broeske, "Puttnam vs. Columbia . . . the Sequel: The Studio Tells Its Side in *Variety,*" *Los Angeles Times,* May 19, 1988, http://articles.latimes.com/1988–05–19/entertainment/ca-4735_1_david-puttnam.

17 http://www.lukeford.net/profiles/profiles/stacey sher.htm.

18 Wesley Clarkson, *Quentin Tarantino: Shooting from the Hip* (Woodstock, NY: Overlook Press, 1995), 165–178.

19 Todd McCarthy, "*Pulp Fiction,*" *Variety,* May 30–June 5, 1994, 52.

20 Janet Maslin "*Pulp Fiction,*" *New York Times,* September 23, 1994, C1.

21 RogerEbert,"*PulpFiction,*"http://www.rogerebert.com/reviews/great-movie-pulp-fiction-1994.

22 John Brodie, "Script Grunts Trade Tales," *Variety,* November 14–20, 1994, 1, 61.

23 Dana Polan, *Pulp Fiction* (London: BFI, 2008).

24 Pat Dowell, "*Pulp Fiction,*" *Cineaste* 21, no. 3 (July 1995): 4.

25 Todd McCarthy, "*Erin Brockovich,*" *Variety,* http://variety.com/2000/film/reviews/erin-brockovich-2-1200461403/.

26 Thomas Doherty, "*Erin Brockovich,*" *Cineaste* 25, no. 3 (2000): 40–41.

27 Jeff Giles and David Ansen, "Pass Me an Oscar," *Newsweek,* February 5, 2001, 56.

28 Steve Daly, "Erin Brockovich: The Woman, the Myth, the Legend," *Entertainment Weekly,* February 23, 2001, http://www.ew.com/ew/article/0,,279950,00.html.

29 Patrick Goldstein, "The Trio Behind Jersey Films' Success," *Los Angeles Times,* March 23, 2001 B1.

30 "Jersey Films at 10," *Variety,* March 6, 2001, A1–A2.

6 The Modern Entertainment Marketplace, 2000–Present

1 http://www.producersguild.org/?page=history.

2 The PGA represents *individual* producers rather than companies. These individuals may include industry titans, but also jobbing craftspeople who are basically employees.

3 http://www.producersguild.org/?page=history.

4 Adam Davidson, "How Does the Film Industry Actually Make Money?," *New York Times,* June 26, 2012, http://www.nytimes.com/2012/07/01/magazine/how-does-the-film-industry-actually-make-money.html?r=0.

5 Pamela McClintock, "Box Office Report: 'Men in Black 3' Becomes Highest-Grossing Title in Franchise," *Hollywood Reporter,* http://www.hollywoodreporter.com/news/box-office-report-men-black-mib3-will-smith-tommy-lee-jones-josh-brolin-sony-343957.

6 We recommend http://meninblack3sunglasses.com/ for those blinded by the light.

7 "Sony's Loss Grows as Company Cuts Earnings Forecast," *Guardian,* August 2, 2012, http://www.theguardian.com/technology/2012/aug/02/sony-loss-grows-cuts-earnings-forecast.

8 http://criticalmanagement.org/.

9 John T. Caldwell, "Para-Industry: Researching Hollywood's Blackwaters," *Cinema Journal* 52, no. 3 (2013): 157–165.

10 A handful of examples among dozens, covering classical Hollywood to the end of the last century, might include Jamal Shamsie, Xavier Martin, and Danny Miller, "In with the Old, In with the New: Capabilities, Strategies, and Performance: Among the Hollywood Studios," *Strategic Management Journal* 30, no. 13 (2009): 1440–1452; Gino Cattani, Simone Ferriani, Marcello M. Mariani, and Stefano Mengoli, "Tackling the 'Galácticos' Effect: Team Familiarity and the Performance of Star-Studded Projects," *Industrial and Corporate Change* 22, no. 6 (2013): 1629–1662; Dean Keith Simonton, "Cinematic Success Criteria and Their Predictors: The Art and Business of the Film Industry," *Psychology & Marketing* 26, no. 5 (2009): 400–420; Allègre L. Hadida, "Commercial Success and Artistic Recognition of Motion Picture Projects," *Journal of Cultural Economics* 34, no. 1 (2010): 45–80; Greta Hsu, Giacomo Negro, and Fabrizio Perretti, "Hybrids in Hollywood: A Study of the Production and Performance of Genre-Spanning Films," *Industrial and Corporate Change* 21, no. 6 (2012): 1427–1450; Gino Cattani, Simone Ferriani, Marcello M. Mariani, and Stefano Mengoli, "Mixing Genres and Matching People: A Study in Innovation and Team Composition in Hollywood," *Journal of Organizational Behavior* 28, no. 5 (2007): 563–586.

11 How do we know these numbers? Hollywood accounting is notoriously opaque even as it is indiscreet: we learn a great deal about the cost of movies, especially blockbusters, in the bourgeois press, but the information frequently comes from publicity departments. Getting "real" figures on costs and revenue through the forms mentioned above is notoriously difficult. The one reliable, opportunistic avenue is a lawsuit where a blockbuster's accounts are subpoenaed. That rarely happens.

12 Organization for Economic Co-operation and Development (OECD), *Remaking the Movies: Digital Content and the Evolution of the Film and Video Industries* (Geneva: Organization for Economic Co-operation and Development, 2008), 16.

13 Ibid., 17.

14 Robert Verrier, "Paramount Stops Releasing Major Movies on Film," *Los Angeles Times,* January 18, 2014, http://www.latimes.com/entertainment/envelope/cotown/la-et-ct-paramount-end-to-film-20140118,0,806855.story; Robert Verrier, "Paramount to Make Some Exceptions to All-Digital Policy," *Los Angeles Times,* January 28, 2014, http://www.latimes.com/entertainment/envelope/cotown/la-et-ct-paramount-pictures-digital-20140128,0,276668.story#axzz2sLvViX9i.

15 Norbert Morawetz, Jane Hardy, Colin Haslam, and Keith Randle, "Finance, Policy, and Industrial Dynamics—The Rise of Co-Productions in the Film Industry," *Industry and Innovation* 14, no. 4 (2007): 421–443.

16 Jade L. Miller, "Producing Quality: A Social Network Analysis of Coproduction Relationships in High Grossing versus Highly Lauded Films in the U.S. Market," *International Journal of Communication* 5 (2011): 1018.

17 Of which more below.

18 OECD, *Remaking the Movies,* 52–54.

19 Simone Ferriani, Gino Cattani, and Charles Baden-Fuller, "The Relational Antecedents of Project-Entrepreneurship: Network Centrality, Team Composition and Project Performance," *Research Policy* 38, no. 10 (2009): 1548.

20 Mark Lorenzen, "Internationalization vs. Globalization of the Film Industry," *Industry and Innovation* 14, no. 4 (2007): 350.

21 M. Bjørn von Rimscha, "Managing Risk in Motion Picture Project Development," *Journal of Media Business Studies* 6, no. 4 (2009): 77.

22 Ulrich Beck, Anthony Giddens, and Scott Lash, *Reflexive Modernization: Politics, Tradition and Aesthetics in the Modern Social Order* (Stanford, CA: Stanford University Press, 1994), 5; Ulrich Beck, *World Risk Society* (Cambridge: Polity Press, 1999), 135.

23 Toby Miller, *Makeover Nation: The United States of Reinvention* (Columbus: Ohio State University Press, 2008).

24 When Toby Miller attended a 2003 conference on the economics of Hollywood at a large university in the Midwest, every paper from business and economics faculty focused on one topic—how firms could increase their revenues and diminish their risks. He felt like a fossil that had been invited to walk the earth one more time among these very contemporary hand-servants of capital.

25 OECD, *Remaking the Movies,* 7.

26 Toby Miller, "Culture + Labour = Precariat," *Communication and Critical/Cultural Studies* 7, no. 1 (2010): 96–99; Toby Miller, "The Cognitariat," *Cognitariat: Journal of Contingent Labor* 1 (2013), http://oaworld.org/ojs/index.php/cognitariat/article/view/4/4; Richard Maxwell and Toby Miller, "Learning from Luddites: Media Labour, Technology, and Life Below the Line," in *Theorising Cultural Work: Labour, Continuity, and Change in the Cultural and Creative Industries,* ed. Mark Banks, Rosalind Gill, and Stephanie Taylor (London: Routledge, 2013), 113–121. The term "cognitariat" refers here to people undertaking casualized cultural work who have heady educational backgrounds yet live at the uncertain interstices of capital, qualifications, and government in a post-Fordist era of mass unemployment, limited-term work, and occupational insecurity. The term "precariat" was initially used to refer to temporary and seasonal workers, but now, with labor insecurity a feature of most western economies, it more generally refers to temporary and/or part-time, adjunct workers who enjoy few of the benefits won by organized labor during the twentieth century.

27 Mette Hjort, ed., *The Education of the Filmmaker in Africa, the Middle East, and the Americas* (New York: Palgrave Macmillan, 2013).

28 Though some ran quasi-independent outfits, such as Selznick International Pictures.

29 Raymond Chandler, "Writers in Hollywood," *Atlantic,* November 1, 1945, http://www.theatlantic.com/magazine/archive/1945/11/writers-in-hollywood/306454.

30 Raymond Chandler, "Hollywood's Big Sleep," *Nation,* March 15, 2001, http://www.thenation.com/article/hollywoods-big-sleep.

31 Alejandro Pardo, "The Film Producer as a Creative Force," *Wide Angle* 2, no. 2 (2010): 1–23.

32 Miller, "Producing Quality."

33 OECD, *Remaking the Movies*, 7.

34 For a blend of approaches, authorial and otherwise, that cover this era, listen to podcasts with Jonathan Taplin: http://culturalstudies.podbean.com/2013/09/09/jonathan-taplin/; Lloyd Segan: http://culturalstudies.podbean.com/2011/05/18/a-conversation-with-lloyd-segan-hollywood-producer-about-the-bachelor-boondock-saints-dead-zone/; and Bill Grantham: http://culturalstudies.podbean.com/2011/05/15/a-conversation-with-bill-grantham-on-hollywood-and-the-law/.

35 Davidson, "How Does the Film Industry Actually Make Money?"

36 OECD, *Remaking the Movies*, 26.

37 DVD revenue has been declining since its 2004 peak, but it remains significant.

38 Ben Morris, "Blockbuster Economics: So You Want to Make a Movie?," *BBC News*, May 8, 2012, http://www.bbc.co.uk/news/business-17812247.

39 Tejaswini Ganti, "No Longer a Frivolous Singing and Dancing Nation of Movie-Makers: The Hindi Film Industry and Its Quest for Global Distinction," *Visual Anthropology* 25, no. 4 (2012): 344; Jha Manisha, "A ⊠300-Crore Fund for Hollywood, South Indian Films," *HinduBusiness Line*, June 9, 2014, http://www.thehindubusinessline.com/economy/a-300crore-fund-for-hollywood-south-indian-films/article6098203.ece.

40 Morris, "Blockbuster Economics."

41 Thorsten Hennig-Thurau, André Marchand, and Barbara Hiller, "The Relationship between Reviewer Judgements and Motion Picture Success: Re-Analysis and Extension," *Journal of Cultural Economics* 36, no. 3 (2012): 249–283.

42 Stephanie M.Brewer, Jason M. Kelley, and James J. Jozefowicz, "A Blueprint for Success in the US Film Industry," *Applied Economics* 41, no. 5 (2009): 589–606.

43 Ibid.

44 Jade Miller, "Producing Quality," 1019.

45 Morawetz et al., "Finance, Policy, and Industrial Dynamics," 436.

46 Azmat Rasul and Jennifer M. Proffitt, "An Irresistible Market: A Critical Analysis of Hollywood-Bollywood Coproductions," *Communication, Culture & Critique* 5, no. 4 (2012): 567.

47 Mark Graham, "Warped Geographies of Development: The Internet and Theories of Economic Development," *Geography Compass* 2, no. 3 (2008): 771–789; George Ritzer and Nathan Jurgenson, "Production, Consumption, Prosumption: The Nature of Capitalism in the Age of the Digital 'Prosumer,'" *Journal of Consumer Culture* 10, no. 1 (2010): 13–36.

48 OECD, *Remaking the Movies*, 10.

49 Toby Miller, *Cultural Citizenship: Cosmopolitanism, Consumerism, and Television in a Neoliberal Age* (Philadelphia: Temple University Press, 2007).

50 OECD, *Remaking the Movies*, 21.

51 Ibid., 77.

52 Robert Tannenwald, *State Film Subsidies: Not Much Bang for Too Many Bucks* (Washington, DC: Center on Budget and Policy Priorities, 2010); Toby Miller, "Hollywood, Cultural Policy Citadel," in *Understanding Film: Marxist Perspectives,* ed. Mike Wayne (London: Pluto Press, 2005), 182–193.

53 See Gillian Doyle, *Understanding Media Economics* (London: Sage Publications, 2002); any issue of the *Journal of Cultural Economics;* James Heilbrun and Charles M. Gray, *The Economics of Art and Culture,* 2nd ed. (Cambridge: Cambridge University Press, 2001). The Post-Autistic Economics Network is an alternative. See http://www.paecon.net/PAEmovementindex1.htm.

54 John Northdurft, "Film Tax Credits: Do They Work?," *Heartland Institute,* http://heartland.org/policy-documents/film-tax-credits-do-they-work.

55 Joseph Henchman, "Film Tax Credits: Lower Taxes for Celebrities, Higher Taxes for You," *Tax Policy Blog* May 30, 2008, http://taxfoundation.org/blog/film-tax-credits-lower-taxes-celebrities-higher-taxes-you.

56 Jack P. McHugh and James M. Hohman, "Legislators' Hollywood Dreams Defy Economic Reality," *Mackinac Center for Public Policy,* April 10, 2008, http://mackinac.org/article.aspx?ID=9367.

57 Vicki Mayer and Tanya Goldman, "Hollywood Handouts: Tax Credits in the Age of Economic Crisis," *Jump Cut* 52 (2010), http://www.ejumpcut.org/archive/jc52.2010/mayerTax/.

58 Darcy Rollins Saas, "Hollywood East? Film Tax Credits in New England," *New England Public Policy Center at the Federal Reserve Bank of Boston* (October 2006), http://www.bostonfed.org/economic/neppc/briefs/2006/briefs063.pdf.

59 Margo Sullivan, "Is There Hollywood Gold in Our Hills? Tax Incentives for Filmmakers Get Mixed Reviews," *Eagle-Tribune,* February 25, 2007, http://www.eagletribune.com/local/x1876328263/Is-there-Hollywood-gold-in-our-hills-Tax-incentives-for-filmmakers-get-mixed-reviews.

60 Tannenwald, *State Film Subsidies;* Pacey Foster, Stephan Manning, and David Terkla, "The Rise of Hollywood East: Regional Film Offices as Intermediaries in Film and Television Clusters," *Regional Studies* (2013), 10.1080/00343404.2013.799765.

61 Actual use of these incentives by Hollywood tends to be concentrated in a small number of states—Louisiana, Georgia, New Mexico, New York (where there are both state and New York City benefits). See http://www.ncsl.org/research/fiscal-policy/state-film-production-incentives-and-programs.aspx. The number of states is now forty-five (plus Puerto Rico).

62 Robert Verrier, "Hollywood's New Financiers Make Deals with State Tax Credits," *Los Angeles Times,* December 26, 2013, http://www.latimes.com/entertainment/envelope/cotown/la-et-ct-hollywood-financiers-20131226,0,5151886.story.

63 *Filming on Location Los Angeles 1993–2013* (Los Angeles: FilmL.A. Inc., 2014).

64 "The Money Shot," *Economist* 57 (August 15, 2009); Rollins Saas, "Hollywood East? Film Tax Credits in New England," 3; see also Richard Maxwell and Toby Miller, *Greening the Media* (New York: Oxford University Press, 2012).

65 "DGA Commends Action by Governor Gray Davis to Fight Runaway Production," Directors Guild of America Press Release (May 18, 2000); Aida A. Hozic, *Hollyworld: Space, Power, and Fantasy in the American Economy* (Ithaca, NY: Cornell University Press, 2001).

66 Tricia Jenkins, "Get Smart: A Look at the Current Relationship between Hollywood and the CIA," *Historical Journal of Film, Radio and Television* 29, no. 2 (2009): 229–243.

67 Paula Bernstein, "Hardest-Working Actor of the Season: The C.I.A," *New York Times,* September 2, 2001, http://www.nytimes.com/2001/09/02/arts/television-radio-hardest-working-actor-of-the-season-the-cia.html. Also see Jeff Cohen, "The CIA Goes Primetime," *FAIR,* September 4, 2001, http://www.commondreams.org/views01/0904–08.htm.

68 Andreas Behnke, "The Re-enchantment of War in Popular Culture," *Millennium: Journal of International Studies* 34, no. 3 (2006): 937–949.

69 Mike Macedonia, "Games, Simulation, and the Military Education Dilemma," *The Internet and the University: 2001 Forum* (Boulder, CO: Educause, 2002), 157–167.

70 Andy Deck, "Demilitarizing the Playground," *Art Context* (2004), http://artcontext.org/crit/essays/noQuarter/; David Silver and Alice Marwick, "Internet Studies in Times of Terror," in *Critical Cyberculture Studies,* ed. David Silver and Adrienne Massanari (New York: New York University Press, 2006), 50; Nick Turse, *The Complex: How the Military Invades Our Everyday Lives* (New York: Metropolitan Books, 2008), 120; W. J. Hennigan, "Computer Simulation Is a Growing Reality for Instruction," *Los Angeles Times,* November 2, 2010, http://articles.latimes.com/2010/nov/02/business/la-fi-virtual-reality-20101102; http://ict.usc.edu/news/item/usc_institute_for_creative_technologies_receives_135_million_contract_exten.

71 Jonathan Burston,"War and the Entertainment Industries: New Research Priorities in an Era of Cyber-Patriotism," in *War and the Media: Reporting Conflict 24/7,* ed. Daya Kishan Thussu and Des Freedman (London: Sage Publications, 2003), 163–175; Stephen Stockwell and Adam Muir, "The Military-Entertainment Complex: A New Facet of Information Warfare," *Fibreculture* 1 (2003), http://one.fibreculturejournal.org/fcj-004-the-military-entertainment-complex-a-new-facet-of-information-warfare; Robin Andersen, "Bush's Fantasy Budget and the Military/Entertainment Complex," *PRWatch.org,* February 12, 2007, http://www.prwatch.org/node/5742; Turse, *The Complex,* 108, 122; Amy Harmon, "More Than Just a Game, But How Close to Reality?," *New York Times,* April 3, 2003, http://www.nytimes.com/2003/04/03/technology/more-than-just-a-game-but-how-close-to-reality.html?pagewanted=all&src=pm.

72 Herman M. Schwartz and Aida Hozic, "Who Needs the New Economy?," *Salon.com,* March 16, 2001, http://www.salon.com/2001/03/16/schwartz2/.

73 Nora Caplan-Bricker, "Hollywood's Animal-Cruelty Problem Must Look Familiar to the NFL and Military," *New Republic,* November 25, 2013, http://www.newrepublic.com/article/115740/hollywoods-animal-cruelty-pitfalls-self-regulation; Maxwell and Miller, *Greening the Media.*

74 Jonathan Polansky and Stanton A. Glantz, *Taxpayer Subsidies for US Films with Tobacco Imagery* (San Francisco: Center for Tobacco Control Research and Education, UC San Francisco, 2009).

75 World Health Organization, *Smoke-Free Movies: From Evidence to Action,* 2nd ed. (Geneva: World Health Organization, 2011), 1, 3.

76 Ibid., 8, 9, 25.

77 Lynda Obst, quoted in Daniel D'Addario, "Hollywood Memoirist Lynda Obst: 'Women Make Wonderful Producers,'" *Salon,* June 14, 2013, http://www.salon.com/2013/06/14/hollywoodmemoiristlyndaobstwomenmakewonderfulproducers/.

78 Paul F. Skilton, "Similarity, Familiarity, and Access to Elite Work in Hollywood: Employer and Employee Characteristics in Breakthrough Employment," *Human Relations* 61, no. 12 (2008): 1749; Diana Mitsu Klos, *The Status of Women in the U.S. Media 2013* (Women's Media Centre), http://www.womensmediacenter.com/pages/statistics (2013); Martha M. Lauzen, *The Celluloid Ceiling: Behind-the-Scenes Employment of Women in the Top 250 Films of 2012* (2013), http://womenintvfilm.sdsu.edu/files/2011CelluloidCeilingExecSumm.pdf.

79 Gary Baum, "Animals Were Harmed." *Hollywood Reporter* (2013), http://www.hollywoodreporter.com/feature/.

80 http://www.peta.org/blog/bob-barker-hollywood-must-protect-animals/.

81 Charles J. Corbett and Richard P. Turco, *Sustainability in the Motion Picture Industry,* report prepared for the Integrated Waste Management Board of the State of California, http://personal.anderson.ucla.edu/charles.corbett/papers/mpis_report.pdf (2006); Maxwell and Miller, *Greening the Media.*

82 OECD, *Remaking the Movies,* 28.

83 It borrows from Richard Maxwell and Toby Miller, "'For a Better Deal, Harass Your Governor!': Neoliberalism and Hollywood," in *Neoliberalism and Global Cinema: Capital, Culture, and Marxist Critique,* ed. Jyotsna Kapur and Keith B. Wagner (New York: Routledge, 2011), 19–37..

SELECTED BIBLIOGRAPHY

Anger, Kenneth. *Hollywood Babylon*. Phoenix: Associated Professional Services, 1965.

Arkoff, Samuel, with Richard Trubo. *Flying through Hollywood by the Seat of My Pants*. New York: Birch Lane Press, 1992.

Arneel, Gene. *"Cut Directors Down to Size: Bob Evans: 'We Keep Control.'"* *Variety*, February 3, 1971, 1, 22.

Bach, Steven. *Final Cut: Dreams and Disaster in the Making of Heaven's Gate*. New York: New American Library, 1985.

Balio, Tino. *Hollywood in the Age of Television*. Cambridge: Unwyn, 1990.

———. *United Artists, vol. 2, 1951–1978: The Company That Changed the Film Industry*. Madison: University of Wisconsin Press, 2009.

Baxter, John. *Von Sternberg*. Lexington: University Press of Kentucky, 2010.

Belton, John. *American Cinema/American Culture*. New York, McGraw-Hill, 2013.

Bernstein, Matthew H. *"Era of the Moguls: The Studio System."* In *The Wiley-Blackwell History of American Film*, vol. 2, edited by Cynthia Lucia, Roy Grundman, and Art Simon, 22–43. West Sussex: Wiley Blackwell, 2012.

———. *Walter Wanger: Hollywood Independent*. Minneapolis: University of Minnesota Press, 2000.

Biskind, Peter. *Easy Riders, Raging Bulls: How the Sex-Drugs-and-Rock-and-Roll Generation Saved Hollywood*. New York: Simon and Shuster, 1999.

———. *The Godfather Companion*. New York: Harper Perennial, 1990.

Bordwell, David, Janet Staiger, and Kristen Thompson. *The Classical Hollywood Cinema: Film Style and Mode of Production to 1960*. Madison: University of Wisconsin Press, 1985.

Bowser, Eileen. *The Transformation of Cinema, 1907–1915*. Berkeley: University of California Press, 1990.

Brewer, Stephanie M., *Jason M*. Kelley, and James J. Jozefowicz. "A Blueprint for Success in the US Film Industry." *Applied Economics* 41, no. 5 (2009): 589–606.

Buhle, Paul, and Patrick McGilligan. *Tender Comrades*. New York: St. Martin's Press, 1997.

Caldwell, John T. *"Para-Industry: Researching Hollywood's Blackwaters." Cinema Journal* 52, no. 3 (2013): 157–165.

Carr, Steven Alan. *Hollywood and Anti-Semitism: A Cultural History up to World War II*. Cambridge: Cambridge University Press, 2001.

Clarkson, Wesley. *Quentin Tarantino: Shooting from the Hip*. Woodstock, NY: John Blake, 2007.

Cooper, Mark Garrett. *Universal Women: Filmmaking and Institutional Change in Early Hollywood*. Urbana: University of Illinois Press, 2010.

Crowther, Bosley. *The Lion's Share: The Story of an Entertainment Empire*. New York: E. P. Dutton, 1957.

Custen, George. *Twentieth-Century's Fox: Darryl F. Zanuck and the Culture of Hollywood*. New York: Basic Books, 1997.

Davidson, Adam. *"How Does the Film Industry Actually Make Money?" New York Times*, June 26, 2012. http://www.nytimes.com/2012/07/01/magazine/how-does-the-film-industry-actually-make-money.html?r=0.

Dick, Bernard F. *Columbia Pictures*. Lexington: University Press of Kentucky, 1992.

Doyle, Gillian. *Understanding Media Economics*. London: Sage Publications, 2002.

Dunne, John Gregory. "Bully Boy." *New Yorker*, February 5, 1996, 26–31.

Evans, Robert. *The Kid Stays in the Picture*. New York: Hyperion, 1994.

Fitzgerald, F. Scott. *The Love of the Last Tycoon*. New York: Scribners, 1994.

Goldstein, Patrick. *"The Trio behind Jersey Films' Success." Los Angeles Times*, March 23, 2001, B1.

Gomery, Douglas. *The Hollywood Studio System: A History*. London: BFI Publishing, 2005.

———. "Industrial Analysis and Practice." In *The Hollywood Blockbuster*, edited by Julian Springer. London: Routledge: 2003.

Griffith, Mrs. *D.* W. [Linda Arvidson]. *When the Movies Were Young*. New York: E. P Dutton, 1925.

Guest, Haden. *"Hollywood at the Margins: Samuel Fuller, Phil Karlson, and Joseph H. Lewis."* In *The Wiley Blackwell History of American Film,* vol. 3, *1946–1975,* edited by Cynthia Lucia, Roy Grundmann, and Art Simon, 158–176. Oxford: Wiley Blackwell, 2012.

Hamill, Katharine. *"The Supercolossal—Well, Pretty Good—World of Joe Levine."* *Fortune,* April 1964, 130–132, 178–180, 185.

Harmetz, Aljean. *Round Up the Usual Suspects: The Making of Casablanca—Bogart, Bergman, and World War II.* New York: Hyperion, 1992.

Hennig-Thurau, Thorsten, André Marchand, and Barbara Hiller. *"The Relationship between Reviewer Judgements and Motion Picture Success: Re-analysis and Extension."* *Journal of Cultural Economics* 36, no. 3 (2012): 249–283.

Hope, Laura Lee. *The Moving Picture Girls at Rocky Ranch.* New York: Grosset and Dunlap, 1914.

Horne, Gerald. *Class Struggle in Hollywood 1930–1950: Moguls, Mobsters, Stars, Reds, and Trade Unionists.* Austin: University of Texas Press, 2001.

Izod, John. *Hollywood and the Box Office 1895–1986.* New York: Columbia University Press, 1988.

Jarvie, Ian. *"The Postwar Economic Foreign Policy of the American Film Industry, Europe 1945–1950."* *Film History* 4 (1990): 277–288.

Jeancolas, Jean-Pierre. *"From the Blum-Byrnes Agreement to the GATT Affair."* In *Hollywood and Europe: Economics, Culture, National Identity 1946–1996,* edited by Geoffrey Nowell-Smith and Steven Ricci, 47–59. London: BFI, 1998.

Jenkins, Tricia. *"Get Smart: A Look at the Current Relationship between Hollywood and the CIA."* *Historical Journal of Film, Radio and Television* 29, no. 2 (2009): 229–243.

Kelijer, Alice V., *Franz Hess, Marion LeBron, and Rudolf Modley. Movie Workers.* New York: Harper and Brothers, 1939.

Kemper, Tom. *Hidden Talent: The Emergence of the Hollywood Agents.* Berkeley: University of California Press, 2010.

Kipps, Charles. *Out of Focus: Power, Pride, and Prejudice—David Puttnam in Hollywood.* New York: Century, 1989.

Kolker, Robert. *A Cinema of Loneliness.* Oxford: Oxford University Press, 1988.

Koszarski, Richard. *Von: The Life and Films of Erich von Stroheim.* New York: Limelight Editions, 2001.

Kozloff, Sarah. *The Best Years of Our Lives.* London: Palgrave Macmillan, 2011.

Kramer, Stanley, with Thomas M. Coffey. *A Mad, Mad, Mad, Mad World: A Life in Hollywood.* New York: Harcourt Brace and Company, 1997.

Langdon-Teclaw, Jennifer. *"The Progressive Producer in the Studio System: Adrian Scott at RKO, 1937–1947."* In *Un-American Hollywood: Politics and Film in the Blacklist Era,* edited by Frank Krutnik, Steve Neele, Brian Neve, and Peter Stanfield, 152–169. New Brunswick, NJ: Rutgers University Press, 2007.

Lev, Peter. *Twentieth Century-Fox: The Zanuck Years, 1935–1965.* Austin: University of Texas Press, 2013.

Lewis, Jon. *The Godfather.* London: BFI, 2010.

Lorenzen, Mark. "Internationalization vs. Globalization of the Film Industry." *Industry and Innovation* 14, no. 4 (2007): 349–357.

Maas, Frederica. *The Shocking Miss Pilgrim: A Writer in Early Hollywood.* Lexington: University Press of Kentucky, 1999.

Martin, Mel. *The Magnificent Showman: The Epic Films of Samuel Bronston.* Albany, GA: Bear Manor Media, 2007.

Maxwell, Richard, and Toby Miller. *Greening the Media.* New York: Oxford University Press, 2012.

———. "Learning from Luddites: Media Labour, Technology, and Life below the Line." In *Theorising Cultural Work: Labour, Continuity, and Change in the Cultural and Creative Industries,* edited by Mark Banks, Rosalind Gill, and Stephanie Taylor, 113–121. London: Routledge, 2013.

Mayer, Vicki, and Tanya Goldman. "Hollywood Handouts: Tax Credits in the Age of Economic Crisis." *Jump Cut* 52 (2010). http://www.ejumpcut.org/archive/jc52.2010/mayerTax/.

McBride, Joseph. *Steven Spielberg.* New York: DaCapo, 1997.

Miller, Jade L. "Producing Quality: A Social Network Analysis of Coproduction Relationships in High Grossing versus Highly Lauded Films in the U.S. Market." *International Journal of Communication* 5 (2011): 1014–1033.

Miller, Toby. *Cultural Citizenship: Cosmopolitanism, Consumerism, and Television in a Neoliberal Age.* Philadelphia: Temple University Press, 2007.

———. "Hollywood, Cultural Policy Citadel." In *Understanding Film: Marxist Perspectives,* edited by Mike Wayne, 182–193. London: Pluto Press, 2005.

———. *Makeover Nation: The United States of Reinvention.* Columbus: Ohio State University Press, 2008.

Mordden, Ethan. *The Hollywood Studios: House Style in the Golden Age of the Movies.* New York: Alfred A. Knopf, 1988.

Natale, Richard. "Lew Wasserman at 80: A Firm Hand at the Helm." *Variety,* March 17, 1993, 17.

Obst, Lynda. *Hello, He Lied: And Other Truths from the Hollywood Trenches.* Boston: Little, Brown, 1996.

Pardo, Alejandro. "The Film Producer as a Creative Force." *Wide Angle* 2, no. 2 (2010): 1–23.

Phillips, Julia. *You'll Never Eat Lunch in This Town Again.* New York: Signet, 1991.

Pickford, Mark. *Sunshine and Shadow.* New York: Doubleday, 1955.

Polan, Dana. *Pulp Fiction.* London: BFI, 2008.

Polansky, Jonathan, and Stanton A. *Glantz. Taxpayer Subsidies for US Films with Tobacco Imagery.* San Francisco: Center for Tobacco Control Research and Education, UC San Francisco, 2009.

Prime, Rebecca. *Hollywood Exiles in Europe: The Blacklist and the Cold War Film Culture.* New Brunswick, NJ: Rutgers University Press, 2013.

Puttnam, David. *Movies and Money*. New York: Alfred A. Knopf, 1998.

Pye, Michael, and Lynda Miles. *The Movie Brats: How the Film Generation Took Over Hollywood*. New York: Holt, Rinehart, 1979.

Ramsaye, Terry. *A Million and One Nights: A History of the Motion Picture through 1925*. New York: Simon and Schuster, 1926.

Rosten, Leo C. *Hollywood the Movie Colony, the Movie Makers*. New York: Harcourt Brace and Company, 1941.

Saloman, Julie. "*Budget Busters: The Cotton Club's Battle of the Bulge*." *Wall Street Journal*, December 13, 1984, 22.

Schary, Dore. *Heyday. An Autobiography*. Boston: Little, Brown, 1979.

————, as told to Charles Palmer. *Case History of a Movie*. New York: Random House, 1950.

Schatz, Thomas. *Boom and Bust: The American Cinema in the 1940s, vol. 6, History of the American Cinema*. Berkeley: University of California Press, 1997.

————. *The Genius of the System: Hollywood Filmmaking in the Studio Era*. New York: Pantheon, 1989.

————. "'*A Triumph of Bitchery*': Warner Bros., Bette Davis, and *Jezebel*." *Wide Angle* 10, no. 1 (1988): 74–92.

Sharp, Kathleen. *Mr. and Mrs. Hollywood*. New York: Carroll & Graf, 2004.

Singer, Ben, and Charlie Keil. *American Cinema of the 1910s: Themes and Variations*. New Brunswick, NJ: Rutgers University Press, 2009.

Sklar, Robert. "*Hollywood about Hollywood: Genre as Historiography*." In *Hollywood and the American Historical Film*, edited by J. E. Smyth, 71–93. New York: Palgrave, 2011.

————. *Movie-Made America: A Cultural History of American Movies*. New York: Random House, 1994.

Sperling, Cass, and Cork Millner, with Jack Warner Jr. *Hollywood Be Thy Name: The Warner Brothers Story*. Rocklin, CA: Prima Publishing, 1994.

Spoto, Daniel. *Stanley Kramer, Filmmaker*. New York: G. P. Putnam's Sons, 1978.

Sragow, Michael. "*Godfatherhood*." *New Yorker*, March 24, 1997, 48.

Tannenwald, Robert. *State Film Subsidies: Not Much Bang for Too Many Bucks*. Washington, DC: Center on Budget and Policy Priorities, 2010.

Taubin, Amy. *Taxi Driver*. London: BFI, 2000.

Taves, Brian. *Thomas Ince: Hollywood's Independent Pioneer*. Lexington: University Press of Kentucky, 2012.

Thomson, David. *Showman: The Life of David O. Selznick*. New York: Alfred A. Knopf, 1992.

Vasey, Ruth. *The World according to Hollywood*. Madison: University of Wisconsin Press, 1997.

Vieira, Mark A. *Irving Thalberg: Boy Wonder to Producer Prince*. Berkeley: University of California Press, 2009.

Wallis, Hal, with Charles Higham. *Starmaker, the Autobiography of Hal Wallis.* New York: Macmillan, 1980.

Whitfield, Eileen. *Pickford: The Woman Who Made Hollywood.* Lexington: University Press of Kentucky, 1997.

Wood, Robin. *Hollywood from Vietnam to Reagan.* New York: Columbia University Press, 1986.

Yule, Andrew. *Fast Fade, David Puttnam, Columbia Pictures, and the Battle for Hollywood.* New York: Delacorte, 1989.

NOTES ON CONTRIBUTORS

Mark Lynn Anderson is an associate professor of film studies in the Department of English at the University of Pittsburgh. He has published numerous articles and book chapters on the early Hollywood star system, censorship, celebrity scandals, film historiography, and early film education. He is the author of *Twilight of the Idols: Hollywood and the Human Sciences in 1920s America*.

Saverio Giovacchini, a cultural and intellectual historian, is an associate professor of history at the University of Maryland. He is the author of *Hollywood Modernism: Film and Politics in the Age of the New Deal* and, with Robert Sklar, of *Global Neorealism: The Transnational History of a Film Style*.

Douglas Gomery is the author of twenty-one books and more than six hundred articles on the history and economics of the mass media. His book *The History of Broadcasting* is a standard in the industry. Professor Gomery taught in the Merrill College of Journalism from 1993 to 2005, when he was named professor emeritus. He is currently Resident Scholar at the Center for Visual and Mass Media at the University of Maryland Libraries.

Bill Grantham is a film lawyer based in Beverly Hills, California. He is the author of *Some Big Bourgeois Brothel: Contexts for France's Culture Wars with Hollywood.*

Jon Lewis is Distinguished Professor of Film Studies in the School of Writing, Literature, and Film at Oregon State University. He has published ten books, including *Whom God Wishes to Destroy . . . Francis Coppola and the New Hollywood, Hollywood v. Hard Core: How the Struggle over Censorship Saved the Modern Film Industry* and, most recently, with Eric Smoodin, *The American Film History Reader.* Between 2002 and 2007, Professor Lewis was editor of *Cinema Journal.* He is the editor of the Rutgers University Press series Behind the Silver Screen.

Toby Miller is a professor of Journalism, Media, and Cultural Studies at Cardiff University/Prifysgol Caerdydd in Wales and Sir Walter Murdoch Professor of Cultural Policy Studies at Murdoch University in Australia. The author and editor of over thirty books, his work has been translated into Spanish, Chinese, Portuguese, Japanese, Turkish, German, and Swedish. His two most recent volumes are *Greening the Media* (with Richard Maxwell) and *Blow up the Humanities.*

Joanna E. Rapf is a professor of English and interim director of Film and Media Studies at the University of Oklahoma. She most recently coedited *A Companion to Film Comedy.* Her grandfather, Harry Rapf, was a producer at MGM.

INDEX

3 in the Attic (1968), 106

12 Years a Slave (2013), 2–4, 5

42nd Street (1933), 51

1941 (1979), 115, 116

2001: A Space Odyssey (1968), 97

ABC, 114

Abominable Mr. Phibes, The (1971), 106

Accord Marchandeau (1936), 73

Acres, Brit, 9

Adventures in Babysitting (1987), 123

Adventures of Tom Sawyer, The (1938), 45

AIP, *see* American International Pictures

Albeck, Andy, 104

Algiers (1938), 93

Alice Doesn't Live Here Anymore (1974), 98

Alison, Joan, 53

All about Eve (1950), 60

Allen, Woody, 106, 110

Amazon.com, Inc., 138

Amblin Entertainment, 116

AMC Networks, 2

American Association of Producers, 131

American International Pictures (AIP), 105–110

Amityville Horror, The (1979), 107, 108

Amityville Horror: A True Story, The, 107

Anderson, Mark Lynn, 12

Andrews, Dana, 61

Andrews, Del, 41

Anna Christie (1930), 40

Anson, Jay, 107

Apocalypse Now (1979), 102, 105, 170n39

Arkoff, Samuel Z., 11, 87, 105–110

Arkoff International Pictures, 109

Armed and Dangerous (1986), 121

Arvidson, Linda, 19–20

Arzner, Dorothy, 47, 48

Asher, Irving, 43

Asher, William, 106

Assassination of Jesse James by the Coward Robert Ford, The (2007), 2

Associazone Nazionale Industrie Cinema-
tografiche e Affini (ANICA), 74
Atlantic Releasing Corporation, 106
At the Front in North Africa (1942), 61
Attila the Hun (1958), 79
Aubrey, James, 91
Avakian, Aram, 92
Avary, Roger, 126
Avatar (2009), 138
Avildsen, John G., 98, 109
Aylesworth, Merlin, 55

Bach, Stephen, 104
Bacon, Lloyd, 51
Bad and the Beautiful, The (1952), 65
Baden-Fuller, Charles, 134
Bagelman, Stephen, 129
Balio, Tino, 76, 79
Ballard, Jack, 92–93
Barison, Ed, 78
Barrymore, John, 45
Bart, Peter, 90, 169n20
Baxter, John, 46
Bazin, André, 4, 86, 110
Beach Party (1963), 106
Beat, The (1988), 100
Beatty, Warren, 119
Beaumont, Harry, 38
Beery, Wallace, 40, 45
Begelman, David, 98, 99
Belton, John, 38
Bender, Lawrence, 126
Benedek, Laszlo, 71
Bengal Brigade (1954), 71
Bennett, Murray, 53
Berkeley, Busby, 43
Berle, Adolf, 70
Berman, Marshall, 84
Berman, Pandro S., 56
Bern, Paul, 40
Bernhardt, Sarah, 23
Bernstein, Matthew, 36, 47
Bessie, Alvah, 66
Best Years of Our Lives, The (1946), 38, 57
Beverly Hills Cop (1984) 14
Biberman, Herbert, 66
Big House, The (1930), 40

Big Parade, The (1925), 40
Bill of Divorcement, A (1932), 44, 55
Biloxi Blues (1988), 119
Biograph Company, 19–20
Blackboard Jungle (1955), 90
Blacklist, 6, 12, 51, 65–69, 74
Blacksmith Scene (1893), 7, *7*
Blackton, J. Stuart, 15
Blacula (1972), 106
Blade Runner (1982), 109
Bloch, Richard, 106–107, 108
Blockade (1938), 66
Blonde Venus (1932), 47
Blood on the Sun (1945), 66
Bloody Mama (1970), 106
Blow Out (1981), 109
Bluhdorn, Charles, 87–88
Blum, Leon, 73
Bodeen, DeWitt, 56
Body Snatcher, The (1945), 56
Bogart, Humphrey, 49, 53
Bordwell, David, 32
Bow, Clara, 46, 48
Bowser, Eileen, 21
Boxcar Bertha (1972), 106
Boyum, Joyce Gould, 105
Brady, William A., 26–28
Brando, Marlon, *88*, 91, 94
Brazzi, Rossano, 75
Brecht, Bertolt, 66
Breen, Joseph, 36, 37, 51, 56
Breen Office, *see* Production Code
 Administration
Breslin, Jimmy, 91
Brest, Martin, 14
Brewer, Roy, 64
Brewer, Stephanie M., 139
Bridges, Jeff, 121
Brighton Beach Memoirs (1986), 119
Briskin, Samuel, 56
Broadway Melody (1929), 38, 40
Brockovich, Erin, 129
Bronfman, Edgar Jr., 117
Bronson, Charles, 110
Bronston, Samuel, 84
Brooks, Richard, 90
Brotherhood, The (1968), 89

Brower, Otto, 59
Brown, Clarence, 40, 41
Bruckheimer, Jerry, 14
Buchwald, Art, 45
Burr, Raymond, 78
Burstyn, Ellen, 98
Bush, George W., 146
Bussard, Steve, 101–102
Bus Stop (1956), 93
Butler, David, 59
Byrnes, James F., 72, 73

Cabin in the Sky (1943), 43
Cagney, James, 49
California Film Commission, 144
California Studios, 76
Cameron, James, 124, 138
Cannon Releasing Corporation, 106
Capra, Frank, 69
CARA, *see* Classification and Rating
 Administration
Carelli, JoAnn, 87, 101–105
Carpenter, John, 123
Casablanca (1942), 50, 53
Casanova 70 (1965), 81
Casiraghi, Ugo, 72
Cassarotto, Jenne, 3
Cat People (1942), 56
Cattani, Gino, 134
CBS, 114
Center for Computational Analysis, 145
Center for Tobacco Control Research and
 Education, 147
Champ, The (1931), 40
Chandler, Raymond, 136
Chaney, Lon, 33
Chaplin, Charles, 25, 33
Chaplin Studios, 76
Chariots of Fire (1981), 121
Chertok, Jack, 43
Chinatown (1974), *89*
Chown, Jeffrey, 87
CIA, 145
Cimino, Michael, 87, 101–105, 119
Cinecittà, 74
Cinerama Releasing Corporation, 88
Citizen Kane (1941), 38, 60

Ciukhrai, Grigorij, 82
Clark, Tom, 67
Classification and Rating Administration
 (CARA), 99, 100, 107, 147
Close, Glenn, 121
Close Encounters of the Third Kind (1977),
 96–98
Coates, Anne V., 128
Coca-Cola Company, 111, 112, 117–122
Cochrane, Robert H., 22
Cohen, Larry, 109
Cohn, Harry, *68*
Coke, *see* Coca-Cola Company
Cole, Lester, 66
Colombo, Anthony, 96
Colombo, Joseph, 96
Columbia Pictures, 13, 37, 44, 48, 56, 68, 83,
 97, 98, 112, 117–122, 123, 130
Columbus, Chris, 123
Comcast, 148
Compton, Richard, 106
Conference of Studio Unions (CSU), 64
Confessions of a Nazi Spy (1939), 51
Connick, H. D., 27–28
Consent Decree (1941), 43
Contempt (1963), 81
Conti, Bill, 128
Cool and the Crazy, The (1958), 106
Cooper, Mark Garrett, 21, 33
Cooper, Merrian C., 38, 55–56
Coppola, Francis Ford, 87–96, *92*, 98, 102,
 106, 110, 169n20, 170n39
Corman, Roger, 106, 110
Costa-Gavras, Constantin, 90
Cotton Club, The (1984), 94
Count of Monte Cristo, The (1913), 23
Cowie, Peter, 89
Crain, Hall, 23
Crain, William, 106
Crash Dive (1943), 61
Crawford, Joan, 45
Crescent Decision (1943), 67
Crichton, Michael, 117
Cromwell, John, 45, 93
Crosland, Alan, 49
Crowe, J. Michael, 108
Crowther, Bosley, 40, 59, 78, 83

CSU, *see* Conference of Studio Unions
Cukor, George, 44, 45, 55, 56
Cummings, Irving, 59
Cummings, Jack, 40
Curtis, Tony, 76
Curtiz, Michael, 50, 54

Dakhil, Maha, 3
Damiani, Damiano, 81
Dancing Lady (1933), 45
Dane & Arthur, 40
Dark Victory (1939), 53
Darnel, Linda, 59
Dassin, Jules, 75
Daves, Delmer, 66
Davidson, Adam, 13, 132, 137, 138
Davies, Marion, 33, 41
Davis, Bette, 49, 53
Day the World Ended, The (1955), 106
Deer Hunter, The (1978), 101–103
Defense Advanced Research Projects
 Agency (DARPA), 145
Defiant Ones, The (1958), 83
De Laurentiis, Dino, 11, 81
De Laurentiis Entertainment Group, 106
De Luca, Mike, 100, 169n36
Dementia 13 (1963), 106
DeMille, Cecil B., 24, 34, 35
De Niro, Robert, 98–99, *99*
De Palma, Brian, 98, 107, 109
Derby, The (1895), 9
De Santis, Giuseppe, 81, 82
De Sica, Vittorio, 81
DeVito, Danny, 124, 125, 128, 129
Dewey, John, 47
Dickson, W.K.L., 6, 8
Dies, Martin, 52, 66
Dieterle, William, 52, 66
Dietrich, Marlene, 76
Dillinger (1973), 106
Dinner at Eight (1933), 45
Dirty Harry (1971), 99
Disney, *see* Walt Disney Company
Disney, Walt, 11, 56, 66
Dmytryk, Edward, 66
Doherty, Tom, 127
Dole, Bob, 126–127

Dominick, Andrew, 2
Don't Tell Mom the Babysitter's Dead (1991),
 100
Double Features Films, 130
Dragoti, Stan, 107
Dressed to Kill (1980), 107, 108
Dressler, Marie, 40–42, 45
Duel in the Sun (1946), 79
Dulles, Allen, 71
Dunne, John Gregory, 14
Dunne, Phillip, 60

Eagle-Lion Films, 67, 72
Eakin, Sue, 3
Ebert, Roger, 109, 126
Edelson, Arthur, 54
Edison, Thomas, 6–9, *7, 8*, 11, 15, 19
Edison Manufacturing Company, 8
Education of Private Slovik, The (1974), 99
Edwards, Blake, 121
Edwards, Gus, 40
Eisenberg, Jesse, *137*
El Cid (1961), 84
Embassy Pictures Corporation, 77, 79–81
Emerald City, The (1915), 23
Emma (1932), 40–41
Empire Strikes Back, The (1980), 99
Empty Canvas, The (1963), 81
Ephron, Nora, 86
Erin Brockovich (2000), 127–129
ERP, *see* Marshall Plan
Esbin, Jerry, 104
Escape from New York (1981), 123
Etkes, Ralph, 108
E.T.: The Extraterrestrial (1982), 111, 114,
 116, 122, 129
European Reconstruction Plan, *see* Mar-
 shall Plan
Evans, Robert, 11, 13, 87–96, *89*
Everybody Comes to Rick's (source of *Casa-
 blanca*), 53

Fairbanks, Douglas, 25
Falk, Peter, 82, 83
Fall of the Roman Empire, The (1964), 84
Famous Players Film Company, 23
Famous Players–Lasky, 19, 24–30, 44

Fashions for Women (1927), 48
Fast and the Furious, The (1954), 106
FBO, *see* Film Booking Offices of America
FCC, *see* Federal Communications Commission
Federal Communications Commission (FCC), 79, 80, 115
Federal Technology Reinvestment Project, 145
Federal Trade Commission (FTC), 29, 115
Feeling Minnesota (1996), 129
Feldman, Charles, 76
Fellini, Federico, 79
Ferriani, Simone, 134
Fields, Verna, 97
Film 4, 3
Film Booking Offices of America (FBO), 55
Film California First Program, 144
Film L.A., Inc., 144
Filmways, 106, 107, 108–109
Fincher, David, *137*
Fine Mess, A (1986), 121
Finney, Albert, 128
First National Pictures, 25, 49
Fisher King, The (1991), 123
Fisk, Jack, 121
Fitzgerald, F. Scott, 9, 10, 11, 35, 36–37, 160n9
Flashdance (1983), 14, 86, 123
Fleiss, Heidi, 14
Fleming, Victor, 43, 45, 94
Flynn, John, 106
Focus Features, 11
Fonda, Henry, 59
Foolish Wives (1920), 31
Footlight Parade (1933), 51
Ford, Henry, 51
Ford, John, 59
Foreman, Carl, 67, *68*
Forman, Milos, 109, 129
Fountainhead, The (1949), 161n46
Four Friends (1981), 109
Fowler, Gene Jr., 106
Fox, William, 26, 57
Fox Film Corporation, 57
Fox Searchlight, 3
Foy, Brian, 49

Francisci, Pietro, 79, *80*
Franklin, Sidney, 39
Frederick, Pauline, 23
Freed, Arthur, 43, 121; Freed unit, 43, 121
Frohman, Daniel, 23
FTC, *see* Federal Trade Commission
Fuest, Robert, 106
Full Spectrum Warrior (videogame), 146
Furie, Sydney J., 95

Gable, Clark, 45
Galatea, 81
Gangs of New York, The (2002), 109
Gang That Couldn't Shoot Straight, The (1971), 91
Gardner, Dede, 2, 3
Garland, Judy, 43
Garvis, Howard R., 158n3
Genius of the System, The (Schatz), 4, 34
Gessner, Nicholas, 106
Ghostbusters II (1989), 121
Gibbons, Cedric, 38, 55
Gilbert, John, 33
Gilbert, Lewis, 90
Gilliam, Terry, 123
Gilula, Steve, 3
Ginsberg, Henry, 65
Giovacchini, Saverio, 12
Glantz, Stanton A., 147
Godard, Jean-Luc, 81
Godfather, The (1972), 87–96, *88, 92,* 101, 104, 107, 169n25
Godfather: Part II, The (1974), 93, 98, 169n25
Godzilla (1954), 77, 78, 79
Godzilla, King of the Monsters (1956), 78–79
Going My Way (1944), 59
Goizueta, Roberto C., 118, 120
Goldman, Tanya, 142
Goldstein, Patrick, 129
Goldwyn, Samuel, 38, 56, *66,* 66, 67, 69
Goldwyn Pictures, 39
Gomery, Douglas, 13, 28, 123
Gone with the Wind (1939), 45, 94
Goulding, Edmund, 39, 53
G. P. Putnam (publisher), 89
Grable, Betty, 38, 59, 61

Graduate, The (1967), *84*
Grand Hotel (1932), 39
Grant, Cary, 75
Grant, Lee, 109
Grant, Susannah, 128
Grantham, Bill, 13
Grapes of Wrath, The (1940), 59, 61
Great Ziegfeld, The (1936), 39
Griffith, D. W., 19, 20, 25
Grundberg, Robert, 109
Guber, Peter, 122
Guess Who's Coming to Dinner (1967), 83
Guest, Haden, 67
Gulf + Western, 87, 88, 95
Gundle, Stephen, 75
Gwynne, Fred, 94

Hackett, James, 23
Hallelujah (1929), 40
Halloween (1978), 123
Hamill, Katharine, 76
Hansen, Miriam, 71
Hard Day's Night, A (1964), 104
Harding, Warren, 29
Hardy, Jane, 140
Harlow, Jean, 45
Harmetz, Aljean, 53–54
Harper & Row (publishers), 88
Hart, William S., 33
Haslam, Colin, 140
Hathaway, Henry, 61
Hawks, Howard, 76
Hayakawa, Sessue, 33
Hayes, Helen, 40
Hays, Will, 29, 51
Hearst, William Randolph, 33, 159n20
Heaven's Gate (1981), 87, 101–105, *103*, 107, 119
Heffernan, Kevin, 77
Heinreid, Paul, 54
Heise, William, 8
Hellman, Lillian, 161n46
Henchmen, Joseph, 142
Henie, Sonja, 59
Hepburn, Audrey, 75
Hepburn, Katharine, 44, 55
Hercules (1958), 79, *80*

Hess, Franz, 16
Higham, Charles, 54
Hill, Debra, 123, 130
Hill, George Roy, 96
Hill, George W., 40
Hill/Obst, 123, 130
Hiller, Arthur, 88
Hitchcock, Alfred, 122, 129
Hitler, Adolf, 51, 52
Hoffa (1991), 129
Hoffman, Dustin, *84*, 119
Hogan's Heroes (TV series, 1965–1971), 95
Hollywood Babylon (Anger), 33
Hollywood Blacklist, *see* Blacklist
Hollywood Revue of 1929, The (1929), 40
Hollywood Ten, 66–67
Hollywood the Movie Colony, the Movie Makers (Rosten), 63
Honda, Ishirō, 77
Hope, Laura Lee, 17–18
Horne, Lena, 43
Hot Rod Girl (1956), 106
House Committee on Un-American Activities (HUAC), 12, 52, 63, 65–69
House of Rothschild, The (1934), 52, 162n7
Howard the Duck (1986), 115
How Green Was My Valley (1941), 61
HUAC, *see* House Committee on Un-American Activities
Hudson, Hugh, 121
Humberstone, Bruce, 61
Hunt, Marsha, 163n14
Huston, John, 53
Hutton, Brian G., 95
Hyman, Bernie, 40, 43

I Am a Fugitive from a Chain Gang (1932), 38, 49
IATSE, *see* International Alliance of Theatrical and Stage Employees
ICT, *see* Institute for Creative Technologies
IFC Films, 2
IMP, *see* Independent Motion Picture Company
Ince, Thomas, 32–33, 159n20
Inceville, 33
In Cold Blood (1967), 90, 93

Independent Motion Picture Company (IMP), 20–21
Indus Media, 138
Institute for Creative Technologies (ICT), 146
Integrated Waste Management Board, 149
International Alliance of Theatrical and Stage Employees (IATSE), 64
Ireland, John, 106
Ishtar (1987), 119
Italian-American Civil Rights League, 95–96
Italiani Brava Gente (1964), 81–83, 167n116
It Could Happen to You (1937), 66
I Walked with a Zombie (1943), 56, 57
I Was a Teenage Werewolf (1957), 106
Izod, John, 71

Jackson, Samuel L., 126
Jagged Edge (1985), 121
Jarvie, Ian, 76–77
Jaws (1975), 96, 97, 111–114, *114*, 122
Jazz Singer, The (1927), 49
Jersey Films, 113, 124, 127–130
Jewison, Norman, 121
Joffe, Roland, 121
Johnson, Lamont, 99
Johnson, Nunnally, 60
Johnston, Eric, 66, 73
Jo Jo Dancer, Your Life Is Calling (1986), 121
Jolson, Al, 49
Jones, Dorothy, 71
Journey for Margaret (1942), 43
Jozefowicz, James J., 139
Judgement at Nuremberg (1961), 83
Judt, Tony, 72
Jurassic Park (1994), 113, 117, 171n9

Kael, Pauline, 101
Kamen, Stan, 102
Katagas, Anthony, 2, 3
Katz, Lee, 103–104
Katz, Sam, 42
Kazan, Elia, 61, 90
Keaton, Diane, 109
Keith-Albee-Orpheum theater chain, 55

Keliger, Alice V., 16
Kelley, Jason M., 139
Kemper, Tom, 76
Kennedy, Arthur, 82, 83
Kennedy, Joseph P., 55
Kent, Sidney, 58
Keough, Don, 120
Kerkorian, Kirk, 91, 118
Kershner, Irvin, 99
Kidnapped (1938), 61
Killing Fields, The (1984), 121
King, Henry, 59, 61
King Kong (1933), 55, 79
Kitty Foyle (1940), 66
Kleiner, Jeremy, 2, 3
Kline, Herbert, 43
Koch, Howard, 51, 54
Koerner, Charles, 38, 56
Korshak, Sidney, 91
Koscina, Sylva, *80*
Kozloff, Sarah, 57
Kramer, Stanley, 67, *68*, 75, 76, 83–84
Kristofferson, Kris, 102
Kubrick, Stanley, 97

Laemmle, Carl, 11, 19–22, 24, 30, 170n1
LaGravenese, Richard, 129
Laird International Studios, 116
Lancaster, Burt, 90
Lardner, Ring Jr., 66, 67
Lasky, Jesse, 22, 34, 35, 44, 159n20
Lasky Feature Play Company, 24
Lassie Come Home (1943), 43
Latham loop, 158n7
Laura (1944), 61
Lawrence, Florence, 20–21, 24
Lawson, John Howard, 66
LeBaron, William, 55
Lebron, Marion, 16
Lee, Irene, 53,
Leigh, Janet, 76
Leonard, Robert Z., 39, 45
Leone, Sergio, 109
Leon Schlesinger Studios, 51
LeRoy, Mervyn, 38, 40, 43, 49, 74
Lester, Mark, 121
Lester, Richard, 104

Lev, Peter, 57
Levin, Gerald, 169n36
Levin, Ira, 88
Levine, Joseph E., 11, 12, 77–83, *78*
Lewin, Albert, 40
Lewton, Val, 56–57, 121
Lichtman, Al, 43
Lief, Max, 41
Life of Emile Zola, The (1937), 52
Lights of New York, The (1928), 49
Little Big Man (1970), 89
Little Caesar (1931), 49
Little Colonel, The (1935), 59
Little Fauss and Big Halsey (1970), 95
Little Girl Who Lives Down the Lane, The
 (1977), 106
Little Lord Fauntleroy (1936), 45
Littlest Rebel, The (1935), 59
Little Women (1933), 55, 56
Litto, George, 107, 108
Litvak, Anatole, 51
Living Out Loud (1998), 129
Llosa, Louis, 125
Lloyd, Frank, 39, 66
Lockheed Martin, 146
Loew, Arthur, 71
Loew, Marcus, 23, 28, 39, 57
Loew's/MGM, *see* MGM
Loew's Inc., 71
Logan, Joshua, 93, 95
Looney Tunes, 51
Loren, Sophia, 75
Lorenzen, Mark, 134
Lorimar, 106
Louis B. Mayer Productions, 39
Love, Bessie, 40
Love at First Bite (1979), 107, 108
Love of the Last Tycoon, The (Fitzgerald),
 9–11, 35–37
Loves of Queen Elizabeth, The (1912), 23
Love Story (1970), 88
Lubin, Sigmund, 15
Lucas, George, 90, 115, 128, 136
Lumière, Auguste, 8
Lumière, Louis, 8
Lynda Obst Productions, 123
Lyne, Adrian, 14, 86, 123

Maas, Frederica, 46, 59
Machine Gun Kelly (1958), 106
Madison Pollock and O'Hare, 103, 104
Mad Max (1979), 108
Magnani, Anna, 84
Maltese Falcon, The (1941), 53
Maltz, Albert, 66
Mamoulian, Rouben, 61
Mancini, Henry, 169n20
Manhattan Institute, 142
Mankiewicz, Joseph L., 60, 61
Mann, Anthony, 84
Mannix, Eddie, 43
Man on the Moon (1999), 129
Marion, Frances, 40, 41
Marnie (1964), 122
Marquand, Roger, 121
Marshall Plan, 70–71
Martin, Dean, 76
Martinson, Leslie, 106
Marx, Samuel, 43
Marx Brothers, 44
Mary Pickford Film Corporation, 24
Maslin, Janet, 125
Masry, Ed, 129
Mass, Irving, 73
Matsushita Electric Industrial Company,
 116–117
May, Elaine, 119
Mayer, Edith, 36
Mayer, Irene, 36, 45
Mayer, Louis B., 11, 23, 25, 36, *39*, 39, 40, *42*,
 42–45, 64, *65*, 66
Mayer, Vicki, 142–143
Mayo, Archie, 53, 61
Maysles, Albert and David, *78*
MCA, *see* Music Corporation of America
MCA/Universal, 115–117
McCarey, Leo, 59
McCarran Internal Security Act (1950), 81
McCarthy, Todd, 125, 127
McDowell, John, 65
McGraw, Ali, 89
McGuiness, James K., 65
McLean, Barbara, 60
McQueen, Steve, 2, 3
Medavoy, Mike, 124, 127

Meet Me in St. Louis (1944), 43

Men in Black 3 (2012), 13, 132

Menke, Sally, 126

Merrie Melodies, 51

Merry Go Round (1923), 31

Metro Pictures, 23, 25, 28, 39

Metro-Goldwyn-Mayer, *see* MGM

MGM (Metro-Goldwyn-Mayer), 9, *10*, 10, 30, *31*, 36–46, 62, 65, 66, 69, 71, 74, 91, 121, 160n9

Midnight Express (1978), 121

Milestone, Lewis, 61

Milius, John, 99, 106

Miller, Jade L., 133, 137, 139

Miller, Toby, 13

Minnelli, Vincente, 43, 64

Miramax, 2, 11, 124

Mission to Moscow (1943), 51

Modley, Rudolf, 16

Mones, Paul, 100

Monicelli, Mario, 81

Monogram Pictures, 37

Morawetz, Norbert, 140

Morse, Terry O., 78

Motion Picture Alliance for the Preservation of American Ideals, 65

Motion Picture Association of America (MPAA), 66, 69–73, 99, 146

Motion Picture Board of Trade of America, 26

Motion Picture Exports Association (MPEA), 69, 72–74

Motion Picture Patents Company (MPPC) Trust, 9, 15, 19, 21, 26

Motion Picture Producers and Distributors Association (MPPDA), 29, 51

Movie-Made America (Sklar), 64

Movies and Money (Puttnam), 119–120

Movie Workers (Kelijer et al.), 16–17

Moving Picture Girls, The (book series), 18

Moving Picture Girls at Rocky Ranch, The (Hope), 17, *18*

MPAA, *see* Motion Picture Association of America

MPEA, *see* Motion Picture Exports Association

MPPDA, *see* Motion Picture Producers and Distributors Association

Mr. Edison at Work in His Chemical Laboratory (1897), *8*

Mrs. Miniver (1942), 39

Murphy, Art, 122–123

Murray, Natalie, 84

Murray, William, 84

Music Corporation of America (MCA), 76, 113–117

Mutiny on the Bounty (1935), 39

NAMPI, *see* National Association of the Motion Picture Industry

NASA, *see* National Aeronautics and Space Administration

National Aeronautics and Space Administration (NASA), 145

National Association of the Motion Picture Industry (NAMPI), 26, 27, 29, 159n20

National General Pictures, 88

Nazimova, Alla, 25

NBC, 95, 114

Negulesco, Jean, 75

Nelson, Donald M., 67

Netflix, 138

New Century, 106

New Line Cinema, 169n36

Newman, Thomas, 128

New Regency, 3

New World Pictures, 106

Nicholson, Jack, 110

Night and the City (1950), 75

Nixon, Richard, 84, 97

North by Northwest (1959), 129

Northdurft, John, 142

Northrup, Solomon, 3–4

Not as a Stranger (1955), 76

Nye, Gerald, 52

Objective Burma! (1945), 66

Obsession (1982), 129

Obst, Lynda, 11, 86, 123, 130, 148–149

O'Dell, Denis, 103, 104

OECD, *see* Organization for Economic Co-operation and Development

Office of Naval Research, 145

Office of War Information (OWI), 71

O'Hara, Maureen, 61
Okun, Charles, 103, 104
Once Upon a Time in America (1984), 109
O'Neill, Eugene, 40
O'Neill, James, 23
Organization for Economic Co-operation and Development (OECD), 137–138, 140–141, 149–150
Orion Distribution Corporation, 108
Orion Pictures Corporation, 108, 109
Ornitz, Samuel, 66
OWI, *see* Office of War Information
Oxford and Cambridge University Boat Race (1895), 9

Pacino, Al, *88*, 91, *92*, 94
Paint Your Wagon (1969), 95
Pajetta, Gian Carlo, 82
Panasonic, 116
Panic in Needle Park, The (1971), 91
Paramount Decision (1948), 6, 12, 34, 67–68, 75–76, 77, 86
Paramount Pictures, 13, 24, 37, 38, 44, 46–48, 65, 75, 87–96, 104, 123, 161n46
Parker, Alan, 121
Paul, Robert, 8
PCA, *see* Production Code Administration
Peck, Gregory, 75
Penn, Arthur, 89, 90, 92, 109
People for the Ethical Treatment of Animals (PETA), 149
PETA, *see* People for the Ethical Treatment of Animals
Peter Stark Producing Program, 113, 122–123, 130
Peters, John, 122
Petrified Forest, The (1936), 53
Petulia (1968), 104
PGA, *see* Producers Guild of America
Phillips, Julia, 11, 87, 96–100, 169n36
Phillips, Michael, 96–98
Pickford, Mary, 20, 23–25
Pinocchio (1940), 56
Pisorno studio, 74
Pit and the Pendulum, The (1961), 106
Pitt, Brad, 2–4
Plan B, 2, 3

Plastic Age, The (1925), 46
Pohlad, Bill, 3
Polan, Dana, 126
Polanski, Roman, 89
Polansky, Jonathan, 147
Polglase, Van Nest, 55
Polonsky, Abraham, 67
Ponti, Carlo, 81
Power, Tyrone, 61
Praskins, Leonard, 41
Preferred Pictures, 46
Preminger, Otto, 61
Pride and the Passion, The (1958), 75, 83, 84
Pride of the Marines (1945), 66
Prisoner of Zenda, The (1913), 23
Prisoner of Zenda, The (1937), 45
Producers Guild of America (PGA), 131–132, 150, 172n2
Producers Releasing Corporation, 72
Production Code Administration (PCA), 36, 51, 52, 106
Professionals, The (1967), 93
Proffitt, Jennifer M., 140
Psycho (1960), 122
Publix Theatres Corporation, 44
Pulp Fiction (1992), 113, 124–126, *125*, 129
Purple Heart, The (1944), 61
Puttnam, David, 13, 119–122, *120*, 130
Puzo, Mario, 89, 91, 92

Q: The Winged Serpent (1982), 109
Quasar, 116
Quinn, Anthony, 84
Quirk, James R., 24
Quo Vadis (1949), 74

Radio Corporation of America (RCA), 55
Raft, George, 47, 49, 53
Ragtime (1981), 109
Raimi, Sam, 146
Rains, Claude, 54
Rand, Ayn, 161n46
Randle, Keith, 140
Rank, J. Arthur, 71
Ransohoff, Martin, 107
Rapf, Harry, 38–45, *42*, 62
Rapf, Joanna E., 12

Rapf, Maurice, 36, 45
Rasul, Azmat, 140
Raven, The (1963), 106
RCA, *see* Radio Corporation of America
Reagan, Ronald, 115
Rear Window (1954), 122, 129
Red River (1948), 76
Reeves, Steve, *80*
Reitman, Ivan, 121
Reliance Big Pictures, 138
Renoir, Jean, 59–60
Republic Pictures, 37
Reservoir Dogs (1992), 124
Return to Macon County (1975), 106
Reynolds, Kevin, *117*
Reynolds, William, 103, 104
Richmond, Ted, 71
Rin Tin Tin, 40
Riskin, Robert, 69
Ritt, Martin, 89
River Road, 3
RKO, 37, 38, 44, 45, 55–57, 60, 62, 66, 67, 69, 79, 121
RKO Television Corporation, 56
Roberts, Julia, 127, 128
Robinson, Casey, 54
Rocky (1976), 98
Rodgers, Ginger, 55
Rogers, Will, 59
Rolling Thunder (1977), 106
Roman Holiday (1953), 75
Rooney, Mickey, 43
Rosemary's Baby (1968), 88
Rosen, Phil, 66
Rosenberg, Stuart, 107
Rose Tattoo, The (1956), 84
Ross, Tessa, 3
Rosten, Leo C., 63
Rota, Nino, 169n20
Rough Sea at Dover (1895), 9
Rowland, Richard, 25
Roxanne (1987), 121
Rubin, J. Robert, 23
Ruddy, Al, 87, 95–96, 169n25
Ruggles, Wesley, 46
Russell, Elizabeth, 57
Rybnick, Harry, 78

Saas, Rollins, 144
Sackheim, Bill, 97
Salinari, Carol, 71
Sampson, Edward, 106
Samuel Goldwyn Inc., 37
Santi, Nello, 82
Sascha-Film, 38
Schaefer, Bill, 50–51
Schaefer, George J., 38, 56
Schaffner, Franklin, 90
Schamus, James, 11
Schary, Dore, 38, 43, 44, 63, 66, 67, 69
Schatz, Thomas, 4, 5, 12, 13, 34–35, 37, 38, 43
Schatzenberg, Jerry, 91
Scheider, Roy, *114*
Schenck, Joseph, 57, 58
Schenck, Nicholas, 44, 52, 163n14
Schlesinger, Leon, 51
Schoedsack, Ernest, 55
Schrader, Paul, 98, 99
Schulberg, Adeline Jaffe, 46–47
Schulberg, Ben (B. P.), 44, 46–48, 50, 59
Schulberg, Budd, 36
Scorsese, Martin, 96, 98, 100, 106, 109, 110
Scott, Adrian, 66, 67, 163n14
Scott, Randolph, 61
Scott, Ridley, 109
Scott, Tony, 14, 109
Screen Plays Inc., 67
Seagram Company, 117
Sealey, Peter, 118
Sears, Zelda, 41
Secret of Santa Vittoria, The (1969), 84
Segal, Erich, 88
Seitz, George B., 43
Seitz unit, 43
Selig, William, 15
Selwyn, Edgar, 40
Selznick, David O., 11, 35, 38, 40, 44–47, *46*, 55, 60, 79
Selznick, Lewis, 25, 45
Selznick, Myron, 76
Selznick International Pictures, 37, 45
Shamberg, Michael, 124, 125, 128
Shaw, George, 97
Sheehan, Winfield, 58
Sher, Stacey, 11, 13, 113, 123–130

Showman (1963), *78*
Sicilian, The (1987), 103
Sidney, George, 76
Siegel, Don, 99
Siegel, Sol C., 75
Simon, Neil, 119
Simpson, Don, 14
Sinatra, Frank, 75
Sin of Madelon Claudet, The (1931), 40
Sklar, Robert, 63, 64, 84
Sleepless in Seattle (1993), 86
Smith, Alexander, 70
Smith-Mundt Act (1948), 70
Snow White and the Seven Dwarfs (1937), 56
Social Network, The (2010), *137*
Society of Independent Motion Picture Producers, 67
Soderbergh, Steven, 127, 128
Sonnenfeld, Barry, 13, 132
Sony Corporation, 112, 115, 122, 124, 132
Sony-Columbia, 115
Sony-TriStar, 124
Sony USA, 112
Sorkin, Aaron, 136, *137*
Sorrell, Herbert, 64
Sound of Music, The (1965), 93
Specialist, The (1994), 125
Sperling, Cass, 49
Sperling, Milton, 49
Spider-Man 2 (2004), 146
Spielberg, Steven, 96, 97, 111, 113–116, 136, 138, 145
Staiger, Janet, 17
Stallone, Sylvester, 125
Stanley and Livingstone (1939), 59
Star Is Born, A (1937), 45
Star Wars (1977), 113
Star Wars 1—The Phantom Menace (1999), 128
Stark, Ray, 113, 119, 121, 122
Stark Program, *see* Peter Stark Producing Program
Stevens, George, 66
Stewart, Anita, 25
Sting, The (1974), 96
Stone, Oliver, 121

Story of Alexander Graham Bell, The (1939), 59
Story of a Soldier (1959), 82
Strike Up the Band (1940), 43
Stripling, Robert E., 65
Stromberg, Hunt, 39, 42
Summer Holiday (1963), 106
Sunset Blvd. (1950), 64, *65*
Swamp Water (1941), 59–60
Swanson, Gloria, 64, *65*
Swofford, Beth, 3
Sydney, Silvia, 44

Talmadge, Norma, 25
Talmey, Allenne, 22
T.A.M.I. Show, The (1964), 106
Tandem Productions, 109
Taniguchi, Senkichi, 106
Tarantino, Quentin, 113, 124–126, *125*
Taurog, Norman, 45
Taves, Brian, 33, 159n27
Taxi Driver (1976), 87, 96–100, *99*
Technics, 116
Tell Me a Riddle (1980), 109
Temple, Shirley, 59
Terminator 2 (1991), 124
Thalberg, Irving, 5, 10, 11, 23, 30–32, *31*, 35, 36, 39, 40, 42, *42*, 45, 160n9
Thau, Bennie, 43
Thomas, J. Parnell, 65
Thompson, Kristin, 32
Thomson, David, 44
Three Coins in a Fountain (1954), 75
Thurman, Uma, 126
Tierney, Gene, 59
Time Warner, 148, 169n36
Together Again (1944), 66
Tomkins, Calvin, 80
Top Gun (1986), 14
To the Shores of Tripoli (1942), 61
Tourneur, Jacques, 56, 57
Towne, Robert, 110
TransWorld Releasing Corporation, 78
Travolta, John, 124, 126
Trip, The (1967), 106
Tri-Star, 124
Trumbo, Dalton, 66

Trumbull, Douglas, *97*, 97–98
Tugboat Annie (1933), 40
Turner, Terry, 78, 79
Twentieth Century–Fox, 2, 3, 37, 38, 52, 57–59, 73, 75, 80, 113, 115
Twentieth Century Pictures, Inc., 58
Two Flags West (1950), 60
Two Women (1960), 81

UFA, 38
United Artists, 25, 36, 37, 57, 58, 76, 101, 102–104, 170n39
United States Department of Defense, 145
United States Department of Justice, 29
Universal City, 21
Universal Film Manufacturing Company, 19, 21–22, 170n1
Universal Studios, 2, 30, 37, 72, 96, 111–118, 130, 148, 170n1
University of Central Florida Institute for Simulation and Training, 145–146
Utley, Nancy, 3

Valenti, Jack, 96
Valentino, Rudolph, 30
van Dyke, W. S., 43
Vertigo (1958), 122, 129
Vidal, Gore, 109
Vidor, Charles, 66
Vidor, King, 40, 79, 161n46
Viera, Mark A., 31–32
Vincent, Fay, 118
Violets Are Blue (1986), 121
Vista Films International, 106
Voluntary Movie Rating System, 106
von Sternberg, Josef, 47
von Stroheim, Erich, 31–32

Waldorf Statement (1947), *66*, 67
Wallis, Hal, 50, *53*, 53–54, 76, 161n46
Walsh, Raoul, 66
Walt Disney Company, 2, 56, 115, 124, 146, 148
Walt Disney Productions, 37
Wanger, Walter, 44, 46, 67
Warner, Abe, 48–49
Warner, Harry, 48–49, 51, 54–55, 59

Warner, Jack, 48–51, 53, 54, 57, 65, 66, 76, 161n46
Warner, Sam, 48
Warner Bros., 9, 37, 38, 40, 43, 48–55, 57, 59, 60, 76, 108, 115
Wasserman, Lew, 11, 13, 111–117, 119, 122, 129–130
Waterworld (1995), 117, 171n9
Watson, Neil, 119
Weingarten, Larry, 40, 43
Weinstein, Bob, 11
Weinstein, Harvey, 11, 124
Weintraub Entertainment Group, 106
Weiser, George, 89
Welles, Orson, 38, 56, 124
Wellman, William, 38, 45
Werker, Alfred L., 52, 61, 162n7
West, Mae, 47–48
Weston, Brad, 3
WGA, *see* Writers Guild of America
What's Up Tiger Lily? (1966), 106
Wheeler, Burton, 52
White, James, 8
Whitney, William, 106
Who Was That Lady? (1960), 76
Widmark, Richard, 75
Wilcox, Fred M., 43
Wild Angels, The (1966), 106
Wilder, Billy, 64, *65*
Wild in the Streets (1968), 106
Wild Party, The (1929), 48
Wild Seed (1965), 95
Willis, Gordon, *92*
Willkie, Wendell, 52
Wilson, Richard, 106
Wilson (1940), 59, 60, 62
Wings (1927), 38
Wise, Robert, 56, 60, 93
Wizard of Oz, The (1939), 43
Woman of the Year (1942), 66
Wood, John, 65
Wood, Sam, 66
Woods, Paula, 3
World Film Corporation, 25
World Health Organization (WHO), 147–148
Wray, Ardel, 56–57

Writers Guild of America (WGA), 134
Wurtzel, Sol, 59
Wyler, Robert, 75
Wyler, William, 38, 39, 57, 60, 75

Xbox, 146

Yablans, Frank, 95
Yank in the R.A.F., A (1941), 61
Yates, Peter, 90, 106, 110
Yesterday, Today, and Tomorrow (1963), 81

Yorkin, Bud, 109
Young, Clara Kimball, 25
Young Mr. Lincoln (1939), 59, 61

Zanuck, Darryl F., 11, 38, 42, 49, 50, 52, 57–62, 67, 75, 80, 162n7
Zimbalist, Sam, 74
Zinnemann, Fred, 90
Zinner, Peter, 93
Zukor, Adolph, 19, 22–26, 34, *35*, 44, 46, 159n20